Shanghai
ART OF THE CITY

SHAN

Art of the City

GHAI

by Michael Knight and Dany Chan

with contributions by Nancy Berliner, Britta Erickson,
He Li, Li Lei, Shan Guolin, and Wen-hsin Yeh

Published on the occasion of the exhibition *Shanghai,* co-organized by the Shanghai Museum and the Asian Art Museum—Chong-Moon Lee Center for Asian Art and Culture. The exhibition was presented in San Francisco at the Asian Art Museum from February 12 through September 5, 2010.

Presentation at the Asian Art Museum was made possible by Carmen M. Christensen, the Koret Foundation, the Bernard Osher Foundation, the MetLife Foundation, the National Endowment for the Arts, Credit Suisse, and China Guardian Auctions Co., Ltd.

The museum gratefully acknowledges the underwriting of this catalogue by Fred M. and Nancy Livingston Levin, the Shenson Foundation, in memory of Ben and A. Jess Shenson and in honor of their family's passion for Chinese art.

PHOTO PERMISSIONS: The Asian Art Museum extends its thanks to our partner institutions—the Lu Xun Memorial Hall, the Shanghai Art Museum, the Shanghai History Museum, the Shanghai Museum, and the Shanghai Propaganda Poster Art Centre—which have generously provided images of works from their collections for this catalogue. We are also grateful for additional image permissions as follow: *Appearance of Crosses 1991–3* and *Cloth Sculptures on the Street* reproduced by permission of ShanghART Gallery and Ding Yi. *Augustine Heard and Company's Hong and Residence, Shanghai* (M5131), *House of Dent, Beale & Company* (M3794), *Shanghai* (M10565), *Shanghai: The Bund, within the Premises of Russell & Company* (AE85781), and *View of the Shanghai Bund* (E82723): photographs courtesy of the Peabody Essex Museum. *Can You Tell Me?* and *Shadow in the Water* reproduced by permission of Liu Jianhua. Images from *City Light, Honey,* and *Liu Lan* reproduced by permission of ShanghART Gallery and Yang Fudong. *The Dimension of Ink No. 1* reproduced by permission of Zheng Chongbin. *Forest* reproduced by permission of Li Huayi. *Landscape—Commemorating Huang Binhong—Scroll* reproduced by permission of ShanghART Gallery and Shen Fan. *Mawangdui 2009* reproduced by permission of Liu Dahong. *MOCA Shanghai* reproduced by permission of MOCA Shanghai. Images from *The New Book of Mountains and Seas Part 1* reproduced by permission of Qiu Anxiong. Opening of the Gallery of the Shanghai Drama Institute reproduced by permission of Zheng Shengtian. Panda Couture reproduced by permission of ShanghART Gallery and Zhao Bandi. *Shanghai Lily* reproduced by permission of ShanghART Gallery and Zhou Tiehai. *Un/Limited Space (4): The Shower* reproduced by permission of Zhou Tiehai. *Vestiges of a Process: Shanghai Garden, Vestiges of a Process: ShiKuMen Project 2007,* and Zhang Jian-Jun at the '83 Experimental Painting Exhibition reproduced by permission of Zhang Jian-Jun.

CHINA GUARDIAN AUCTIONS CO., LTD.

FRONT COVER: Detail, cat. no. 62; BACK COVER: Detail, cat. no. 63
HALF TITLE AND ELSEWHERE: Chinese characters for Shanghai. *Shang* means "upon or above"; *hai* means "sea." Therefore *Shanghai* can be translated as "Upon the Sea," an appropriate name for this port city.
PAGES II–III: Detail, cat. no. 121; PAGES IV–V: Detail, cat. no. 33; PAGES VI–VII: Detail, cat. no. 93;
PAGES VIII–IX: Detail, cat. no. 82; PAGE XI: Detail, cat. no. 89; PAGES XII–XIII: Detail, cat. no. 10, leaf E;
PAGES 2–3: Detail, cat. no. 65; PAGES 8–9: Detail, cat. no. 103; PAGES 24–25: Detail, cat. no. 37;
PAGES 32–33: Detail, cat. no. 13; PAGES 246–247: Detail, cat. no. 26; PAGES 260–261: Detail, cat. no. 13

視遠惟明
周慕橋

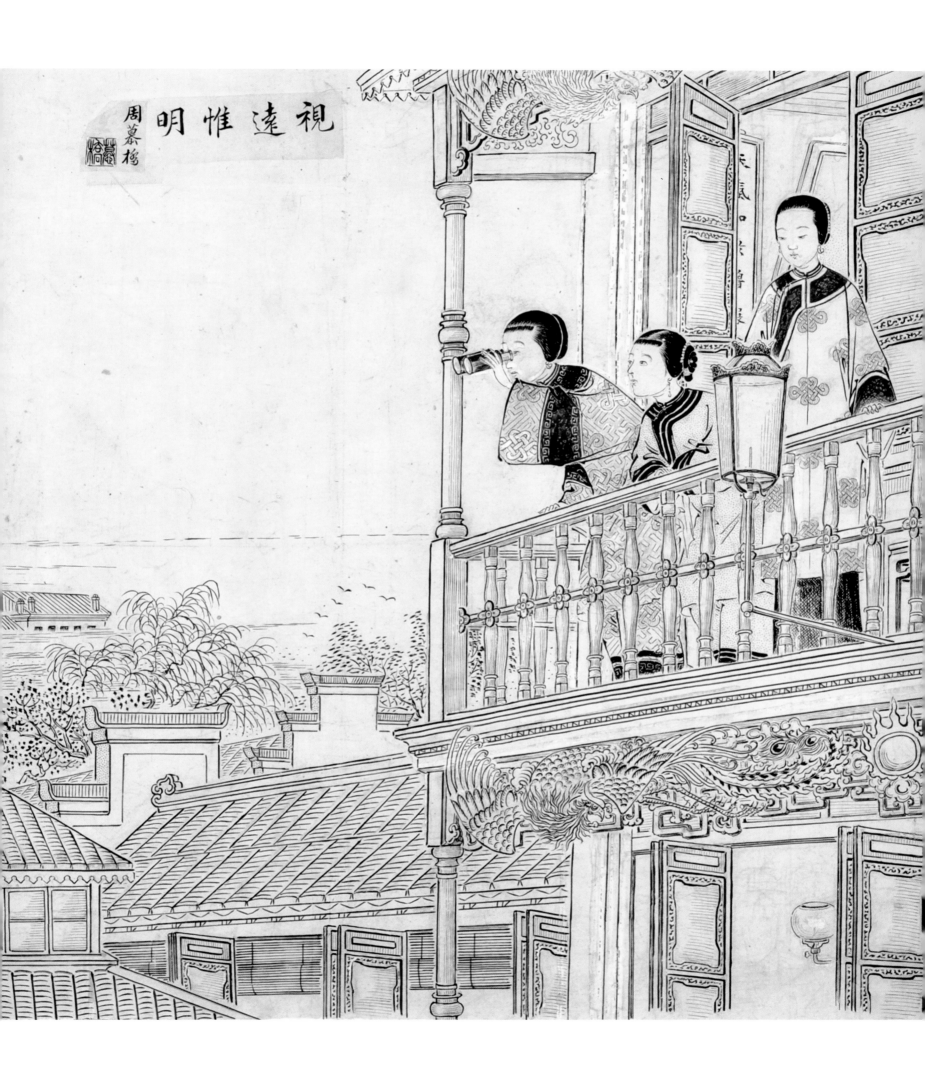

Contents

CATALOGUE

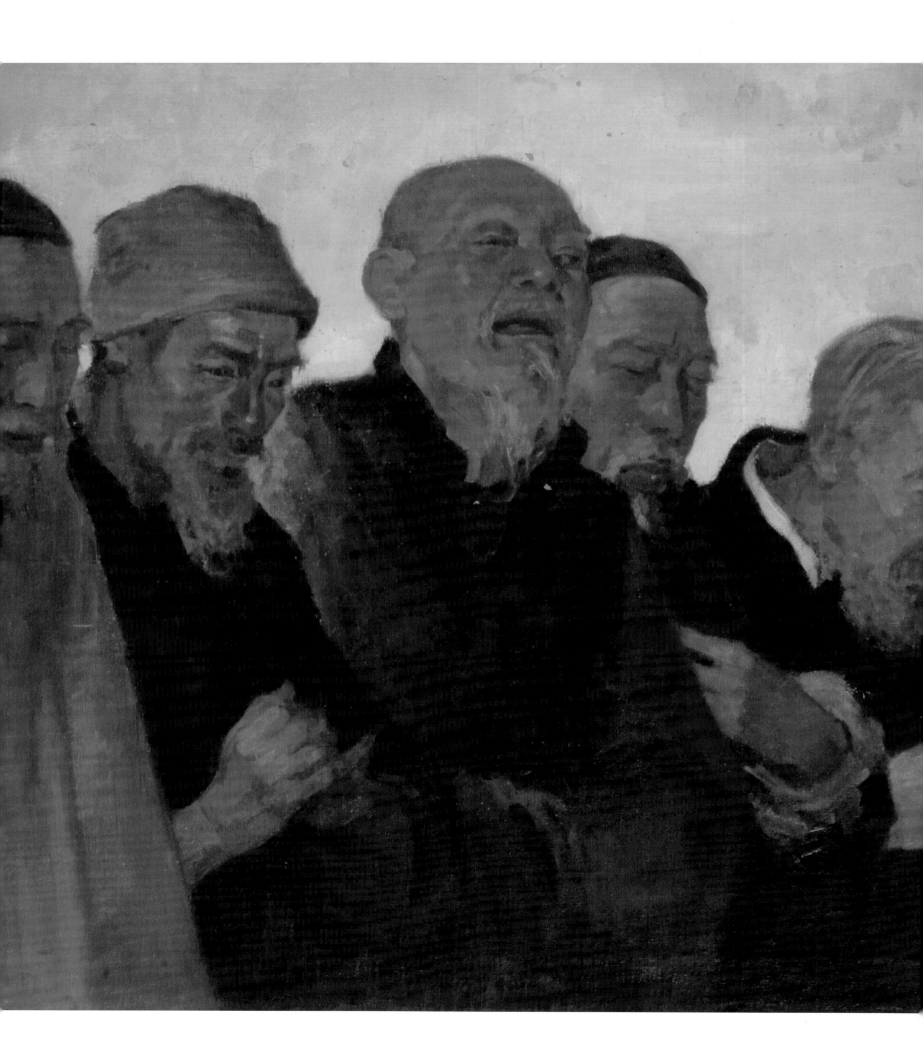

In November 2008, I visited my hometown of Shanghai in the company of San Francisco Mayor Gavin Newsom and other members of a delegation from San Francisco. On that occasion, I joined my international colleagues in signing a memorandum of understanding between the Asian Art Museum and the Shanghai Museum, commemorating our collaboration for the exhibition that this catalogue documents. This was the culmination of several years' work on an exhibition that celebrates the visual culture of Shanghai from its beginnings as a trade port to its current status as an economic and artistic powerhouse that has captured the world stage.

At the event, the mayor noted that "this exhibition was conceived to take place during the same year that Shanghai hosts the World Expo 2010 as a way to honor the long-standing relationship that our city and theirs have maintained for over 150 years." He added that the exhibition and plans for a citywide celebration of Shanghai provide "a wonderful opportunity for artistic, educational, and commercial organizations to unite around a common interest and present to our neighbors locally, across the nation, and across the Pacific the truly international flavor that we collectively share."

The history of the exhibition is tied to the unique relationship between the cities of San Francisco and Shanghai. In 1980 San Francisco and Shanghai established a Sister City relationship, the first such relationship between a city in the United States and one in China. More than two hundred projects have been sponsored by the Sister City relationship during the past thirty years. Exchanges have included commercial, cultural, educational, governmental, and technological programs. One of the earliest cultural exchanges was the exhibition *Treasures from the Shanghai Museum* hosted by the Asian Art Museum in 1983. The two museums have cooperated on a number of projects since that time.

Shanghai continues the tradition of cooperation between these two great cities. In 2006 Michael Knight, the Asian Art Museum's Senior Curator of Chinese Art, began discussions with the Shanghai Museum concerning an exhibition for 2010, the year in which Shanghai will host its World Expo. His vision was to invite our respected museum

counterparts in Shanghai to partner with the Asian Art Museum's curatorial staff to prepare an exhibition focused on the visual and material culture unique to their city.

As the project progressed, Michael found that Nancy Berliner at the Peabody Essex Museum in Salem, Massachusetts, was also working on an exhibition pertaining to Shanghai. Rather than compete, the two curators decided to cooperate. Dr. Berliner was invaluable in developing the core concepts for the exhibition, choosing the objects, and negotiating with our colleagues in Shanghai. The Peabody Essex Museum has lent five China Trade paintings with scenes of Shanghai to the exhibition, and Dr. Berliner has contributed an essay to this catalogue.

In Shanghai, Mr. Chen Xiejun, Director of the Shanghai Museum; Ms. Zhou Yanqun, the Shanghai Museum's Head of the Foreign Relations Bureau; and Mr. Chen Kelun, Vice Director of the Shanghai Museum, arranged for loans from their own collection and enlisted the cooperation of the Shanghai Art Museum, which is dedicated to modern and contemporary art; the Shanghai History Museum; the Lu Xun Memorial Hall; and other Shanghai cultural and artistic entities. We are immensely grateful for their contributions.

Li Lei, Director of the Shanghai Art Museum, and Shan Guolin, head of the painting department at the Shanghai Museum, have each contributed an article to this catalogue. Britta Erickson served as the consulting curator for the contemporary section of the exhibition and provided an essay and entries for this catalogue. Our thanks to ShanghART Gallery in Shanghai for its assistance in arranging several loans from contemporary artists living in Shanghai. Wen-hsin Yeh, of the University of California, Berkeley, served as an advisor to the overall project and contributed a substantive essay on the history of Shanghai, for which we are most grateful.

The exhibition would not have been possible without generous contributions from Carmen M. Christensen, the Koret Foundation, the Bernard Osher Foundation, the MetLife Foundation, the National Endowment for the Arts, Credit Suisse, and China Guardian Auctions Co., Ltd. Fred Levin and Nancy Livingston also provided generous funding that made this catalogue possible.

Christine Taylor and her team at Wilsted & Taylor provided both editorial and design services for the catalogue, with its production overseen by Dany Chan and Thomas Christensen on the museum's staff. Dany has been vital in all aspects of the exhibition. She served as a liaison between the Asian Art Museum and the institutions in China and was critical in negotiating and maintaining the object list. She is one of the major contributors to this catalogue while also meeting the needs of all the authors and keeping them on schedule.

Nearly all the museum's staff is involved in preparing a large exhibition such as this, and it is impossible to name all those whose work was vital. Special recognition, however, goes to Deborah Clearwaters and Allison Wyckoff in the Education department; Pauline Fong-Martinez and the staff in Visitor Services; Robin Groesbeck and her Museum Services team; Michele Dilworth and her colleagues in Public Relations and Marketing; Cathy Mano and her colleagues in Registration; Katie Holbrow and her team in Conservation; exhibition designer Stephen Penkowsky, Head of Preparation Brent Powell, and the museum preparators; Amory Sharpe and the Development department team; museum librarian John Stucky and the library volunteers; photographer Kaz Tsuruta and Aino Tolme and Jessica Kuhn in Image Services; and many more. It is to the credit of such team effort that we have succeeded in bringing to San Francisco the dynamic visual culture of our sister city Shanghai.

Jay Xu
Director, Asian Art Museum

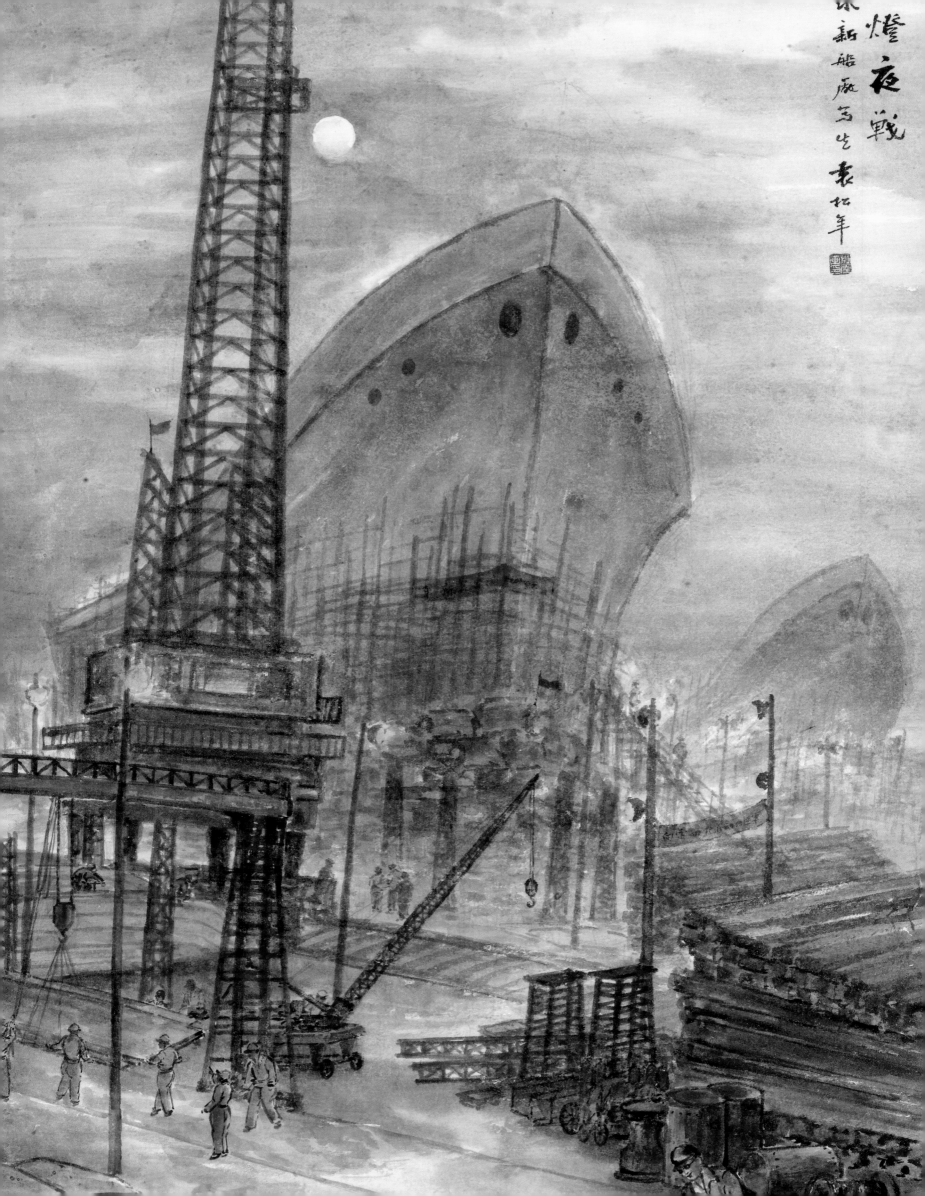

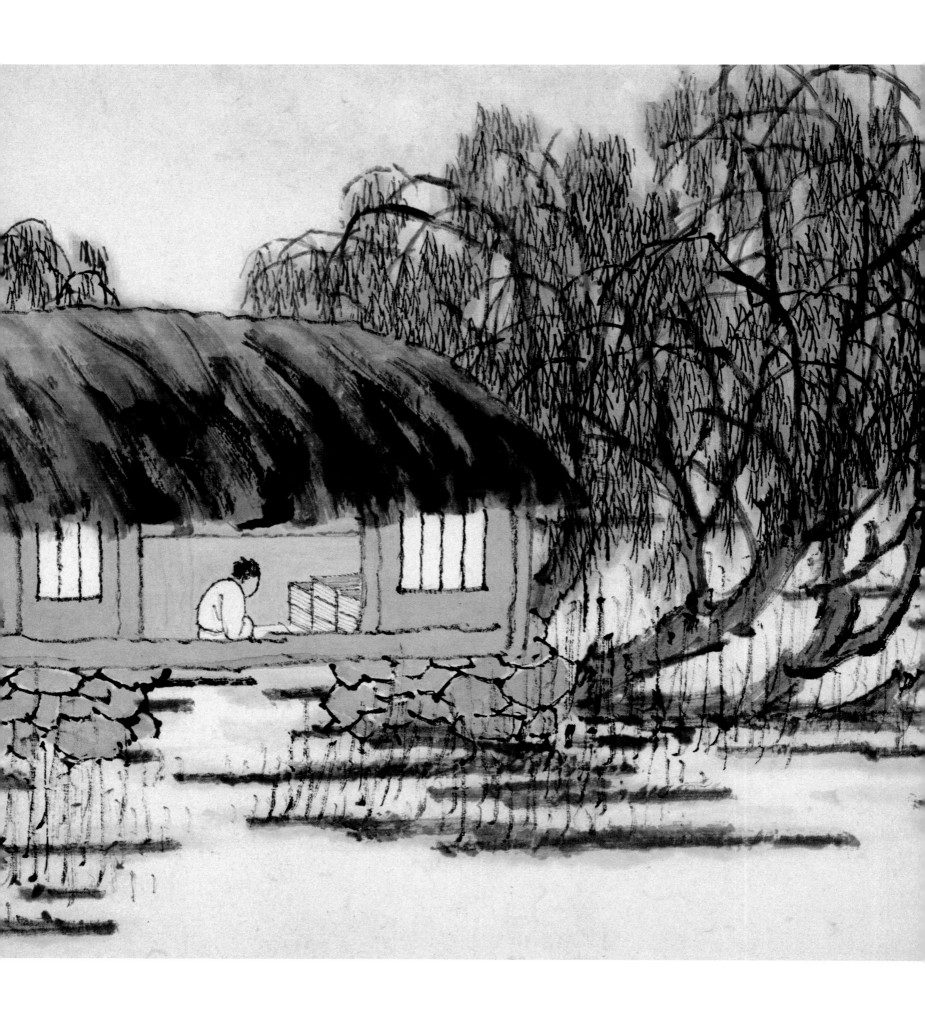

In the hundred-plus years since Shanghai opened in 1843, the treaty port has grown rapidly to become China's major city of finance and trade. During that time the unceasingly turbulent political situation transformed Shanghai into a stage for all kinds of competing ideologies and cultural trends. The city's art and culture bustle with a multitude of developments, the new constantly replacing the old. Their rich diversity of content and forms strongly reveals a zeitgeist and regional characteristics.

Shanghai, an exhibition co-organized by the Shanghai Museum, the Shanghai Art Museum, the Shanghai City History Museum, the Lu Xun Memorial Hall, and the Asian Art Museum of San Francisco, presents artworks and historical documents of the past one hundred fifty years. Through these representative works, the exhibition draws a general overview of the cultural evolution of Shanghai.

Featured in the exhibition are Shanghai-school paintings that were prominent from the late Qing dynasty through the Republic period. Other pieces represent the different styles that emerged from the reform current beginning in the early twentieth century, which tended to absorb Western art techniques in attempts to modify traditional Chinese painting.

The growth of business and the inflow of Western culture brought new arts such as oil painting, watercolor, gouache, and comics. Commercial and package arts, including advertisements, posters, book design, and illustrated publications, gradually became more popular. Illustrated calendars especially appealed to Shanghai townspeople, and woodcuts pointedly addressed political issues during the wars.

The exhibition also encompasses works of ink and colors, oil, woodcuts, and video from the late 1950s to the present day, depicting daily life and the fresh atmosphere of the new China.

In 2010, while the World Expo takes place in Shanghai, the Asian Art Museum of San Francisco will host the exhibition *Shanghai*, thus providing a platform for the American audience to learn about and better understand Shanghai's history and culture. Recalling history and looking to the future, I hope the ideal "to make metropolitan urban life happy and beautiful" will find its way deep into people's hearts.

Chen Xiejun
Director, Shanghai Museum

上海

Shanghai
ART OF THE CITY

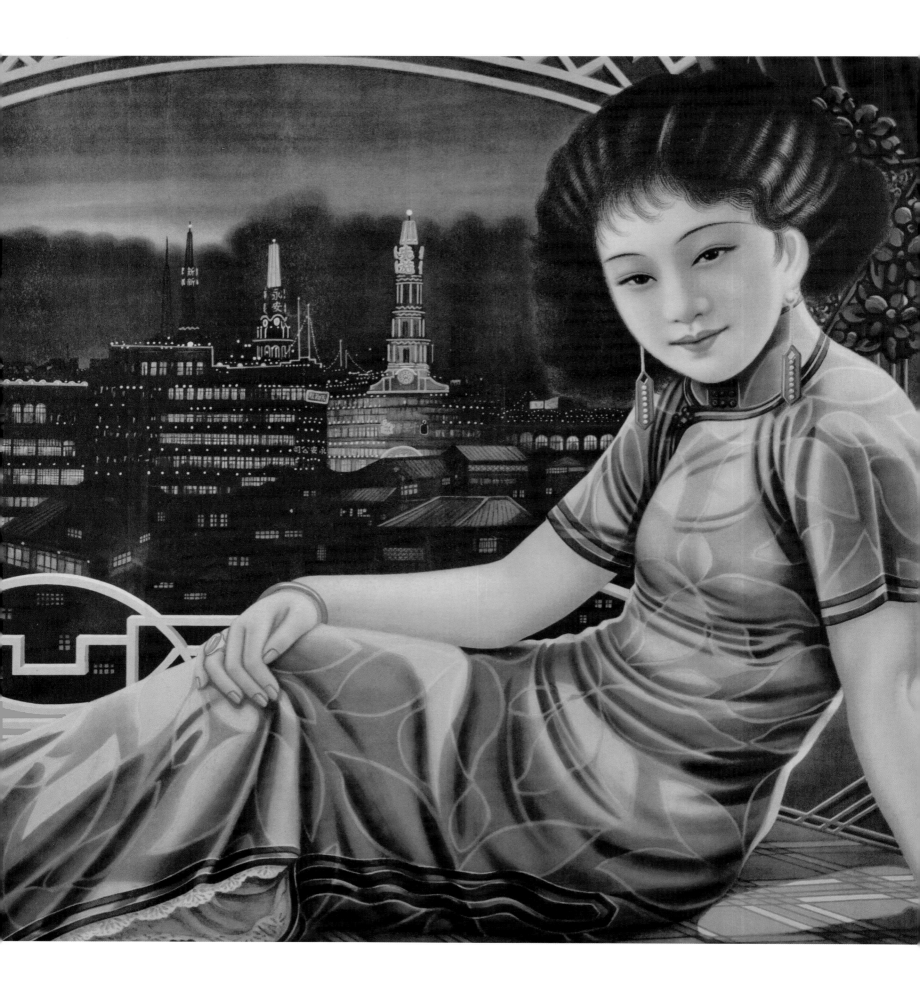

Shanghai

Art of the City

by Michael Knight and Dany Chan

Globalization is an undeniable reality that affects all aspects of contemporary life, including art, politics, commerce, and ecology. It has become a source of deliberation and discourse among world leaders and thinkers. In the humanities, the effects of globalization on the world's cultures have been both lauded and decried. One often-expressed fear is that cultural diversity will be supplanted by bland homogeneity;[1] another fear cited is the resulting fragmentation or wholesale destruction of local identities.[2] Those on the other side of the argument assert that cultural homogeneity is not necessarily a given with globalization; rather, countermovements have emerged in adaptation, interpretation, or outright resistance. Certain cultures have diversified their ideas and practices in response to global pressures,[3] while others have sought reinvention of local identity, and still others have chosen indigenization in reaction to foreign influences.[4]

Shanghai: Art of the City examines and interprets these myths and realities of globalization within the context of the development of one city's visual culture. It presents the city of Shanghai as a case study of the politics of cultural globalization as traced over a period of 160 years. How has Shanghai been affected by a globalizing history? Which responses were utilized, successfully or unsuccessfully? Shanghai proves to be an ideal object of study for two reasons: 1) it can be argued to possess the most internationalized history of all of China's cities, and 2) the majority of images composing the city's visual culture stemmed from deliberate and self-conscious decisions on the part of the image makers. In defining "art of the city," several layers of meaning unfolded: on one layer, it means the images that depict the cityscape, of which there are many, or the works created by its residents, or simply the visual material one finds within the city's boundaries; on another layer, it intimates the role of art in creating a public persona for the city— in other words, "Shanghai-the-city" may have been first imagined in pictures before becoming political reality.[5]

Shanghai emerged as an international city due to a clash over trade between China and Great Britain. The Chinese had three products for which a vast and unquenchable demand existed in Great Britain, the United States, and other Western countries: tea, porcelain,

and silk. The primary product the West had to offer in exchange, however, was opium, which the Chinese government attempted to ban. In 1840, the British declared war to force the Chinese government into accepting the importation of opium. In what is commonly known as the First Opium War, British forces quickly defeated the Chinese, resulting in the 1842 Treaty of Nanjing that dictated the opening of five "treaty ports"—Ningbo, Fuzhou, Xiamen (Amoy), Guangzhou (Canton), and Shanghai—to direct trade with the West. Following British example, American traders, led by American merchants with a strong presence in China, such as Russell & Company (cat. no. 5), also pressured Chinese authorities to grant them special privileges in Shanghai.[6] France, Germany, and other nations soon claimed similar spheres of influence within China, with the French possessing their own concession in Shanghai.

Despite its relatively small size and population, Shanghai was considered valuable to Western powers because of its excellent seaport and its access by river to the Yangzi River basin, China's wealthiest and most populous region. As Shanghai grew throughout the late 1800s, it developed into three distinct parts, each with its own governing body: the French Concession, the International Settlement (British and American), and the Chinese city. Only the Chinese city was governed by Beijing. The French Concession was administered by a consul who was appointed by the French government—loosely analogous to the British governor of Hong Kong. Its territory flanked and included parts of the old city. The French population in Shanghai was never large, and the French Concession became a residential district for many of the city's wealthy. The International Settlement was made up of the British Concession on one side of Suzhou Creek and the American Concession on the other; they were joined in 1863. The International Settlement was governed by a municipal council made up of nine men elected by the foreign property owners; Chinese were not allowed to hold office or to vote.

This division from China and the Concessions' special form of government remained in effect for one hundred years.

Shanghai was an attractive destination for many people for a variety of reasons. One was economic promise, and another was political refuge. For the former, such world events as regular service by the Pacific Steamship Company (1867), the opening of the Suez Canal and completion of the transcontinental railroad in the United States (1869), and the opening of the Panama Canal (1914) all contributed to a surge of international trade and Shanghai's importance in this network. Traders and adventurers from all corners of China—and the globe—flocked to the city to make their fortune. Some were successful in their quest; many were not.

Regarding political refuge, Shanghai became a haven for millions of Chinese forced to flee from major rebellions that erupted in the mid- to late 1800s. Two of them, the Taiping (1851–1864) and the Nian (1851–1868) Rebellions, threatened to overthrow the Manchu-ruled Qing dynasty. The most disruptive of these, the Taiping Rebellion, ravaged central China, killing as many as twenty million people and creating an enormous number of refugees. More than half a million of these refugees made their way to the confines of the International Settlement of Shanghai. By 1895, China was a country in utter turmoil, beset by internal strife, widespread famine, warfare, increasing demands of Western powers, and an imperial system in disarray.

As a result of its atypical form of government and economic system, however, Shanghai was largely resistant to these events; in fact, it flourished into what many regard as a golden era, with the city's population exceeding one million by 1910. In describing the appeal of Shanghai under the Nationalist government (1912–1949), Wen-hsin Yeh states:

As urban middle class employees surveyed the landscape, they saw China's vast rural interior in the grip of famine, flooding,

4

banditry, warring generals, marauding soldiers, rioting peasants, opium addicts, and gamblers. The city, by contrast, was not only a place of jobs and opportunity, but also a carefully constructed space with tree-lined boulevards, public parks, private gardens, neon lights, glittering shop fronts, bustling entertainment quarters, towering office buildings, and so forth. Urban inhabitants had access to various forms of modern culture: theaters, cinemas, concerts, sports, bookstores, publishing houses, newspapers, schools, and so on. It was also a more secure life because of the availability of doctors, hospitals, policemen, fire fighters, welfare agencies, and benevolent societies.[7]

Shanghai's surging population included many distinct ethnic groups in addition to the Chinese. One example is the city's strong and influential Jewish community. Among the first to arrive were Iraqi Jews, who came to the city in the mid-1800s as merchants. Their descendants financed the building of the Sassoon House, also known as the Cathay Hotel (now the Peace Hotel), and other architectural landmarks, as well as much of the famous shopping district along Nanjing Road. A second group of Jews— at least thirty thousand—came to Shanghai from Eastern Europe in the late 1930s and early 1940s, seeking safety from the horrors of the Holocaust. After the Japanese occupied Shanghai in 1937, a Jewish ghetto in Hongkew, just north of the Bund, was designated for this community. It was poor but thriving, with Yiddish radio stations and newspapers. Other European groups who sought refuge in Shanghai included "White" Russians fleeing the turmoil from Russia's 1917 Communist revolution.

Because of its economic power and close contact with Japanese, Western, and other world cultures, Shanghai became a major

BELOW LEFT Map of Shanghai showing city districts, including the large Pudong New Area on the eastern shore of the Huangpu River. BELOW RIGHT Map of Shanghai showing the original walled Chinese city and the British, American, and French Concession areas (the former two combined as the International Settlement). (Maps courtesy of Wen-hsin Yeh, modified by Jason Jose)

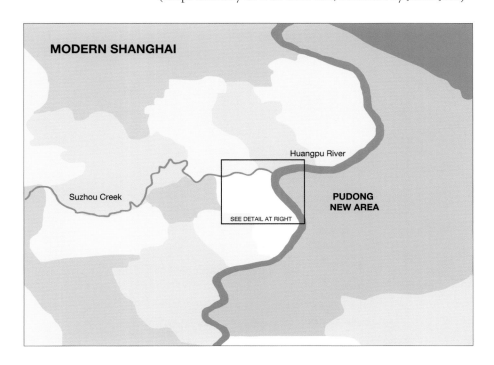

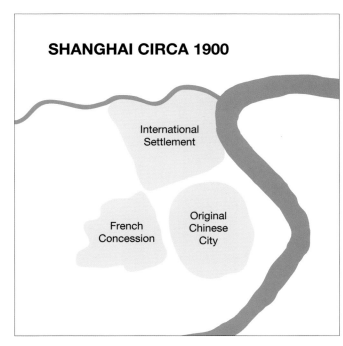

Chinese center for creative thinking beginning in the early 1900s. Various political movements had headquarters in the city, including those that eventually led to the fall of imperial China, the establishment of the Republic of China (1912–1949), and the later establishment of the People's Republic of China. For example, the First National Congress of China's Communist Party was held in the city in 1921.[8] When the Communist Party gained control in 1949, however, Shanghai's status as a wealthy, globalized enclave did not endear it to China's new leadership. The situation worsened for foreigners in the city during the ten years of the Cultural Revolution (1966–1976). During this period the city was closed to trade from the West, and Shanghai was transformed into one of China's key industrial and shipbuilding centers.

From a visit in 1960, Edgar Snow described the changes he observed from the Shanghai he had known in the 1930s:

> Gone the glitter and the glamour; gone the pompous wealth beside naked starvation. Good-bye to all that: the well-dressed Chinese in their chauffeured cars behind bullet-proof glass; the gangsters, the shakedowns, the kidnappers, the exclusive foreign clubs, the opium dens and gambling halls; the flashing lights of the great restaurants, the clatter of the mah-jongg pieces, the yells of Chinese feasting and playing the finger game for bottoms-up drinking, the innumerable shops spilling over with silks, jades, embroideries . . . the peddlers and their plaintive cries; the armored white ships on the Whangpoo [Huangpu] . . . the Japanese conquerors and American and Kuomintang successors; gone the wickedest and most colorful city of the old Orient; good-bye to all that. . . . The tall buildings are there, but the International Settlement and the French Concession, which used to be the heart of a modern megalopolis, are strangely quiet now and downtown after dark is as quiet as Wall Street on ι Sunday.[9]

During the late 1970s and 1980s, Shanghai proved essential to China's financial health. Due to its earlier wealth, the city was tapped to be the single largest contributor of tax revenue to the central government, providing financial support for nationwide construction and the "experimental" economic reforms of the 1980s. The consequences for Shanghai included the weakening of both city infrastructure and capital development. In addition, owing to its status as the nation's financial backbone, the city was prohibited from participating in any of the risky economic reforms that it was subsidizing, lest its revenue production be hampered by an experiment gone awry.[10]

In 1991, the central government permitted Shanghai to initiate economic reforms, and the consequent response has been remarkable. This time, with the Chinese at the helm, the city has become the world's largest port and is developing at a dizzying pace to re-emerge on the international stage as a significant cultural and economic player. Despite a hiatus of fifty years that included a world war, Japanese occupation, and the Cultural Revolution, Shanghai's creative and mercantile energy could not be dampened. The world has rushed back to Shanghai, resulting in a construction boom from skyscrapers to art galleries. The city returns to its former status as an icon of globalization.

By all accounts, Shanghai remains a global city, possessing a heterogeneous population and a pluralism of cultures.[11] In tracing the development of the city's *visual* culture, several facets render Shanghai unique: 1) the city is a powerhouse in the production of a range of cultural material, including oil paintings, lifestyle magazines, film, and interior design; 2) its producers, comprising both Chinese and foreign-born residents, serve domestic and overseas markets of both Chinese and foreign-born consumers; and 3) this visual enterprise has been, from the start, intended to be accessible to all. Through individual object study and thematic considerations, this catalogue will explore Shanghai's responses to its globalizing history, predicated on the premise

that Shanghai did resist such "ill fates" as cultural homogenization through reflexive awareness and active participation on the part of its producers, and consumers, in shaping the dynamic image of the city into what can be branded a "Shanghai style" (or *haipai*).

1 Cohen and Kennedy, *Global Sociology*, 528 and 536.
2 Ibid., 51 and 507.
3 Dikötter, *Exotic Commodities*, 22.
4 Cohen and Kennedy, *Global Sociology*, 331.
5 The idea of an "imagined community" was first suggested by Anderson in *Imagined Communities*; cited in Lee, "Shanghai Modern," 113.
6 Lockwood, "Augustine Heard and Company," 4.
7 Yeh, *Shanghai Splendor*, 119.
8 Schoppa, *Modern Chinese History*, 72.
9 Snow, *Red China Today*, 529–530.
10 Shanghai Star, "History."
11 Cohen and Kennedy, *Global Sociology*, 519 and 540.

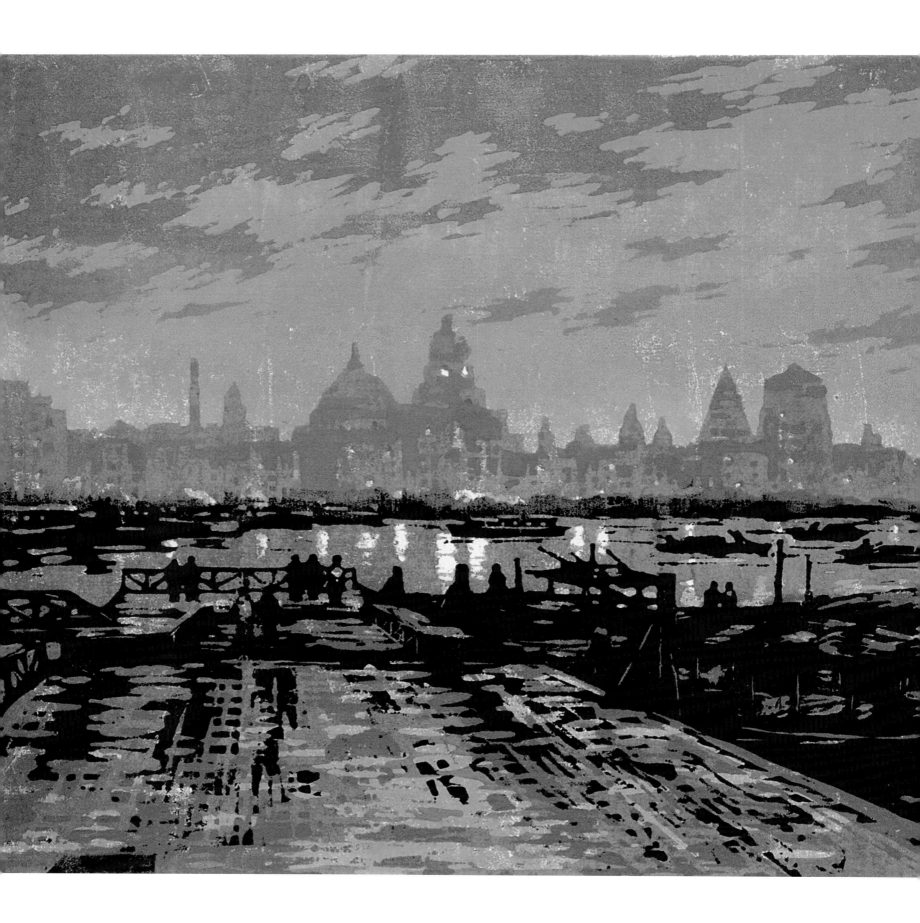

A Tale of Three Cities

Shanghai from 1850 to the Present
by Wen-hsin Yeh

The Huangpu River (Huangpu Jiang) is the city's shipping artery both to the East China Sea and to the mouth of the Yangzi River, which the Huangpu joins 29km (18 miles) north of downtown Shanghai. It has also become a demarcating line between two Shanghais, east and west, past and future. On its western shore, the colonial landmarks of the Bund serve as a reminder of Shanghai's 19th-century struggle to reclaim a waterfront from the bogs of this river (which originates in nearby Dianshan Hu or Lake Dianshan); on the eastern shore, the steel and glass skyscrapers of the Pudong New Area point to a burgeoning financial empire of the future.

The Huangpu's wharves are the most fascinating in China. The port handles the cargo coming out of the interior from Nanjing, Wuhan, and other Yangzi River ports, including Chongqing, 2,415km (1,500 miles) deep into Sichuan Province. From Shanghai, which produces plenty of industrial and commercial products in its own right, as much as a third of China's trade with the rest of the world is conducted each year. A boat ride on the Huangpu is highly recommended: Not only does it provide unrivalled postcard views of Shanghai past and future, it'll afford you a closer look at this dynamic waterway that makes Shanghai flow. Between the stately colonial edifices along the Bund, the glittering skyscrapers on the eastern shore of Pudong, and the unceasing river traffic, there is plenty to keep your eyes from ever resting. (http://www.frommers.com/destinations/shanghai/0717023877.html#ixzz0GT59asWP&B)

In the late fall of 1843, a ship carrying a party of thirteen English traders and missionaries entered the Huangpu River. The travelers had sailed from Calcutta under Charles Elliott, who had been charged to open up Britain's consulate in Shanghai, which was to be the first European diplomatic post in the Qing empire. The Englishmen had come armed with the terms of the Treaty of Nanjing that concluded the First Sino-British Opium War (1839–1842), which opened Shanghai—along with Guangzhou (Canton), Xiamen (Amoy), Fuzhou, and Ningbo—as a port for European trade. Still, local residents of Guangzhou had rioted earlier to block the British from entering and establishing residence inside their walled city. As the ship approached the northern gates of Shanghai in the gathering dusk, Elliott ordered his company to spend the night aboard on the river.

What the dawn revealed was not only a crowd of curious onlookers who had alerted the local magistrate about the presence of the strangers, but also that the English had moored against a swampy marshland of interconnecting waterways. This muddy flat was plentiful with reeds and mosquitoes but not much else. To its south lay the Chinese established city, where the soaring eaves, painted roofs, and towering structures of temples, offices, guilds, and gentry homes and gardens punctuated a plane of teeming shops, narrow streets, busy markets, makeshift theaters, and numerous drinking and eating places.

In a way and unbeknownst to themselves, Elliott and his fellow nineteenth-century travelers had cruised up the Huangpu River to two Shanghais, north and south, future and present. The southern Chinese Shanghai was a town that contained about four hundred thousand people and had enjoyed, for centuries, pride in and fame for its orchards, fruits, peach blossoms, seasonal crabs, and fish from local lakes. The gardens and guild houses adjacent to its curio shops and dumpling restaurants centering on the Temple of the City God, to which Elliott and his company were invited, would continue to draw tourists in the twenty-first century. Well before the arrival of the British, this city had produced its share of long-distance traders, shipping firms, and money shops, albeit all with a riverine or coastal orientation. It was also home to gourmets and poets who celebrated the bounties of the land and eulogized the beauty and sophistication of an agrarian life enriched by the comforts afforded by an advanced monetary economy.

The northern open expanse of watery flat, underdeveloped as it was, offered, in contrast, easier access to the Yangzi and the East China Sea. There was plenty of space for the wharves and warehouses for the maritime shipping that was to be Shanghai's future. With the advance of steamships and the opening of maritime trade, the northern swamp gained advantage over the southern town. Within a decade the British were not only to drain and build on this mud but also

to secure their right to a permanent lease, over which they established a municipal council with its rate-payers board, court, police, fire brigade, volunteer force, paved roads, public utilities, church, hospital, school, library, newspapers, parks, race course, hotels, theaters, and clubs (see cat. nos. 1–5). To the south of the English-speaking International Settlement the French secured, in 1856, their separate French Concession under the French consul and the Catholic Church. By the late nineteenth century there emerged a colonial port city distinguished by a line of stately buildings along the Bund that serviced the maritime shipping, trading, banking, and customs operations connecting East Asia and the European markets. There were also two colonial administrations, linguistically differentiated and territorially demarcated, each maintaining a police force and respectively exercising extra-territorial authority under the auspices of an expanding corps of consular officials.

Anyone cruising up the Huangpu River for sights of the city today thus enters a stream of time that saw the construction of three Shanghais between the 1850s and the present. The first Shanghai was the southern town (Nanshi) of cash crops, canals, and coastal trade, which the colonialists referred to as the "Native City." The second Shanghai, consisting of the International Settlement and the French Concession, was the western colonial Shanghai on the bank of the Huangpu River. This Shanghai emerged in the decades after the First Opium War to become the leading center of modern-style finance, trade, manufacturing, printing, publishing, journalism, higher education, and missionary enterprises in central China. Even as the Chinese resisted the colonial nature of the concession administrations, the minority rule of the colonialists in this second Shanghai gave rise, in the first decades of the twentieth century, to a Chinese middle-class society with its consumer culture, an urban working class armed with ideology and organization, and powerful organized gangs that dealt in opium, arms, intelligence, and

labor. Shanghai urbanites strove both to indigenize what had seemed foreign about the city's material culture and to fight the foreign domination of the urban political order. The dialectics between the two—between a pragmatic receptiveness of European material culture and a persistent contest against its hegemonic power—was to characterize the nature of Shanghai's development for a whole century.

European Shanghai survived and thrived when the rest of China went through the Republican Revolution of 1911 and the Nationalist Revolution of 1927. In 1928 a Shanghai municipality was established under the Chinese Nationalist government, which exercised full power and authority in the lands encircling the foreign concessions. In 1937 this Chinese sector of Shanghai fell into Japanese hands at the outbreak of the Sino-Japanese War. The besieged foreign concessions became isolated lone islets in a sea of Japanese occupying forces. In December 1941 Japanese troops marched into the concessions at the outbreak of the Pacific War. Allied British and American governments formally gave up their extraterritorial claims on all Chinese soils acquired in the nineteenth-century treaties. Steadily the Europeans departed, whether in the face of intensified Japanese military presence, in the turmoil of the Chinese civil war (1946–1949), or under the pressure of Socialist reconstruction in the early 1950s.

In May 1949 the People's Liberation Army marched into Shanghai. For the next four decades lights went dim, and the voices and dances fell silent in the former colonial Shanghai. The major buildings were either locked up or divided up by the winners of the civil war. It was only in the early 1990s that the city awoke from its buried past, and a new generation of Shanghai residents—a majority of them born and raised under the red flag—sought to recall Shanghai's former glamour so as to inspire the construction of a third Shanghai on the eastern bank of the Huangpu River.

This newest Shanghai, with its soaring skyscrapers of glass, steel, and unbound ambition, showcases a post-Socialist Chinese modernity that was to transcend both the dull dustiness of the Socialist present and the faded glamour of the colonial past (see cat. no. 121). This eastern Shanghai straddles the Yangzi and the Qiantang Rivers and sits on the East China Sea. It encompasses more than twice the acreage of the old colonial Shanghai and consolidates under a single municipality the administrations of three former districts under the Qing. It was a product of central and municipal state planning, major overseas investment capital, and dramatic shifts in Chinese policies at the end of the Cold War. This newest Shanghai was both a great leap outward to join the global market dominated by Western countries and a reassertion of Shanghai's old place in East Asia in the 1930s.

On a standard tourist map of today, the three Shanghais coexist contiguously in space, each offering something—the old temple in Nanshi, the long bar atop the glimmering Huangpu River, the sleek Maglev to the airport —for amusement and comfort. What this smoothness leaves out is much of the tension and the dynamics that had cut into the social landscape of the city in history. Colonial Shanghai spurred the fastest urban growth in East Asia of its day and set in motion dynamics that profoundly challenged the established ways of life in its host environment. Wars and revolutions fragmented Shanghai's urban communities. Nonetheless a certain Shanghai lore and dream, born of the initial encounters between China and the West, lived on to inspire the imagination and production of a Shanghai style in art and place that is to be the city's enduring legacy.

The Encounters

In a fictionalized account serialized in a Shanghai newspaper in the early 1900s, three educated young Chinese regard the lure of Shanghai from behind the high walls of their gentry compound in Suzhou at the turn of the last century. Suzhou,

famed in Marco Polo's days as "Heaven on Earth," lights kerosene lamps on its streets that are ten times brighter than the oil lamps used elsewhere in China. Yet the electric streetlights in Shanghai's concessions are said to be yet another ten times brighter. Suzhou's better informed, famed as the most literate and learned in late imperial China, periodically read about the world in newspapers. They receive their newspapers via boats that travel inland for a whole week from Shanghai. In Shanghai every commoner on the street learns about the happenings in the world on the same day the news gets printed.

Master Yao, a fictional provincial degree-holder (*juren*) from Suzhou, takes these young men to Shanghai on a study tour. They arrive at the center of happenings at the International Settlement. They sit down for breakfast in a teahouse on a busy street behind the Bund, and Master Yao announces his study plan for his disciples. The plan includes meetings with fellow scholars and students, and visits to bookstores and publishing houses. There will be tours to Western-style schools as well as visits to public gardens and theaters, or public places where political commentaries and reform viewpoints are heard. They will fill their mornings and afternoons with programs, daily or thrice or four times a week. Even the meals will be educational, as different cuisines will be sampled and the etiquette for "Western food" is to be mastered. Weekends are for sightseeing, for rides in horse-drawn carriages, and for exploring the nooks and crannies of the city. The Zhang Garden (Zhangyuan) will be a highlight, since the gentry and elite assemble there for the soapbox and a fearless rally against the Qing under the protection of European extraterritoriality.

As the group makes its plans, a quarrel breaks out at the next table. A young woman, casually dressed in gaudy colors and wearing cheap jewelry, sits in the company of three men. She has been pouring from their pot of tea, and she now begins to speak excitedly in a raised voice. She turns out to have attended some sort of missionary school and is now the mistress of the man sitting across from her, who works as a clerk in a European trading firm. Their companions include a coach driver who has brought the couple together for a fee and a runner on the detective squad of the Shanghai Municipal Police. Presently the young woman pounds on the table to underscore her point, the many gold bangles on her wrist clanking and clashing. In no time at all she jumps to her feet. Grabbing her estranged lover by his vest, she entangles him in a struggle. The detective jumps to his feet to separate them, and the coach driver leaps up to help. The two men then drag the couple downstairs to the street level where two waiting policemen, "one Chinese and the other a foreigner with a red turban and a dark face," promptly step forward. The episode ends with the couple on their way to the court of the foreign magistrate and in the hope of a new kind of justice over their none-too-uncommon grievance, although the woman in this case rather than the man expects satisfaction.

Master Yao, seasoned and respectable in the Chinese world, is scandalized by these transgressions of sexual propriety, social norms, and judicial authority. His curious disciples nonetheless look on with intense interest. European Shanghai, alas, was no place for an upright, conservative Chinese man. A Western-looking man presently climbs the stairway and enters the teahouse. This tanned figure carries a walking stick, wears a suit, and sets his feet forward in a pair of expensive leather shoes. His presence prompts a shabby-looking man in a cotton gown with patched holes—known by the name "Yellow Countryman (Huang Guomin)"—to call out from a hidden corner. The suited person removes his straw hat to reveal a "full head of hair tied into a bun, rather different from the short hair of the foreigners." Instead of a Westerner, the newcomer is but "a transformed Chinese."

What does it take to become a "transformed Chinese" who may pass, at least in Chinese eyes, as a European? "Ever since my adoption of Western-style clothing, I have changed all my

habits of eating, drinking, sleeping, and walking," says the hybrid man. He eats two meals a day and refrains from having snacks in between. He has tried cold showers and nearly dies of the practice. He endeavors to bathe every day as Europeans do. Still, he needs European advice about whether he is to keep his hair long or short so as to live up to the guidelines of a hygienic existence.

These teahouse episodes register, albeit not without scorn, some of the early moments of Sino-Western encounter and the emergence of hybrids in the foreign concessions. Chinese women, against elite Confucian injunctions, openly consorted with men through arrangements made outside parental or lineage circles and stridently asserted their rights and place in public. Chinese men endeavored, meanwhile, to adopt Western-style food, fashion, and furnishing in pursuit of health. Chinese educated elite learned about the world in Western-style schools and publications and found their political voice in gatherings protected by the concession authorities from Qing officials. The West offered a full and radically alternative curriculum for Chinese students from the empire's cultural heartland. The learning experience required not only openness to new things but also critique and abandonment of accomplishments of the past.

For the Chinese who came to the city, colonial Shanghai was where happenings of novelty and license—which elsewhere would surely incur sanctions and discipline—could become doctrines of modernity and freedom. Beyond the lit buildings and streets, the radios, gramophones, cameras, magazines, movie houses, and more, there sat the steamships and gunboats on the Huangpu with their foreign flags, and a world of nations and civilizations beyond the power of the Qing. The "Shanghai style" in all its multifaceted dimensions, one might argue, was an articulated representation of a creative tension between Chinese aspirations for the freedom and modernity in Western civilizations and a profound Chinese ambivalence about the emasculation of the Chinese state from Western powers.

The Crowd in the City

Western presence in Shanghai began with the arrival of the English and the French in the mid-nineteenth century. Americans were the next to come, establishing permanent lease at the confluence of Suzhou Creek and the Huangpu. The British and the Americans soon joined forces to form the International Settlement. Other foreigners continued to arrive. By the first decade of the twentieth century Shanghai's foreign community included nationals of Japan, Russia, Germany, Portugal, Italy, Spain, Poland, and Greece in addition to those from India, Indochina, and other colonial possessions of the British and French empires.

The overall number of foreigners in Shanghai at any given point in time never exceeded 150,000 individuals. Meanwhile, colonial Shanghai's population reached nearly four million by 1945, thanks largely to an influx of Chinese from the surrounding countryside. From the 1850s onward, each round of warfare and social unrest in the hinterland spurred massive Chinese flights into the safety of the foreign concessions. The first such movement took place in the late 1850s, when the rebel troops of the Kingdom of Heavenly Peace (the Taipings), which ravaged eighteen provinces in fifteen years (1850–1864), swept through the lower Yangzi Valley, capturing major cities such as Nanjing, Suzhou, and Hangzhou. The Taipings did not take Shanghai, but the Chinese city was plunged into chaos by an uprising of the Cantonese and Fukienese dock workers and the sailors of the Small Swords Society against the Qing authority. Between 1855 and 1865 the population of the International Settlement went from approximately twenty thousand to ninety thousand. The French Concession during the same period gained about forty thousand people. Foreign consuls and residents viewed this influx of Chinese with alarm. The Municipal Council of the Shanghai International Settlement was created in the summer of 1854 as a response to the emergencies of

shelter, disease, and order that accompanied the Chinese influx.

Newcomers to Shanghai in the 1860s included a large number of the affluent from major Yangzi Valley cities. Their spending capacity spurred the migration into Shanghai of courtesans, restaurateurs, opera troupes, storytellers, painters, craftsmen, jewelers, fabric dealers, silk and fur merchants, book vendors, writers for the popular press, curio collectors, and moneylenders from urban Jiangnan, transforming the districts behind the Bund into busy commercial centers.

A second wave of migration occurred between 1915 and 1919, when war broke out in Europe, and Japanese and Chinese investors moved in to turn Shanghai into a manufacturing center. Textile and flour mills expanded along with the production of such goods as cigarettes, matches, light bulbs, cement, paper, pencil, and coal. Tens of thousands of workers from the surrounding countryside were recruited to supply labor for the industries. The unskilled among them, women in particular, were brought in from home villages on contractual terms by labor bosses who had secret society ties. Thousands of cotton mill workers were housed in factory dormitories, paid meager wages, and subjected to harsh discipline. Their concentrated presence and collective discontent greatly contributed to the rise of working-class agitations in industrial Shanghai in the 1920s.

Single male workers often returned to their home villages to seek marriage partners. A majority of the married men left their wives and children behind in the countryside to avoid the higher expenses of living in town. The demographic composition of Shanghai subsequently reflected these patterns in immigrant lives. During the Nationalist decade (1927–1937) less than 30 percent of Shanghai's population had been born in the area. The male-to-female ratio was 142 to 100, and nearly a quarter of Shanghai's population was younger than fourteen years in age. An estimated one out of ten women in Shanghai made her living as a sex

worker. Mobility was high, with people moving in and out of crammed quarters shared with fellow provincials who came from all over central and southeastern China. Following the ties of common native-place origins, neighborhoods and shantytowns sprouted up in back alleys and on the fringes of the concessions. Ethnic, social, and vocational hierarchies were evident in the workplace as well as in town, as the provincials struggled to understand each other's accent, dialect, and customs. Manual workers who carried night soil, dredged river mud, or served in bathhouses were among the most despised. They made do in conditions of squalor and tended to come from northern Jiangsu. These northern villagers, known as the Subei people, were particularly looked down upon as uncouth, unintelligent, filthy, and untrustworthy—with little to share, in other words, with the superior stock of Chinese who hailed from south of the Yangzi and worked in banks.

The third and most dramatic wave in population took place between 1937 and 1941, when the Sino-Japanese War broke out and the lower Yangzi region fell into Japanese hands. Hoping to find safety, Chinese refugees poured into the foreign concessions by the tens of thousands. Concession authorities bolted the gates and instead negotiated with the Japanese military command, the result of which was the creation of a demilitarized refugee zone in the old Chinese city. Chinese government agencies meanwhile sought to use the concessions as a base to mount anti-Japanese actions. While the population in the Chinese city declined during the war, in the concessions it rose to nearly two and a half million, with a gain of 780,000 from 1937. In 1850 less than 1 percent of Shanghai's population was to be found outside the Chinese city. In 1941 over 65 percent of the people sought refuge in the two foreign concessions that together made up about 6 percent of the total area of metropolitan Shanghai. The push of social disturbance and the pull of economic opportunities, in short, combined to redraw Shanghai's map of

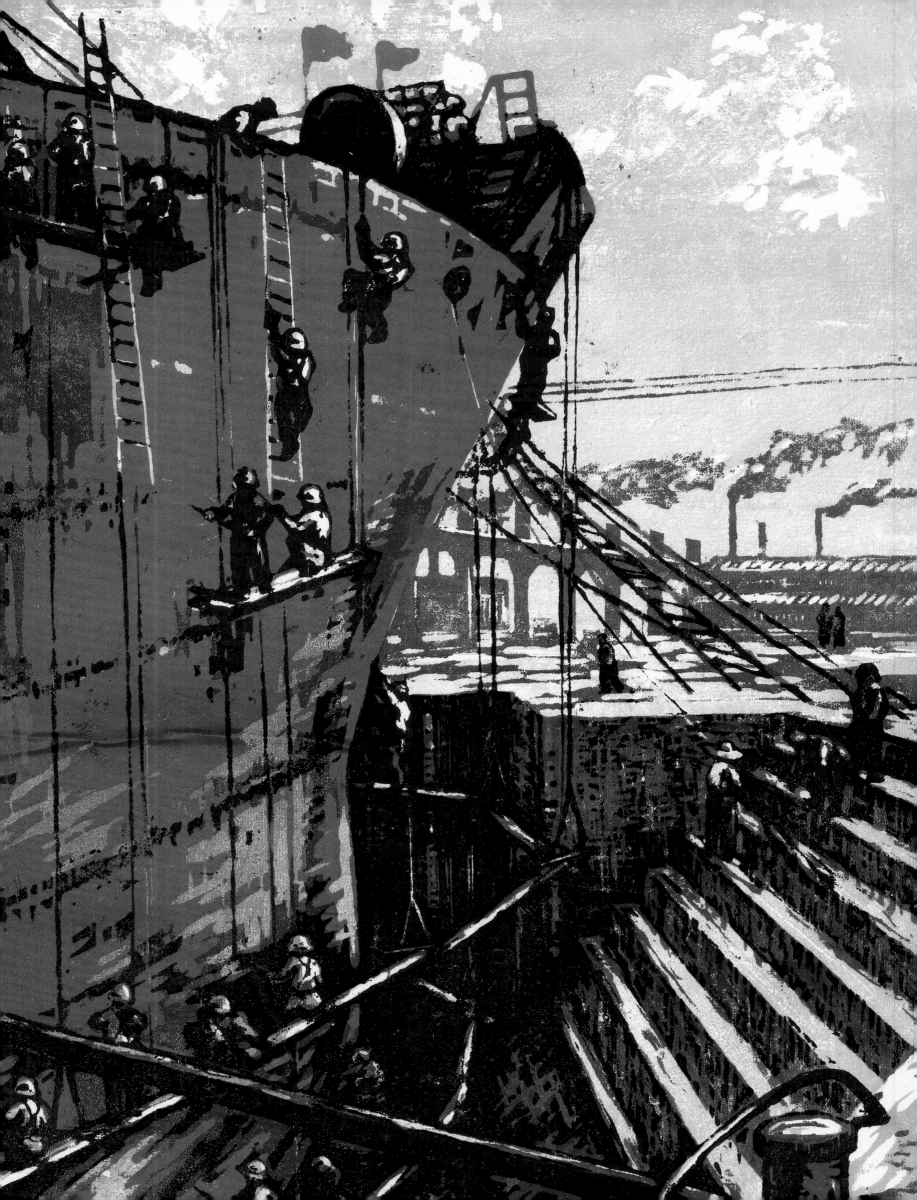

social geography and democratic composition in the century after the First Opium War.

This fast-growing industrial city of restless migrant workers was beyond the capacity of minority colonial administrations to control. In addition, neither the International Settlement, the French Concession, nor the Chinese Shanghai municipality exercised full jurisdiction across the city. While migrants and workers crossed boundaries with agility, municipal authorities were hemmed in by territoriality. Against this international division in administrative structures the Green Gang, a home-grown secret society of rural origins built on ties of sworn brotherhood and generational hierarchy, rose to prominence as a broker and collaborator in the dealing of information, connections, and the use of coercion.

Against this backdrop the legendary Du Yuesheng, the undisputed boss of the Green Gang in the 1920s and 1930s, enjoyed his reputation as the most dubious yet most powerful fixer and broker in Republican Shanghai (see cat. no. 16). Born in a poor village east of the Huangpu, Du was orphaned at a tender age and apprenticed to become a fruit grocer. He joined the Green Gang in his teens and rose quickly to be the confidant and right-hand man of Huang Jinrong, the Green Gang boss who led the detective squad of the French Concession police force. The team built a monopoly in the dealing of opium and arms and ran fancy brothels and casinos on the side, all in the safety of the French Concession, beyond the grip of the warring Chinese provincial military strongmen and their hunger for revenue.

In the 1910s the Green Gang further expanded its organizational cells into the migrant laborers. Its influence among the industrial workforce expanded in tandem with the shipping and manufacturing boom of the 1910s and 1920s. This labor presence gave Du the capacity to manipulate and settle strikes as no other man could, gaining leverage against the industrialists and the concession authorities. It also placed the Green Gang in head-on competition with radical young Chinese intellectuals, mainly of provincial origins, who convened the first congress of the Chinese Communist Party in the French Concession in 1921 and, with Soviet advisors in tow and a united front with the Chinese Nationalist Party, plunged into the organization of industrial labor for the making of an anti-imperialist and Socialist revolution.

Foreign Concession authorities were wary of Communist presence in industrial Shanghai, especially as the young Chinese radicals consorted with fellow anti-colonialists and Socialists from Vladivostok to Saigon. The service of the Green Gang proved to be invaluable not only in the supply of critical political intelligence but also in the organization of labor unions—the "yellow union"—that fought the red brigades of the Communists. As the Chinese Nationalist Revolutionary Army marched on Shanghai in April 1927, Green Gang collaboration from within was crucial in the summary executions of suspected Communist labor activists that eased the Nationalist control of the city. The French writer André Malraux captured the darkness of these episodes in his 1933 fiction *Man's Fate (La Condition Humaine)*, with scenes set in Shanghai and inspirations drawn from French Indochina.

Green Gang assistance in the purge of the Communists transformed Shanghai upon the inauguration of the Nationalist government in Nanjing (1928). Thanks to the new political backing, in the Nanjing decade Du Yuesheng emerged as a major figure in the city's respectable circles. He established his own bank, initiated the Pudong Native Place Association, organized yet another membership association, and accepted seats on the boards of directors of banks, companies, charities, and even universities. Apart from banking, he represented his main business as philanthropy. He showed his patriotism by leading fund drives to enhance the military budget of the Nationalist government. He rallied his followers to support the Nationalist government's wars against the Communists and the Japanese.

He joined the "National Goods Campaigns" with fellow Chinese entrepreneurs: campaigns that urged patriotic Shanghai ladies to refrain from buying European or Japanese imports. He was on the board of the National Goods Department Store (*Guohuo baihuo gongsi*), a company organized to encourage Chinese women to take pride in the fine quality of Western-style goods produced by a coalition of Chinese manufacturers. He burnished his image as a filial son and an upright man in traditional terms. He built a majestic Du Lineage Shrine at his birthplace, engaged the service of some of the most learned classicists of the time, and commissioned an elegant eulogy in ornate prose for his parents. The inauguration ceremony of the shrine, attended by thousands, amounted to one of the grandest social events in Shanghai in the 1930s.

In *The Shanghai Triad* (*Yao, yao, yaodao waipo qiao,* 1995) the film director Zhang Yimou sought to capture the spectacle and charged atmosphere of the Shanghai gangster land in the 1920s. One may argue that the film was only partially successful with regard to the subtlety and complexity of the historical character, if Du the Green Gang boss was in fact the figure who had inspired the production. The real-life Du, who moved in and out of networks and formulated strategies on his feet, was no poster-image, gun-toting gangster in a scholarly gown. He was instead the master of a town of bounded legitimacy and boundless ambiguity who was skilled in the exploitation of such discrepancy. The Du legend warmed the hearts of its contemporaries, as it offered a success story of Shanghai from the bottom up: a man who scaled hierarchy "in a city of forty-eight-storey skyscrapers atop twenty-four layers of hell."

The Shanghai Dream

A major landmark on the Shanghai waterfront was the giant clock above the Imperial Maritime Customs House. Made in England as an exact copy of the Westminster clock, it sat at a height of ten stories atop the customs building, its four dials visible to all who approached the Bund on foot, by car, or by boat. The largest clock in Asia at the time, it chimed quarterly and hourly, as did Big Ben. More than the jazz concerts in the river park, the foghorns on the water, or the bustling noises rising from the streets, the chimes dropping from the Customs House set the pace of urban life in Shanghai. To be part of the modern crowd meant living within the temporal frame set by the clock and accepting the commodification of time as the new wave of life.

An estimated three hundred thousand individuals worked in Shanghai's businesses and various enterprises in the 1920s. Hundreds of trades thrived in all parts of the city. As a social class, these urban desk workers represented a highly diverse workforce. Few common factors united them except literacy, which was achieved at various levels.

Contemporaries sometimes referred to these desk workers as "petty urbanites." They were the faces in the crowd in the amusement halls, teahouses, pleasure quarters, and streets lined with shops. They made up the readers and listeners of newspapers and radio. Their taste sustained the circulation of popular novels and comic strips. The bachelors among them might drink or gamble a little. The married ones might smoke a bit. They lived their days between work and home, fully immersed in local rituals as well as politics.

Young men with college degrees and on professional tracks in the fields of banking, customs collection, and railroad management stood at the pinnacle of this class. Their high salaries and job security commanded the highest prices in the marriage market. Their purchasing power and informed consumption inspired the urban dream, written and read about in popular journals, depicted in films and pictures, and manipulated in the pages of advertisements.

The Shanghai Dream centered on an idealized urban family consisting of a married couple and their unmarried children. This "small household" was defined in opposition to the "big

family," or the traditional extended family that continued to be the norm in vast areas of Republican China. While the "big family," sanctified by Confucian ethical norms of filial piety and female docility, had functioned for centuries as the foundation of lineage power in the provinces, the "small household"—Western in inspiration and urban in its constituency—presented a direct challenge to that old authority. A unit of consumption instead of production, the "small household" emphasized the strength of emotional bonds between the conjugal couple over the filial obligations toward lineage members. It promised happiness to self-supporting men who earned their salaries on the basis of intellectual labor in the new economy. It also portrayed the city, with its modern institutions, facilities, and abundance of industrial products, as a cleaner, safer, and more advanced and enlightened place than the countryside.

With the passage of a new marriage law in 1931, men and women of eighteen years of age gained full rights to arrange their own affairs, to own property, and to sue for divorce. The enlightened way became to marry out of love and choice, to manage household finances with discipline and competence, to make intelligent consumer decisions based on scientific and technological knowledge, and to raise children with an equal emphasis on intellectual and physical development. The Shanghai Dream was within the reach of any man and woman capable of arranging their lives in an enlightened fashion.

However, not every woman raised in the "unenlightened," old-fashioned home had been prepared for a new life as an urban wife. The "big family" generally prepared women to be better companions to other women—mothers, grandmothers, sisters-in-law, aunts, cousins, nieces, maids, and female visitors—than to men, including husbands. The communal nature of property ownership prevented the development of a personal sense of financial accountability. And above all, social status usually mattered far more than financial means in the making

of consumer decisions. An urban dream family required the presence of a different kind of mistress of the house.

This ideal urban woman must combine a feminine appearance—stylish hair, tastefully made-up eyes and lips, earrings, bracelets, gowns, heels, and a smile—with a hard-headed competence about home economics and household management (see cat. no. 67). The old Confucian female virtues of being an "able wife" and a "good mother" still applied. This woman would complement and support the work of her salary-making man, who as the provider and protector remained the center of the family.

Yet unlike in the past or inside the walled compound of the big family, the new urban woman gained a public presence. She had shopping to do, deposits to make in the savings account, men and women to socialize with at sports and art events, walks in the parks, visits to the nursery and elementary schools, and the social calendar to arrange. Wives and daughters, in addition, appeared in charitable associations and patriotic assemblies on behalf of their husbands and fathers. Appearances in public mattered, as they said much about knowledge and sophistication. Conversely, it mattered to the public how urban women made their decisions about their adornment and their household management.

More than traditional wives, urban women drew public attention: their conduct and appearance were the subjects of much comment and scrutiny. Chinese manufacturers wanted these women to understand patriotism, to select "national goods" over foreign imports. Civic leaders lectured on discipline and economy, instructing women to give to worthy causes rather than giving in to vanity. Chinese newspaper editors intoned on the severity of the national crisis and the importance of household saving rather than spending. New-style urban women were central to the Shanghai Dream. On the pillar of their feminine virtue—or the crumbling of it—the city would stand or fall. Urban women occupied

a space between the domestic and the public, the private and the civic. Ideally they would combine, in appearance as well as conduct, the "modern" and the "Chinese": Confucian in virtue while modern in practice, Western in consumer choices while comfortably Chinese in person. In their serene smiles would be the resolution of the cultural contradictions that the Chinese nation often grappled with. Shanghai's urbanites sought the fulfillment of their urban dreams in the poster images of these women (see cat. nos. 64–72).

The 1930s, to be sure, were hardly years of peace and prosperity. The decade opened with the Sino-Japanese Battle of Shanghai and ended with the fall of Shanghai into Japanese hands. In between it saw the effects of the global Great Depression and the American Silver Purchase Act. More than two hundred thousand casualties occurred in active fighting on the outskirts of Shanghai, many jobs were lost, and many homes and structures were bombed out or burned down.

The urban climate shifted in the deepening crises. Women soldiers emerged to assume the pride of place in urban imagination. Women of sophistication without spartan virtue became vulnerable to charges of bourgeois decadence, capitalist parasitical existence, individualistic irresponsibility, and collaborationist politics. In the 1940s the foundation was laid for full equality between men and women—delivered, however, on the defeminization of all proper women.

Under Socialist Reconstruction

When the People's Liberation Army marched into Shanghai in May 1949, it presented the sight of peasant soldiers reclaiming for the Chinese people a Westernized city of colonial legacies and free-market enterprises, in a country in which under 5 percent of the population lived in cities. For the remainder of the Maoist era (1949–1976), rural-based ambivalence toward Shanghai prevailed. Socialist Chinese culture, politics, and economic planning kept alive the notion that

the city was a site of corruption, colonialism, and collaboration. Consumption was vice and production was virtue. Victorious Communist soldiers were alternately encouraged to and reprimanded for dining in Shanghai's fine restaurants. Whether Shanghai's renowned cuisines deserved celebration as the achievement of the "people" or should be banished as the corruption of capitalism was never satisfactorily settled. Within a decade Shanghai, "Paris of the East" and "Paradise of Adventurers," was set on its right course and transformed into the "Ruhr on the Huangpu," where no speculative adventurer or carefree consumer would go unpunished.

Meanwhile, the city that the Communist liberators took in 1949 was on the brink of collapse. The final moments of the civil war were ruinous days in Shanghai, as astronomical inflation and ineffectual price controls wiped out savings and income along with the wage-earning classes. Departing Nationalist officials and business elite further emptied the major banking and manufacturing enterprises of reserves and assets. It was up to Communist officials to put a bankrupt city back in order.

For much of the 1950s, the transformation of Shanghai involved the interconnected workings of three factors. First, a regime shift meant that Communist authorities stepped in to fill the positions of their departed Nationalist predecessors, "nationalizing" properties and enterprises previously held under the public authority of the Nationalist state and party. Second, economic recovery required the resuscitation of an economy that had been much strained by wars and occupations for well over a decade. To restore Shanghai to its former level of productivity, Communist authorities pumped credit and resources into the city's banking and manufacturing sectors. To engineer a Socialist revolution, however, it was at the same time imperative that new laws be put in place with regard to property ownership and corporate governance, and that Shanghai be rid of its capitalist entrepreneurs and private business leaders. Urban economic recovery

occurred in Shanghai in the 1950s when public authority changed hands and property rules were redrawn. The postwar economic recovery took place within the context of a Socialist revolution and a political takeover.

The third factor had to do with the place of Shanghai in China's war and peace with the outside world. Colonial Shanghai had come into being as one of the initial treaty ports after the First Opium War, which opened China to Western trade. A century later, the outbreak of the Korean War in June 1950 brought an embargo upon China that was sanctioned by the United Nations and led by the United States. Within years, shipping in and out of the port of Shanghai diminished to a trickle, and Hong Kong emerged as the busiest free port in East Asia. Outbound cargo ships heading south from Shanghai ran the gauntlet of U.S. and Taiwan naval forces in the Taiwan Strait. With its aging fleet, limited tonnage, and much-curtailed trading agreements, the former European hub on the East Asian coast was barely able to maintain, for much of the third quarter of the twentieth century, shipping connections with ports other than those of Poland and North Korea.

Formal diplomatic ties with the United States in 1979 and the Hong Kong communiqué with the United Kingdom in 1984 were important factors contributing to the relaxation of tension along the China coast. Previously, China had invested heavily to build railroads and highways that turned Shanghai into a hub of overland transportation oriented toward China's interior. The shifting tides of the 1980s brought back the banished connections of the maritime world and prepared the conditions for a reconnection with the suppressed histories of pre-1949 Shanghai.

In 1988 the Shanghai writer Cheng Naishan completed her manuscript *The Banker,* which broke decades of silence on the subject of Shanghai's pre-Socialist history. Based on the life experience of the author's grandfather Cheng Muhao, who had fled to Hong Kong, the book told the story of an eminent Chinese banker who led his bank and family through the dark days of the Sino-Japanese War. This fictional banker came across as a patriarch and patriot, who looked after an extended family that included his employees and their widowed and orphaned in an old-fashioned way. He shared his wealth like a Socialist, and he even risked his own safety to protect a young Communist agitator. In other words, a grandfather could be a banker and be *almost* as virtuous as a Socialist. Laboriously and painstakingly, Socialist Shanghai refashioned its urban tale and positioned itself to claim the buried colonial history of the city.

Shanghai Rising

In the early 1980s the Chinese Communist Party launched the "Four Modernizations" program and opened up the Shenzhen Special Economic Zone in the Pearl River Delta region. Shenzhen proved to be an enormous economic success. Student protests and worker unrest nonetheless gripped Chinese cities in the ensuing decade. Still, after the armed suppression of student protesters at Tian'an men Square in 1989, the party reaffirmed, in 1992, its commitment to the "openness" policies.

This second declaration spurred in Shanghai a "second high tide" in its search for a developmental strategy. Shanghai in the 1990s would reorient itself to "face the world, face modernization, and face the twenty-first century"— or, correspondingly, to turn its back on Chinese provinces, Socialist conservatism, and prevailing Socialist practices of the twentieth century. It would rise to become an "international center for economy, finance, and trade." This engine of growth would develop in leaps and bounds, and would take along on the developmental train not just the lower Yangzi Delta but also the entire Yangzi Valley.

To "jump-start" so as to "ascertain a central place in international economy" within "as brief a period as possible," Shanghai adopted a "grand

view encompassing its urban surroundings." Through strategic concentrations of human, material, and economic resources, Shanghai would "allocate its limited resources differentially so as to better realize its comparative advantages in targeted areas."

The farming counties east of the Huangpu River and the former home districts of the Green Gang, which until the 1980s had lain idle under the Shanghai municipality, represented an enormous amount of landed capital that could be "exchanged into more advanced modes of capital" for the development of a greater Shanghai. Shanghai was to lease or rent its land to international developers in exchange for the much-needed capital, which in turn would bankroll the city's leap into the new century. Under a massive regional development plan backed by the state council during the presidency of Jiang Zemin, the land-grant program in exchange of overseas capital and technology enclosed the entire lower Yangzi Delta from the mouth of the Yangzi to the bank of the Qiantang—an area that had been divided up under the jurisdiction of three counties under the Qing.

No land in the intensively cultivated lower Yangzi, of course, was without people. In the premier sectors of the former colonial Shanghai, four decades of Socialism had seen little improvement in the sewage, running water, heating, power, and public transportation systems of the city. Housing and traffic had become acutely congested. In some parts of the city each occupant took up, on average, a mere 3.6 square meters of living space. The premier sectors of the city in the former International Settlement and the French Concession—Huangpu, Luwan, and Xuhui—had been weighed down in particular by a maturing population consisting of multigenerational families, the working population and their households that had been multiplying since the victory of the Communist revolution in the mid-twentieth century.

To achieve the "leaps and bounds" and to make room for outside investors and their

developmental capital, Shanghai simply had to relocate its established residents to the urban peripheries. The ramifications were broad and far-reaching. Such a change meant, for instance, breaking up the system that for decades had provided accommodations to workers in compounds near their workplace. It meant, furthermore, either relocating or shutting down Shanghai's state-run factories in order to reduce pollution and make room for commercial enterprises on prime locations. It meant a thorough remaking of the city, replacing factories with shopping arcades, restaurants, offices, hotels, and expatriate apartments; building rapid mass transportation systems; and sending blue-collared workers away in favor of white-collared ones. It meant, in short, the construction of an outward-looking economy of consumption on imported capital, which was to be layered on top of a rooted economy of industrial production.

The social and political challenges of the transformation were to be matched only by the magnitude and audacity of the economic vision. In the cryptic language of the official reports and the recommendations, the best possible scenario for the city's leap into the new century was thus "a modernized international city of Socialism, which achieves internationalism without betraying the principles of Socialism."

Beyond the Colonial Glamour

Against this backdrop Shanghai historians, over the course of the next fifteen years, resurrected the city's pre-1949 past. They set aside the old-fashioned revolutionary orthodoxy and refashioned the city's urban identity, successfully supplying the critical historical justification in favor of the city's strategic repositioning in the 1990s.

By shifting attention away from the standard Party story of colonialism, capitalism, Nationalist betrayal, and Communist martyrdom, new images emerged that described a middle-class city of material comfort in everyday life that

was making steady progress in the enhancement of wealth and health. Women, merchants, foreigners, and entertainers gained in visibility, marginalizing workers, martyrs, patriots, and revolutionaries in the Shanghai tale. Instead of dwelling upon the structural injustice in the "social relationships of production" under capitalism, innovative historians chronicled the scientific and technological advancement in the "modes of production" as the city was undergoing modernization. There were plenty of achievements to be recorded in publishing, journalism, education, architecture, fashion, theater, civil associations, local self-governance, custom reform, family life, women's status, migrant integration, merchandising, shopkeeping, cuisine, and advertising.

Colonial Shanghai regained its glamour in Chinese historical representations of the 1990s. Yet this was glamour with a difference. According to a new generation of Chinese historians, pre-1949 Shanghai was the making neither of the colonialists nor of the large capitalists. It was, instead, the work of the petty urbanites who occupied those neighborhoods with stone portals and narrow alleys. In the words of Zhang Zhongli, president of the Shanghai Academy of Social Sciences, "The bottom line is: Shanghai was Chinese, Shanghai was Shanghainese. The city developed as a result of the people in Shanghai making innovations on inspirations taken from the West." Shanghai, in other words, had *always* been Chinese thanks to the labor of the Chinese people. It did not have to await 1949 to *become* Chinese upon the triumphant march of the People's Liberation Army.

In the mid-1990s construction cranes went to work at a feverish pitch in Shanghai. Between 1992 and 1996 more than two thousand skyscrapers, financed largely by Hong Kong, Taiwanese, and Southeast Asian Chinese dollars, went up in the city. These buildings—the Jinmao and the Pearl of the Orient included—flank the banks of the Huangpu River, encircling the former foreign concessions and transforming the farming fields of Pudong into a towering forest of steel. The gleaming structures dwarf the old colonial mansions on the Bund that once benchmarked Shanghai's modernity.

Meanwhile, in the old colonial city, Shanghai builds a brand-new civic center. This one succeeds the colonial-era administrative centers and replaces the Nationalist-era structures bombed out by the Japanese during the Sino-Japanese War. It boasts of world-class art museums and a glittering opera house that face the stately city hall across an expansive boulevard. Many more museums, shops, and restaurants enliven the scene, not to mention municipal parks and zones of green that landscape the municipal core. True to city plans and expectations, many of these projects were joint enterprises between local government offices and large overseas investors. The collaboration brought to Shanghai a new breed of sojourners. By 2005 at least five hundred thousand Taiwanese had set up residence in Shanghai. The sojourners and the locals once again commingle, amid signs of growing disparity between the rich and the poor, the globalizing and the localized.

When the Expo opens in 2010, it will take place in a country in which over half of its people are newly urbanized (becoming residents in a territorial administration under a municipal authority). It will also take place in a city that is a shining example of China's engagement with the world. For a century and a half Shanghai has sat at the center of crisscrossing currents between the country and the city, the Chinese hinterland and the world beyond the sea. For decades, the tension between these poles had been acute. Shanghai became modern in the 1930s, with its stylish women and urban dreams, under the auspices of the colonial administrations in the foreign concessions. It showcased the splendor of modernity on Chinese soil, although achieved at a site where the Chinese state had compromised its sovereignty claims. Seven decades later, with gleaming towers rising on the eastern bank of the Huangpu and a multitude of the

world's top financial and industrial brands vying for top spots above the recently plowed-under fields, a new Shanghai came into being under the auspices of the Chinese Communist state. Shanghai joined the world, and so did much of the rest of China.

The Shanghai Dream, which once inspired so many of the city's youths to strive to do their best, has become much more than a mere dream. A growing number of young Chinese have settled in urban homes with educated spouses and material comfort. The poster images of Shanghai women, inviting as they may be, hold no greater significance than a place in the city's nostalgia. Shanghai modernity, which in the twentieth century set the benchmark of Chinese modernity, has become, in the twenty-first century, an event in the larger story of Chinese modernity.

Meanwhile, the city moves along with the rest of the nation, joining an ever-expanding world of international styles and globalizing technology. It adroitly takes its place in a new order on the banks of the Huangpu River—blurring memories of historical tension, confounding multiple linguistic practices, and producing, for the benefit of the tourist industry that is the lifeline of affluence and happiness, poster-perfect pictures of the past as well as the future.

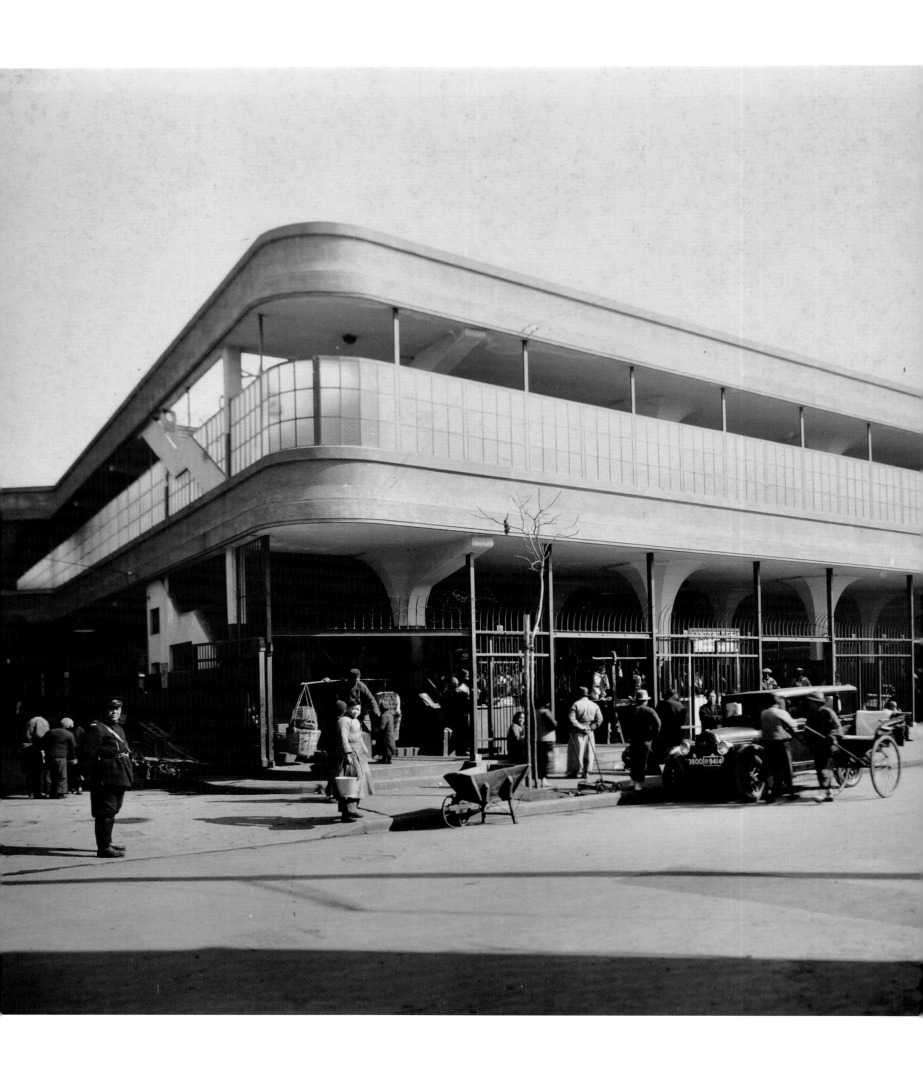

Reaching to Heaven

Shanghai Architecture and Interiors
by Nancy Berliner

The man-made landscape of Shanghai has been a continual visual renegotiation between a Shanghai cultural status quo and newly arriving cultures, both from abroad and from within China. This highly urban, highly complex, ever-changing environment envelops the residents of the metropolis and contributes significantly to molding their unique and multifaceted cultural attitude.

Commentators from all generations and nations have noted the powerful visual impression of Shanghai:

COSMOPOLITAN Shanghai, city of amazing paradoxes and fantastic contrasts; Shanghai the beautiful, bawdy, and gaudy, contradiction of manners and morals; a vast brilliantly-hued cycloramic, panoramic mural of the best and the worst of Orient and Occident.

Shanghai, with its modern skyscrapers, the highest buildings in the world outside of the Americas, and its straw huts shoulder high.

Modern department stores that pulse with London, Paris, and New York; native emporiums with lacquered ducks and salt eggs, and precious silks and jades, and lingerie and silver, with amazing bursts of advertising colour and more amazing bursts from advertising musicians, compensating with gusto for lack of harmony and rhythm.[1]

As the most Westernized city in China after Hong Kong, Shanghai is on the cutting edge of China's race for modernization. Almost a quarter of the world's construction cranes stand in this city of 15 million. On the other hand, architectural remnants of a strong colonial past survive along the charming, winding, bustling streets that make this city undeniably and intimately Chinese.[2]

Relive the past with a stroll along tree-lined avenues or a visit to a 10th-century monastery, or get with the hard-paced future in the city's fast-growing forest of skyscrapers.[3]

Each of these authors, one writing in 1934 and the others in 2009, was seeing a different Shanghai—with a different skyline and disparate appearances of streets, parks, and building interiors under distinct

lighting technologies. What were once considered "modern skyscrapers, the highest buildings in the world outside of the Americas," are today dwarfed by edifices that loom ever closer to the sky. Yet while the city's buildings come and go—or stay, as the case may be—the character of the visual environment in this city remains constant, just as an individual's face changes over the decades, the same character evident in infant pictures appearing in a middle-aged portrait. The inner personality expresses and re-expresses itself on its exterior, over and over.

The visual impact Shanghai has on those who grow up within it, and even those who come to call it home, is powerful and infectious. Those growing up within it absorb and inherit its character, and as they build anew, they do so in a similar spirit. Thus, the writers quoted above, though seeing the city at different times, were reflecting on a similar and consistent visual character that penetrates the entire urban area and reproduces itself in each generation.

Artists and writers painting, photographing, or describing Shanghai have typically turned to the city's monumental architecture because it is the most articulatable defining element. Architects designing for Shanghai have been unabashed in their aspirations to make a mark on the city and its inhabitants. Thus the Bund, with its expansive open foreground that allows for maximum photogenic exposure, became a dense assemblage of massive buildings. Artists and guidebooks often focus on these monuments, but between the colossal works of masonry are more intimate structures housing families, businesses, or both. These more modest buildings frequently proffer a personality similar to their larger brothers' so that the macrocosm is reflected in the microcosm. Consider as well how previous generations' constructions shine next to one another, and the effect of the city's unique character multiplies.

Instead of turning to the oft visually quoted and verbally pictured monuments of the city, let us glance first at a more modest edifice and its inhabitants depicted within the jangling streets of Shanghai over one hundred years ago.

The illustrations by the well-known artist Wu Youru in the two volumes of *Haishang baiyantu* (One Hundred Beauties of Shanghai, cat. nos. 27–34) published in the 1890s by Dianshizhai, the first publishing house in China to produce lithograph-illustrated periodicals, portray Shanghai women, almost exclusively Chinese, and an occasional auxiliary man, in their homes or on the streets. More often than not, the interiors they inhabit are filled with typical late-nineteenth-century Chinese-style furniture—screens, chairs, *luohan chuang* (bed-couches), and tables with archaic bronze–inspired decorative stretchers and side rails—and the women are dressed in charming silk Chinese robes. But various details and accoutrements already display a definite European wink. A woman alighting from a palanquin wears a wide-sleeved, side-closing flower-patterned robe, her small feet just peeking out from below her lengthy, wide-cuffed pants. She and her companions, one of whom is carrying a stringed *pipa*, are about to enter a building with European-style shutters on the window exteriors. Inside one window, a European-style glass-domed lamp hangs from the ceiling. On the following page, another beauty, also accompanied by a young *pipa* player behind her, bends over her lattice balcony railing whose design incorporates the *shou* (longevity) character to gaze at two birds (cat. no. 32). The birds are perched upon the electric wires of street lamps (installed in Shanghai in 1882), but it is the birds, not the marvel of light, that absorb her. Another well-dressed maiden (cat. no. 30)—adorned from her delicate, silver hairpins to the silk-embroidered shoes on her tiny feet in Chinese-style fashion—is seated on a European-style caned armchair, which has round, lathe-turned legs (previously unknown in China), at a round, three-legged, European- or American-style pedestal table. One female servant holds her child; another sits on a simple, low, utilitarian Chinese stool, next to the marble-inlay bed-couch, pulling a *punkha*, the horizontal

fabric hung from the ceiling for fanning the air (a device developed in India during the British occupation that was then imported to Shanghai). On the wall, in a Western-style frame, is what appears to be a portrait of a European personage. Like her compatriot watching birds on the earlier page, the maiden does not turn her attention to these multiple foreign accoutrements; she is completely focused on her Chinese solitaire game spread out on the table.

Despite some of these women's nonchalance, a number of images do demand that the viewer focus on exotic imports. Several women play a game of billiards (cat. no. 27); two other daring dames don Victorian-style dresses for a garden outing under the caption "eye catching clothes" (cat. no. 34); elsewhere, a group gathers around a European oval dining table set with knives, forks, and spoons, a European-style fireplace—topped by a European-style clock—warming the happy bevy (cat. no. 28). Image after image in *Haishang baiyantu* bespeaks the polycultural layering that is still Shanghai today, in its monumental as well as its intimate architecture.

An illustration of three beauties standing on a second-floor verandah (cat. no. 33; a work signed by Zhou Muqiao, though most of the other images in the book were painted by the far more celebrated Wu Youru, under whose name the collection was published[4]) shows the range of architecture in a typical Shanghai neighborhood of the 1890s. The verandah here is a descendant of a style brought to Shanghai by Europeans who earlier had been building offices and residences for themselves in the more tropical environs of Hong Kong and India. (F. L. Hawks Pott describes the buildings erected by "foreigners" in Shanghai in the late 1840s: "Many of them were bungalows and *all had deep veran-dahs*. They were adapted to a tropical climate, and the builders seemed to have had only the four months of hot weather in mind, and to have overlooked the need of sunshine in their homes during the rest of the year."[5]) By the 1890s, build-ings with second-story verandahs were housing

not only Europeans but also middle-class Chinese, who were integrating and readapting the style to their own tastes.

The corner column in the verandah depicted here is a lathe-turned post of a form originated by European furniture makers and house build-ers. (Chinese carpenters traditionally did not use lathes and therefore never developed such forms.) The smaller spindles supporting the balcony railing on which the ladies confidently lean are also of the lathe-turned style. We page-turning viewers cannot but be aware of the enor-mous street lamp attached to their balcony, so prominently placed in the picture's foreground. Shanghai citizens were undeniably proud of the brightness of their streets after the installation of gas lamps and electric street lighting in 1882. The dazzling glow of the Shanghai streets was still a feature flaunted in many photographs of the 1930s and 1940s. In 1934, a guidebook to Shanghai noted, "At night this section of Nanking Road is a glittering fairyland with the brilliant display of multi-coloured lights which all Chinese adore and which illuminate the lofty towers of the three largest department stores in China."[6] Another writer commented, "When a traveler arrives in Shanghai to-day he is struck by the fact that to all intents and purposes he might be in a large European city. The tall build-ings, the well paved streets, the large hotels and clubs, the parks and bridges, the stream of automobiles, the trams and buses, the numerous foreign shops, and, at night, the brilliant electric lighting."[7] And *Malu Tianshi* (*Street Angel*), one of the most beloved films in Chinese history, produced in 1937, opens with bright neon signs and lights flashing against the night background. Our women on the verandah, however, are not so interested in the street light. They instead are peering into the distance through oh-so-fashionable modern binoculars.

The partitions in the beauties' quarters separating the indoors from the outdoors are Chinese-style screen panels, called *geshan*, most likely fitted with glass sheets within the carved

wooden frames. Under the eaves, elaborately carved phoenixes loudly embellish the upper horizontal beams of their porch and the covered area below them. The brashness of the phoenix fastened to the building's exterior is a manifestation of the cosmopolitan, mercantile character inherent in much of Shanghai architecture, large and small, whether the visual expression be more of Chinese or European origin. The artist has arranged the perspective of the building to allow the viewer a peek into the beauties' domicile. There again we see a fondness for both Chinese décor—a calligraphic couplet—and imported accoutrements, such as the framed mirror or painting upstairs and the gas or electric lamp below.

The building abutting the residence is presented to contrast with the ladies' up-to-date abode. This lower structure, and the one just beyond it, would have been more typical of modest traditional Shanghai houses, having one story and a tiled roof with stepped walls (known colloquially as "horse-head walls") at the gable ends that separate one building from the next to prevent fires from spreading across a district. This architectural style was the vernacular throughout the rural and urban Zhejiang and Jiangsu regions around Shanghai long before and long after Europeans arrived and continued to be a part, if ever-diminishing, of the polycultural landscape of Shanghai.

The picture draws the viewer's eyes first to the splendor of the ladies in the foreground and then to the soaring church steeple in the distant background. The steeple and the odd supplementary steeples surrounding it overwhelm all the architecture in the area and may be the object of the women's intense scrutinizing through the binoculars. While the substantial European-style buildings on the Bund made an impressive sight from a ship in the harbor or a spot along the water's edge, Christian churches and other religious buildings, because of their proliferation, made an even more significant impact on the skylines and landscapes throughout Shanghai's neighborhoods.

As early as 1847, just five years after the British began settling in Shanghai, members of the Episcopal community from England erected Trinity Church. In 1849, Spanish Jesuits made their mark on Shanghai's landscape with the establishment of their Dongjiadu (St. Xavier) Cathedral, which is still standing today, and five years later the American Episcopalians built the Church of Our Saviour in Hongkew. The non-Chinese population of Shanghai was just over two hundred, and yet the skyline had already been drastically altered by these new types of towers. The potency of spiritual beliefs and the necessity for community bonds that grow out of religious gatherings would ultimately result in the erection of many grand religious structures punctuating Shanghai's streets.

The visual rhythm and temperament of Shanghai conveyed in this late-nineteenth-century *Haishang baiyantu* appears generation after generation: fashionable, international architecture flaunting up-to-date accoutrements with soaring towers on the skyline accented by Chinese aesthetics.

Early oil paintings commissioned by Europeans and Americans, pleased with their own creations, depict the Bund and other neighborhoods developed by the non-Chinese with dignified European-style masonry buildings (cat. nos. 1–5). Such paintings were rarely complete, however, without intimating the Chinese environment, either human or built. Many early images of the Bund include the Customs House, which for many years maintained a Chinese architectural style. The first British arrivals in the 1840s, unable to immediately begin major construction, rented small Chinese houses for their own residences and established the Customs House in a Chinese temple. That building burned down in the 1850s and was rebuilt in 1857, again in a traditional Chinese style. Both of these Chinese-style Customs Houses are

prominently depicted in early oil paintings of the Bund. Eventually the later structure was replaced by a five-story Gothic-style edifice, which was demolished in 1925 and replaced with an even grander one designed in London.

Despite this ultimate appearance of a European-style Customs House, the Chinese accent of Shanghai never succumbed to foreign influence. Returning to our libraries of images, and moving on to the early twentieth century, grand examples of international architecture and style bait our attention, but they are still created and understood within the unique Shanghai Chinese context. The intersection of ever-growing commercial prosperity and international players brought more foreign styles to the city, but the guidebooks and their commentators, both Chinese and non-Chinese, insist on expressing the vision of the city as a polycultural realm. *Shanghai fengjing*, for instance, a two-volume, English and Chinese photographic guide to Shanghai, published in 1916 and 1917, features a range of architectural styles (cat. no. 62); some pages present such traditionally Chinese sites as the ancient Longhua Pagoda, the Confucius Temple, and the Yu Gardens, while others illustrate the Bubbling Well Road with Tram, the Railroad Station, the Sincere Department Store, the Shanghai Club, and the blinding lights of Nanjing Road at night. Another page brings the viewer face-to-face with a natural product of the unique polycultural Shanghai, the estate home of Silas Aaron Hardoon. Hardoon, a Jewish merchant born in Baghdad around 1847,[8] settled in Shanghai in 1868 and eventually amassed an enormous fortune there. (Many claim he was worth $150 million at his death.) An embodiment of the polycultural Shanghai spirit, he married a Eurasian woman (who was devoted to Buddhism), adopted orphans of various ethnic backgrounds, and was a major supporter of both the Buddhist and the Jewish communities in Shanghai. His contributions to the Shanghai built environment were as varied in style as his personal interests. In 1909,

he engaged a Chinese monk, Huang Zongyang, to design a twenty-six-acre Chinese garden estate in Shanghai, complete with rockeries, streams, and pavilions. The same Hardoon was responsible, according to many estimates, for developing up to 40 percent of the buildings along Nanjing Road, including the classical European-style buildings of the Wing On and Sincere Department stores. The latter, built in 1917, added yet another grand spire to the Shanghai skyline. In the 1920s, Hardoon supported the construction of a synagogue for one of several Jewish congregations in Shanghai. F. L. Hawks Pott, a contemporary of Hardoon's, noted in his book on Shanghai history that "the erection of the beautiful new Synagogue, Beth Aharon, on Museum Road, and its opening on June 30th attracted a large number of interested spectators. This building of Moirish [*sic*] and Byzantine architecture is one of the most striking in Shanghai, and furnished the Jewish community with a worthy house of worship."[9] Even a British resident was so attuned and receptive to the polycultural facade of Shanghai that he was able to appreciate the distinct and probably unfamiliar appearance of this building.

Two other Baghdadi Jewish merchant families, the Kadouries and the Sassoons, significantly influenced Shanghai's man-made landscape for generations. David Sassoon (1792–1864) opened David Sassoon and Sons in 1845 in Shanghai, and his financially successful descendants became primary participants in the community. Members of both families traveled between and inhabited such distant cities as London and Bombay. With a highly tuned sense of up-to-date architectural styles, a grasp of amalgamating cultures, and the affluence to support extensive construction —combined with the jazzy Deco-style design that was bursting onto scenes across the world— these families offered the Shanghai skyline buildings that successfully captured the city's bold energy. Many Sassoon landmarks still stand today, evoking the classical zenith moment of

Shanghai style during the 1920s, '30s, and '40s. The facade of the Cathay Hotel, opened in 1929, may initially impart the appearance of a fine New York establishment, but the designers in fact did not ignore their immediate cultural surroundings. Walking through a revolving door at the building's central entrance on the Bund, visitors climbing the symmetrical steps toward the second floor would encounter two massive, striking Deco-style stained-glass windows, depicting not biblical or European scenes but Chinese workers and farmers. Ascending by elevator to the top floor to take in the panorama of the Bund and the Huangpu River, they would arrive at a Chinese restaurant decorated in a distinctly Chinese-influenced Deco style. The Cathay, Grosvenor House, and the Metropole—all built by the Sassoons—with their elegant Deco flourishes and subtle Chinese gestures, became not only celebrated monuments and defining styles of the metropolis but also inspiration for more modest structures, including homes, shops, and even automobile garages throughout Shanghai.

The opening scenes of 1937's *Street Angel*, which tells the story of the lower classes in the city, portray the sensation that was Shanghai at the time. Mesmerizing camera shots are masterfully edited with a fast-paced, jazzy rhythm. Throngs of rushing residents on automobile-filled streets are overlaid with shots of the grand range of architecture that crowds the air space of the city: skyscraping apartment buildings, spires of cathedrals and churches, domes of Russian Orthodox houses of worship, department stores, office towers, neon signs in Chinese and English, and street lamps, all seen from the air, or from a moving tram, or from a handheld camera that cannot hold still because, we imagine, the cinematographer is so awed by the towering Broadway Mansions (cat. no. 40). Like the women looking through their binoculars forty years earlier, the 1930s residents were enamored of the ever-increasing heights of Shanghai buildings.

The Chinese-international amalgamation that blossomed during the 1920s, '30s, and '40s and came to define Shanghai style manifested itself not only in architecture, large and small, but also in furniture, dress, and graphics. The *qipao* (cat. nos. 73–77)—the fashionable close-fitting dress worn by modern women that adorned cigarette, battery, and soap advertisement posters—epitomized this Shanghai style, as did the striking book covers designed in Shanghai that seemed to reverberate with the jazzy rhythms that could be heard at the Cathay Hotel bar.

The jazzy rhythm that lifted Shanghai into a frenzy of construction and thoroughly spread the Shanghai style into the details of daily life was hushed for a time after the city took on the Communist approach to lifestyles following 1949. The great buildings of the former age that once visually broadcast their mercantile ideals still stood, but now they were occupied by state offices and enterprises. And the state, which was primarily focused on transforming Beijing into a unique Chinese Communist–style built atmosphere, mostly ignored the development of Shanghai, offering the great city only one major architectural statement, the Sino-Soviet Friendship Building (now called the Shanghai Exhibition Center, or Shanghai Zhanlanguan) —built, ironically, on the land that had once been Hardoon's Chinese-style garden estate. Constructed in 1955, with the assistance of the Russians, the monument was created in the lavish architectural style known as Stalinism. The extensive, generously ornamented complex added yet another series of foreign-style spires —not unlike those in Zhou Muqiao's lithograph— to Shanghai's skyline. Though it is unlike any structure seen before in Shanghai, the Exhibition Center even today can be considered contiguous with the Shanghai style.

In the early 1980s, the twenty-two-story Park Hotel, originally built in 1932 and considered one of the paramount examples of Shanghai Deco architecture, was still the tallest building in the city. In a short story published in 1983, just as China was emerging from the muting effects of the Cultural Revolution, aspiring

young characters—jokingly referred to by their friends as "amateur overseas Chinese" because they so yearn to appear "foreign"—gather at the cafe in the Park Hotel to be seen and to drink expensive, imported Nescafe. Interestingly, young men and women in recent years have flocked to Xintiandi, a shopping, bar, and restaurant district developed to recreate buildings and styles of the early 1900s.

While the nostalgia for the 1930s successfully manifested itself in the twenty-first century at Xintiandi, most developers and municipal planners continued to promote the hundred-plus-year-old vision of Shanghai's spires. Liu Jianhua's porcelain skyline, *Shadow in the Water* (cat. no. 121), does not look at the classical Shanghai Bund band of buildings. The artist instead turns his head, as if standing on the Bund—thereby acknowledging its respected presence—to look across to Pudong, the new skyline of skyscrapers, all erected in the past two decades since Deng Xiaoping and the Chinese Communist Party's Central Committee decided that the district be commercially developed.

Most prominent in the sculpture and on the Pudong waterfront is the Oriental Pearl Tower (Dongfang Mingzhu Ta),[10] completed in 1995, a tall television tower with large and small bulbous "pearls" arranged along its height. The design was said to have been inspired by a poem by the Tang dynasty poet Bai Juyi (772–846), who described the music of a *pipa* player as "pearls, large and small, on a jade plate falling"; the greenery in the park around the building was intended to suggest the jade plate. Some commentators have also compared the two bridges crossing the Huangpu, on either side of the tower, to two dragons playing with the "pearl," an ancient imperial motif.

The Jin Mao Tower, completed in 1998 (which also appears in Liu's skyline), is a Skidmore Owings and Merrill building with a profile meant to evoke a pagoda, and an auspicious, according to Chinese tradition, number of floors—eighty-eight.

In *Street Angel,* the two main characters find themselves in a lawyer's office in a Shanghai skyscraper.

> CHEN: Look, we're already standing above the clouds!
> WANG: This is really heaven.[11]

No doubt, their image of heaven incorporated pearls and jade plates as well as tall buildings.

NOTES

1　*All About Shanghai and Environs.*
2　Fodor's Travel, http://www.fodors.com/world/asia/china/shanghai/.
3　Harper and Eimer, *Shanghai City Guide.*
4　Wu Youru, *Wu Youru Huabao Haishang Baiyantu,* collection 3, vol. 2, p. 14.
5　Pott, *A Short History,* 22 (italics added).
6　*All About Shanghai and Environs.*
7　Pott, *A Short History,* 1.
8　Hardoon's exact year of birth is not known. Dates given in various sources range from 1847 to 1851. He died in 1931.
9　Pott, *A Short History,* 304.
10　The building was designed by Jia Huancheng of Shanghai Modern Architectural Design Company.
11　Translated by Andrew F. Jones, published at mclc.osu.edu/rc/pubs/angel/default.htm by MCLC Resource Center (copyright 2000).

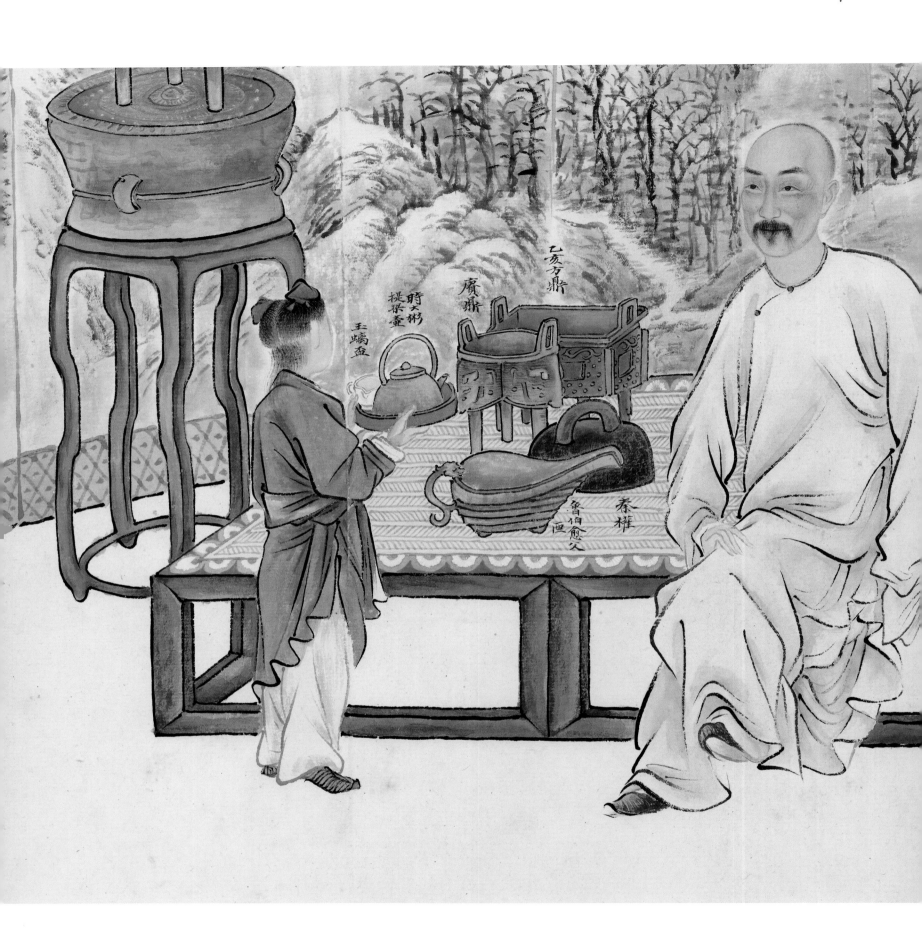

Catalogue

China Trade Paintings

As with many travelers today, traders and others visiting Shanghai during the nineteenth century desired a record of the place, something to take home to demonstrate the conditions in which they lived and worked. Prior to the advent of photography in the 1860s, paintings and drawings were the primary mediums for this type of memento. Traditional Chinese painting in ink on paper or silk was too foreign both in style and in its emphasis on the act of creation over the representation of actual places to fill this demand; rather, it was filled by a genre generally known as China Trade paintings. These works were created by Chinese artists in the Western mediums of oil on canvas or gouache on paper. The paintings are often so site-specific that many can be dated by the buildings depicted in them.

Even though they worked not long ago for a largely Western clientele, relatively little is known about the artists who created these works.[1] China Trade paintings were outside the realm that the Chinese considered "fine arts" and had a larger impact on chinoiserie in Europe and the Americas than they did on later Western-influenced paintings in Shanghai.[2] Few records from the period on the artists' backgrounds, their training, or the methods of commission and distribution of paintings exist in Chinese or in Western languages. Those few descriptions that do exist indicate that the paintings were created in workshops generally known by the name of a single master. The names of these master artists are also a mystery. Most end with the suffix *kwa* (or *qua*), which appears as well on names of major Chinese merchants. Apparently this suffix has nothing to do with the Chinese name of the artist, and its use became a tradition mainly directed at Western patrons.[3] A miniature painting that depicts an interior from around 1855 provides the best visual record of the workings of these shops.[4] In it, three artists, one wearing glasses, paint at separate tables in a room filled with examples of their work. The content and compositions of paintings of the same scene created by these workshops are remarkably similar,

indicating that they were done in an assembly-line fashion, with details added as commissioned. Carl Crossman even suggests that for the watercolors created at these shops, the preliminary composition may have been created by a woodblock or other printing technique, the colors then filled in by skilled artisans.[5] Preliminary outlines and other mass-production techniques were likely used for oil paintings as well.

The China Trade painting workshops in Guangzhou (Canton) are the best known and certainly the most numerous; by the 1800s this city had served as a center for Chinese trade with the West for centuries, and a number of Western-influenced art forms had developed there.[6] The artists active in Canton were also commissioned to create works for the new residents of Hong Kong when it was ceded as a colony to Great Britain in 1842. These Canton-based artists likely created scenes of Shanghai and other treaty ports on commission as well. Scholars have proposed that inaccuracies in some scenes of Shanghai might be explained by foreign buyers having commissioned paintings from artists in Canton who had never seen the places they were depicting.[7]

The best-known Shanghai-based China Trade painter was Chowkwa (or Chowqua), whose Chinese name was Su Zhaocheng. Described as the "unrivaled master of Bund views," Chowkwa was active from around 1850 to 1880 and had his studio first on Park Lane (which was renamed Nanjing Road in 1862) and later on Hankow Road.[8] Four of the works illustrated here either carry his signature or are associated with this artist.

The world depicted in these paintings is dominated by Western buildings and Western life. The patrons for these paintings and the companies they represented had little, other than economic, interest in the people they traded with; these were the companies whose insistence on trading in opium rather than silver had led to the Opium Wars and the establishment of Shanghai as a treaty port.

When British and American traders began to occupy Shanghai, they located many of their

company buildings along an approximately one-mile-long stretch of the bank of the Huangpu River where it is joined by Suzhou Creek north of the old walled city of Shanghai. Initially the settlement was British; in 1863 the British and American settlements were combined in the International Settlement. This area was to become what is now known as the Bund; the vast majority of scenes in China Trade paintings of Shanghai are of this vicinity. Even the name *Bund* is an indication of Shanghai's globalized past; it means an embankment or an embanked quay and is likely based on an Urdu term. In use in India during the sixteenth century, the word came to Shanghai either with the British or with the first influx of Jews from Iraq.

Very little has survived from the first sixty years of building along the Bund. The collapse of corporations, the changing needs of firms located there, and other changes led to the majority of the original buildings being torn down and new structures being erected in their place. These relatively frequent changes make it possible to date the China Trade paintings of the area and its individual buildings with some precision.

The last great building boom along the Bund was from the late 1910s through the 1930s. Most of those buildings survive today. There are now fifty-two buildings, many first built as financial institutions in Romanesque, Gothic, Renaissance, Baroque, Neoclassical, Beaux-Arts, and Art Deco styles. Starting from the south, some of the most significant buildings, listed by address, are:

1 The McBain Building
2 The Shanghai Club
3 The Union Building
5 The NKK Building, which housed a Japanese shipping company
6 The Russell & Company Building

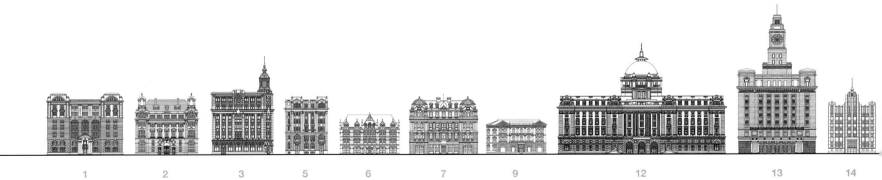

1 2 3 5 6 7 9 12 13 14

THE BUND – SHANGHAI

Most of these buildings have changed owner-ship a number of times, and many now serve pur-poses far different from those originally intended.

Michael Knight

NOTES

1 For a general discussion, see "The Port Views and Ship
 Portraits" in Crossman, *Decorative Arts*, 106–150.
2 Politzer, "Changing Face," 70.
3 Clunas, *Chinese Export Watercolours*, 99, 82–83.
4 Crossman, *Decorative Arts*, color pl. 64.
5 Ibid., 187.
6 For a description of the Western settlements in Canton
 and the establishment of these workshops, see Clunas,
 Chinese Export Watercolours, 10–22.
7 Politzer, "Changing Face," 62.
8 Ibid., 70; and Crossman, *Decorative Arts*, 197–198.

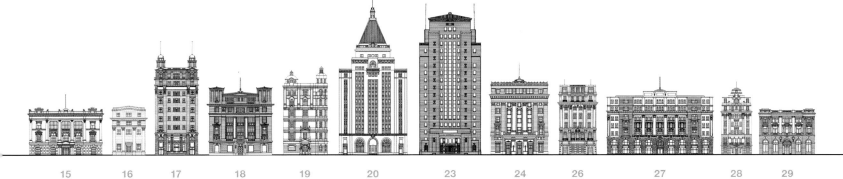

15 16 17 18 19 20 23 24 26 27 28 29

SIMON FIELDHOUSE 2008

1 *Shanghai*, approx. 1855–1862*

Anonymous
Oil on canvas
H. 45.4 × w. 76.2 cm
Peabody Essex Museum, M10565

2 *View of the Shanghai Bund*, approx. 1862–1865

Anonymous
Gouache on paper
H. 54.9 × w. 118.1 cm
Peabody Essex Museum, E82723

Changes in company fortune and historical events have erased almost all traces of the first buildings created along the Bund. China Trade paintings are the main records of the area's appearance from the late 1840s to the advent of the common use of photography in the 1860s. It is possible to track the changes in the buildings along the Bund even in this early period by combining accounts in company records, local newspapers and gazettes, and related information. These details can then be used to approximate the date a particular view of the Bund was painted.

The first painting illustrated here is a general scene of the Bund and can be dated no later than 1862, since in that year a tower was added to the buildings owned by Augustine Heard and Company and this view contains no tower.[1] Other details indicate a date no earlier than 1855. This painting provides a strong contrast to ink paintings created in Shanghai at roughly the same time (see cat. no. 10). Clearly the anonymous artist who created this work was well trained in Western techniques of oil on canvas.

The second painting can be dated no earlier than 1862, since the tower on the Heard and Company building is clearly visible. The British consulate, located on the far right of this painting, sold some of its adjoining property in 1862. By 1865 new buildings were completed on this property and are clearly visible to the left of the consulate in paintings and photographs dating after 1865.[2] These buildings do not appear in this view, suggesting it was painted before 1865.

Differences between the ships depicted in these two paintings also indicate some of the changes that were occurring both in maritime technology and in Shanghai itself. All the ships in the earlier painting are sailing vessels, a combination of Chinese-made junks and Western craft. The later painting shows a number of steamships with side paddles; one is quite small and likely meant for local trade. Two large covered craft appear as well, one in the center of the painting and one on the right side, which are likely to be opium hulks. Following the legalization of the sale of opium in China in 1860, these hulks were pulled into Shanghai harbor from more discreet locations.[3] They are depicted in China Trade paintings of the mid-1860s. MK

1 Politzer, "Changing Face," 70.
2 Ibid., 78.
3 Ibid.

* Complete object data in Chinese appears
 in the Checklist in Chinese (page 250).

2

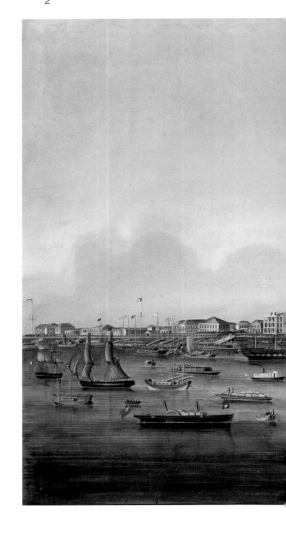

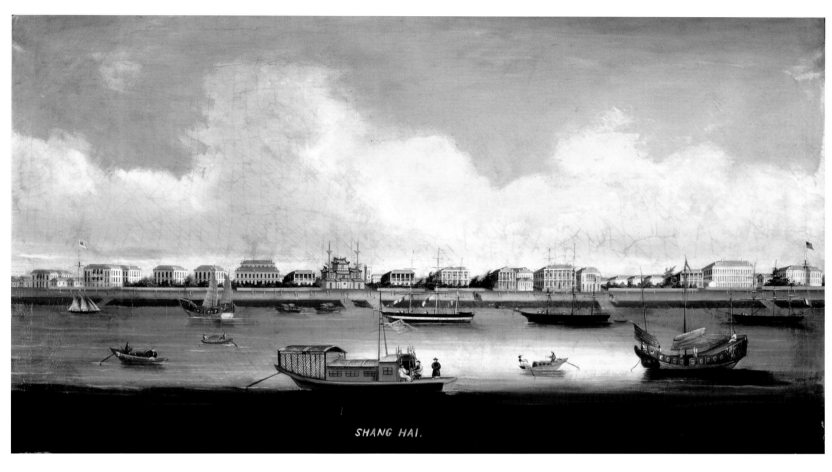

SHANG HAI.

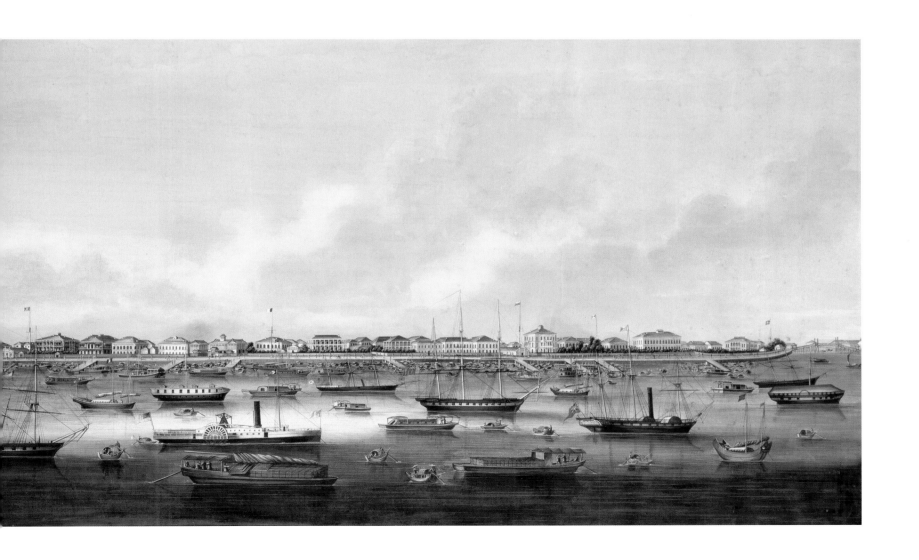

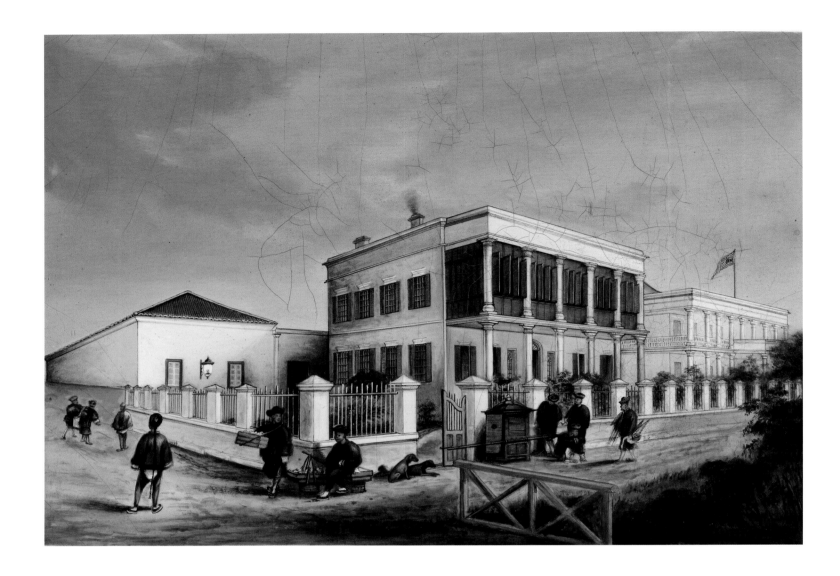

3 *Augustine Heard and Company's Hong
 [Warehouse] and Residence, Shanghai*, 1849

By Chowkwa (active 1849–1880)
Oil on canvas
H. 31.1 × W. 42.5 cm
Peabody Essex Museum, M5131

The title and date appear along the base of this painting. Augustine Heard and Company was a Massachusetts-based company founded in 1840; it opened offices in Shanghai in 1847. This painting depicts the company's first Shanghai offices, which were on lot 33 at the northeast corner of Park Lane and Church Street, next to the offices of Russell & Company. The company purchased lot 4 on the Bund from King & Company sometime in the summer of 1857 and vacated their earlier building. Heard and Company failed in the spring of 1875, and their buildings were pulled down in the spring of 1877.[1] The Sassoon family purchased the property after Heard and Company failed and had two office buildings constructed that can be seen in photographs and China

Trade paintings dated 1879 and later. The Sassoons later had the Cathay Hotel built on this site.

This work is one of the earlier depictions of Shanghai, which had only been a treaty port for seven years when it was completed. The streets, still unpaved and lined on one side with grass and brush, are occupied by a number of Chinese laborers and a pair of dogs. The imposing building in the background flying the American flag is the offices of Russell & Company (see cat. no. 5), which housed the American consultate in Shanghai.[2] MK

1 Politzer, "Changing Face," 70.
2 Information was provided by Amy Huang.

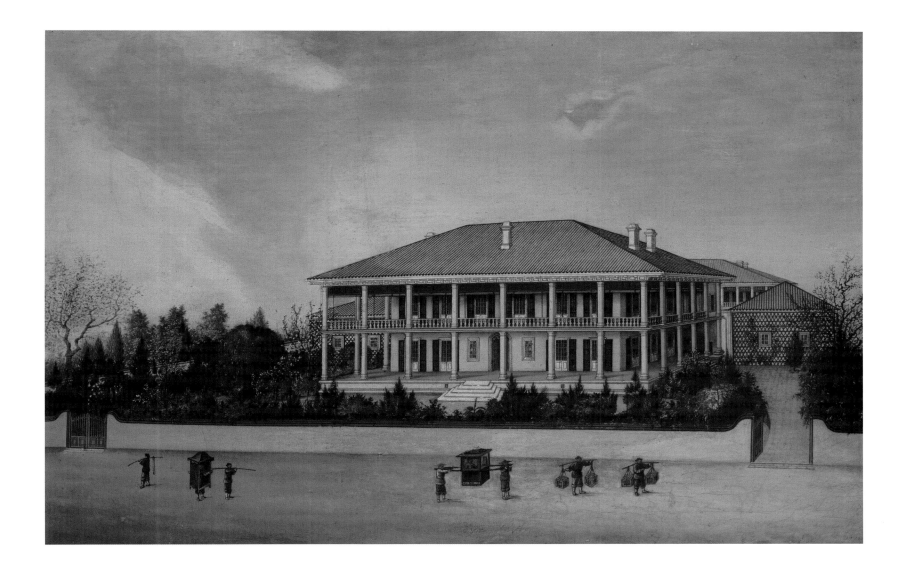

4 *House of Dent, Beale & Company,*

approx. 1857–1859

Anonymous

Oil on canvas

H. 42.9 × W. 65.7 cm

Peabody Essex Museum, M3794

Thomas Dent arrived in Guangzhou from England in 1823 and joined the firm of Davidson & Co. as a partner. When Davidson left in 1824, the company changed its name to Dent & Company. In 1826, Thomas Dent was joined by Lancelot Dent, who succeeded Thomas as senior partner when Thomas departed the company in 1831. Lancelot Dent was arrested by Chinese authorities in 1839 and forced to surrender his supply of opium, an event that contributed to the beginning of the Opium Wars.

T. C. Beale joined the firm as partner in 1840 and the firm became Dent, Beale & Co. It once again became Dent & Co. upon Beale's departure in 1857. Dent was one of the first traders to open offices in Shanghai. It had offices at 14 The Bund just to the right of the Customs House. This image of the building can date to no earlier than 1857, since the greenhouse built in that year is clearly visible (the small outbuilding just to the right of the main building). However, this view does not include the new building constructed in 1859, thus providing a probable date between 1857 and 1859.

In 1866 the financial world was rocked by the collapse of Overend, Gurney and Company, a discount house on Lombard Street, London, causing a run on many banks that in turn brought down numerous other businesses. Dent was forced to shut its Hong Kong office, and its headquarters moved to Shanghai.[1] The company officially folded in 1867. MK

1 Politzer, "Changing Face," 78.

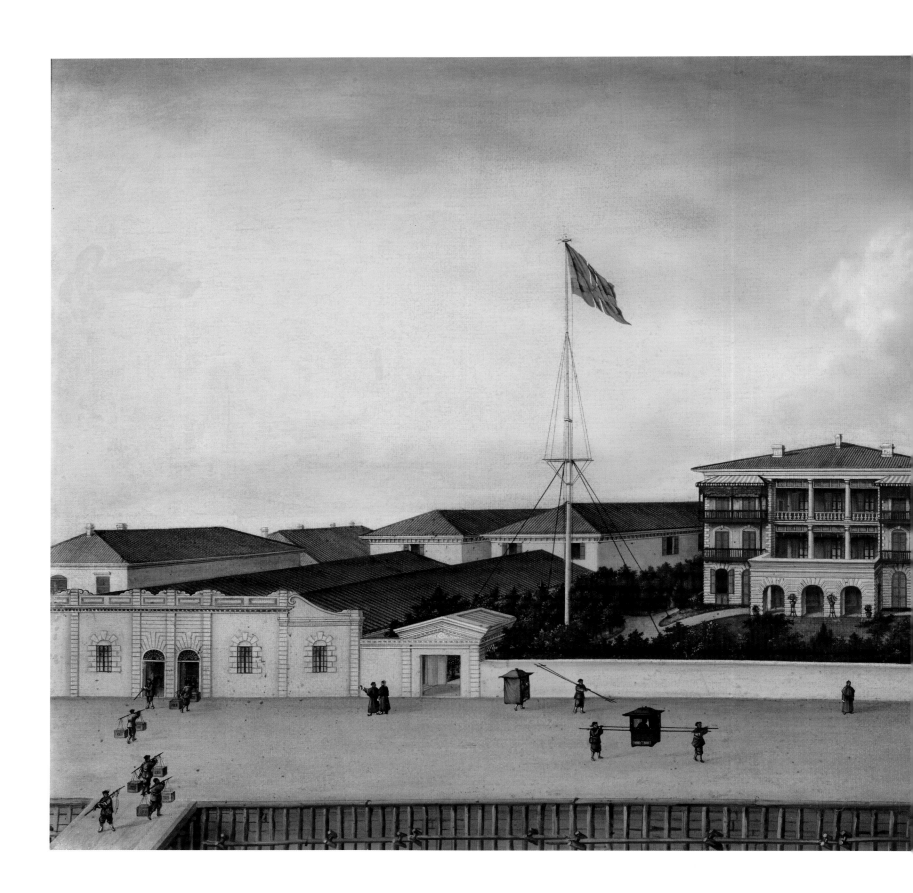

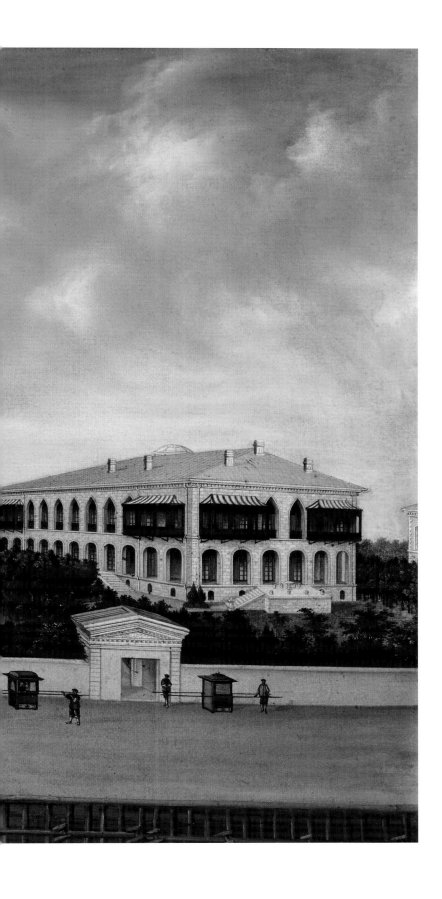

5 *Shanghai: The Bund, within the Premises of Russell & Company*, approx. 1857

By Chowkwa (active 1849–1880)

Oil on canvas

H. 50.8 × W. 82.9 cm

Peabody Essex Museum, Museum purchase by the friends of Evelyn Bartlett and in honor of Dr. H. A. Crosby Forbes, 2000, AE85781

Founded in 1818 by Samuel Russell of Boston, Russell & Company was for many years the foremost American merchant business operating on the China coast; it was rivaled in Shanghai only by Augustine Heard and Company (cat. no. 3). Russell opened in Shanghai on September 1, 1846, on Park Lane and moved its Shanghai offices to the Bund in 1852. On the Bund, Russell & Company occupied a large compound between Foochow and Canton Roads near the Customs House. The complex was expanded in 1856 to include the partners' residence, known as the Stone House, together with the company's offices and warehouses (commonly known as godowns). These are depicted in this painting in meticulous detail, illustrating the stone facings and upper-floor verandahs, the gardens, the tea porters and the palanquin bearers, and the wooden construction of the Bund itself.

The presence of the Stone House is one indication of the date of this painting. Another is the appearance of the flag of the kingdom of Sweden and Norway. The first salaried consul of the United States arrived in Shanghai in February 1854 and lived in the Russell buildings until the summer of 1855.[1] Paintings predating 1857 should show the building flying the American flag. Russell's principal partner served as U.S. consul until 1857, and after that date Russell & Company often flew the Sweden and Norway flag. MK

1. Politzer, "Changing Face," 70.

Chinese Export Silver

Similar to China Trade paintings, silver vessels and luxury items were made in various parts of China for export. The tradition first developed in Guangzhou (Canton) during the seventeenth century. H. A. Crosby Forbes divides its development into three parts. The majority of the earliest group, which date between 1600 and 1785, were in Chinese styles with landscapes, floral designs, and other patterns found on various export arts of the same period. The works catered to the chinoiserie craze that began to sweep Europe at that time.[1]

During the second period, from the 1780s to the 1860s, the Chinese specialized in interpretations or copies of designs popular in the West. By this time, Chinese artisans in Canton had developed considerable skill in the medium and were able to copy almost anything. Carl Crossman discusses how recent scholarship has begun to clarify long-standing confusion between fine pieces of silver made in China and the pieces made in the West on which they were modeled.[2] Forbes, Kernan, and Wilkins devote an entire section of *Chinese Export Silver, 1785 to 1885* to providing clues on how to distinguish pseudo-European and -American marks or even fake marks appearing on Chinese silver.[3]

The third stage, beginning around 1840 and lasting to the 1930s, has been called Chinese Revival and features a return to surface decoration and some forms based on Chinese traditions.[4] While the centers of production during this final period spread to the newly occupied ports with foreign concessions and to Hong Kong, Cantonese styles and traditions remained dominant.[5] The two examples illustrated here were made in Shanghai and belong to this third group.

The silver used to create these objects came from one of three sources: from locally mined silver, from deposits in Japan, or from the large amounts of silver currency used in trade for Chinese tea, porcelain, and silk. Silver bars or other unfinished forms were also shipped to China specifically for the use of Chinese silversmiths.[6]

The industrial revolution in Europe and the Americas impacted a number of trade-related arts in China, including this later group of silvers. By this time, Western factories were mass producing flatware and other silvers with relatively simple forms and surface decoration. These products competed with those produced in China, which relied on cheap labor to be economical. As a result, the Chinese began to focus on more elaborate forms and surface decoration that required a great deal of handwork. Labor in China remained so inexpensive that it was economically viable to ship raw silver from sources in Europe or America to China, have it worked there, and ship the final products back.[7]

In part, new technologies in shipping, including steamships and transcontinental railroads, made this practice feasible. Equally important were the skills and low cost of Chinese labor. However, competition for this market came from other sources, including India and Japan. After 1884 the Japanese began to make more silver for export than the Chinese.[8]

Michael Knight

NOTES

1 Forbes, *Chinese Export Silver*, 5.
2 Crossman, *Decorative Arts*, 338.
3 Forbes, Kernan, and Wilkins, *Chinese Export Silver, 1785 to 1885*, 80–85.
4 Forbes, *Chinese Export Silver*, 5.
5 Ibid., 4.
6 Crossman, *Decorative Arts*, 339–340.
7 Ibid., 347.
8 Forbes, Kernan, and Wilkins, *Chinese Export Silver, 1785 to 1885*, 79.

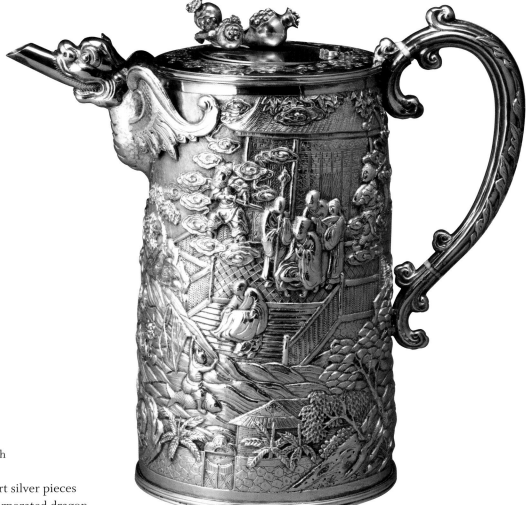

6 Coffeepot with dragon spout,
approx. 1875
Shanghai, mark of Luen Wo workshop
Silver
H. 22.6 × DIAM. 12.4 cm
Collection of Stephen J. and Jeremy W. Potash

This coffeepot is typical of Chinese export silver pieces
dating from around 1860–1930 that incorporated dragon
designs for the handles or spouts and familiar Chinese
motifs for the surface decoration. Coffeepots had no
precedent in works made for use by Chinese patrons and
indicate that the piece was made with a Western market
in mind. The decoration, however, is Chinese, perhaps
indicating a continuation of the chinoiserie movement
in Europe and the Americas that by this time had been
in existence for more than a century. The knob on the
lid is in the form of a group of pomegranates, a fruit
that, due to its many seeds, is associated with fertility
in traditional Chinese decorative arts. The main pattern
on the body of the vessel depicts a group of scholars in
a rural pavilion. Similar decoration can be found on

ceramics, carved bamboo, and other wares made for
both Chinese and export markets.

This coffeepot has an LW mark and a Chinese char-
acter associated with the Luen Wo company. Luen Wo
appears in a directory from 1909 as a jeweler located at
42 Nanking (Nanjing) Road in Shanghai.[1] MK

1 Forbes, Kernan, and Wilkins, *Chinese Export Silver, 1785 to
 1885*, 78.

7 Bowl with dragon handles, approx. 1875

Shanghai, mark of Tuck Chang workshop
Silver
H. 19.1 × DIAM. 26.4 cm
Collection of Stephen J. and Jeremy W. Potash

This large silver bowl combines elements of Western and Chinese design and decoration. The basic shape had little function in a Chinese context, a likely indication that the piece was made with the European or American market in mind. The handles take the form of two large dragons of a type frequently found on Chinese metalware and other decorative arts. These dragon handles are a feature of later Chinese export silver. The top band of decoration on the body of the piece consists of a series of smaller dragons, details of which are cut through the silver. The main part of the body is decorated with floral patterns surrounding a central cartouche. Such floral patterns, which here consist of bamboo and acanthus leaves, are commonly found on Chinese decorative arts. The central cartouche appears on ceramics and related arts created at the Qing court during the eighteenth century under the influence of the Jesuits.

The bowl has a TC mark and Chinese characters indicating that it was made by Tuck Chang and Company, which had offices in Shanghai at 1285–86 Broadway, Hongkew, and at 80 Taku Road in Tianjin. The company created both jewelry and objects in gold and silver.[1] MK

1 Forbes, Kernan, and Wilkins, *Chinese Export Silver, 1785 to 1885*, 78.

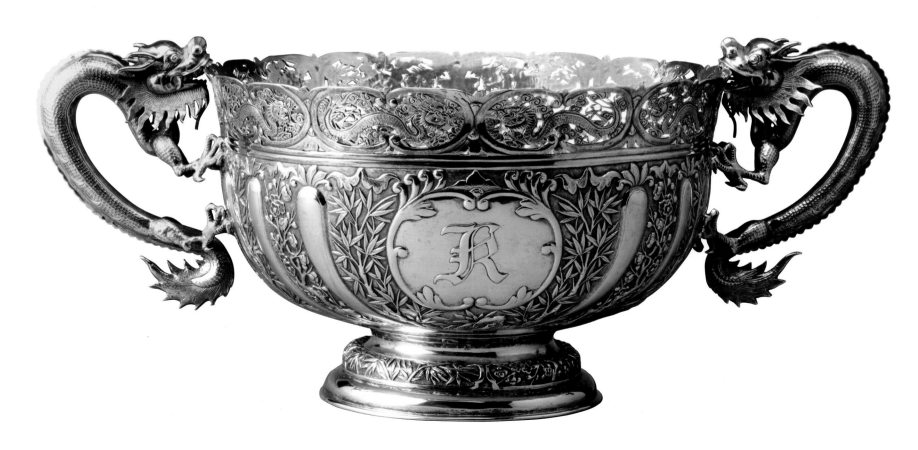

Modern Art and Culture in Shanghai 1840–1940

Shanghai is situated where the Yangzi River meets the sea; bordered by the East China Sea to the east and the Grand Canal on the north, the city is surrounded by rich, fertile lakes and rivers. Shanghai was listed as one of five major trading ports following the First Opium War in 1840. It became a treaty port in 1843, and trade by sea and river grew rapidly. The treaty port expanded continuously over the next sixty years, and foreign investors poured capital into Shanghai, building numerous banks and factories. At the same time, commerce by the local Chinese also grew, and Shanghai went from a seaside town to China's number-one city—an international financial and commercial metropolis.

As China experienced an influx of Western philosophy, political theory, and art at the turn of the twentieth century, Shanghai became the place for the initial meeting of Chinese and Western thought and culture. Because Shanghai was in the unusual position of being a treaty port subject to special rules, various schools of thought and "-isms" could be debated there with relative freedom. Democracy, science, and new cultural movements were promulgated in Shanghai. From 1937 to 1945 the city fell under Japanese occupation, and anti-Japanese sentiment arose. All of these political events and societal changes had an enormous influence on Shanghai's development. Looking back over this hundred-year period, we could say that in Shanghai various political and cultural ideologies mingled, battled, and fluctuated, resulting in art and culture that was multidimensional, abundant, and rich in local flavor.

The objects in this exhibition reflect the period's vitality. They were chosen from the collections of the Shanghai Museum, the Shanghai Art Museum, the Shanghai History Museum, the Lu Xun Memorial Hall, and the Peabody Essex Museum, as well as from private collections. Although it cannot show the entirety of cultural development, this exhibition provides an overview of Shanghai's culture since the middle of the nineteenth century.

The Teaching, Improvement, and Evolution of Traditional Chinese Painting

In the second half of the nineteenth century Shanghai's economy was booming, and newly prosperous employees of foreign traders, government entities, and wealthy merchants along with all kinds of urban classes created new art markets. Painters from around the country flocked to Shanghai, selling art for a living. According to Huang Shiquan's *Records of the Illusive Dream of Shanghai (Songnan mengying lu)*, written in the fifteenth year of the reign of the Guangxu emperor (1889), a group of artists enjoyed great fame during that time. "The landscape paintings of artists such as Hu Gongshou [Hu Yuan, 1823–1886] and Yang Nanhu [Yang Borun, 1837–1911]; figure paintings by Qian Jisheng [Qian Hui'an, 1833–1911], Ren Fuchang [Ren Xun, 1835–1893], Ren Bonian [Ren Yi, 1840–1896], and Zhang Zhiying [Zhang Qi]; flower and bird paintings of Zhang Zixiang [Zhang Xiong, 1803–1886] and Wei Zhijun; and portraits by Li Xian'gen enjoyed great repute near and far. Anyone from any level of society was proud to own even a shred of their work."[1]

Since the early Qing dynasty, Chinese painting had been dominated by landscapes done in the style of the Four Wangs[2] and by flower and foliage paintings in the style of Yun Nantian (Yun Shouping, 1633–1690). However, by the late Qing period, these techniques were becoming stagnant. Exhaustive efforts to imitate artists of old, striving only for simplicity and gentle beauty, resulted in a lifeless, spiritless style. Artists in Shanghai knew that to meet the needs of their city's new population, they had to make breakthroughs in all areas, including subject matter, technique, form, and aesthetics. A group of unconventional artists emerged around this time, the more famous of whom included Zhang Xiong, Ren Xiong (approx. 1820–1864), Xu Gu (1824–1896), Zhao Zhiqian (1829–1884), Wang Li (1817–1885), Hu Yuan, Qian Hui'an, Ren Xun, Ren Yi, Wu Qingyun (1845–1916), and Wu

Changshuo (1844–1927). These artists and others who worked in a similar style were later known as the Shanghai school.

Xu Gu (cat. no. 10), whose secular name was Zhu Huairen, was once a low-ranking officer in the Qing army. Disenchanted with the politics and war of the times, he became a monk at around the age of thirty-one and wandered around the Suzhou, Shanghai, and Hangzhou area, selling paintings for a living. He specialized in flowers and plants, animals and birds, and fruits and vegetables. Xu Gu was adept at catching a subject's fleeting expression or movement, such as a squirrel skipping onto a tree branch, fish meandering among willows, or a red-crowned crane standing upright, full of life and vitality. At the same time, he produced many paintings of everyday objects with a flavor of the countryside, such as bamboo shoots, cabbage, loquats, grapes, and lotus roots in a style that was simple and approachable. He sometimes painted pines and cranes, as well as peaches, peonies, and Buddha's hand citrons, symbolizing wishes of blessings and good fortune. His work catered to the tastes and interests of the new urban classes. Xu Gu's landscape paintings were more realistic than traditional examples. His vibrant, energetic brushwork included new techniques, such as "pausing brush" (dotting), "broken" strokes, and guiding the brush against regular movements (up to down, and left to right), resulting in a forthright style rich in movement and rhythm, one that swept away the fragility and shallow beauty of the Nantian (Yun Shouping) school of the late Qing dynasty.

The brothers Ren Xiong and Ren Xun produced art with a more urban flavor. Ren Xiong's style, traceable to that of Chen Hongshou (1598–1652), employed precise, forceful lines; figures in his paintings tend to be slightly exaggerated to emphasize personality and mood. His unusual landscapes contained bold lines and strong colors, making them rich in decorative appeal. Ren Xun, whose work was influenced by his elder brother, produced strongly realistic paintings.

Ren Yi, notable for his creativity, was adept at painting all types of subjects, including figures, flowers and birds, and landscapes. He initially studied under Ren Xun, and therefore his work shows strong traces of influence from Chen Hongshou. Ren Yi moved to Shanghai in midlife and at one point, along with Liu Dezhai, studied figure sketching at the Art School in Tushanwan; as a result his portraits convey a sense of realism and show both a clear knowledge of facial structure and effective use of light and shadow. His portrait of Feng Gengshan (cat. no. 11) is representative of this approach. Ren Yi was skilled at depicting legends and myths, historical tales, customs, plants, insects, and fruits as well as landscapes. Many of his works are direct portrayals of daily life, such as poor tradesmen, townspeople, artists, and fighters. His strong sense of national pride is apparent in his repeated use of themes related to a popular deity, Zhong Kui, traveling the Three Gorges, and historical tales. To meet the needs of businessmen and other city residents, he also created works with various auspicious themes, including wishes for good luck, professional success, and longevity. His flower-and-bird paintings—unique in concept, lively in form, and bright in color—evoke a sense of joy. Ren Yi's work shows a noticeable tendency toward common, everyday people. Clearly, Chinese art in Shanghai evolved to keep up with the times.

During the end of the Qing dynasty and the early days of the Republic, artists such as Ni Tian (1855–1919) and Yu Ming (1884–1935) successfully adopted the style and flavor of Ren Yi; this influence can be seen in Ni Tian's portrait of Wu Changshuo (cat. no. 14) and Yu Ming's portraits of Huang Jinrong and Du Yuesheng (cat. no. 16).

Zhao Zhiqian (cat. no. 8) reached a high level of attainment in both calligraphy and seal carving. He studied first the calligraphy of the Two Wangs (Wang Xizhi [303–361] and Wang Xianzhi [344–386/388]) and Yan Zhenqing (709–785) and later the Northern Wei (386–534) style; his work is imposing and magnificent. In his

flower-and-plant paintings can be seen the influence of the freehand styles of Bada Shanren (Zhu Da, 1626–1705), Shitao (1642–1707), Chen Chun (1483–1544), and Xu Wei (1521–1593) as well as Zhao's own calligraphic and seal-carving style, one that is profound and strong, fleshy yet with definite structure. The strong colors and ink blend and mutually enhance, and the result is a new type of flower-and-plant painting with an epigraphic (*jinshi*) flavor, full of simplicity, richness, and depth.

After Zhao Zhiqian came Wu Changshuo (1844–1927), another master of the "epigraphic school" (*jinshi pai*) who was well known early in his career for seal cutting and calligraphy. Later in life, he adapted his carving and calligraphy techniques for use in painting. He was adept at flower-and-plant paintings (see cat. no. 15), placing special emphasis on the essence of the scene, and in fact once said, "Kutie [his alias] captures the essence, not the form." His compositions are unusual; they contain a strong contrast between sparse and dense and an interplay of form and essence, conveying a sense of rhythm. With an even brush he applied strong, rich strokes in flowing ink. In his later years, in addition to ink and water, he incorporated fuchsia, lemon yellow, deep greens, and heavy browns to achieve an effect that was strikingly beautiful. His flowers and plants bore no trace of fragility or weak charm; they were instead vigorous and bold, the embodiment of the ability of the Chinese spirit to bolster itself in the midst of national weakness. Wu Changshuo mastered calligraphy, painting, seal carving, and poetry; in fact, his paintings combined and harmonized these elements. As a master of the four arts, he had many followers, and his influence has extended to contemporary art.

In the late Qing, new art forms such as copperplate prints and religious paintings were introduced into China from the West. Although few in number, there were Chinese artists who were familiar with these works and experimented with Western art techniques; the most notable was Wu Youru (1839–1897), who in his early years worked primarily with traditional methods. His album *Ladies* (cat. no. 26) depicted wealthy women at their toilette, playing the *qin* or *pipa*, or going for a boat ride, and all dressed not in clothing of earlier periods but in contemporary garb. In 1884 Wu was hired by the Shanghai newspaper *Shenbao* as the chief artist for its illustrated periodical, the *Dianshizhai huabao*. By the end of the periodical's print run in 1896, Wu and his assistants had created more than four thousand works, mainly on contemporary news and local customs, and reporting on important political and social events. (The periodical at times also included strange, unsubstantiated stories.) For the images in skillful line drawing (cat. nos. 27–32), Wu utilized Western perspective and strove for realistic depiction of such features as architecture, furniture, and fashion. Although he did not adhere strictly to the rules of perspective and spatial distance, his work heralded a new practice of adopting Western methods to re-form traditional Chinese painting.

Also noteworthy was Wu Qingyun (cat. no. 12), who created landscapes after the style of Mi Fu (1051–1107) and Gao Kegong (1248–1310), using the splashed-ink method. After Wu's return from a visit to Japan, he incorporated Western watercolor techniques, placing emphasis on light and shadow. His depictions of Jiangnan's misty landscapes and the interplay of colors at sunset are especially lovely.

The Collision and Harmony of East and West

The revolution of 1911 toppled the Qing imperial court, and the changes taking place on the political front led to a reevaluation of traditional thought and culture. At the same time, cultural perspective expanded as numbers of students studied abroad in Europe, the United States, and Japan, bringing back with them Western philosophy, culture, and art. Liang Qichao described this as "the vast European winds whip[ping] the Asian rains."[3] Then came the New Culture Movement,

in which a group of forward-thinking intellectuals heralded "science" and "democracy," attacking the political, moral, and ethical ideologies that focused on Confucianism. The art world was caught up by this movement, and in 1918 Kang Youwei (1858–1927) attacked traditional painting in his *Catalogue of the Art Collection at the Hut of Ten Thousand Trees*: "Up to the current dynasty traditional Chinese painting is completely degenerate."[4] Chen Duxiu (1879–1942) added fuel to the fire, writing that "in order to improve traditional Chinese painting, we must first revolutionize 'imperial painting' (*wang hua*), because the improvement of Chinese painting cannot exclude the realism of Western art."[5] In 1920 Xu Beihong suggested that the way to improve was to "protect the strengths of the ancient methods, carry on the admirable methods, correct the bad, bolster the inadequate, and incorporate the useful elements of Western painting."[6] Chinese painting found itself facing enormous challenges.

Traditional Chinese painting has a long, profound history, and many aspects of it remained popular. Furthermore, various artists viewed traditional Chinese painting as the best medium for conveying national pride and insisted upon gleaning methods for improvement from within Chinese culture, choosing instead to revamp ancient teachings. The most notable traditionalists of the Shanghai painting circles in the 1930s and 1940s were Wu Hufan (1894–1968), Wu Zheng (1878–1949), Wu Zishen (1894–1972), and Feng Chaoran (1882–1954), known as "the Three Wus and One Feng." Also of note were Zheng Wuchang (1894–1952), He Tianjian (1891–1977), Lu Yanshao (1909–1993), and Xie Zhiliu (1910–1997). All used tradition as a foundation for creativity, simultaneously preserving the elegance of the painting of the educated elite and adapting to the needs of the populace, thus bringing new life to traditional painting.

In the wave of artistic revolution, another group of artists proposed a merger of East and West, or a compromise between the two, basically suggesting that Western techniques be used to improve traditional Chinese art. Two main approaches to this compromise existed. The first involved keeping the fundamental methods and forms of traditional Chinese painting while integrating the concepts of light and shadow, anatomy, and color from Western painting. Cheng Zhang (1869–1938), Zhao Shuru (1874–1945), and Tao Lengyue (1895–1985), all from Shanghai, were representatives of this type of selective improvement.

The second approach was to employ Western theory and technique in the creation of Chinese painting. Obvious differences between this method and that of traditional painting were numerous, such as subject matter, composition, brushwork, and color. This approach caused major changes in the very substance of traditional Chinese painting and became the model for new Chinese work. Successful proponents included Xu Beihong (1895–1953) and Lin Fengmian (1900–1991).

Xu Beihong (cat. nos. 53 and 54) studied Western painting in Shanghai during his youth. In 1919 he studied in France. There and in Germany, he trained in Western sketching and oil techniques and studied famous oil paintings of Western realism. Upon his return home, he worked mainly in fine arts instruction. In his paintings, he focused on creative subject matter rich in meaningful thought. Some examples would be *Five Hundred Warriors Traversing the Fields*, done in oil, and *The Fool Who Moved the Mountain*, done in traditional Chinese techniques. In each the focus is on the human. Correct anatomical structure and use of light and shadow are evident in his depictions of people and animals, and his landscapes adhere to the principles of realism. In all of his work he employed Western methods and theory, reinventing Chinese painting on a large scale.

Lin Fengmian (cat. nos. 20 and 21) worked while studying in France; he received training in sketching and oil painting, and he studied as well a large amount of Chinese art, thus gaining a deeper understanding of traditional Chinese

painting. Upon his return to China, he brought with him the ideas of French Postimpressionism and Fauvism. Lin Fengmian strongly emphasized the expression of subjective feeling in art. In his essay "Art for Art's Sake and Art for Society's Sake," he stated, "Art is really the outward expression of human emotion. Art exists completely for the sake of art and contains no trace of societal function."[7] He also pointed out, however, that "after an artist produces a work, what is exhibited with this artwork will ultimately influence society. What appears in art will impact reality." In addition to oils, Lin liked painting in ink and colors on paper; his lines are reminiscent of various elements of folk art and were inspired by Han-era bricks with painted decorations, Song ceramics, and traditional shadow puppets. Lin combined all this with brushwork inspired by the great Fauvist Matisse to create works with fresh, vigorous lines. The colors he used were at times strong and bright like those favored by Impressionists and at other times subtle like those in the painting of the Chinese educated elite. Occasionally he used only ink and water with a touch of ochre in an abundance of rich layers. The women he painted were lovely and graceful, and his paintings of scenery were quiet and simple, calling to mind the "field and garden" lyric poetry of old, very much meeting the traditional Chinese standard of "beauty of content and rhythm of poetry" in painting. His paintings in ink and colors convey both the essence of traditional Chinese painting and an air of modern Western art in a unique, original style.

The Rise of New Art Forms and the Prevalence of Commercial and Popular Art

By the later Qing period, oil painting—a major medium in Western art—had already made its way to Shanghai. In the third year of the reign of the Tongzhi emperor (1864), a Catholic church in Xujiahui established the Tushanwan Art School, which held classes in subjects such as pencil sketching, watercolors, and oil painting. In August 1910 Zhou Xiang, having lived in Japan and visited France, established the East-West Art School, which specialized in the instruction of watercolor painting. In September of the same year he founded the Shanghai Academy of Oil Painting. By the twentieth century, numerous students who had gone to Japan and France to study Western art returned home, setting up classes in Western art instruction and starting a series of Western fine arts societies. In 1931 Pang Xunqin (1906–1985) and Ni Yide (1901–1970) founded the Storm Society (*Juelan she*) in Shanghai, the first such organization dedicated to oil painting, and Shanghai became the home of the Western art movement in China. Notable artists of this period included Wu Shiguang (1885–1968), Chen Baoyi (born after 1893–died after 1945), Ni Yide, Liu Haisu (1896–1994), Xu Beihong, Lin Fengmian, Zhou Bichu (1903–1995), and Guan Zilan (1903–1986). These artists studied and referenced in their work various schools of art, including realism, Impressionism, Postimpressionism, Fauvism, and various types of Western modernism, which resulted in a kaleidoscope of styles.

Other types of painting came from the West as well, including watercolor and gouache (*shuifen*). Early Shanghai artists adept at watercolor included Xu Yongqing (1880–1953), Zhou Xiang, Li Shutong (1880–1942), Li Yongsen (1898–1998), Zhang Meisun (1894–1973), Pan Sitong (1904–1980/81) and Chen Qiucao (1906–1988). Oil painters such as Zhang Chongren (1907–1998) and Wang Jiyuan (1893–1975) were also talented in watercolor. The early watercolor artists created a number of scenic paintings that are both historically and artistically valuable.

Gouache refers to a type of painting that uses color made by mixing water with powdered pigments. The colors are opaque and can be employed over large areas and to render precise lines. Gouache paints are used not only in scenery, figures, and flower-and-plant paintings but also in propaganda art, New Year's art, decorative

paintings, commercial art, product packaging, stage sets, and handicraft design. A portrait of Kang Youwei's wife (cat. no. 53) is an early example of a painting in gouache by Xu Beihong.

During the late-Qing and early-Republican period, Shanghai's prosperous economy compelled the need for art related to product packaging and marketing, such as commercial advertisements, posters, cigarette box inserts, and textile pattern design. At the same time, high-volume publication of books and periodicals created a demand for cover art and layout design. Posters—the majority of which were created in gouache—such as *Nanjing Road*—from *Series of Views of Shanghai* (cat. no. 62) and *Great World Entertainment Center* (cat. no. 63) serve as records of the wonderful architecture and flourishing commercial environment that was Nanjing Road in the early decades of the twentieth century.

Calendar poster art derived from designs of early advertising posters. A calendar poster was composed of a central artwork, a calendar printed on either side of or below the artwork, and a product advertisement. Given to customers at the beginning of the year, it served both decorative and practical purposes. The earliest calendar poster was created with gouache, although some were produced using traditional Chinese painting methods. Shanghai was the birthplace of calendar art and its main place of production. Zhou Muqiao (1868–1923) was its pioneer, and Xu Yongqing and Zheng Mantuo (1885/88–1961) later improved and perfected the techniques. When painting fashion models, they first used fine coal powder to create light and shadow and then added subtle pastel colors to depict youthful skin. The beauty of calendar art made it popular with consumers, and at one point it took the city by storm. Notable subsequent calendar artists included Hang Zhiying (1899–1947), Jin Meisheng (1902–1989), Li Mubai (1913–1991), Jin Xuechen (1904–1997), and Xie Zhiguang (1900–1976).

Most calendar posters portrayed fashionable Chinese beauties and secular sensibilities; some depicted scenes from history and legends. For the posters of Chinese beauties (cat. nos. 64–72), women were set against suitable backgrounds and shown undressing, gazing in a mirror, or dancing. They usually wore the latest-style clothing, often a *qipao*, which was popular during the Republican era. The calendar poster encompassed the distinct features of Shanghai-style culture: the beauty of the models, their willowy figures and fashionable attire, and the bright colors matched the aesthetic requirements of the modern citizen—the pursuit of trends, the attention to fashion and accessories, and the love of the ostentatious.

What is known today as a cartoon was an art form that evolved slowly from the late-Qing and early-Republican period. At the time it had many names, such as satire, "implied art" (*yuyi hua*), farce, or jokes. Later, Feng Zikai (1898–1975) coined the term "cartoons," or "comics" (*manhua*). Early cartoons were used for political critique or to satirize current events; hence they were dubbed "current-events cartoons." Later they covered such topics as everyday life, societal maladies, and funny occurrences. Chinese cartoons have played a central role in fights against imperialist aggressions, feudal corruption, and Japanese invasions.

Most of Feng Zikai's cartoons were geared toward emotional expression, merging poetry and pictures. In them we find philosophy, humor, and food for thought. He created his cartoons with a brush using simple, concise lines in a unique style that is free and spontaneous. Another artist, Zhang Leping (1910–1992), invented the cartoon character Sanmao, an impoverished boy. Zhang created serial comics such as *Sanmao Follows the Army* (cat. no. 102) and *A Record of the Wanderings of Sanmao* to attack injustice and corruption. Sanmao as a character was laughable yet lovable, and the plots were exaggerated yet logical. The result was a creation that drew laughs from readers while at the same time plunged them deep into thought.

The New Woodcut Movement

Woodcut prints had already appeared in Shanghai by the late Qing period. Works such as *Illustrations of the Dream of the Red Chamber* by Gai Qi (1774–1829), produced during the Jiaqing reign (1796–1820), and New Year's prints created during the Tongzhi reign (1862–1874) were used solely for book illustrations or seasonal decoration. The new woodcuts, however, were intended as an art form unto itself, an influence of European woodblock-print artists. In 1931 a woodcut workshop was held in Shanghai to commence the new woodcut movement.

The development of the new woodcuts closely paralleled political movements. In his brief preface to *Selected Paintings from New Russia*, Lu Xun (1881–1936) stated, "In times of revolution, print art has the broadest use; even if one is in a hurry, it can be completed in an instant."[8] After 1927, with the rise of left-wing literary movements arose left-wing art movements. The League of Left-Wing Artists was established in 1930 in Shanghai, and under its leadership the woodcut movement was launched through successive formations of woodcut organizations such as the M. K. Woodcut Research Society, the Wild Spike Society, the Unnamed Woodcut Society, and the Iron Horse Prints Society. Lu Xun gave his utmost support to the woodcut movement. Besides holding training courses on techniques, he published outstanding woodblock prints from abroad, such as the two-volume *Selections of Modern Woodcuts,* which he published in 1929 with Rou Shi (1902–1931) and others under the name of the Morning Flowers Society. Lu collaborated as well on the publication of woodblock prints of the October Revolution in *Jade-Attracting Collection* (1934), *Selected Prints by Käthe Kollwitz*

(1935), and *Prints from the Soviet Union* (1936). He also held exhibitions so that artists could view and contemplate important works. Lu Xun's leadership and assistance were instrumental in the development of a number of woodcut artists.

During the years from the Manchurian Incident of 1931 until the end of the world war in 1945, woodcut artists from all over China produced huge amounts of anti–Japanese occupation prints that awakened the fighting spirit of the masses. From 1946 to 1949, woodcut artists again took up their tools to fight against civil war and hunger. This exhibition includes such works as Hu Yichuan's *To the Front!* (cat. no. 95) and Li Hua's *Roar, China!* (cat. no. 98), which sought, through jolting images, to ignite people to battle against Japanese invasion and occupation. Shao Keping's *Street Corner* (cat. no. 101) and *On the Streets of Shanghai* (cat. no. 100) brought into focus the sharp contrast between the suffering of the laboring masses and the luxury of the wealthy, powerfully exposing the injustices of society. The new woodcut movement led the art world in carrying out the adage of "art for the people."

Shan Guolin
Translated by He Li

NOTES

1 Huang Shiquan, *Songnan mengying lu*.
2 Four orthodox masters of the early Qing dynasty: Wang Shimin (1592–1680), Wang Jian (1598–1677), Wang Hui (1632–1717), and Wang Yuanqi (1642–1715).
3 Liang Qichao, "Taichou xingzhou yugong jianhuai yi shouci yuanyun."
4 Kang Youwei, "Wanmu caotang canghua mu (jiexuan)."
5 Chen Duxiu, "Meishu geming."
6 Xu Beihong, "Zhongguohua gailiang lun."
7 Lin Fengmian, "Yishu de yishu yu shehui de yishu."
8 Lu Xun, "*Xin E huaxuan* xiaoyin."

A pair of calligraphies in seal script, and a pair of calligraphies in clerical script, 1869

By Zhao Zhiqian (1829–1884)
Hanging scrolls, ink on paper, set of four
H. 176.3 × W. 47.0 cm each
Collection of the Shanghai Museum

These two pairs of hanging scrolls are written in ancient scripts, one in seal script and the other in clerical script. The pair in seal script records two unrelated events in Chinese history. The first (A) describes the emperor Qinshihuang (reigned 221–210 BCE) and his efforts to unify China after a long period of discord by establishing a regular system of government and standardizing weights and measures. The second (B) consists of three sentences from the Taoist text *Bao Puzi* by Ge Hong (approx. 281–341) that was contained in an encyclopedia entitled *Taiping Yulan* (Peace and Tranquility for Imperial Review), compiled between 977 and 985. The sentences summarize the fundamental Taoist view of the world: "The force of yin and yang concurs within the Tao. The sacred fluid nourishes nature with the five elements. Its combination of supreme numinous elements repulses feebleness of the world."

The second pair of hanging scrolls, written in clerical script, is dated to 1869. It is an appreciation of the ancient technology and government that tied together two enlightened eras. The first scroll of this pair (C) is a passage from *Annotations on the Water Classic (Shui jing zhu)* by Li Daoyuan (?–527). It introduces two famous weapons: the sword *zhanlu* cast by Wu-Yue (Zhejiang and Jiangxu) artisans (fifth century BCE) and the dragon-sparrow *longque* (bow and arrow) of the great Xia dynasty (approx. 2000–1500 BCE). "Both could shuttle a long distance with a speed like the wind"; with their "matchless power the nine divisions could be vanquished." The second work (D) refers to the much-admired administration of the Western Zhou dynasty (approx. 1200–771 BCE), when the country was divided into states according to natural resources and "situations of mountains and rivers; then the nine divisions in their own inhabitancy were managed for individuals according to their specific conditions."

The pair in seal script was probably executed during Zhao's artistic maturity, around the time of the 1869 work. Both pairs testify to his calligraphic skill as well as his knowledge of classical texts. During the nineteenth century, Chinese academics were drawn to modern archaeology. Studies focusing on ancient inscriptions found on bronze ritual objects and stone stelae influenced the visual arts, inspiring scholars to explore not only history but also traditional aesthetics. This revivalist movement—using ancient calligraphy as sources for new techniques—known as the bronze-and-stone school, played an important part in modern calligraphy and painting.

B

A

Zhao Zhiqian was involved in this movement both as a scholar and as an artist. Zhao's biography states that he started to draw lines with water and brush on brick floors at the age of two. At four, he impressed his teacher by reciting texts and exhibiting a sensibility equal to that of older classmates. He completed his education at thirteen, having studied music, board games, writing, and painting. After his hometown of Shaoxing, Zhejiang Province, was destroyed and his family killed during the Taiping Rebellion, Zhao was often homeless and drifted from place to place.

In Zhao Zhiqian's own words, the initiative to "open up a new direction" occurred while he was staying in Beijing from 1863 to 1864.[1] He developed and perfected the duplication of the small-seal script on bronze and ceramic measures and weights of the Qin dynasty (221–207 BCE), and the clerical script and seal script on bronzes, clay bricks, and stone stelae of the Han dynasty (206 BCE–220 CE). Zhao then made a living from carving seals in these scripts for antique collectors. He also became one of the most faithful interpreters of calligraphy on stone sculpture in Buddhist sites dating from the fourth through sixth centuries, especially those in Longmen, Luoyang; Yexian, Shandong; Yixing, Jiangsu; and Baocheng, Shaanxi.

Zhao quickly earned the support of Shen Shuyong (1832–1873), a high official, calligraphy enthusiast and collector, and the owner of the Han Stone Inscription Studio. With Shen applauding his versatility and assuring him access to abundant firsthand materials, Zhao completed some of his finest works. His boldness and confidence are evident in his distinctive transformation of the seal script into the clerical script.[2] The calligraphic and seal works he created became collectibles during his lifetime.

The intense work took its toll. After serving less than six years as governor of Jiangxi Prefecture, Zhao died there at fifty-five of exhaustion. Zhao spent most of his life compiling volumes on the evolution of the writing system that are still used in modern studies of the classics.

Signatures

On the seal-script work: *From scattered Bao Puzi in Taiping Yulan.*

On the clerical-script work: *Painted at the request of respectable brother Xiaoxian Sima, Zhao Zhiqian, in lunar eighth month in the year* jisi [1869] *of the Tongzhi reign.*

Seals *Zhao Zhiqian yin* (seal of Zhao Zhiqian); *Zhao Ruqing* (nickname) HL

1 Wang Chiacheng, "Zhao Zhiqian Zhuan," 79–81.
2 Chen Chuanxi, "Cong 'wuzhong jinhua' dao 'bianzhong jinhua,'" 40.

D C

9 *Sceneries of the Earthborn–Cymbidium Orchid Thatched House*, 1869–1884

By twenty artists: Fei Yigeng (active mid–late 19th c.), Hu Yuan (1823–1886), Qian Hui'an (1833–1911), Yang Borun (1837–1911), Zhang Xiong (1803–1886), Ren Xun (1835–1893), Zhu Shuyu (active mid–late 19th c.), Hu Yin (active mid–late 19th c.), Hu Tiemei (1848–1899), Wang Li (1817–1885), Zhu Cheng (1826–1900), Gu Yun (1835–1896), Sha Fu (1831–1906), Zhou Yong (active late 19th c.), Zhu Quan (active mid–late 19th c.), Li Xiguang (active mid–late 19th c.), Wu Guxiang (1848–1903), Weng Tonghe (1830–1904), Yu Yue (1821–1906), and Xu Sangeng (active mid–late 19th c.)
Set of twenty-two album leaves, ink and colors on paper
Dimensions variable
Collection of the Shanghai Museum

Twenty artists, most of whom belonged to Shanghai artist circles, dedicated twenty-two works depicting the "Earthborn–Cymbidium Orchid Thatched House" to its owner, Hu Yin, whose nickname *Qinzhou* literally means "Zither on a Boat." The country house depicted here is somewhere close to Lake Tai (Taihu) near Suzhou. Available biographical information indicates that Hu originally came from Linhai, Zhejiang Province. Before he settled in this house, he spent a short time exploring painting in Shanghai and probably came into contact with some of the city's artists. Documented sources note that from 1851 to 1874 Hu lived as a hermit. The inscriptions on these paintings, along with a letter by Wang Li kept in the album set, suggest that the reclusive Hu remained in contact with the Shanghai artists through letters. Wang himself, on Hu's request, created a painting in Shanghai; others made their versions in different places at different times.

The most novel aspect of all the depictions is their unique compositions. Each artist must have visited Hu in his thatched house and examined the home in detail from his singular viewpoint, which he later conveyed in a particular scene. The artists' experimentation in the modern art movement is apparent in their use of perspectives, although their simplified, thin brushwork is done in traditional textural strokes.

A

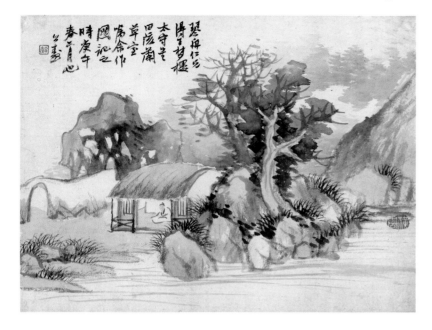

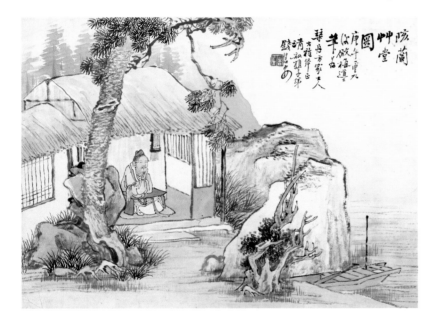

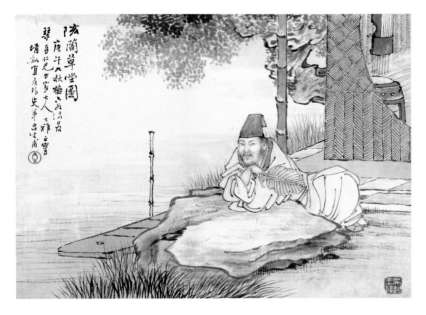

Leaf A Qinzhou, dressed in a red robe, sits by a scholar's table beside a window of the thatched house. Painted in 1869 by Fei Yigeng (who was born in Wuxing, Zhejiang Province), this piece is the earliest of the dated works in this set. Fei's high degree of finish and delicate use of colors reveal his training by his father, Fei Danxu (1801–1850), a painter of figures and flowers. Yigeng's Shanghai connection might have been through the senior Fei, who resided in Shanghai to sell paintings from 1821 to 1850.

Seal *Yubo huaji* ("painted and recorded by Yubo," Fei's nickname)

Leaf B Qinzhou, sitting in the center of the house, looks at the scenery through the open door. Hu Yuan, who executed this composition in the spring of 1870, recorded in the inscription that Qinzhou acquired the property of the county governor and changed the name from Pavilion for Bearing Dream, *Shengmeng lou*, to Earthborn–Cymbidium Orchid Thatched House, *Gailan caotang*.

Seals *Gongshou* (Hu's nickname); *Hengyun* ("horizontal clouds," another of Hu's nicknames)

Leaf C Qinzhou, holding a Buddhist whisk, sits by a narrow table in the house enclosed by stone walls. Beyond the walls, a boat is anchored in tranquil water. Qian Hui'an inscribed that he was "imitating the brushwork of Meidao ren [Wu Zhen (1280–1354]," in the ninth month of 1870.

Qian led a movement to promote folk art and narrative painting. His views prompted him to change his technique from delicate brushwork to vigorous strokes with sharp angles. Well received in Shanghai artist circles, Qian became a close friend of Ni Tian (cat. no. 14); together they sold figure, flower-and-bird, and landscape paintings. Qian Hui'an was one of the most outspoken advocates of Shanghai artists' societies. In 1862 he, Zhu Cheng, and Wu Dacheng (depicted in cat. no. 13) founded the Duckweed Society for Calligraphy and Painting, *Pinghua shuhua she*. In 1909 Qian was elected chairman of the Benevolent Society for Painting and Calligraphy, *Shuhua shanhui*, in Yu Garden.[1]

Seal *Jisheng* (Qian's nickname)

Leaf D Qinzhou, seated and holding a round fan, leans on a rock by a lake. Beside him, the bamboo-walled house is partially seen, a stool and a zither visible inside. In this work, painted at the same time as the previous piece, Qian Hui'an experimented with "the method of Liuru [Tang Yin, 1470–1523]."

Seals *Jisheng*; *Wuyue wangsun* ("royal descendant of the Wu-Yue region")

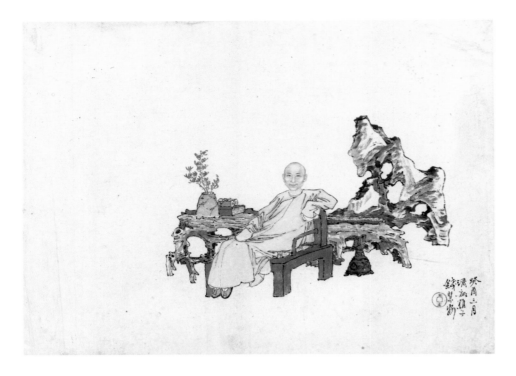

E

F

Leaf E Sitting in a wooden chair, Qinzhou pursues the life of a member of the educated elite. He is surrounded by the scholar's assemblage of a vase, books, handscrolls, a zither, and an incense burner. This third work for Qinzhou by Qian Hui'an was created in 1873.

Seal *Jisheng*

Leaf F This view shows Qinzhou's house from a distant high vantage point. Tall green willows shade the house, and the far rice fields are connected by a tiny bridge that was executed with light brushstrokes. The work was created in the summer of 1871 by Yang Borun from Jiaxing, Zhejiang Province. Yang took up residence in Shanghai

and supported his family by selling paintings. He routinely used a long-tipped brush and light-colored hues to create the sensitive lines in his scenes of the country.

Seal *Nanhu* (Yang's nickname)

Leaf G Most likely in the same place and at the same time, Yang Borun's fellow villager Zhang Xiong adopted a similar viewpoint, looking down at the house and up toward the distant surroundings. Qinzhou sits in the doorway, and before him a path winds along the foreground. Hills, rocks, trees, and water frame the house in a horseshoe-shaped configuration. Zhang was said to have consciously modeled his style on that of Zhou Zhiyuan

G

H

(active mid–late 16th c.), a flower-and-bird painter, a choice that made him extremely popular in Shanghai.

Seal *Zixiang* (Zhang's nickname)

Leaf H Qinzhou looks down at a boy planting cymbidiums in the courtyard. Clusters of bamboo, rocks, and flowers create a harmony of pink and light blue. Ink washes play a secondary role, serving as mist that permeates the right corner. This work is more typical of the tradition of the educated elite than the decorative works of the Shanghai school, and, as the artist himself, Ren Xun, inscribed, he "painted in the Wu school style."

After training with his brother Ren Xiong (approx.

1820–1864), Ren Xun began to sell his works in Jiangnan even before he was twenty. To easily manage selling and teaching painting, he settled in Suzhou around 1886 and lived there until his death at the age of fifty-eight. The Ren brothers modeled their brushwork on that of Chen Hongshou (1598–1652), whose exaggerated images and smooth arcing lines had the most profound impact on their painting. The Rens transformed Chen Hongshou's ideas in unique ways, taking Chen's work as a point of departure for new concerns with worldly pleasures. They brought to late-nineteenth-century painting the popular taste of newly wealthy and sophisticated townspeople.

Seal *Ren Xun*

Leaf I This unusual, well-balanced composition of 1870 by Zhu Shuyu shows Qinzhou, viewed from behind in profile, sitting on a riverbank as he waits to be ferried down the river. Only the thatched roof of his house appears in the lower right of the picture.

Seal *Shuyu*

Leaf J Sitting outdoors on a rock next to a teapot, Qinzhou tells a young boy a story of the cymbidium orchid that grows under a large rock. The setting is rendered in an excellent contrast of delicate and rough lines. But the painting's sweet, warm feeling is far more than a display of technical virtuosity. The work was executed in Shanghai by Hu Yin, known as Juezhi, who was born in She County, Anhui Province. Hu and Zhang Gongjian, who came from Jiaxing, founded the Plum Pavilion Society for Calligraphy and Painting in Shanghai. Hu made trips to Suzhou and Hangzhou to study Buddhist art, which he later emulated with enormous success.

Seal *Juezhi* (Hu's nickname)

I

J

K

L

Leaf K Qinzhou, having just crossed a bridge, walks toward the house built on stilts along the opposite river-bank. Various plants in flowerpots on the front platform of the house indicate Qinzhou's cultivating skill. Revolving around from the left are rocky hills, and to the right the scene is enclosed by tall mountains. This pleasing composition was painted in the summer of 1872 by the son of Hu Yin (see leaf J), Hu Tiemei (born in Tongcheng, Anhui), a specialist in plum-and-flower painting who lived in Shanghai and gained fame in Japan during several of his travels there.

Seal *Tiemei*

Leaf L Qinzhou meditates inside the house. Around the house, luxuriant vegetation is deliberately textured with flickering light-blue ink strokes. The work was executed in the seventh month of 1872 by one of the early Shanghai school painters, Wang Li (born in Wujiang, Jiangsu), in his Shanghai studio. Wang practiced brush technique in the elaborate styles of Chen Hongshou (1598–1652) and Yun Shouping (1633–1690). His remarkable gifts impressed his mentor, Zhang Xiong (1803–1886), the Shanghai school's key figure, who praised him for having "a pen like iron." Ren Yi (cat. no. 11) was strongly affected by Wang's work.[2]

Seal *Qiuyan* (Wang's nickname)

Leaf M Broad brushwork with dry ink and delicate colored hues captures the beauty of the landscape around Qinzhou's house as observed from a distance. The old trees in front of the house reinforce the harmony that is implied by the background of clouds and mists, mountain peaks, and fluid water. Zhu Cheng created this work in the fall of 1872. He began painting with his older brother Zhu Xiong (1801–1864), a native of Jiaxing, Zhejiang Province, and an accomplished artist in the Shanghai school. Later Cheng worked in Wang Li's radical style in his flower and figure subjects.

Seal *Cheng yin* (seal of Cheng)

Leaf N Facing each other on seats in the tea room, Qinzhou and a servant carry on a conversation. Here the signature old trees appear on the right, and water runs to the left of the composition. The bamboo grove behind the lattice fence is meant to signify the hot season. The Suzhou painter Gu Yun presented this work to Qinzhou in the summer of 1874. Although he generally emulated the Qing court styles of the Four Wangs, Gu employed a freer, more spontaneous manner in this work.

Gu made several trips to Japan and taught painting at private studios in Nagoya. His book, *Forms and Styles of Southern School Painting,* published while he was living in Nagoya, sparked an interest in the origin of Chinese painting among the Japanese.[3]

Seal *Ruobo* (Gu's nickname)

Leaf O Sketched from an angle of looking down from the left, Qinzhou bends over a scholar's table to gaze at a flower vase in his house, which is covered, umbrella-like, by large willows. This dramatic composition is by Sha Fu, another Suzhou artist.

Sha was a close friend of Ren Yi, who painted a portrait of him in 1868.[4] In fact, Sha's lasting friendships in Shanghai were with the Rens. He spent more time studying the Rens' works, especially paintings by Ren Xiong, than in any other art training. His practice was the foundation for his later development of figure painting, in which he used fluid, curving lines to create soft contours and natural gestures.

Seal *Shanchun* (Sha's nickname)

Leaf P Unlike the other works of this album, this 1879 composition depicts Qinzhou's house within a dense surrounding. Water begins near the right edge of the scene and continues past hills and midground bushes until it ends at hazy mountains in the background. The artist, Zhou Yong, was clearly devoted to capturing the textural details of mountain peaks. The gifted Zhou, who died at age twenty-eight, took calligraphy lessons from Gao Yi (1850–1921) while studying the Four Wangs' styles of the Orthodox school of the seventeenth century. Ren Yi, Gao Yi, and others enthusiastically admired Zhou's art, which was remarkable in concept and marvelous in ink, with the surfaces built up with textural strokes. Zhou Yong was able to produce four hundred pieces in three months.

Seals *Zhou Yong; Pusheng* (Zhou's nickname)

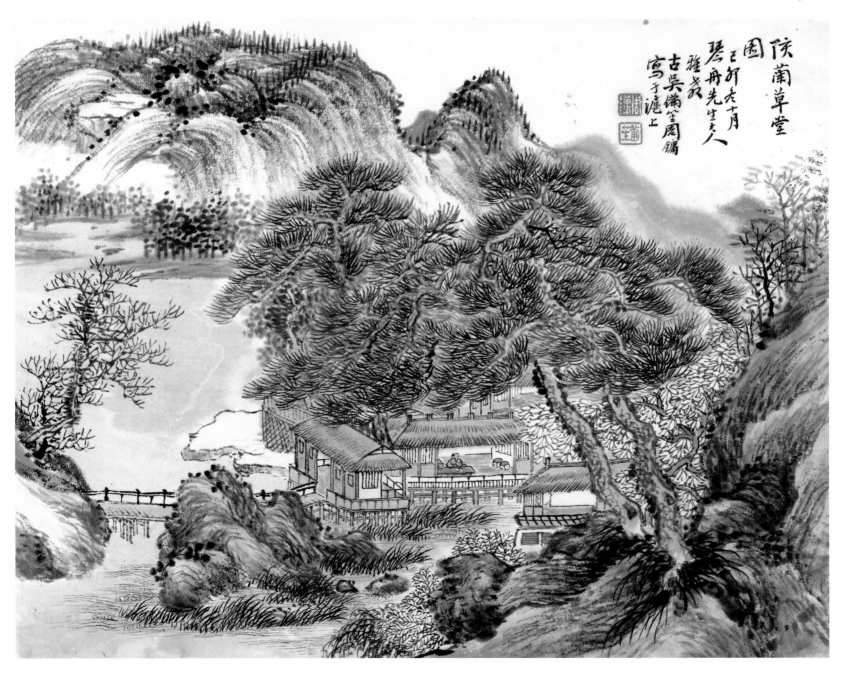

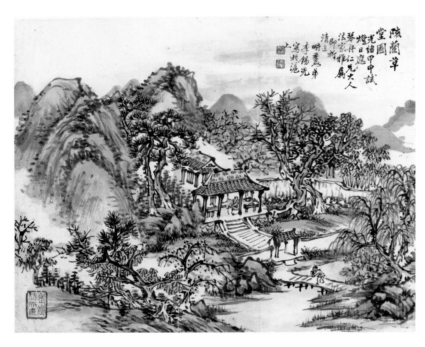

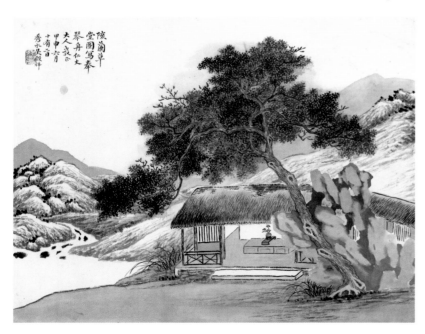

Leaf Q Qinzhou is portrayed in his thatched house. The garden is organized along diagonal walls, with a door on the left and stone stairways on the right. For foliage, colors and ink are reduced to light tonalities, suggesting the arrival of spring. Zhu Quan, born in the Jiading district of Shanghai, painted this in the second month of 1882. Landscape was the essence of Zhu Quan's expression. The influence of the Qing court artist Wang Hui (1632–1717) on Zhu's landscape endured throughout his career. Zhu used dense, textural strokes and dark ink, along with delicate colors. His mature landscapes were often mannered in composition and austere in execution.

Seal *Zhu Quan zhiyin* (seal of Zhu Quan)

Leaf R Shuffling across a bridge toward a mountain gate, Qinzhou is featured as a woodcutter carrying an ax on his shoulder. Ahead of him a stairway climbs up to his thatched house. The thick, mottled brushwork, the varied textural strokes, and the light, warm color tones are strongly oriented toward Northern Song (960–1126) landscape models. Executed by Li Xiguang in 1884, this painting exhibits the most complicated composition among these works for Qinzhou. A native of Hebei, Li lived in Nanjing, where he met Tang Yifen (1778–1853), an artist from Jiangsu, with whom Li experimented with incorporating the characteristics of classical masters' work into his paintings, especially those of the Four Wangs of the seventeenth century. Too few paintings by Li Xiguang survive to allow one to ascertain a direct influence on Tang Yifen.

Seals *Gengjian* (Li's nickname); *Li Xiguang yin* (seal of Li Xiguang); *Laojianzhi er ma* ("old, strong, and wise but dull")

Leaf S The mountain stream that in other paintings flows down the right appears here on the left. Inside the house, a flower vase on a charmingly centered small table symbolizes the absent master. In this latest work in the album, dated 1884, Wu Guxiang applied gray ink in long, broad, flat strokes to depict the summer landscape. This work is a fine example of an unusual composition that the Jiaxing native Wu had made popular in Shanghai.

In Beijing in 1892, Wu became acquainted with Weng Tonghe (1830–1904) and Wang Yirong (1845–1900), with whom he participated in a reform movement to modernize Chinese art. After the unsuccessful attempt, Wu moved to Shanghai and began to focus on the styles of the Ming educated elite and, later, Dai Xi (1801–1860); from both he learned how to translate depth and scale onto the surface of a painting. Wu Changshuo (cat. no. 15) described Wu Guxiang's art as capturing the "elegance of Wen Zhengming [1470–1559]" and the "spirit of Qiu Ying [approx. 1482–1559]."[5]

Seal *Qiunong* (Wu's nickname)

Inscriptions

Leaf T Weng Tonghe (born in Changshu, Jiangsu Province) executed the first title calligraphy in clerical script: "Sceneries of the Earthborn–Cymbidium Orchid Thatched House, at the request of brother Qinzhou, by Weng Tonghe." Weng Tonghe was well known for his rank of excellence at the imperial examination in 1856 and was honored with several positions, including Secretary to the Grand Council in 1872 and Tutor to Emperor Guangxu. All of his peers considered it a great honor to have Weng's calligraphy.

Seal *Shuping* (Weng's nickname)

Leaf U Yu Yue (born in Deqing, Zhejiang Province) executed the second title calligraphy with the same content in an earlier seal script. Yu passed the *jinshi* degree in 1850 and served the court as Junior Compiler. His calligraphy, especially seal and clerical scripts, was avidly sought after by his contemporaries.

Seals *Yu Yue siyin* ("private seal of Yu Yue"); *Yin Fu* (Yu's nickname)

Leaf V The same title was inscribed in seal script by Xu Sangeng in the fourth month of 1872. Xu, a calligrapher from Shangyu, Zhejiang Province, admired and studied the work of Zhao Zhiqian (cat. no. 8). This piece is one of Xu's least known, and yet it is of the same great lineage as the other two title calligraphies, derived from the bronze-and-stone school.

Seal *Yuliang* (probably Xu's nickname) HL

1 Li Chu-tsing and Wan Qingli, *Zhongguo xiandai huihua shi, 1840–1911*, 155.
2 Ibid., 72.
3 Ibid., 38.
4 Ibid., 159.
5 Ibid., 40.

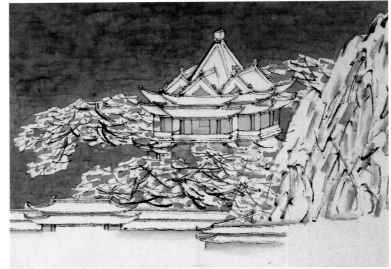

10 *Scenes in Yangzhou,* 1876

By Xu Gu (1824–1896)
Album, ink and colors on paper, set of twelve
H. 38.3 × W. 52.5 cm each
Collection of the Shanghai Museum

This set of twelve small sketches depicts different seasons and locales in Yangzhou, a town on the bank of the Yangzi, downstream from Nanjing in Jiangsu Province. The artist Xu Gu has painted several of the city's famous scenic spots as personal gifts to Gao Yi (1850–1921), who served as district magistrate in Jiangsu Province and was a core figure in Shanghai art circles. Many artists came from cities such as Nanjing, Yangzhou, Suzhou, and Guangdong but were based in Shanghai; Xu Gu himself was a native of Yangzhou. Some of these artists were leaders in attempts to integrate Chinese traditional methods with elements from Western art.

Xu Gu's sketchlike execution omits details and tends toward free brushwork and loose compositions. As seen in the plants in this album set, he frequently combined spontaneous brushwork with economical use of dry ink. In his landscapes he balanced heavy and dense elements by setting them against empty backdrops. His use of color is subdued and often diffused.

As a youth, Xu Gu served in a local military defense unit that was involved in the Taiping Rebellion (1851–1864). With no wish to follow the Qing court's campaign against the rebellion, he escaped from the army in

1852, seeking seclusion in a Buddhist temple on Mount Jiuhua in Anhui Province. Xu Gu referred to his monk's life as being nonvegetarian and nonworshipping of the Buddha—merely a self-indulgence in calligraphy and painting. Beginning in the 1860s, he traveled frequently between Yangzhou, Suzhou, and Shanghai and was accepted into Shanghai art circles. His painting and calligraphy sold well in the tourist area around the Guandi Temple, in western Shanghai. Quiet and a loner, Xu Gu had only a few friends, though his relationships with Gao Yi, Hu Yuan, and Ren Yi remained warm throughout his later years.

Xu Gu stands apart from the Shanghai artistic circle focused around the Rens; his painting style recalls the concise compositions of the monk-painter Hong Ren (1610–1683), a master of the Xin'an school. In fact, the Xin'an school was established by a group of seventeenth-century artists of the educated elite from Anhui, where Xu Gu spent time in refuge as a Buddhist monk. Later in his life Xu studied traditional Anhui woodblock prints and works by Yangzhou artists such as Hua Yan (1682–1756).

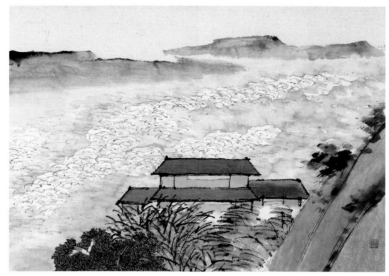

Leaf A Flourishing bamboo grove

The original garden of this house, called Shouzhi Yuan, was planted between 1692 and 1707 by the monk-artist Shi Tao (1642–1707), who had journeyed on foot into the mountains of Anhui. Shi Tao was a well-known artist and art theorist who painted in the manner of the Xin'an school. A wealthy nineteenth-century salt merchant later extended the garden into a dense bamboo grove in the form of the character *ge* (个)—said to resemble a leafing stock of bamboo—and renamed the garden Ge Yuan.

Seal *Sanshiqi feng caotang* (Thatched Cottage on 37 Peaks)

Leaf B Old palace on silvery background

Seal *Sanshiqi feng caotang* (Thatched Cottage on 37 Peaks)

Leaf C Thatched cottage under the light of early dawn

Seal *Xu Gu*

Leaf D House among clouds and green foliage

Seal *Xu Gu*

Leaf E Writing in a house by willows

Seal *Xu Gu*

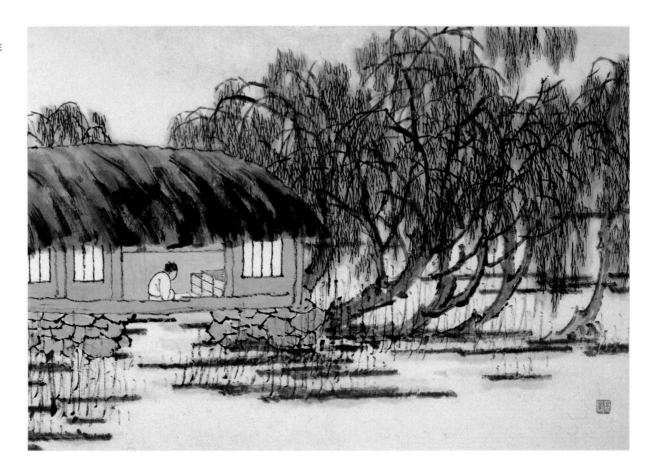

F

G

Leaf F Thatched cottage with bamboo fence and mulberries

Seal *Sanshiqi feng caotang* (Thatched Cottage on 37 Peaks)

Leaf G Old temple sounds bells

Seal *Xu Gu*

Leaf H Hermits in autumn forest

Inscription *Late masters mockingly compare themselves to wooded foliage, / as autumn wind blows day by day; only sparser and sparser.*

Seal *Xu Gu*

Leaf I Idling away in the shadows of shrubs

Seal *Sanshiqi feng caotang* (Thatched Cottage on 37 Peaks)

Leaf J Gazing into the distance from among reeds and arrowheads

Inscription *Leisurely up on a slab bridge to look into the open, vast space. / In sight is boundless autumn water, overflowing reeds, and arrowheads.*

Seal *Xu Gu*

Leaf K Slow boating on blue lake

Seal *Sanshi qi fengcao tang* (Thatched Cottage on 37 Peaks)

Leaf L Surviving bamboo in early winter

Inscription *For the refined judgment of Master Yuzhi [Gao Yi], / His Excellency. Xu Gu in summer of the year bingzi* [1876]

Seal *Xu Gu* HL

H

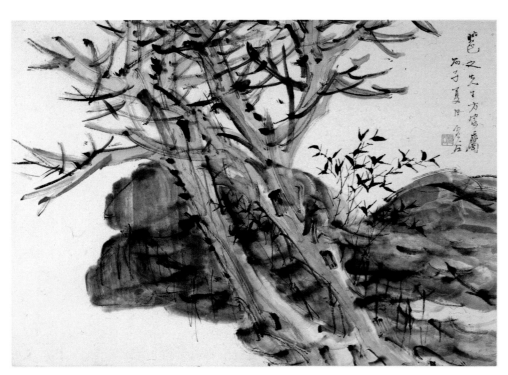

Feng Gengshan, 1877

By Ren Yi (1840–1896)
Hanging scroll, ink on paper
H. 127.4 × W. 55.2 cm
Collection of the Shanghai Museum

Ren Yi, also known as Ren Bonian, created this portrait of Feng Gengshan as a farewell memento for Feng before he journeyed to Japan in 1877.[1] The inscriptions on this painting are by four artists who were natives of either Shanghai or adjacent Jiaxing and Hangzhou. They indicate that Feng was closely associated with artistic circles in Shanghai. Three of the inscriptions were added by Hu Yuan (1823–1886), Zhang Xiong (1803–1886), and Wu Gan (active mid- to late nineteenth century); all were known to have earned their living selling artwork in Shanghai. The fourth artist, Chen Honggao (?–1884), traveled through Japan during his later years and promised Feng they would make a trip there together.

Ren Yi portrays his subject concentrating on a book in his left hand, leaning his right arm on rocks by water. The precisely drawn face, crisp outlines—some showing a triangular fold or a nail-like tip—sensitive shadows on the robe, and dark texture-strokes on the rocks lend the work a sense of reverence and peace.

Born in Shanyin, Zhejiang Province, Ren settled in Shanghai with Hu Yuan's help during the winter of 1868. Ren Yi found the new environment so inspiring that he began to move in a different direction in his painting. Some scholarship suggests that from 1872 to 1877 Ren Yi received training in sketching models at the Tushanwan Art School in the Xujiahui district.[2] There he learned methods of chiaroscuro, a step toward creating his individual style. New acquaintances, including Xu Gu (cat. no. 10), Pu Hua (1832–1911), Wu Changshuo (cat. no. 15), and Gao Yi, shared their insights, experiences, and art collections, all of which contributed to Ren's painting technique.[3] His study of the works of Bada Shanren (1626–1705) and Hua Yan (1682–1756) were also key to his artistic development. His figure works completed after 1872 show flowing, concise lines and washed shadows. Less evident is the line with a "nail-head and a mouse-tail" that Ren Yi employed during the 1860s.[4] The elaborate forms he used earlier became diluted, focused instead on expression and movement of the figure.

The youngest yet most influential of the "four Rens" of the Shanghai school, Ren Yi was very involved in art training. He instructed a number of later prominent artists, including Chen Shizeng (1876–1923), Qi Baishi (1864–1957), Wang Zhen (cat. no. 17), and Pan Tianshou (1897–1971).

Signature *Bonian Ren Yi painted on the full-moon day of the lunar ninth month, the year* dingchou *of the Guangxu reign* [1877].

Seal *Yi yin (seal of Yi)*

Colophons, from upper right
By Hu Yuan
A small portrait of Gengshan, Master Feng recites old poetry
* by flowing streams. Inscribed by Hu Gongshou from*
* Huating, in fall, the ninth month of the year* dingchou
* [1877].*
A poem by Chen Mantao (nickname of Honggao), calligraphy by Tang Jingchang
A vast stretch of open mountains with barely a human trace—
off and on between the gates birds chirp pleasantly.
You, outstanding master, sit here alone,
holding a scroll, your mind at peace.
A delightful breeze on this spring day,
as streams whistle through the rocks.
The flowing water sounds harmoniously,
clear and ringing as tumbling jade.
The secular life is bitter, uneasy.
Poverty makes your red face haggard.
Itching for decades of reading,
the spirit of the late sages infuses your modest soul.
You, humble gentleman, diligent to study the classics,

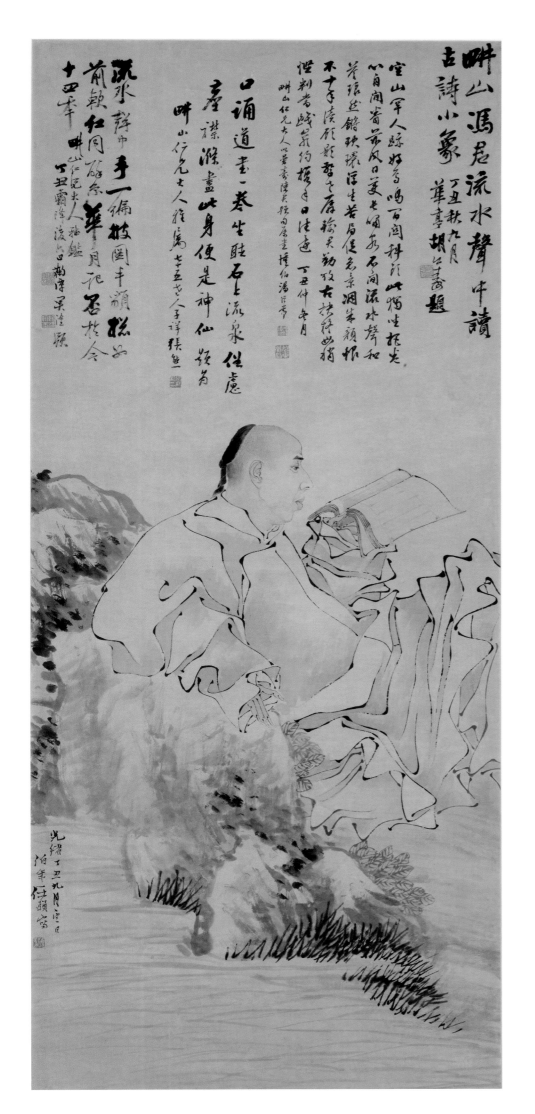

resolve knotty problems on meager earnings.
A promise at farewell by mountain peaks,
we shall travel hand in hand.
For Gengshan, my dear friend. A poem by Master
 Chen, Manshou, written on a request by Xunbo
 Tang Jingchang, middle winter season of the
 year dingchou [1877].

By Zhang Xiong
While reciting a Taoist scroll,
sitting on a rock to listen to a flowing stream,
concerns of secular affairs are all washed out.
Such a man is a true supernatural being.
For your refined inspection, Gengshan, my dear
 friend. A 75-year elder Zixiang Zhang Xiong.

By Wu Gan
With a volume in your hand among sounds
 of flowing water,
Vigorous-looking yet still displaying a graceful
 manner.
The times we used to drink together at the
 imperial service in the capital—
remember, fourteen years have already passed since
 then.
The sixth day after frost, inscribed by Jutan
 Wu Gan.

HL

1 Ding Xiyuan, *Ren Bonian*, 37.
2 Ding Xiyuan, "Ren Bonian renwu hua zongshu," 56.
3 Wang Jingxian, "Ren Bonian qiren qiyi," 57–112.
4 Shan Guolin, "Lun Haishang huapai," 512.

12 *Morning Sun Rising Over the Sea*, 1891

By Wu Qingyun (1845–1916)
Hanging scroll, ink and colors on paper
H. 32.0 × W. 33.6 cm
Collection of the Shanghai Museum

This painting of a sunrise scene heralds a new direction for the painter Wu Qingyun. Wu has taken advantage of the morning light, choosing a low point of view below the range of mountains to effectively highlight sunshine above ocean waves. In style and technique, this picture is characteristic of Wu's blending of Chinese and Western. He followed the traditional composition for landscapes, laying out rocky hills from opposite directions and leaving the central space for water. The foreground mountains with their detailed foliage are rendered in traditional texture strokes to give weight and substance. In his inscription, Wu describes the brushwork as being in the manner of the fourteenth-century painter Wang Meng. But Wu mastered certain aspects of coloring with an impressive skill not seen in Wang Meng's art. Using a light touch of red between the mountains, and covering the sky with grayish blue tones to suggest the amount of sunlight, Wu conveyed the sensation of sunrise.

A native of Nanjing, young Wu Qingyun made his way to Shanghai, where his works were openly inspired by the Four Wangs of the seventeenth-century Orthodox school. One source has suggested that a trip to Japan in the 1890s or even earlier greatly influenced Wu's painting.[1] Wu gradually turned away from the style of the Four Wangs, employing instead a combination of two extremes: Western watercolors and a classical Chinese technique associated with Mi Fu (1051–1107) and Gao Kegong (1248–1310). From Western watercolors and Impressionism he borrowed the use of diluted ink and color to make gradations of sky and sunshine in conveying the quality of natural light. In contrast, he maintained traditional brushwork to draw mountains with dark layers of dots in the style of Mi Fu.

Wu applied this work's depiction of water and cottage to two other paintings dated 1901 and 1914, also in the Shanghai Museum collection.[2] His sun and sea remain unique, rich in color and strong in contrast, effectively capturing brilliant light. His new versions met with success in the export market of this time and were especially favored by Guangdong merchants. In contemporary criticism, Wu Qingyun is generally considered one of the most distinctive Chinese landscape painters to employ Western methods in modern painting.[3]

Inscription

Morning sun rising over the sea
To my kind brother Master Ziyou for correction
After the brushwork of Huanghe shanqiao [Wang Meng, 1308–1385]
Autumn of the year xinmao [1891], *Wu Shiqian* [nickname] *in Bairia.*

Seal *Qingyun yin* (seal of Qingyun) HL

1 Ding Xiyuan and Hui Laiping, *Zhongguo jindai minghuajia tujian,* pl. 6.
2 Shan Guolin, Preface, pls. 69 and 70.
3 Xue Yongnian, "Bai'nian shanshuihua zhi bianlun gang," 3.

72

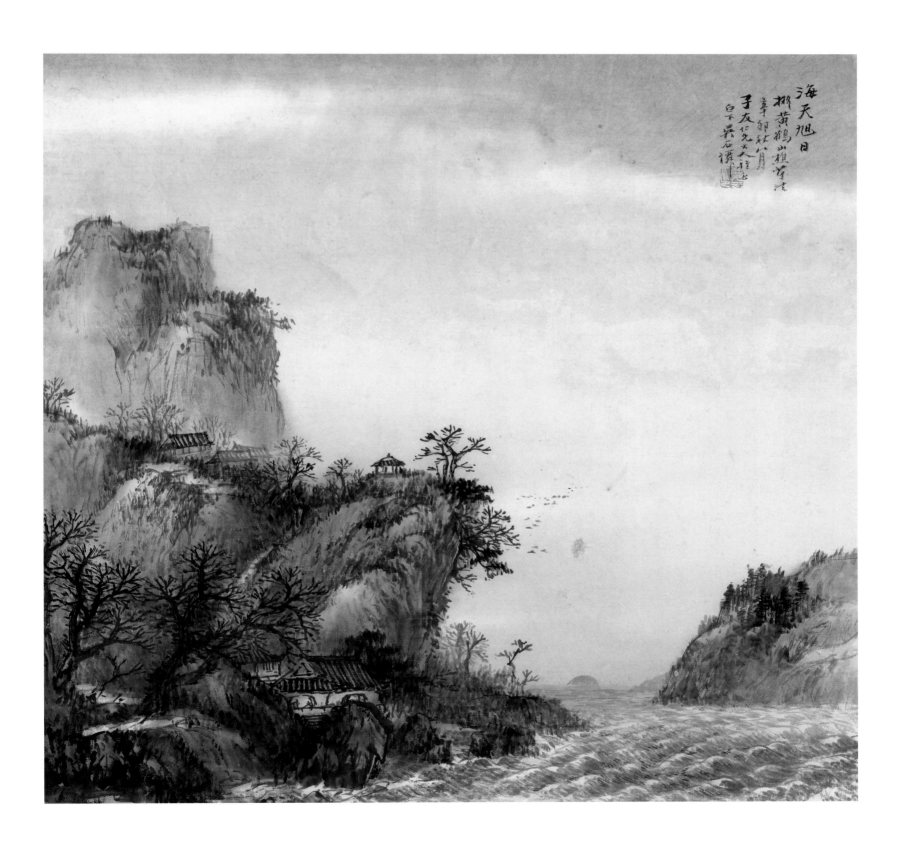

13 Detail from *Illustrations of the*
 Antique Collection of Kezhai, 1892

By Lu Hui (1851–1920) and Hu Qinhan (active late 19th c.)
One of two handscrolls, ink and colors on silk
H. 41.5 × W. 1696.0 cm
Collection of the Shanghai Museum

This painting illustrates a scene in the residence of
Wu Dacheng, also known as Kezhai (1835–1902),
an art collector, seal carver, and calligrapher originally
from Suzhou. Wu, a member of the Qing bureaucracy
who served as governor of Guangdong and Hunan
provinces, is best known for his studies of ancient
Chinese art. His association with Shanghai began as
early as 1862, when he became one of the twenty-four
members of the Duckweed Society for Calligraphy and
Painting. This society was located in the Guandi Temple,
near the Yu Garden.[1] From the late nineteenth through
the early twentieth century, several art societies were
established in the temple, and it served as an intimate
milieu for members to create, trade, and comment on
their own artworks.

In addition to creating artwork for friends, Wu
compiled catalogues of his collections. This painting,
Illustrations of the Antique Collection of Kezhai, or *Kezhai*

jigu tu, presents a survey of his collection, with a focus
on significant ritual vessels from the Bronze Age. Several
examples are shown here with Wu's annotations.

The fifty-eight-year-old (according to the Chinese
lunar calendar) Wu Dacheng is depicted as an elegant
gentleman being served tea by a young servant in a pri-
vate setting. In his inscription on the left of the painting,
Wu Hufan (1894–1968) states that Hu Qinhan painted
the face of Wu Dacheng while Lu Hui executed the
clothes, vessels, and surroundings.

Little is known about the life of Hu Qinhan, but Lu
Hui—like Wu Dacheng—came from Suzhou. He was
known for his paintings of landscapes and domestic
interiors. Chinese texts describe Lu as having mastered
the style and technique of Wang Meng (1308–1385),
one of the major artists of the Yuan dynasty.[2] Wu and Lu
became good friends at their first meeting, and Wu let
Lu study his entire collection; he also generously eased

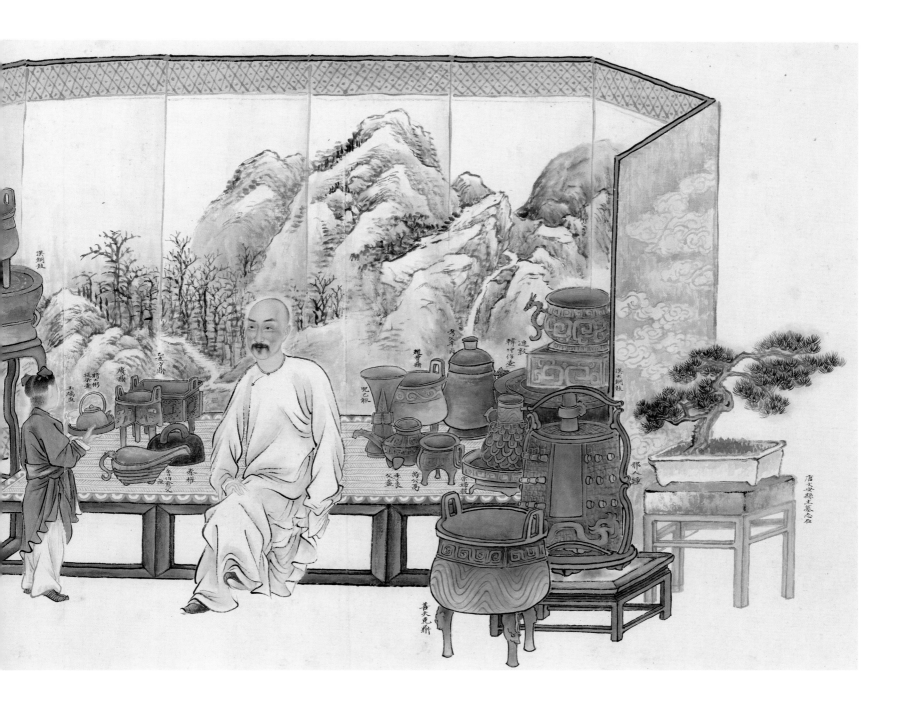

Lu's financial burdens. Lu Hui later became the central person in various famous art salons of the educated elite in Shanghai.

Inscriptions

1. In the year *gengchen*, 1940, at the request of Wu Hufan, Wang Tongyu (1855–1941), the Jiangxi provincial education commissioner, wrote the title calligraphy, *Illustrations of the Antique Collection of Kezhai* (*Kezhai jigu tu*).

2. The inscription in 1936 by Wu Dacheng's adopted grandson, Wu Hufan, attributes the art to Hu Qinhan and Lu Hui, whose seal appears on the painting. Wu Hufan counted up the number of vessels surrounding Kezhai, a total of thirty, to all of which he added the titles.

3. The postscript by the Imperial Editor Wang Yirong (1845–1900), recorded in 1892, says that Wu Dacheng shared this work with him when Wu came to the capital

to attend the ceremony for his inauguration at court as the governor of Hunan. Wang expressed his admiration and respect for Wu's studies in the classics. As an example, this handscroll is an assemblage of Kezhai's portrait and rubbings of the antiques that Kezhai had collected over thirty years.

Seals

Lu Hui siyin ("private seal of Lu Hui"); *Wang Tongyu yin* (seal of Wang Tongyu); *Meijing shuwu* ("Library with a View of Plums," the name of Wu Hufan's studio); *Gongzhuan cebaoyin Rong* ("seal of Rong in reverent seal script for registering treasures," Wang Yirong's seal)

HL

1 Shan Guolin, "Lun Haishang huapai," 507.
2 Li Chu-tsing and Wan Qingli, *Zhongguo xiandai huihua shi, 1840–1911*, 28.

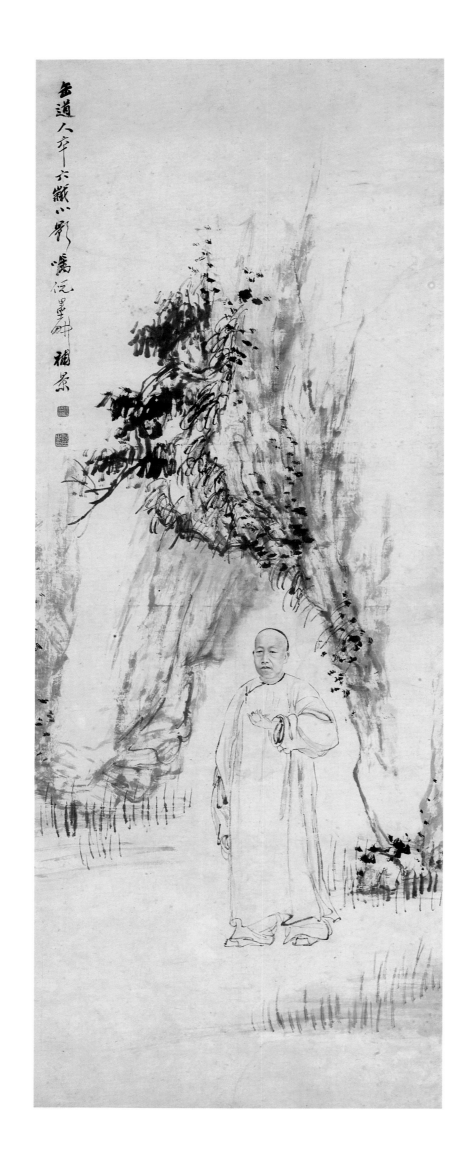

*The Esteemed Wu Junqing
at Age Sixty-six*, 1909 or 1910
By Ni Tian (1855–1919)
Hanging scroll, ink on paper
H. 120.0 × W. 45.5 cm
Collection of the Shanghai Museum

This painting is another example of the shared appreciation, respect, and communication among one circle of Shanghai artists. Ni Tian created this portrait for the group's senior member, Wu Junqing, better known by his nickname, Changshuo. Wu, who had just turned sixty-six when this work was painted, along with Ren Yi and Zhu Cheng (1826–1900), were the people who most influenced Ni's art and career in Shanghai. The work was probably painted in 1910, the same year that Ni Tian became the executive secretary of the Shanghai Society for Calligraphy and Painting, in which Wu Changshuo was a core figure. Wu was also involved in several associated societies.

Ni Tian depicts Master Wu as a gentleman wearing the traditional clothing of China's educated elite: a full-length robe over baggy trousers and shoes with a trapezoidal toe box. Smoking a tobacco pipe held in his left hand, Wu strolls through stone caves, suggested by high rocks above and behind him. Ni's brushwork is evenly textured, and his lines are of uniform density and smoothness. The same structural approach is evident in the works of Ni's early instructor, Wang Su (1794–1877), and, later, those of Ren Yi (cat. no. 11).

Born in Jiangdu, Jiangsu Province, the young Ni Tian began to study painting with the Yangzhou native Wang Su (also known as Xiaomei), a painter of figures and flowers who followed the style of the Yangzhou-school artist Hua Yan (1823–1886). Ni once even signed his teacher Wang Su's name on a painting, which he forged for selling. Once the hoax was exposed, Wang's reputation was damaged, and Ni was immediately driven out of Wang's studio. Ni Tian left Yangzhou and settled in Shanghai, where he had no connections or support. A painting of his displayed in front of Cuixiu Hall in Yu Garden caught the eye of Ren Yi, who invited Ni to his home and into his Shanghai circle. Inspired by Ren's work, Ni reestablished himself as a painter of figural subjects and gained a reputation among his contemporaries.

Inscription *A small portrait of Guandaoren* [Wu's nickname] *at age 66, on your request, in addition to a scenic background, Ni Mogeng* [Ni's nickname].

Seals *Mogeng* (Ni's nickname); *Ni Tian zhiyin* ("seal of Ni Tian") HL

15 Red plum blossoms, 1916

By Wu Changshuo (1844–1927)
Hanging scroll, ink and colors on paper
H. 159.2 × W. 77.6 cm
Collection of the Shanghai Museum

This impressive exuberance of red blossoms and interlaced branches reveals the technical assurance Wu Changshuo had achieved by the time he painted it at age seventy-two. Wu was a distinctive artist who applied the lessons of calligraphy to flower painting; in fact, he blended the four classics of poetry, calligraphy, painting, and seal carving. Instead of illustrating the flowers' delicacy, he demonstrated their graphic structure with deliberate calligraphic strength.

Born in Anji, Zhejiang Province, Wu matured into one of the foremost artists in Shanghai, where he had settled in 1912 and remained until his death at age eighty-three. He was a scholar of bronze-and-stone inscriptions, following in the footsteps of his mentor, Zhao Zhiqian (cat. no. 8); he was also a master painter of the Shanghai school in the style of Ren Yi (cat. no. 11), to whom Wu was apprenticed during his fifties. Ren Yi, judging Wu's plum and bamboo paintings inferior, advised Wu to "use seal script to draw flowers, and cursive script to outline stems." Upon hearing this advice, Wu worked even harder and went to Ren's home every day for critique.[1]

Wu's self-estimate was modest: "I do the best in bronze and stone [seals], the second in calligraphy, the third in flower painting, but [I am] a layman in landscape."[2] Ironically, it was his paintings, not other works, that fetched high prices. His close friend, the art critic Zheng Wuchang (1894–1952), noted that Japanese merchants made enormous profit by selling copies of Wu's paintings they brought from Shanghai.[3]

Inscription

A poem the artist inscribed on the upper left reveals his enthusiasm for painting plums.

An iron wish-granting wand [ruyi] broke corals into pieces
[implying: My *ruyi*-like brush-pen splashes plum petals]
Blowing east wind to scatter plums' pistils
[implying: Ink on my pen is like wind flying off dot
 pistils]
*With whom can I share such spindled joy under a thatched
 roof?*
*Painting plums produces the same excitement as from
 bronze vessels.*
I, Kutie daoren, value plums as a bosom friend.
[*Kutie daoren* literally means "bitter iron" and "Taoist
 priest"; both were Wu's nicknames.]
In front of plums, I paint out long branches,
And rosy petals chase up squiggling twigs for a dance,
*Using complete energy [to paint] as climbing up mountains
 and rocks.*
[I] used to visit brothels for drink and hedonism,
There [I] stole rose powder to make colors [for painting].
*Rose-powder liquid that nurtures spring in Jiangnan [the
 south of Yangzi]*
Should not be restricted to a maple root in a hall.
[implying: Paintings should be exposed to the world but
 not merely inside a studio]
*Ink splashed in the summer, the fourth month of the lunar
 year bingchen [1916], briefly after brushwork of
 Huazhi siseng [Luo Pin, 1733–1799], Wu Changshuo.*

Seals *Junqing zhiyin* (seal of Junqing, Wu Changshuo's nickname); *Changshuo; Wuxu Wu* ("Wu without mission") HL

1 Zheng Yimei, "Youguan Ren Bonian de ziliao," 1–2.
2 Hui Lan, "Haipai huihua de jindaixing jiqi chuantong neifaxing yanjiu," 735–736.
3 Zheng Wuchang, *Zhongguo huaxue quanshi*, 387.

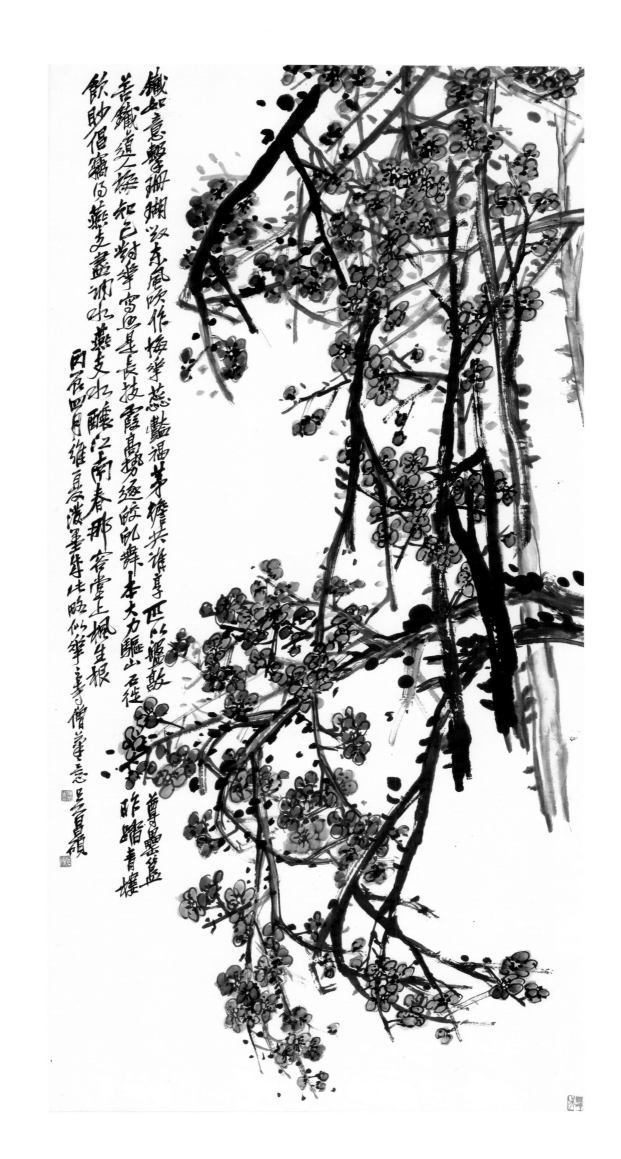

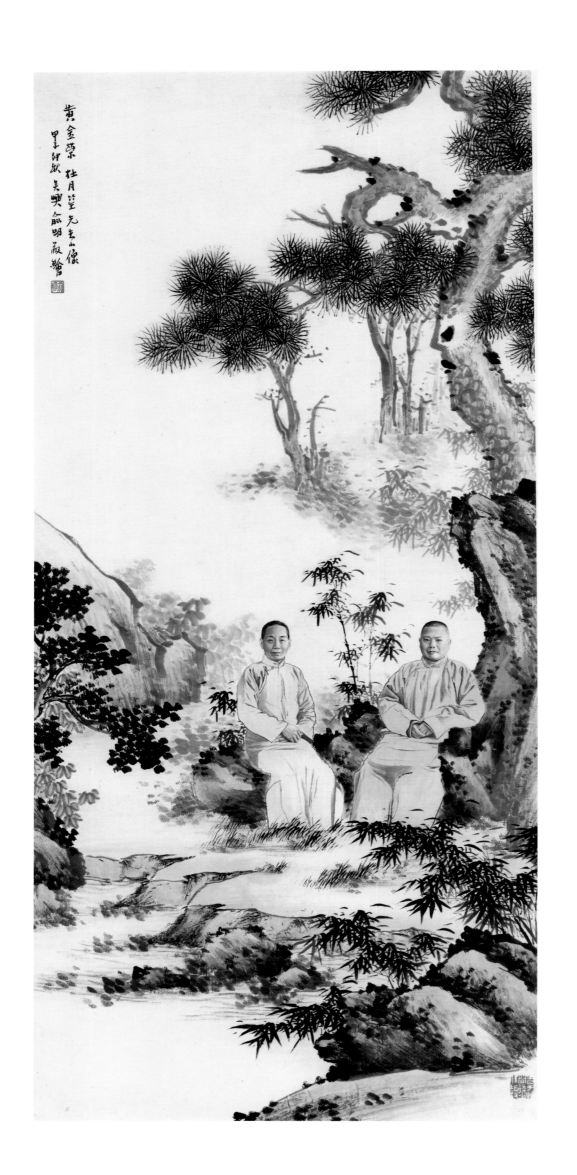

16 *Huang Jinrong and Du Yuesheng*, 1924

By Yu Ming (1884–1935)
Hanging scroll, ink and colors on paper
H. 98.9 × W. 41.3 cm
Collection of the Shanghai Museum

This work by Yu Ming is the only known surviving portrait of the two most powerful chieftains of the Shanghai underworld of the 1920s and 1930s. Their relationship, based on shared ambitions to control the city's economic and political power, contributed to the complex nature of Shanghai society. However, for this composition, the artist was not concerned by all of the charged issues. The two, wearing light-colored, long robes, gather casually in a tasteful garden with clusters of bamboo and pine trees, symbolic of a lasting, staunch friendship. Sitting on rocks, Huang Jinrong (1868–1953) rests his left arm on the gnarled roots of an old pine tree; to his right his nineteen-year junior, Du Yuesheng (1887–1951), poses modestly with his hands in his lap. In the light glow of daytime, the garden scene evokes serenity in reflecting a sense of the men's mutual trust and understanding.

As a twelve-year-old, Huang Jinrong moved with his family from Suzhou to Shanghai. His father then established a teahouse near Yu Garden and sent the young boy to the Cuihua Studio to learn paper mounting. There Huang most likely became acquainted with businesspeople, the educated elite, and artists from all classes. In 1892 Huang took up a new career in the Shanghai garrison, after being recruited to the police station in the French Concession. Du Yuesheng began his apprenticeship in a fruit guild at age sixteen. In 1911, seeking protection, he entered the same gangs that Huang belonged to. Huang and Du, along with Zhang Xiaolin (1877–1940), swore an alliance as brothers and founded San Xin (Three Gold) Company in 1925. Under the protective umbrella of Huang, who was by then the general police commissioner in the French Concession, the business grew rapidly to include jockey clubs, bathing pools, theaters and cinemas, and on to banks, industry, transportation, and the especially lucrative importing and selling of opium. Their yearly profit of more than thirty million dollars earned them the nickname of the "Three Shanghai Tycoons."

To pursue expanding business opportunities, they provided Chiang Kai-shek (1887–1975)—commander of military forces of the national government and later the central figure in the Nationalist Party, the Guomindang—with a superior financial base, which enabled Chiang to keep his opponents divided. In 1927 Chiang in turn appointed Du to be a military adviser to the navy, army, and air force; and Huang a major-general adviser to general headquarters.

Yu Ming probably created this portrait as a commission, to commemorate preparing for the founding of San Xin Company. The Wuxing-native artist began training in watercolor and drawing in Shanghai. Yu assimilated the popular styles of Chen Hongshou (1598–1652) and Ren Yi (cat. no. 11) and pursued refined, elaborate brushwork known in Chinese as the *gongbi* style. Studying figure paintings by the two masters enhanced Yu's awareness of the capacity of facial expression, gesture, demeanor, and surroundings to communicate themes. One particular commission made him famous. On a recommendation from Jin Cheng (1878–1926), a member of Parliament under the Republican government, Yu went to Beijing to paint a portrait of Yuan Shikai, the short-lived president (served October 1913–June 1916).[1] This work established Yu Ming's reputation for portraiture. He also painted historical figures as well as commissions for members of high society. Although at the time the delicate *gongbi* style was not in favor, Yu Ming chose it for this portrait to convey dignity.

Signature *Small portraits of Mr. Huang Jinrong and Du Yuesheng. Respectfully painted by Yu Ming, the middle autumn in the year jiazi* [1924].

Seal *Yu Ming* HL

1 Li Chu-tsing and Wan Qingli, *Zhongguo xiandai huihua shi, 1912–1949*, 99–101.

Pang Yuanji Holding a Rabbit, 1927

By Wang Zhen (1867–1938)
Hanging scroll, ink and colors on paper
H. 136.6 × W. 69.0 cm
Collection of the Shanghai Museum

In this painting Pang Yuanji (1864–1949), a renowned Shanghai businessman, is presented as a virtuous gentleman holding a rabbit in the center of a garden of plum trees.

Known in Chinese literature for its attributes of hardiness, vitality, purity, and faithfulness, the winter plum is considered a symbol of virtue. In Taoism it is often associated with the moon, as if the two together could yield powerful energy. According to Taoist texts, the secret recipe for combining the plum and the moon was known only to the jade rabbit, the servant of the moon goddess. When worship of Taoism reached its peak during the twelfth century, this subject matter was commonly depicted in a pictorial composition with plums under the moon, or with rabbits under flowering trees and the moon.

Wang Zhen, a Buddhist, deliberately transformed this traditional theme into a realistic depiction of a living person while retaining the subject's meaning. Using rabbits—one held by the central figure, two others playing beside the rocks—and plum blossoms in contrasting white and pink as symbols, the artist expressed both his personal devotion and a sense of warmth and peace.

Active throughout his life in finance and business, Wang Zhen was best known as an artist for his leadership role in the Shanghai school. At age fifteen Wang studied painting with Xu Xiaocang, a disciple of Ren Yi (cat. no. 11), at Yichun Gallery, where he began as a painting-mount maker. Xu soon introduced him to Ren Yi and Wu Changshuo, who gave him advice on brush technique.[1]

Pang Yuanji, the subject of this work, began a silk-weaving enterprise in Hangzhou before 1902 and later moved to Shanghai, where he cofounded the paper-manufacturing Dragon-Seal Company; he served as the company's president until 1937. Successful in banking and in running a pawnshop and businesses of wine, rice, and medicine, Pang had already established himself as an important art patron and collector when Wang Zhen painted this work in 1927. By that time Wang, then chairman of the Shanghai Commercial Association, had acquired the ability to display rhythmic strength through his brushwork. Wang and Pang are considered to have been largely responsible for the promotion of art in early-twentieth-century Shanghai.

Inscriptions

1. The inscription on the right is a poem by Wang Zhen.

Age and enlightened being enjoy the vital spring; holding the rabbit, Xuzhai [Pang Yuanji's nickname] speaks of joy and warmth. Fragrant plums under cypress shadows will leave a trace; auspicious clouds welcome new arrivals at the door. Bailong shanren [Wang Zhen's nickname] painted in Haiyun lou [Ocean-Cloud Pavilion], the new year of dingmao [1927].

Seals *Wang Zhen dali* ("great fortune to Wang Zhen"); *Yiting* (Wang Zhen's nickname)

2. A long inscription on the upper left by Wu Changshuo describes Xuzhai: *celebrating-long-life being [who] holds the jade rabbit in his immortal hands; sets foot on the way to the celestial palace.*

Seal *Kutie* ("bitter iron," Wu Changshuo's nickname)

HL

1 Li Chu-tsing and Wan Qingli, *Zhongguo xiandai huihua shi, 1912–1949*, 14–16.

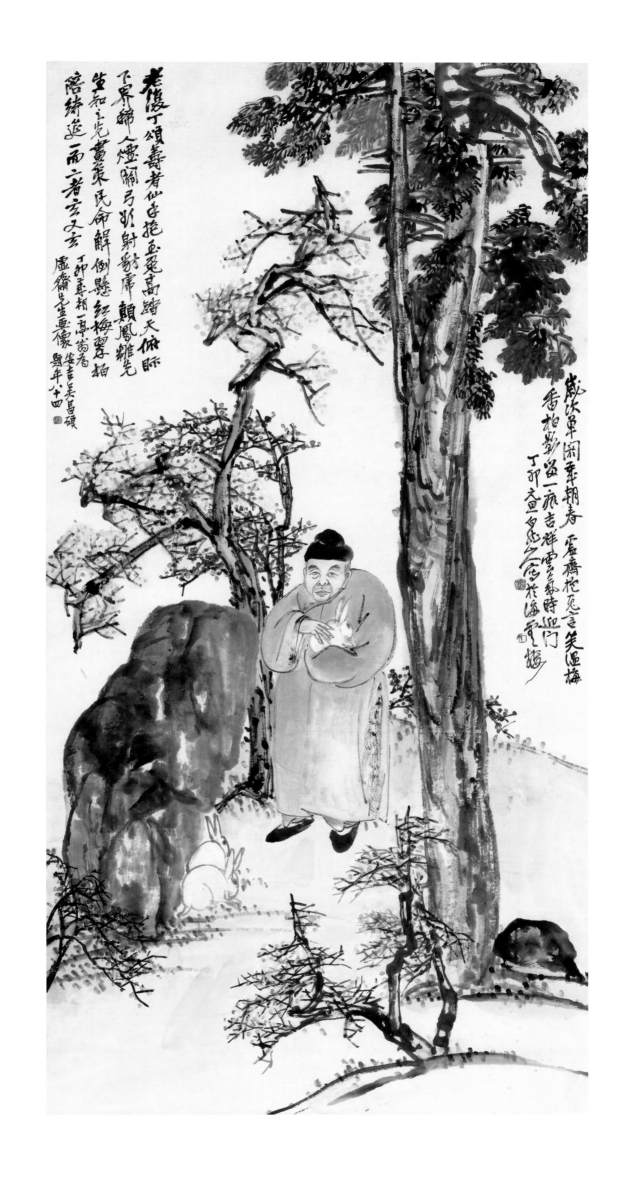

18 Plum blossoms under the moon, 1933

By Tao Lengyue (1895–1985)
Hanging scroll, ink and light colors on paper
H. 246.0 × W. 123.8 cm
Collection of the Shanghai Museum

The full moon gets a unique treatment in this painting by Tao Lengyue, one that is relevant to its symbolism of virtue, peace, and eternity. Tao's distinctive work with ink and composition transformed this popular topic of traditional painting. He used ink and colors to fill shadows with reflected light: pure black or bluish gray here, whitish gray or greenish gray there. The dramatic dark branches against moonlight show the influence of Western art. The moon's soft, cold light reinforces the poetic atmosphere of the painting. Tao did not show the entire tree from roots to tips; instead, he cut out the lower trunk, giving the impression that the upper part was stretching into the vaulting blue. The artist sought to capture the effects of moonlight on floating clouds and interlacing pronged branches not usually found in traditional depictions of moonlit scenes.

Born to a family of the educated elite in Suzhou, Tao (whose original given name was Shanyong) consistently ranked among the best students at art and literature during his boyhood. He and schoolmates Wu Hufan (1894–1968) and Yan Wenliang (1894–1988) began painting with ink in Suzhou elementary school. Tao first became exposed to Western art at age eighteen when teaching at the Wuxian county school. From 1918 to 1921 he taught in Yali University, a private institution in Changsha, Hunan Province. There he was given a new name—*Lengyue* or "Cold Moon"—in honor of his painting specialty, night scenes under the moon. After returning to Suzhou, he was frequently invited to assume teaching and administrative positions at various universities, including National Jinan (Zhejiang), Nanjing College of Arts, and Sichuan University. By the time he turned thirty, Tao had found success as a "Chinese-and-Western blender" in his first solo painting exhibition in Wuxi. Tao was then selected to present paintings at the World Fairs in London, Philadelphia, and Tokyo. Tao refused to serve under the Japanese military government during the Japanese occupation of Shanghai, which began in 1937.

Tao's later years were darkened by the One Hundred Flowers Movement, which eventually gave way to the anti-rightists' purge in the late 1950s. As measures against intellectuals grew harsher, Tao was charged with being a "rightist," and his art lost favor among the academies. Not until 1978, at age eighty-three, could Tao Lengyue show his art again.[1] Recently, his cold moon works have been rediscovered and praised as distinctive art that introduced Western techniques to twentieth-century Chinese painting. His ink, with its loose, expressive brushstrokes that heighten light and shade, has been particularly lauded.[2]

Signature *By Lengyue Tao, the winter of the year* kuiyou [1933]

Seals *Wuliu houren* ("descendant of five willows," Tao's nickname); *Wumen Tao Yong huaji* ("painted and recorded by Tao Yong [his original name] from the Wu school"); *Xinji shuangqing* ("tranquil and unperturbed spiritually and physically") HL

1 Zou Mianmian, "Tao Lengyue nianbiao," 263.
2 Lang Shaojun, "Ershi shiji shanshuihua de chengyu bian," 27.

19 Bird and flower blossoms, 1943

By Xie Zhiliu (1910–1997)
Hanging scroll, ink and colors on paper
H. 139.5 × W. 50.5 cm
Collection of the Shanghai Museum

Born in Wujin, Jiangsu Province, Xie Zhiliu spent most of his career in Shanghai, where he was known for his works in the traditional medium of ink and color (*guohua*). Like many Chinese flower-and-bird paintings, this work is steeped in symbolism. The papery, red camellia blossoms of spring strongly contrast with the white-lobed winter plum petals. A cone-shaped rock between the trees in the center of the picture provides a counterpoint of color and shape. Attracted by the beautiful flowers, a Chinese wagtail, a *huamei*—which literally means "painted eyes"—has perched on a plum branch, as if to join the colorful blossoms in an exuberant celebration of a new season.

Xie's curvaceous forms and high key colors are distinctive elements of his flower-and-bird paintings. His fascination with this genre lay in his obsession with plums that began in the late 1920s. He explored the realistic depictions of Xu Xi, a tenth-century flower painter known for his *luomo,* "putting ink" technique, in which ink or color was directly applied to paint stems, leaves, or petals, then overlapped with dark ink or colors to highlight veins or calyxes. In 1930 Xie turned his focus to fluid lines and bright color schemes, especially those of Chen Hongshou (1598–1652), whose plum painting he purchased and intensively copied.[1] In 1937 his red *Camellia* was exhibited at the *Second National Art Exhibition* in Nanjing and gained for the artist his first critical recognition.

During the Sino-Japanese War, Xie retreated inland to Chongqing, Sichuan, where he served as a secretary for the Custom Affairs Office of the central government under the Nationalist Party. In 1942 Xie received a letter from Zhang Daqian (1899–1983), who invited Xie to join him in Dunhuang, an early Buddhist site in the northwest. Resigning from the government and from teaching, Xie spent about a year with Zhang, studying and documenting the arts in the Buddhist caves in Dunhuang. Sketching the many wall paintings there had a momentous effect on Xie's painting. He executed this work during his stay in Lanzhou as he returned to Sichuan via Gansu and Shaanxi. Xie devoted the rest of his life to art appraisal, connoisseurship, and painting.

After Zhang Daqian left China in 1949, the two lost contact with each other until 1973, when they were able to correspond through Hong Kong. Although Xie did not create this work for his mentor, it remains a reminder of the contributions the two painters made to the fields of art history and conservation.

Signature *For the refined judgment of the revered Mr. Yirun, Xie Zhiliu on visiting Lanzhou, May 27 of the year* kuiwei [1943].

Seals *A Zhi* (Xie's nickname); *Liubaiyi* ("Liu's white coat"); *Chiyan* ("latecomer swallow") HL

1 Zheng Wen, "Xie Zhiliu nianbiao," 33.

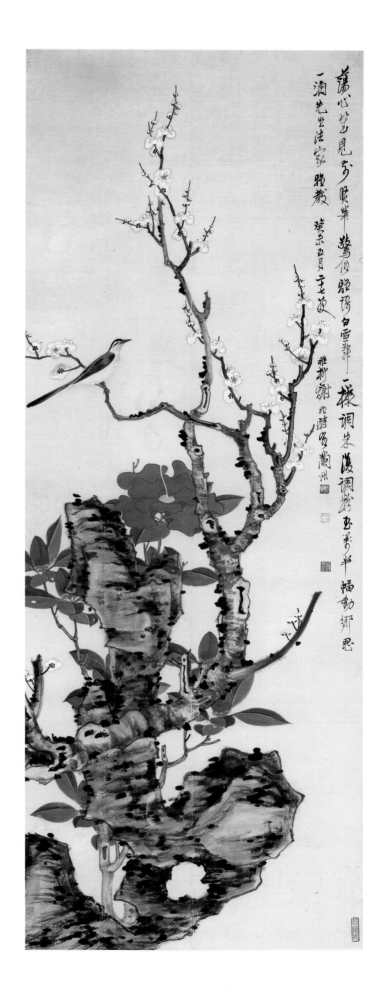

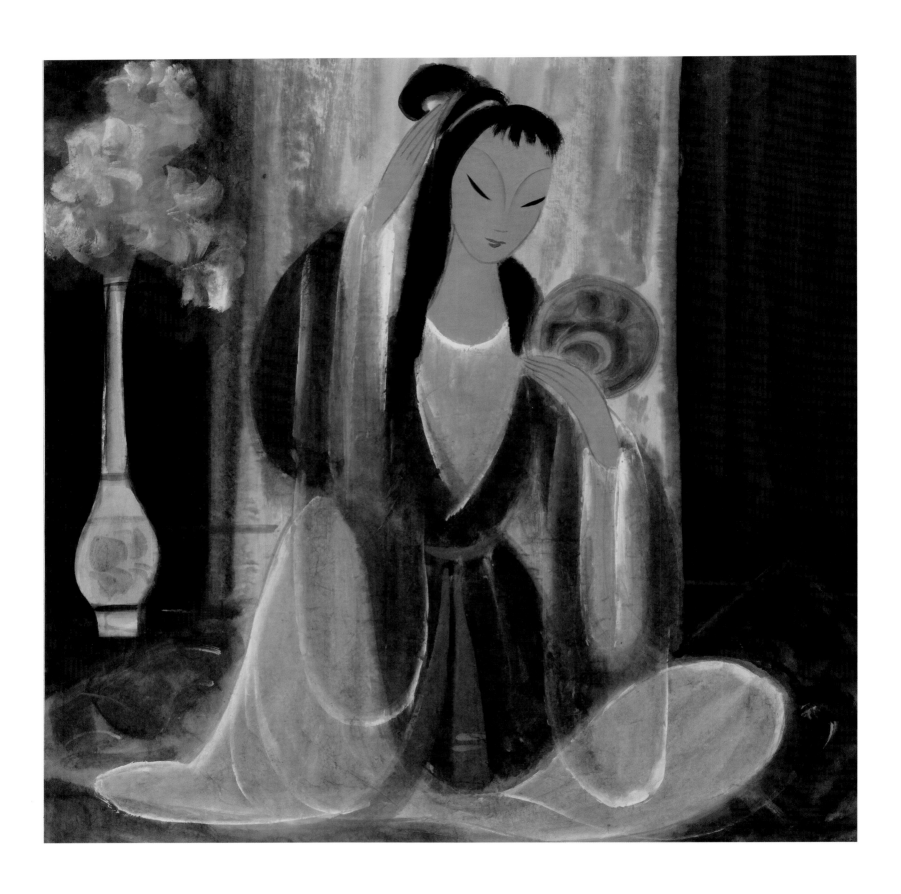

20 Beauty holding a mirror, approx. 1950–1965

By Lin Fengmian (1900–1991)
Ink and colors on paper
H. 66.4 × W. 66.4 cm
Collection of the Shanghai Museum

In this painting, a seated woman adjusts her hair while she holds a bronze mirror in her left hand. The artist, Lin Fengmian, adopted methods from Western Post-impressionism that the majority of his contemporary Chinese art critics took longer to accept. Instead of using the dense strokes and empty space that built up texture and perspective in traditional painting, Lin employs simple linework and flat application of color. The tension in this scene is heightened by the woman's gossamer garment, its fused gray shades seen through thin lines. The curtain glimmers behind her, enabling the viewer to sense the morning sunlight. On the floor where she sits are a rug and a pillow with woven patterns in eggshell green and ultramarine, a treatment that often took precedence over motifs of plants and water. The unrealistic loose structure, the close-up format of the woman's body, and the disproportionate flower vase give this work decorative appeal and directness, different from either Chinese formal ancestral portraits or narrative paintings.

Lin Fengmian was one of few Chinese artists to study at the École Nationale des Beaux-Arts, Dijon, and its studio in Paris, where he spent the years between 1920 and 1926. His experiences in Europe lightened Lin's linear organization and palette and provided him a new treatment of the female form that combined realism with abstraction. Lin sought to reconcile his female figures with the nubile and fluid gestures seen in the works of Modigliani and Matisse. Yet his figures are not simply imitations but rather distillations of many aspects of the old and the modern, Western and Chinese. With thin, upward brows and painted lines from eyebrows down along the nose bridge, the faces of his figures are delicately simplified, like the makeup for theatrical characters. Although in 1927 Lin dismissed

Chinese operas as "only old playthings, not of use,"[1] they became his sole entertainment in the early 1950s, when he lived in Shanghai and taught at the branch school of the Central Academy. Lin then depicted his models in the white tulle train of the fairy maiden from the romantic opera *White Snake;* he also painted dozens of masks of theatrical characters.[2] Before moving on to other subjects, Lin painted over a thousand works of brightly colored women.[3] In keeping with what Lin considered to be Western taste, large nude or scantily dressed women reading a book, playing an instrument, or holding a mirror or a fan became programmatic in his works.[4]

After his second wife, Alice Vatiaur, a schoolmate in Dijon, and their daughter and son-in-law left for Brazil in 1956, Lin became unhappy, both in his personal life and in his career, which was overshadowed by Chinese intolerance of his Western orientation. Some say Lin produced an outpouring of female figures to relieve his distress. Others say he was so depressed he later utterly abandoned the subject matter. The fact is that only a small number of paintings he created before 1977 survived through the Cultural Revolution (1966–1976); thousands of his works were destroyed. Beautiful women did not appear as one of his favorite subjects after he settled in Hong Kong in 1977.

Signature *Lin Fengmian*

Seal *Lin Fengmian yin* (seal of Lin Fengmian) HL

1 Lin Fengmian, "Zhi quanguo yishu jieshu."
2 Bai Xuelan, "Lin Fengmian xiju renwu zhi xingshi yu fazhan licheng," 159.
3 Shen Roujian, "Tongshi yidai zongshi Fengmian xiansheng," 35–36.
4 *Mingjia hanmo*, no. 24 (1991): 28, 30, 42, 44, 84, 86, and 109.

21 Anchoring a boat under
pine trees, approx. 1950–1965
By Lin Fengmian (1900–1991)
Hanging scroll, ink and colors on paper
H. 66.5 × w. 67.8 cm
Collection of the Shanghai Museum

This landscape consists of two scenes observed from different perspectives. The upper part of the picture is viewed from a much higher and more distant point, looking down meandering mountain peaks. The foreground reveals a few trees standing on riverbanks and a boat floating along the water on the right. Light mist divides the perspectives. The picture is enlivened by a wind that blows foliage and slants the boat's mast. Lin Fengmian created the image with swift, thick, and dynamic washes; he used none of the conventional textural strokes that traditionally depict spiky branches or rocky cliffs. This work illustrates Lin's total indifference to traditional landscape form and technique.

Lin's unconventional style reflects a mature vision of the world that he shared with various painters. Lin possessed little confidence in his talents, and he displayed more persistence than arrogance.[1] Before departing for France, Lin copied Lingnan-school paintings by nineteenth-century artists from his native Guangdong. At the studios in Paris he was considered a talented student by his instructor, Fernand Cormon, who invigorated his class with the art of the Symbolist Gustave Moreau. Lin's work was chosen by the Paris Salon to show, along with paintings by Pierre Bonnard and others, at the seasonal exhibition in 1923. After returning to China in 1926, Lin continued to be an outspoken advocate of modern Western art. At the same time, he intensified his interest in Chinese traditional arts, particularly paintings by Zhu Da (1626–1705), drawings on blue-and-white export porcelain, sculpture, and bronze.[2]

Landscape remained Lin's favorite subject throughout his lifetime. His passionate interest in it lay in boyhood memories of his remote hometown, which he recollected as a village with white, floating clouds and winding streams. Following the example of his grandfather, a stone carver, Lin executed his brush in an uncommon way and wished to "forever [paint] sincerely my true feelings."[3]

As early as the 1940s, Lin found that a luxurious life with a private home and car—he held positions for more than ten years as president of art schools in Beijing and Hangzhou—exhausted his "feelings toward humanity." For a while he secluded himself in a shabby storehouse to sketch nature along the Jialing River in Sichuan. His situation there shocked a high official who came to visit him. The official observed: Only the knife, the cutting board, and the bottle of oil available on the riverbank could have remade Lin "a true human with the spirit" to create art.[4]

To Chinese eyes, the art of Lin Fengmian might seem too simple, for it does not contain the complicated brush-work of traditional Chinese landscape. What Lin wanted to create was art with "beauty" and "power" that could overcome "handicaps in both Western and East Asian arts."[5]

Signature *Lin Fengmian*

Seal *Lin Fengmian yin* (seal of Lin Fengmian)　　HL

1 　Xi Dejin, "Lin Fengmian de yishu," 10.
2 　Righterfood, "Tiaohe zhongxi yishu," 50.
3 　Wu Guanzhong, "Yan guilai, daonian Lin Fengmian laoshi," 32.
4 　Wu Mingshi, "Cangku dashi yi Lin Fengmian."
5 　Chen Yongyi, "Shiyan de licheng," 21.

22 Blue-and-green landscape, 1978

By Liu Haisu (1896–1994)
Hanging scroll, ink and colors on paper
H. 108.5 × w. 45.3 cm
Collection of the Shanghai Museum

This landscape by Liu Haisu is striking in its unusual coloration and composition. Liu's work is archaic in spirit while at the same time advanced in technique.

In traditional Chinese landscape, the standard approach is to arrange mountains and rivers in a zigzag or serpentine pattern. Here Liu disregarded this concept and constructs a mountain scene in another way by giving expression to disintegration. Four clusters of foliage lined up in two rows in the foreground serve as a dislodged foundation for overlapping high peaks. Liu flattened, disconnected, and evenly treated the foliage clusters. Only the top mountains, done in the signature dots and peaks of the Song master Mi Fu (1051–1107), reveal a sense of perspective. The sun's warm reflection can be seen in golden touches on the sides of the peaks. Traditional muted ink is exchanged here for a brilliant palette. The foliage's contrasting malachite green and pepper red combined with the blue and russet hills and clouds make this a bold work, a portent of Liu's new direction.

Unlike many of his fellow artists, who began training with traditional brushwork, Liu Haisu was inspired by Western art at age fourteen when he enrolled in a class at the Stage Set and Painting School in Shanghai. As a sixteen-year-old, Liu was a cofounder, and in 1916 the chancellor, of the Shanghai Art Institute of Drawing and Painting, the predecessor of the Shanghai Art Academy; this school expanded rapidly and by the 1930s had a full faculty with eight hundred students. Liu launched a campaign against the imperial institutions and feudal values. Not only did he start using female models in his class, but also he openly exhibited nude paintings. Such activity, which disturbed society's moral sensibilities, frequently caused him to be condemned. As an eager participant in the group of radicals that included Cai Yuanpei (1868–1940), Kang Youwei (1858–1927), and Liang Qichao (1873–1928), he was widely involved in educational reform. His organizing of solo exhibitions and teaching art abroad—from Japan to Europe, including France and Germany, and to Southeast Asia (1919–1941)—motivated him to tout the modern art practices he observed. He advocated replacing the Chinese art legacy with new ideas: "new approach, new artistic ambience, and beautiful taste by flourishing [in] Chinese and Western paintings in order to accomplish, through creation, perfect integration."[1]

Signature *For comrade Yiping, Liu Haisu, the new summer of the year wuwu* [1978]

Seals *Haisu chuangzuo* ("created by Haisu"); *Jinshi qishou* ("immortality to both bronze and stone"); *Shipo tianjing* ("working with stone to amaze the world") HL

<hr />

1 Liu Haisu, "Zhongguohua de jicheng yu chuangxin," 91.

Secluded Valley Yields Fragrance, 1982

By Zhu Qizhan (1892–1996)
Hanging scroll, ink and colors on paper
H. 136.9 × W. 68.0 cm
Collection of the Shanghai Museum

Since the period of the Wei Kingdom (220–265 Y[), the cymbidium-orchid-and-rock has been regarded as "fragrance-and-fortification," a symbol in China of formality and dignity. Its graceful appearance attracts artists to paint it, especially those who grow cymbidium. When Zhu Qizhan created this work in 1982, eighty-two years had passed since he first painted cymbidium at the age of eight. Zhu perfected formulas to depict the flower, basing his simplified style on dry ink and umber dyes, brisk and precise lines, a spare, central space for the cymbidium, and rocks as background. This large-scale painting exemplifies the enigmatic style that Zhu Qizhan's fame rests on today.

Born in Taicang, Jiangsu Province, Zhu Qizhan fought several chronic health problems throughout his life. Heart failures led him to drop out of a professional college in 1914 and to enter the Shanghai Art Institute of Drawing and Painting, founded in 1912 by Liu Haisu (cat. no. 22) and others. His growing desire to study more Western modern art compelled him in 1917 to make a secret trip (kept from his wife and family) to Japan, where he enrolled in the oil painting class taught by Fujishima Takeji in the Kawabata Art School. Upon his return home from that short period of study (probably not more than a year), Zhu devoted himself to introducing to China the color and light effects of impressionism. His work was admired by influential critics and artists, including Xu Beihong (1895–1953), with whom he cofounded the Silent Society for Painting in 1936; and Qi Baishi (1864–1957), who made sixty seals for him, after which Zhu proudly called himself "Rich Elder with Sixty Seals by Baishi."[1] Qi Baishi, Wang Zhen (cat. no. 17), and Huang Binhong (1865–1955) have been credited with convincing Zhu to focus on the style known as *xieyi*, "painting ideas." In 1946 he built a house, named Thatched Studio with Plums, in southern Shanghai, with separate studios for oil on canvas and ink paintings. From the 1950s on, Zhu focused on incorporating characteristics of modern Western art into Chinese painting.

During a visit to San Francisco in 1983, the ninety-one-year-old master completed the gigantic painting *Grapes* in honor of the city's international airport. In 1990 the Shanghai Art Museum organized a solo exhibition to celebrate Zhu's upcoming hundredth birthday. This painting attests to his three mantras of "individuality, strength, and simplicity." Zhu avoided the extreme abstraction of Postimpressionism, displaying more interest in warm colors, thick, mottled strokes, and sharp, crisp effects.

Signature *Painted by Zhu Qizhan in Shanghai, the end of winter in the year* renxu [1982].

Seals *Zhu Qizhan; Nian jiushiyi zuo* ("created at age 91"); *Taicang yisu* ("one grain from Taicang") HL

1 Liu Xilin, "Zhu Qizhan de shengya yu yishu," 349.

Shanghai General Post Office, approx. 1950–1980

By Li Yongsen (1898–1998)
Watercolors on paper
H. 28.0 × W. 39.5 cm
Collection of the Shanghai Art Museum

The Shanghai General Post Office, topped with a belfry and tower, was one of several Western-style buildings completed in 1924 on Suzhou Creek across from the former British American Tobacco Company along the Bund. This painting shows the building at the right, beyond a three-span bridge. The left half of the composition is devoted to a public area along the creek's embankment, diagonally extended to the lower foreground. The freshly washed greens of foliage, blue benches, and light touches of color worn by blurry figures who are sitting or strolling create a sense of summer. Glimmering sunshine seems about to break through gray clouds, and rainwater ripples over the grainy stone bricks of the walkway. Li Yongsen deemphasized details of crowds and busy river traffic to focus viewers' attention on the post office. This painting reveals the modernity of Li's approach, both in color application and in the chosen view.

Li Yongsen and his elementary schoolmate Jiang Handing (1909–1963) studied painting with Tao Songqi in their hometown of Changshu. It did not take long for the two friends to find their own talents. Li became interested in watercolors and Western painting, while Jiang stuck with traditional ink painting.[1] For much of his youth Li worked as a Western-art teacher, illustrator, and editor for art magazines in various cities until he settled in Shanghai in 1926. Beginning in the 1920s he was instrumental in organizing exhibitions of oil painting and watercolor. During the Japanese invasion in the 1930s, Suzhou Art College (which had moved to Shanghai) hired Li as a dean of education and watercolor teacher. He and his artist wife first exhibited their paintings in 1942 in Daxin Gallery, where their works were singled out for their modern conceptions. The next year the Shanghai Art College invited Li to teach design, though his major focus was still painting. He continued with loose brushwork and broke away from traditional compositions, thus contributing to the modernization of Chinese art. Li was among the first Chinese artists to paint modern urban scenes with gouache and watercolor from distinctive viewpoints, such as the one depicted in this work.

Signature *Yongsen* HL

1 Li Yongsen, "Yi tongxue Jiang Handing," 62.

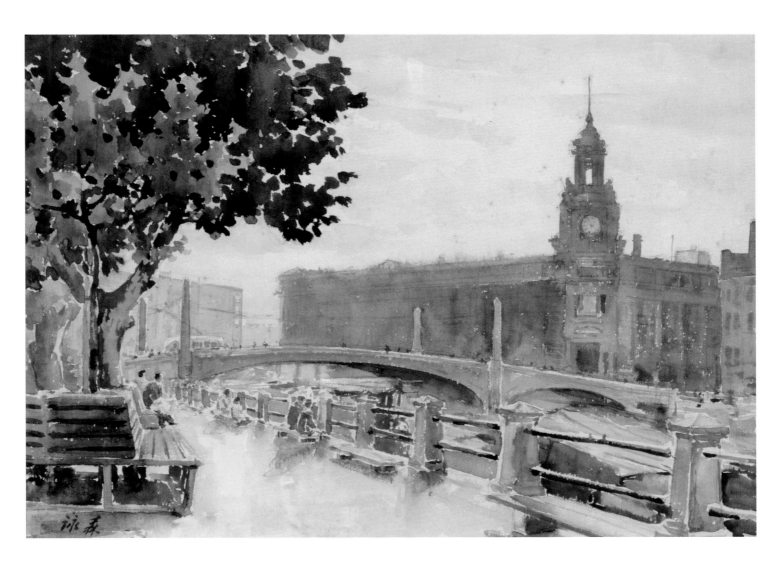

25 Boundary tablet of Hongkew,
the American Settlement, after 1850

Iron or lead
H. 76.5 × W. 68.5 × D. 2.5 cm
Collection of the Shanghai History Museum

The various concessions within Shanghai's International
Settlement were marked by boundary tablets, such as this
one for the American Settlement of Hongkew.[1] However,
since each measured less than three feet in height, the
tablets offered little physical presence within the labyrin-
thine streets of the settlements. DC

1 Lee, *Shanghai Modern*, 6.

Ladies, 1890

By Wu Youru (1839–1897)
Album, ink and colors on silk, set of twelve
H. 27.2 × W. 33.3 cm each
Collection of the Shanghai Museum

Each of the twelve leaves of this album depicts a beautiful lady engaged in a leisurely activity, such as reading or playing music. As did most artists of the Shanghai school, Wu Youru melded tradition and innovation in his works. Painting beautiful women, for which he was acclaimed,[1] has a long tradition in Chinese art, as does the line-drawing technique (*gongbi*) he employed. Furthermore, his paintings were intended to have broad appeal: they are colorful and richly detailed. His paintings have the additional appeal of presenting a particular view of the realities of late-Qing life in Shanghai.[2]

Innovation appears in several aspects of these paintings. First, the women are contemporary in appearance, no longer garbed in the traditional flowing robes.[3] In addition, Wu captures the physicality of his figures; the women appear more rotund and solid than those in traditional works, a feature that points to Western

influence.[4] Another Western influence is his use of linear perspective to depict the furniture and architecture.[5] As one scholar noted, the appearance of such Western spatial devices in Chinese ink drawings points to the spread of lithography by the late 1800s;[6] lithography was a medium Wu helped to popularize in publishing in Shanghai. **DC**

1 Laing, *Selling Happiness,* 54.
2 *Chinese Paintings from the Shanghai Museum,* 98.
3 Ibid.
4 Anita Chung, "Reinterpreting the Shanghai School," 41–42; Andrews, "Commercial Art and China's Modernization," 184.
5 Shan Guolin, "Cultural Significance," 19.
6 Andrews, "A Century in Crisis," 3.

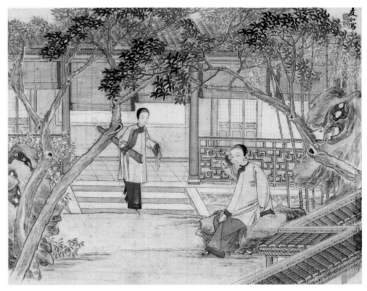

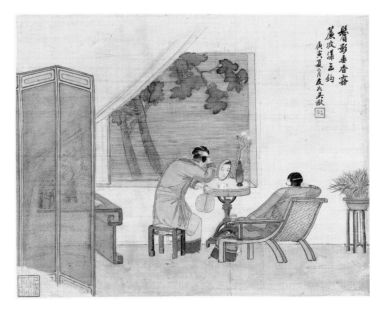

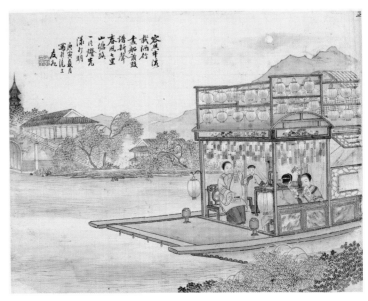

Lithography in Early Shanghai Graphics

The following eight brush-and-ink drawings served as the original works from which photolithographed prints were made. They were compiled in 1893 as part of a three-volume set, *A Treasury of Wu Youru's Illustrations* (*Wu Youru huabao*), that comprises an array of subject matter, including the "hundred trades of Shanghai," the "hundred sights of Shanghai," and the "hundred beauties of Shanghai" (*Haishang baiyantu*),[1] of which eight are presented here. The "hundred beauties" theme was a traditional one, but Wu updated it for the late 1800s[2] by idealizing what was then considered the modern lifestyle of Shanghai women.

Wu's images also bespoke the flourishing print culture in Shanghai during this time. As one contemporary writer and editor, Bao Tianxiao (1876–1973), declared of the city's publishing industry in the late 1800s, "Shanghai was the hub of the wheel" (*Shanghai sitong bada*).[3] Most new printing technology passed through Shanghai first before reaching the interior, and the single most important one that distinguished the city was lithography (*pingban yinshua*).[4] Introduced by Jesuit missionaries in the mid-1800s,[5] lithography involves the manipulation of a flat surface medium predicated on the principle that grease repels water. Shanghai publishers had access to two forms of lithography by 1900: stone-based lithography (1876, *shiyin*)[6] and photolithography or zinc-plate lithography (1882 or 1884, *zhaoxiang shiyin*).[7] The latter arguably became, for several reasons, the definitive technique that helped periodicals such as the *Dianshizhai huabao* to visualize, and in effect construct, Shanghai's fin-de-siècle modernity.[8] One of those reasons was that photolithography allowed for exceptional reproduction of lines and shadings,[9] a capacity that Wu Youru and others exploited to showcase their experimentation with Western perspective and modeling. It also encouraged a frequency of publication (every ten days for the *Dianshizhai huabao*)[10] that seemed to readers to keep pace with their city's changes. The major publishers of the day included Dianshizhai Lithographic Studio (*Dianshizhai shiyinju*), Tongwen Press (*Tongwen shuju*), and Wu's own Feiying Hall Lithographic Studio (*Feiyingguan shiyinju*);[11] the illustrated periodicals they produced favored images that celebrate the material and immaterial facets of a modernizing Shanghai society, such as those appearing in the eight illustrations discussed below.

Dany Chan

NOTES

1 Information was compiled from Zhang, "Corporeality of Erotic Imagination," 122; Yeh, *Shanghai Splendor,* 52; and Cohn, *Vignettes from the Chinese,* 3.

2 Laing, *Selling Happiness,* 54–55.

3 Reed, *Gutenberg in Shanghai,* 191.

4 The invention of lithography is credited to Alois Senefelder in Munich in 1798. See Banham, "Industrialization of the Book," 284.

5 Laing, *Selling Happiness,* 2; and Reed, *Gutenberg in Shanghai,* 62.

6 Reed, "Re/Collecting the Sources," 48n4.

7 The dates offered for the introduction of photolithography into China vary, but it can be dated at the latest to 1884, when two newspapers (the *Shubao* in Guangzhou and the *Dianshizhai huabao* in Shanghai) appeared that year utilizing photolithography. See Pang, "The Pictorial Turn," 20, quoting Xiangxiang Wu, "*Shubao yingyinben xu,*" 1–4. Christopher Reed argues that by as early as 1882 photolithography was already prevalent. See Reed, *Gutenberg in Shanghai,* 62. This date, though, contradicts his assumption in an earlier publication in which he cites 1920 as the date of photolithography's introduction into Shanghai. See Reed, "Re/Collecting the Sources," 48n4.

8 This is the leading assertion regarding the influence of photolithography and the *huabao* in the development of Shanghai's self-identity in the modern era. See Cohn, *Vignettes from the Chinese,* 4; Pang, "The Pictorial Turn," 17; and Reed, *Gutenberg in Shanghai,* 89.

9 For a description of the photolithographic process, see Reed, *Gutenberg in Shanghai,* 62; and Pang, "The Pictorial Turn," 20.

10 Cohn, *Vignettes from the Chinese,* 2.

11 Reed, *Gutenberg in Shanghai,* 90.

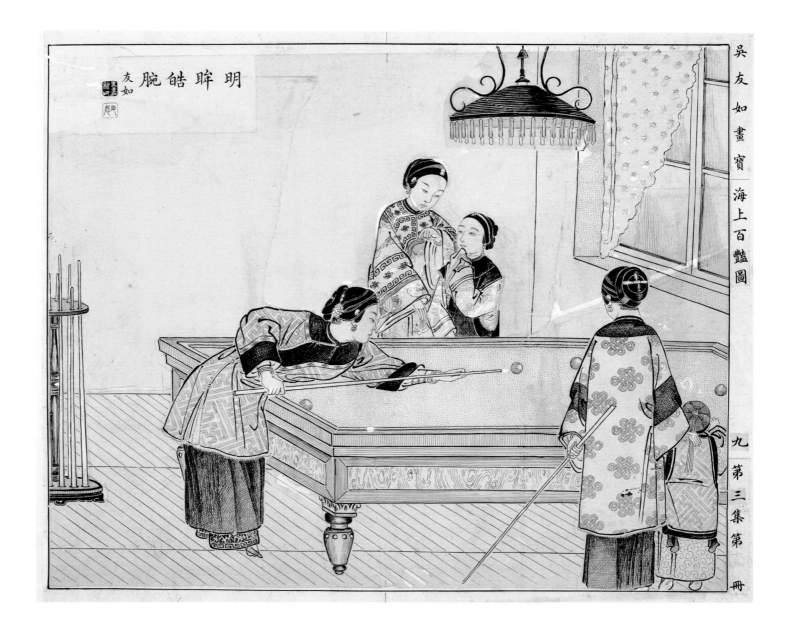

27 *Shining Eyes and White Wrists*, 1887–1893

By Wu Youru (1839–1897)
Ink on paper
H. 53.5 × w. 65.7 cm
Collection of the Shanghai History Museum

Women are presented enjoying a game of billiards in one of the halls in the Zhang Family Weichun Garden, commonly known as Zhang Garden (*Zhangyuan*). Opened to the public in 1885, Zhang Garden was the most famous of the new public gardens in Shanghai and was considered by contemporaries to be the city's first "modern" amusement park, offering an array of novel sites and recreation, such as billiards.[1] The garden remains important to scholars today due to its nature as a "public space," an innovation for its time and for the city of Shanghai.[2]

The specific billiards game most likely being played in Shanghai during this time was snooker, whose origins remain disputed. Begun in the 1500s as a primarily aristocratic pastime in Europe,[3] billiards during the 1800s became popular among the British Armed Forces occupying India. Here, the accepted story is that in India in 1875, Sir Neville Chamberlain created the game and even coined the name.[4] Based on reliable dated references, by 1886 snooker was well established in India and played in England by 1887.[5] Relating the history of the game to its appearance in this illustration indicates the speed at which a form of popular entertainment in the United Kingdom may have been appropriated by Shanghai society—no more than six years after snooker's introduction into England. DC

1 Yeh, *Shanghai Love*, 26; Ye Xiaoqing lists examples of the forms of entertainment offered in *Dianshizhai Pictorial*, 61–63.

2 Ye Xiaoqing, *Dianshizhai Pictorial*, 61.

3 It evolved from a fifteenth-century lawn game that originated in northern Europe. See Shamos, "A Brief History."

4 Ainsworth, "The Origin of Snooker."

5 The references cited were a letter from Calcutta written in 1886 and published columns in *The Sporting Life* newspaper in 1887. See ibid.

Distinguishing Local Flavor, 1890s

By Wu Youru (1839–1897)
Ink on paper
H. 53.5 × W. 65.7 cm
Collection of the Shanghai History Museum

Depicted here are three women being served a meal by their maids at Yipinxiang, the most famous Chinese-operated Western-style restaurant in Shanghai in the late 1800s.[1] The two-story establishment was located on Fuzhou Road, and each of the more than thirty private rooms boasted a foreign décor with long tables, table-cloths, chairs, fireplaces, gas lamps, and clocks. Patrons completed their dining experience by using knives and forks and sampling a menu that included steak, pork chops, pudding, champagne, and beer.[2]

This image hints at the major changes in Chinese dining habits, at least for the upper classes, at the turn of the twentieth century. As one scholar contends, Shanghai's inclusion in a widening global economy expanded the city's culinary repertoire—for example, the advent of manufactured tinned foods enabled the availability of most "Western" food products—and brought about new standards of hygiene—for example, serving spoons or serving chopsticks were now reserved for individual plates.[3] DC

1 As many as nine such Chinese-operated restaurants existed at that time, and they became more popular with Chinese patrons largely due to higher prices at the foreign-owned ones. See Ye Xiaoqing, *Dianshizhai Pictorial*, 61.

2 Information was compiled from ibid., 61; and Yeh, *Shanghai Love*, 26.

3 Dikötter, *Exotic Commodities*, 219 and 228.

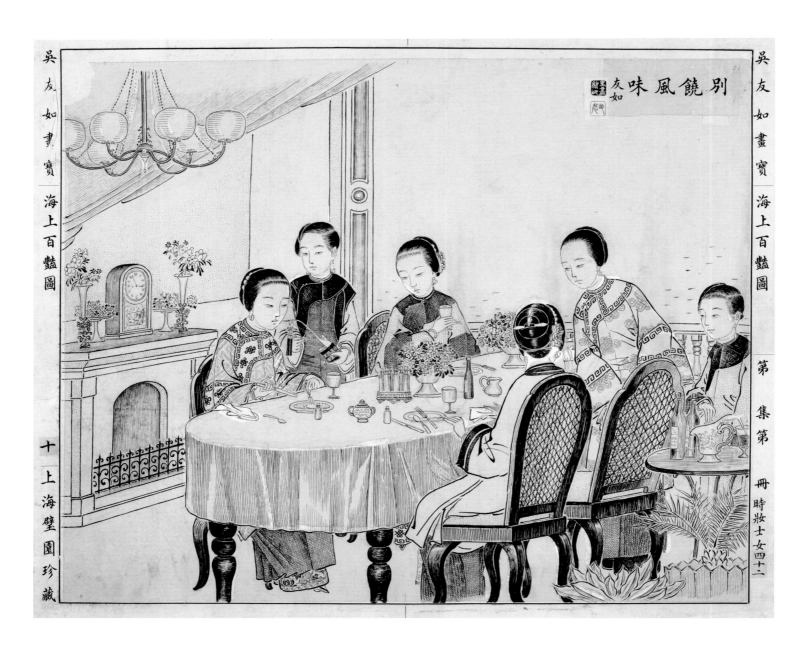

Rivaling the Coming Night, 1890s

By Wu Youru (1839–1897)
Ink on paper
H. 53.5 × W. 65.7 cm
Collection of the Shanghai History Museum

The modern "wonder" in this illustration is the wheel-and-treadle sewing machine (*chezi*), which arrived in Shanghai in the 1860s.[1] A lady is engaged in making a garment with her bound foot working the treadle, and however incongruous this scene may appear at first, the sewing machine was easily accepted for daily use throughout China by the end of the nineteenth century. The Xiechang Company, which was based in Shanghai, also became a popular repair shop and retailed Singer sewing machines beginning in 1925 and its own label after that.[2] **DC**

1 Dikötter, *Exotic Commodities*, 118.
2 Ibid., 118, citing Liu Shanlin, *Xiyangfeng*, 175.

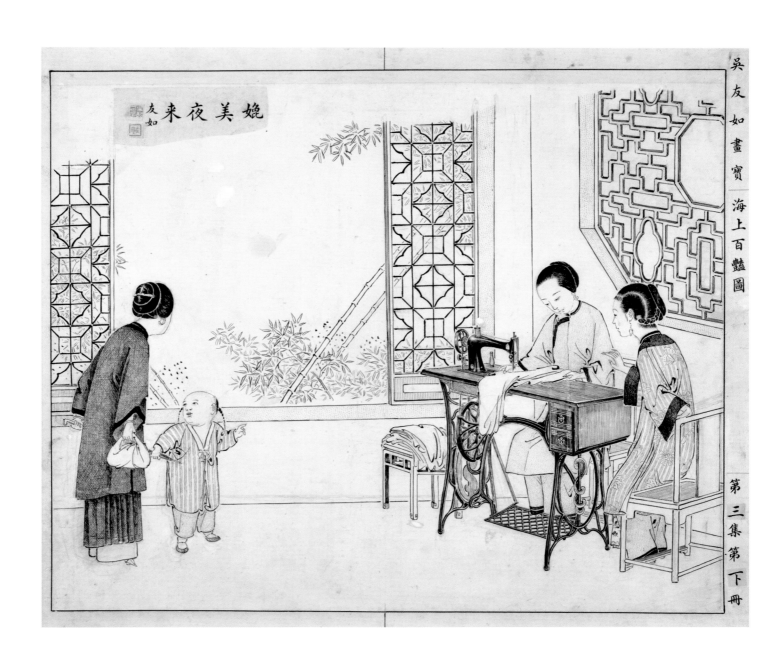

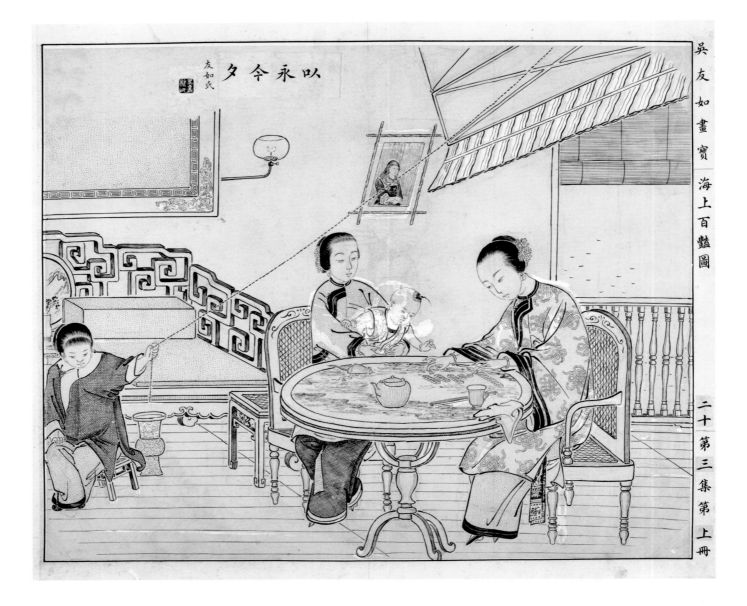

30 *Reciting Poetry This Evening*, 1890s

By Wu Youru (1839–1897)
Ink on paper
H. 53.5 × W. 66.0 cm
Collection of the Shanghai History Museum

The room's décor comprises an eclectic mix of furnishings that were traditional and new, Chinese and foreign-inspired; of particular novelty is the punkah fanning mechanism that hovers above the women at the table. The punkah (*zilai fengshan*) consists of "a large rectangular bamboo frame covered with cheesecloth, fringed at the bottom and suspended from the ceiling by cords."[1] A separate cord extending from the frame is pulled back and forth by the servant girl on the left. Indigenous to India, punkahs were imported in the late 1800s by British officers stationed in Shanghai and, contrary to the depiction in this painting, were popular primarily among the foreign denizens because they regarded the electric fan as a health risk.[2] However, electric fans found early acceptance with the Chinese population.

Another noteworthy object in this room is the framed picture of the European figure hung on the wall. In addition to the framed picture, the artist added a second layer to the Western reference with the mother-and-son composition below it that brings to mind European images of the Madonna and Child. The religious reference here and to the Trinity Church in another illustration (cat. no. 33) provide a glimpse of the Protestant presence in late-1800s Shanghai society. The Jesuits arrived in China as early as the 1600s, but a surge of Protestant missions followed from the 1840s to 1900. In particular, Shanghai became *the* center of Protestant missionary activity in China by 1860.[3] DC

1 Powell, *My Twenty-Five Years in China*, 21 and 23; as quoted in Dikötter, *Exotic Commodities*, 182.
2 Dikötter, *Exotic Commodities*, 182.
3 Elman, *A Cultural History*, 1 and 112.

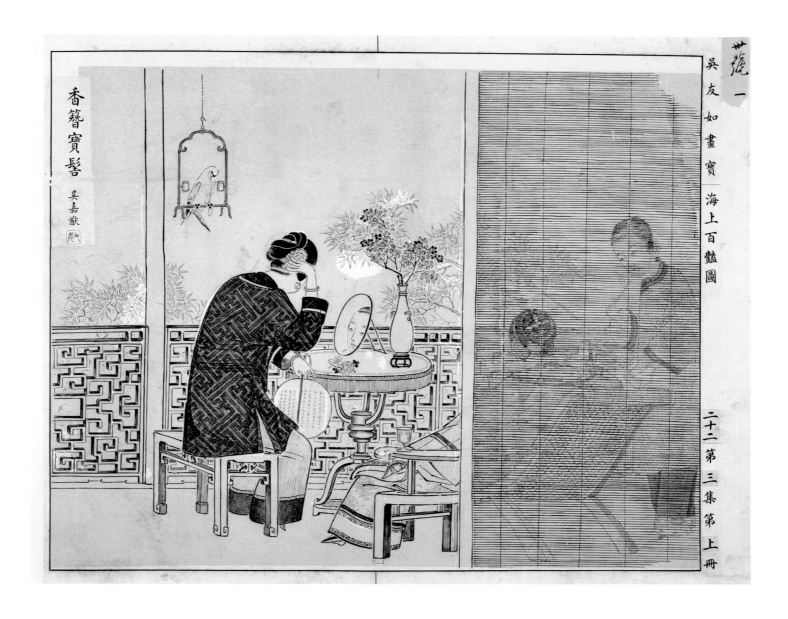

31 *Fragrant Hairpin in Precious Bun*, 1890s

By Wu Youru (1839–1897)
Ink on paper
H. 53.5 × W. 65.7 cm
Collection of the Shanghai History Museum

A beauty contemplating her image before a mirror is a
traditional subject; in fact, the composition of this illus-
tration borrows directly from a silk painting by the same
artist included in this exhibition (cat. no. 26). The mir-
ror into which she gazes is most likely made of imported
glass, instead of copper or tin, as glass mirrors were
generally considered brighter, shinier, and clearer.[1] DC

1 Dikötter, *Exotic Commodities*, 185.

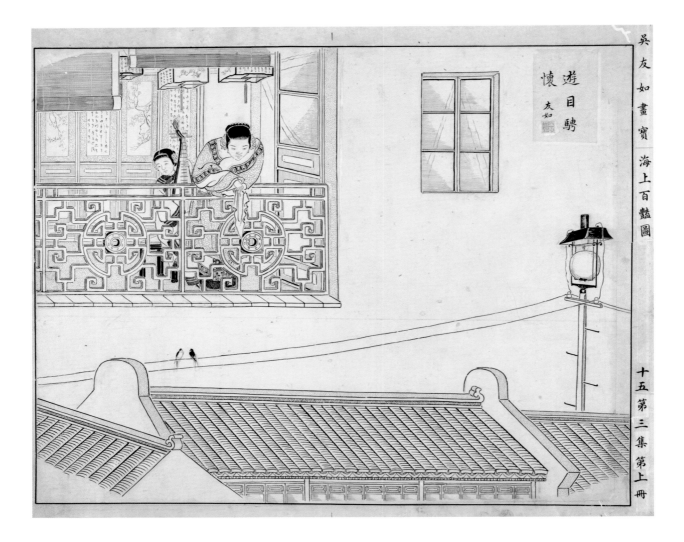

32 *Wandering Eyes Giving Way to Wandering Thoughts*, 1890s

By Wu Youru (1839–1897)
Ink on paper
H. 53.5 × H. 65.7 cm
Collection of the Shanghai History Museum

In this image, two objects compete for the viewer's attention: the courtesan (left) and the electric lamp (right). The title suggests a focus, guiding the viewer to "read" the scene as a woman in contemplation. She is accompanied by her young maid, and the open doors provide a glimpse into her boudoir. Her surroundings become busy—behind her are embellished furnishings and paintings, and fencing her is a balcony rail of intricate scrollwork—so that the overall effect of details draws the eye to this square of the image. However, the viewer's eye is further compelled to follow the courtesan's gaze toward a pair of birds. She finds a moment of respite from the bustle behind her, but not entirely, for the suggestion here is that as her eyes wander to the "couple" below, her thoughts invariably wander to an absent lover.

The street lamp becomes a second object of focus due to the juxtaposition of its blank background against the detailed one surrounding the courtesan; in essence, the empty space functions as a "frame" to the lamp,

directing the viewer's attention to this important feature of Shanghai's urban landscape. As one scholar asserts, the electric street lamp became a visual trope for the city during the late 1800s, so its depiction in this image localizes the scene as one in Shanghai.[1] The introduction of electricity into the city was expedient: gaslight became common after 1865 with the founding of the Shanghai Gas Company, Ltd.,[2] but a mere two years after Thomas Edison first generated electricity in New York City on September 4, 1882,[3] lithographs dated to 1884 appeared in the *Dianshizhai huabao* depicting Shanghai streets already illuminated by tall electric lamps.[4] DC

1 Yeh, *Shanghai Love*, 271–272.
2 Ye Xiaoqing, *Dianshizhai Pictorial*, 53.
3 The Need Project, "History of Electricity," 42.
4 Ye Xiaoqing, *Dianshizhai Pictorial*, 54. Only after 1911 were electric lights installed in individual homes; prior to that time they were reserved for government institutions and public spaces. See Dikötter, *Exotic Commodities*, 144.

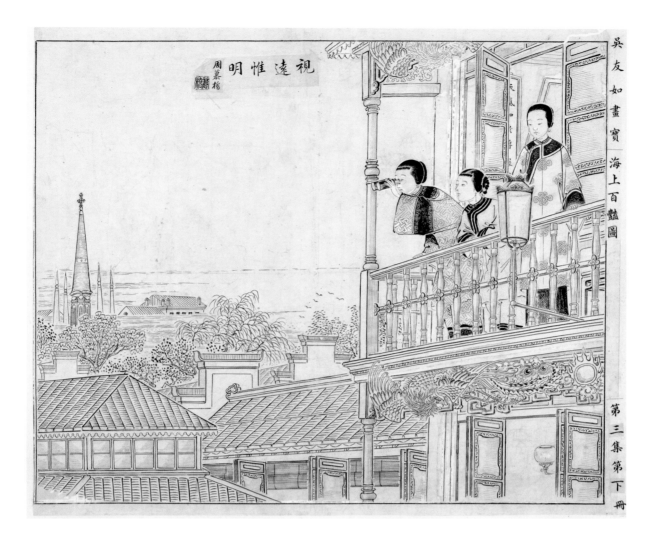

視遠惟明
周慕橋

吳友如畫寶海上百豔圖

第三集第下冊

33 *Only When Looking Far Does It Become Clear*, 1890

By Zhou Muqiao (1868–1923)
Ink on paper
H. 53.5 × W. 65.7 cm
Collection of the Shanghai History Museum

This illustration is one of two in this exhibition (see cat. no. 34) signed not by Wu Youru but by his protégé, Zhou Muqiao.[1] Zhou had trained with Wu in Suzhou on traditional woodblock printing before working with him for the *Dianshizhai huabao* and later joined Wu's own *Feiyingge huabao*,[2] in which this illustration of three courtesans was published in 1890.[3] Two of the courtesans gaze at the Trinity Church from their balcony, with one actually employing binoculars.[4] Trinity Church was erected in the 1860s and became the locus of Anglicanism in East Asia for nearly a century thereafter.[5]

The close proximity of the church to the courtesans' home is an indication of the urban milieu of Shanghai's International Settlement, where religion, government, commerce, and entertainment interacted on a daily basis. Studies of the economics and infrastructure of the city's entertainment sector describe a thriving and influential courtesan culture in Shanghai during the late-Qing period.[6] One of its major influences is exem-

plified by this illustration: courtesans, and women in general, appear in print as agents of the new; they were the trendsetters in embracing the material and social trappings of an urban modernity.[7] By picturing the Chinese courtesan here using Western-style binoculars, or Chinese women enjoying a game of snooker (cat. no. 27), the city's image makers hoped to make more inviting and less intimidating the new foreign technologies and forms of recreation being offered. And as will later become apparent in the early decades of the 1900s, images of Chinese women continue in this role as agents of Shanghai's modernity through advertising and other forms of graphics. DC

1 Zhou Muqiao contributed a total of eight illustrations for the "hundred beauties of Shanghai" set published in *A Treasury of Wu Youru's Illustrations*. See Laing, *Selling Happiness,* 55.

2 Information was compiled from Laing, *Selling Happiness,* 53; and Yeh, *Shanghai Splendor,* 65–66.

3 Yeh, *Shanghai Love,* 171, fig. 3.17.

4 Ibid., 171.

5 Spencer, "Shanghai's Anglican Cathedral."

6 See in particular Yeh, *Shanghai Love.*

7 Ye Xiaoqing, "Commercialisation and Prostitution," 40; Pang, "Photography, Performance, and Female Images," 61; and Yeh, *Shanghai Love,* 33.

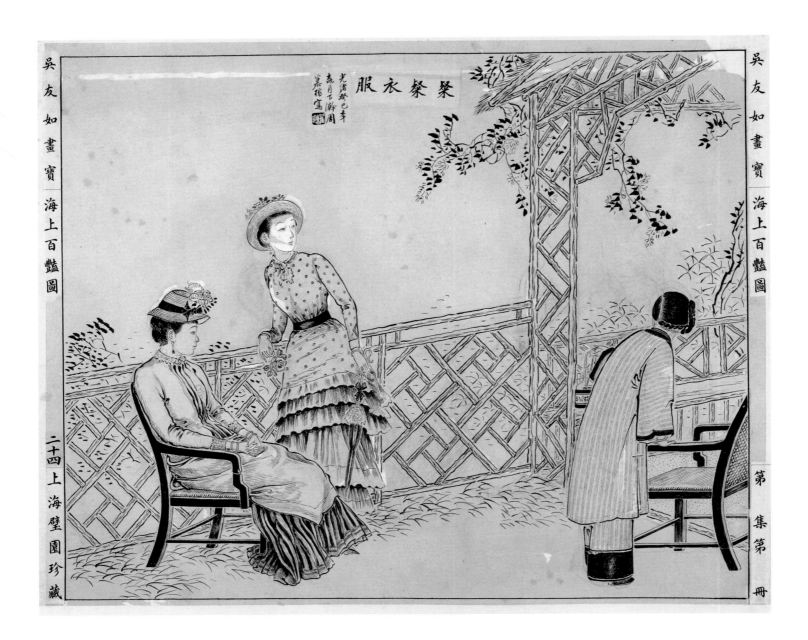

34 *Brilliant Clothing*, 1890s

By Zhou Muqiao (1868–1923)
Ink on paper
H. 53.5 × W. 65.7 cm
Collection of the Shanghai History Museum

In this scene, two Chinese women are modeling late Victorian–style dresses. According to one scholar, they are most likely courtesans, the trendsetters of fashion and the more experimental among the generally conservative, traditionally dressed Chinese people in Shanghai.[1]

It has been suggested that Zhou imitated an unspecified Western engraving, particularly in his employment of several techniques for shading and modeling.[2] Interestingly, he utilized these techniques only for the depiction of the Western dresses and not for the Chinese one worn by the servant girl. Attention is paid to creating shadows, volume, and draping in the courtesans' dresses, whereas the curvature of the girl's figure consists of one fluid line, and scarcely any attempt at segmentation of her body is evident. This feature suggests that Zhou did indeed copy the two courtesan figures from a Western composition to insert in this Chinese scene. DC

1 Ye Xiaoqing, *Dianshizhai Pictorial*, 130 and 162.
2 Laing, *Selling Happiness*, 96.

Architecture and Interior Design

The period of around 1900–1945 often saw tumultuous change in Shanghai. Only shortly after photography made the genre of China Trade painting (see cat. nos. 1–5) obsolete, historical events made the Bund they depicted equally out of date. After the signing of the Treaty of Shimonoseki in 1895, foreign industries gained the right to own and operate manufacturing facilities in Chinese treaty ports. Japan was the first to exploit this right within Shanghai; others soon followed suit. As a result, the mindset of foreigners doing business in China began to change as they placed greater focus on long-term, rather than short-term, gains. In response, the Qing government altered centuries-old attitudes toward commerce and began to become more involved with the marketplace and to encourage private Chinese merchants to invest in industry.[1] In Shanghai, Chinese competed with foreigners in many areas, including investment, shipping, and production.[2] The resulting seeds of nationalism sown among the wealthy urban dwellers in treaty ports such as Shanghai were encouraged to grow by other events of the second and third decades of the twentieth century.

Shanghai was a leader in this movement. Among a series of companies founded there in the 1870s and 1880s was the China Merchants' Steamship Navigation Company, established in 1872 as a partnership between local shareholders and the government to compete with foreign shipping companies. The company, which had offices in number 9 on the Bund, was a success; among the items likely to have been shipped from one treaty port to another were local luxury products such as the Art Deco–style rugs produced in Tianjin (see cat. nos. 48–52).[3]

Many in China were outraged by the 1919 Treaty of Versailles, which gave Japan rights to the territory Germany had controlled in Shandong Province. Residents of Shanghai became primary leaders in the resulting New Culture Movement that sought to modernize the nation and bring about changes in language, culture, and the arts in order to more deeply involve China's masses.

Lu Xun was one of the leaders of this movement (see cat. nos. 91–99).

The rising sense of nationalism that inspired the New Culture Movement was also influential in boycotts against foreign goods generated by specific incidents. One of the first such boycotts occurred in 1905 in response to further restrictions on Chinese immigration into the United States first promulgated in the Chinese Exclusion Act of 1882. These restrictions, and some of the animosity they engendered, remained in effect until 1943.[4] Anti-Japanese boycotts occurred in the aftermath of the May Fourth Movement of 1919; and anti-British boycotts took place in 1925 after Shanghai Municipal Council police killed Chinese workers during what became known as the May Thirtieth Incident.[5]

One result was the National Goods Campaigns (*guohuo*) of the 1920s and 1930s, which turned negative feelings toward foreigners into a positive campaign for local goods.[6] Through these campaigns, powerful and wealthy Shanghai residents were able to spin their lifestyles in terms of modernity and patriotism. According to Wen-hsin Yeh, "Not only was it possible to be simultaneously 'modern' and 'Chinese,' it was virtually imperative for a patriotic Chinese to be modern."[7] Nationalism found much more fertile ground in the urban environment of Shanghai than it did in traditionally rural China, and Shanghai was a hotbed for the national goods movements.

World War I also affected Shanghai's economy. At a time when the Chinese in Shanghai were becoming economically stronger, Europeans were focused on the war and were unable to meet the growing demand for products and services. Chinese-owned and -run factories and service industries rose to fill the needs of local markets as well as those developing elsewhere.

One of these new markets was North America, which began to look to East Asia as trade with and travel to Europe became difficult and unsafe due to World War I. This trade was very different from that carried out by Augustine Heard and other East Coast traders of the late nineteenth century (see

cat. nos. 1–5). The transcontinental railroad and the development of trans-Pacific steamship travel allowed for quicker transfer not only of goods but also of people. By 1920, Dollar Lines, based in San Francisco, had ships covering world trade routes on a strict schedule—a revolutionary idea at the time—with scheduled stops in Shanghai.[8] By 1924 the same line had around-the-world passenger service with a published schedule of departure and arrival times. These around-the-world services attracted patrons who could afford the leisure of staying over at one port or another for shopping and touring, and if the shopping was especially good, they could stay and catch the next ship.[9] Such travelers came from all parts of North America; they first took a luxury coach on the transcontinental railroad or some other convenient means to San Francisco and then caught their ship to Asia. Industries developed in Shanghai and other ports of call to create the products these travelers demanded.

The worldwide prosperity of the Roaring Twenties certainly contributed to the boom in Shanghai. In addition to the foreign and domestic investments mentioned above, Shanghai prospered due to improved maritime transportation systems, the opening of the Panama Canal in January 1914, and other factors inside and outside of China. By the 1920s, an estimated three hundred thousand Chinese worked in Shanghai businesses and enterprises—a remarkable change in just twenty-five years. Many worked for family-owned enterprises or small shops, but others were employed at large companies.[10] Many were literate in both Chinese and foreign languages and were fully aware of the leading international trends in architecture and interior design (see Nancy Berliner's essay in this catalogue) as well as in fashion, film, and graphic design.

The early Western traders in Shanghai had made their fortunes by exchanging opium grown in other areas of the British empire for tea, porcelains, and other goods made in China. Due in no small part to the development of tea plantations in India and elsewhere, in 1917 the British finally agreed to stop their shipments of opium, and the drug once again became illegal in China. In Shanghai, the control of this major industry transferred from foreign traders to local gangs, the most powerful of which was the Green Gang (see cat. no. 16). Gang leaders, with their tremendous wealth and extravagant lifestyles, were another source of demand for the many luxury products made in Shanghai.

In this new environment, the warehouses, residences, and shipping offices of the foreign trading firms that had lined Shanghai's Bund in the late nineteenth century were replaced by financial and other institutions whose image required a very different form of building (see diagram, pp. 36–37). Not all of these new buildings were foreign owned, and other parts of Shanghai also saw a boom in new construction.

The transfer of concepts from the West was often remarkably quick—new Paris fashions might appear in Shanghai mere months after they first debuted. This was also true of trends in architecture. Formal buildings of this period, such as the new banks along the Bund (see cat. no. 35), were often built and furnished in the same Beaux-Arts styles that were employed in civic buildings around the world, such as the 1916 San Francisco City Hall and Public Library. Beyond the Bund, modern influences extended from commercial structures to those built by the city government and many others. The public produce market on Small Shadu Road (cat. no. 37) and the Chengdu Road Police Station (cat. no. 36) are both examples of public buildings created in modern styles heavily influenced by Bauhaus concepts and designs. For more fashionable buildings, Art Deco was the craze.

Although the actual name did not come into common use until the 1960s, the origins of Art Deco can be traced to the *Exposition Internationale des Arts Décoratifs et Industriels Modernes* (International Exposition of Modern Industrial and Decorative Arts), organized in Paris in 1925 by an informal group of French artists known as La Société des Artistes Décorateurs. They based their style on modern geometric concepts but also on influences that were the rage at the time, one notable example being the materials found in Egypt

in 1922 in the tomb of King Tutankhamun. Art Deco employed modern materials such as aluminum and stainless steel, glass, mirrors and other reflective surfaces, and a strong palette in bold geometric shapes.

Art Deco images and motifs reached Shanghai via students, tourists, designers, and others who visited Europe and America in increasing numbers at the end of World War I.[11] This style was thought particularly suited for movie theaters, dance halls, and other places of popular entertainment, and that certainly held true in Shanghai. The Grand Theatre on Nanjing Road, the Peace Hotel, and the Paramount Theatre are examples; many of the elements in settings for the posters *Gliding Like Celestial Beings* (cat. no. 72) and *A Prosperous City That Never Sleeps* (cat. no. 65) are in Art Deco style. Deco was also popular for both exterior and interior design of elegant apartment buildings such as the Broadway Mansions (cat. no. 40), and Deco concepts were applied to edifices as mundane as service stations (cat. no. 41).

A furniture industry developed in Shanghai to fill the demand of the new visitors from the West as well as the new wealthy in the city itself. As with export silver and other materials, the Chinese artisan could reproduce almost anything made in Europe or the Americas. For the Chinese, the attraction was economic (Chinese-produced materials were certainly much less expensive than those produced in the West and imported) and patriotic—both in the sense of being modern and in the sense of buying national goods. Much of this furniture was created in styles influenced by modern concepts and designs.

For domestic use, this furniture had to meet demands very different from those of earlier periods. At least within large urban centers such as Shanghai, the gentry compound with its gardens and pavilions was replaced by modern apartments like the Mark (cat. no. 39) and the Broadway Mansions (cat. no. 40), along with other forms of housing. Many in Shanghai lived in two- or three-story town houses with stone facades known as *shikumen*.[12] The *shikumen* featured bedrooms, kitchens, dining rooms, and the like based on designs current in the West, and Chinese furniture makers in Shanghai were called upon to create bedroom suites (cat. no. 47) and other forms of furniture to fill them.

What is now commonly known as "Shanghai Deco" furniture was one result. Shanghai Deco furniture combines elements of Chinese domestic furniture and Art Deco design. In the examples illustrated here, the extensive use of mirrors (cat. no. 47), the asymmetrical designs (cat. no. 46), and much of the surface decoration reveal Deco influence. The sunburst design on the small cabinet (cat. no. 46) is a good example of a common Deco motif. This asymmetrical design is particularly innovative in China, where balance and symmetry had been fundamental principles in urban planning, architecture, interior design, and furniture. However, this furniture is created from domestic woods or those readily available in China, and certain motifs, such as the bamboo design on the bedroom suite (cat. no. 47) are based on established Chinese traditions.

Michael Knight

NOTES

1 Yeh, *Shanghai Splendor*, 50.
2 Ibid., 21.
3 See Goetzmann and Köll, "History of Corporate Ownership."
4 For a discussion of the impact of this act, see Liu, "Chinese Exclusion Laws."
5 Yeh, *Shanghai Splendor*, 71.
6 Ibid., 72–73.
7 Ibid., 101.
8 Chandler and Potash, *Gold, Silk, Pioneers & Mail.*
9 Knight, "Markets and Tastes in Chinese Jade," 100–101.
10 Yeh, *Shanghai Splendor*, 102.
11 Ibid., 62.
12 An example open to the public can be seen at the Shikumen Museum, in the Xintiandi development in Shanghai.

35 Wall sconce from Huifeng Bank, approx. 1923

Bronze

H. 95.0 × W. 70.0 × D. 30.0 cm

Collection of the Shanghai History Museum

Huifeng yinhang is the Chinese name of the Hong Kong and Shanghai Bank, one of the financial institutions that developed during the mid- and late nineteenth century to serve the growing trade between ports in Asia and the West. Founded by Thomas Southerland in 1865, the bank opened its first Shanghai branch on Nanjing Road. The bank moved to a new location on the Bund in 1873. In 1923 the bank commissioned a new building from the architectural firm Palmer and Turner at what is now number 12 on the Bund. This wall sconce comes from the 1923 building.

The new Hong Kong and Shanghai Bank building was one of several banks built along the Bund during the 1920s and 1930s when many of the buildings of the old trading companies were torn down and replaced by banks, public buildings, and hotels. The banks in particular reflected a change in approach. Often massive, with no expense spared in their building and furnishing, the new bank buildings signaled a new belief in the long-term benefits of doing business in China. The elaborate wall sconce is an example of an item that is Western in both form and function.　**MK**

36 Chengdu Road Police Station, approx. 1930–1939

Imprint of Ah Fong, Shanghai (active 1930s)
Photograph, silver gelatin
H. 23.8 × W. 28.6 cm
Collection of the Shanghai History Museum

By the end of the nineteenth century the Shanghai Municipal Council had organized much of its bureaucracy following the model of an English urban council. This was true of the police department, which had a considerable number of officers from Europe as well as from other parts of the world (Sikhs in particular played an important role). Chinese units were recruited to manage issues with Chinese in the Chinese city and elsewhere. In the early 1900s through the 1930s the municipal council made a concerted effort to keep

abreast of the most up-to-date European police practices.[1] Thus it is logical that the Chengdu Road Police Station depicted in this photograph would have been modern and Western both in the police force it housed and in its architecture. Like many Western-influenced buildings of the time, it was built of steel, concrete, and stone in a style influenced by Bauhaus and other European movements. MK

1 Bickers, "Ordering Shanghai," 192.

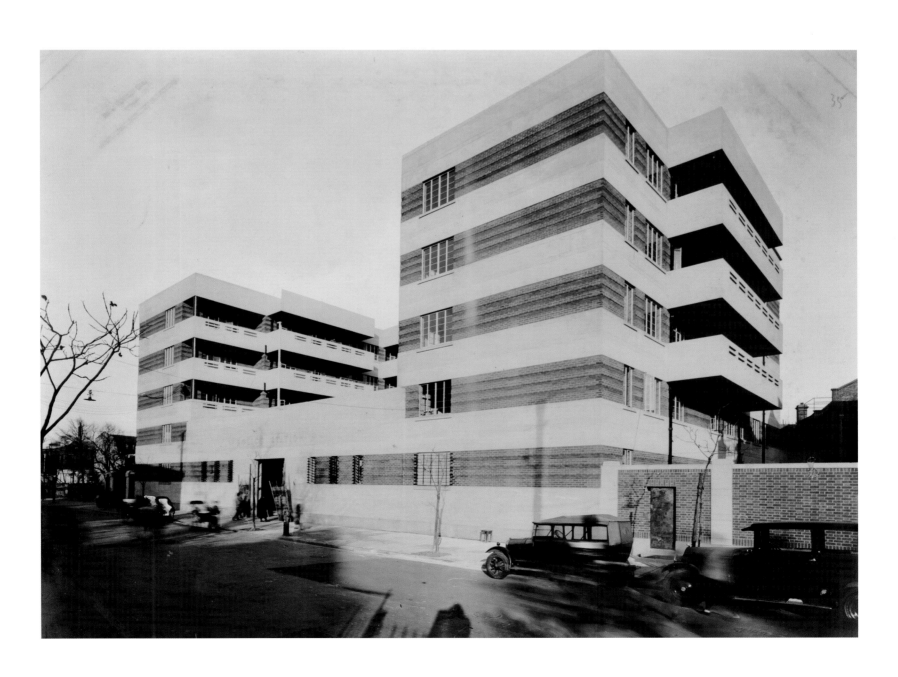

37 Public Produce Market on Small
 Shadu Road, 1930s

Anonymous
Photograph, silver gelatin
H. 19.8 × W. 24.7 cm
Collection of the Shanghai History Museum

38 Municipal slaughterhouse in
 the northeast section of Shanghai,

early 1930s

Anonymous
Photograph, silver gelatin
H. 19.7 × W. 25.2 cm
Collection of the Shanghai History Museum

Architecture in Shanghai during the 1920s and 1930s
was truly global; in addition to indigenous styles and
those from Europe and the United States, influences
from many other cultures also played a role. Jews
from Iraq, such as the Sassoons and Hardoons, often
employed Moorish-inspired elements in their buildings.
A synagogue commissioned in this style still survives.

These two photographs show some of this diversity
in large public buildings. The Public Produce Market's
modern Western style is clearly influenced by contem-
porary movements in Europe such as Bauhaus. It also

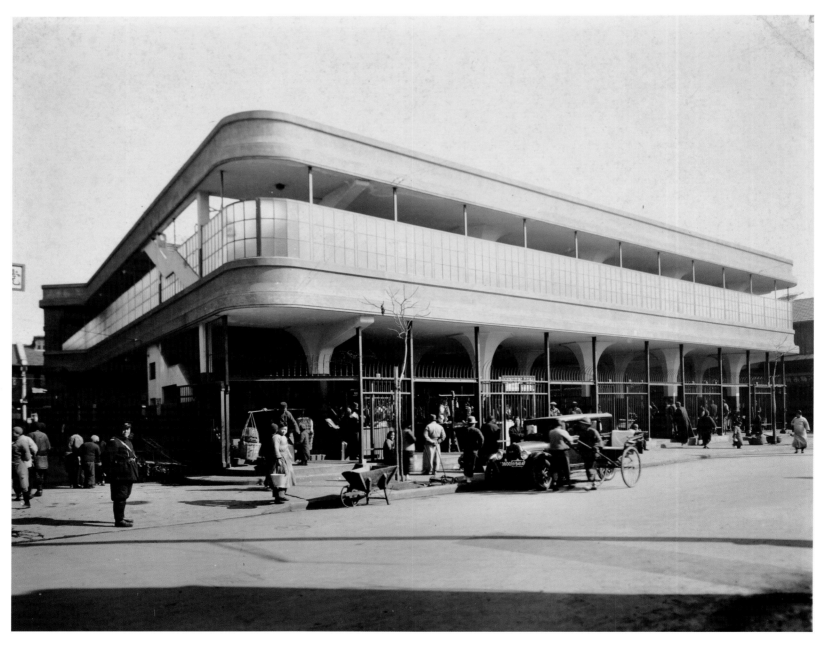

was built using modern construction techniques and materials with extensive use of glass, steel, and concrete.

The municipal slaughterhouse, on the other hand, features certain exterior details that reveal Islamic influence. It was built in 1933, and in fact a section of the complex was specifically designed for producing meat for Muslims.[1] Muslims played an important role in certain crafts in China, particularly in the jade trade, and were among the many ethnic and religious groups adding to the global nature of Shanghai life and architecture. The municipal slaughterhouse, now referred to as "1933," has recently been renovated and expanded. Its mission statement declares: "1933 strives to realize a vision sustained by three core elements of design, lifestyle, and learning. 1933 seeks to define true wealth: a holistic approach to life that is rounded and balanced and not simply material. 1933 will be on the cutting edge for food, fashion, arts, culture, education, and design."[2] MK

1 Lee, *Shanghai Modern,* 346.
2 http://www.1933shanghai.com/index_en.html, April 1, 2009.

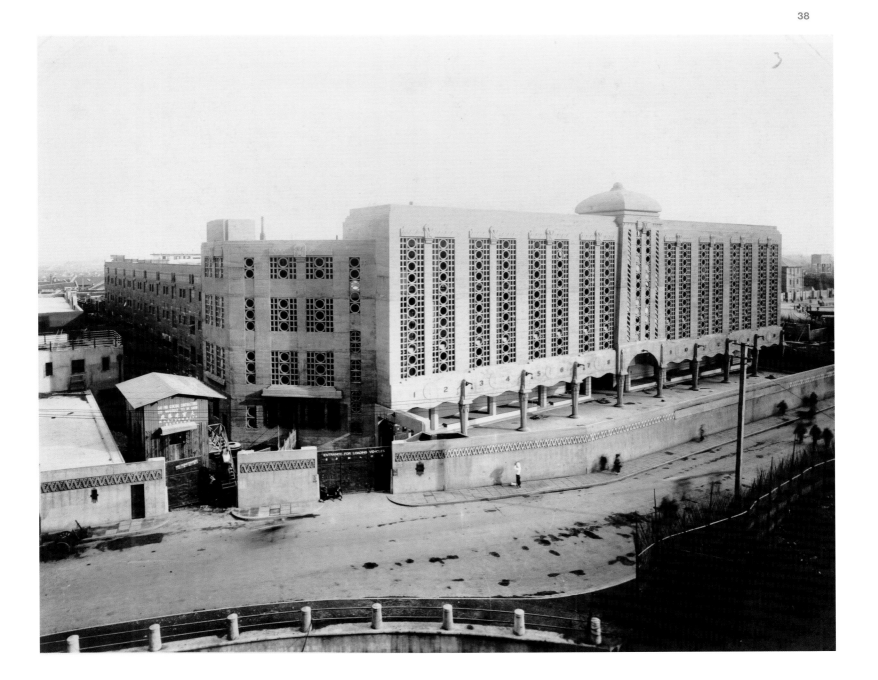

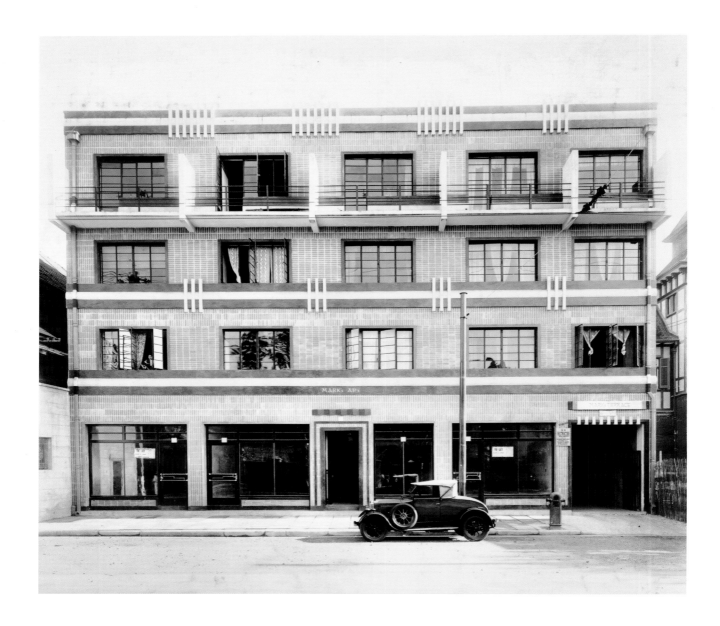

39 Mark Apartment Building, 1930s

By C. H. Wong (active 1930s)
Photograph, silver gelatin
H. 25.5 × W. 36.2 cm
Collection of the Shanghai History Museum

40 The Broadway Mansions Building, 1934
(facing)

Anonymous
Photograph, silver gelatin
H. 27.5 × W. 21.4 cm
Collection of the Shanghai History Museum

Apartment complexes were a Western concept brought
to Shanghai by both Chinese and Western architects
and builders. James Lee was the first Shanghai resident
to build apartment complexes in the city. Impressed
by the multistory complexes he saw during a visit to
the United States, in 1915 he erected the four-story Lee
Apartments on Avenue Joffre in the French Concession.
It was the first apartment complex in Shanghai. His
second apartment complex, on Bubbling Well Road in
the French Concession, had eight stories, an elevator,

a cinema, an arcade, and nightclubs. The concept caught
on, and apartment construction boomed in the 1920s and
1930s.[1] These two photos reveal two very different types
of apartment structures.

The Mark apartments and terrace was a relatively
modest complex of four floors, the first being commer-
cial and the other three residential. The architecture is
completely modern and Western: even the entry signs
are in English.

The Broadway Mansions complex is entirely different
both in scale and in design. Built by P & T Architects and
Engineers Limited in Art Deco style, it was completed
in 1935 with nineteen floors and every possible amenity.
The Broadway Mansions building is located at the northern
end of the Bund, near the confluence of Suzhou Creek and
the Huangpu River. It was renamed Shanghai Mansions by
the Shanghai municipal government in 1951 but reverted to
its original name after China opened up again to the West.
The building survives as a hotel and is one of Shanghai's
many prime examples of Deco architecture. MK

1 Dikötter, Exotic Commodities, 159–160.

110

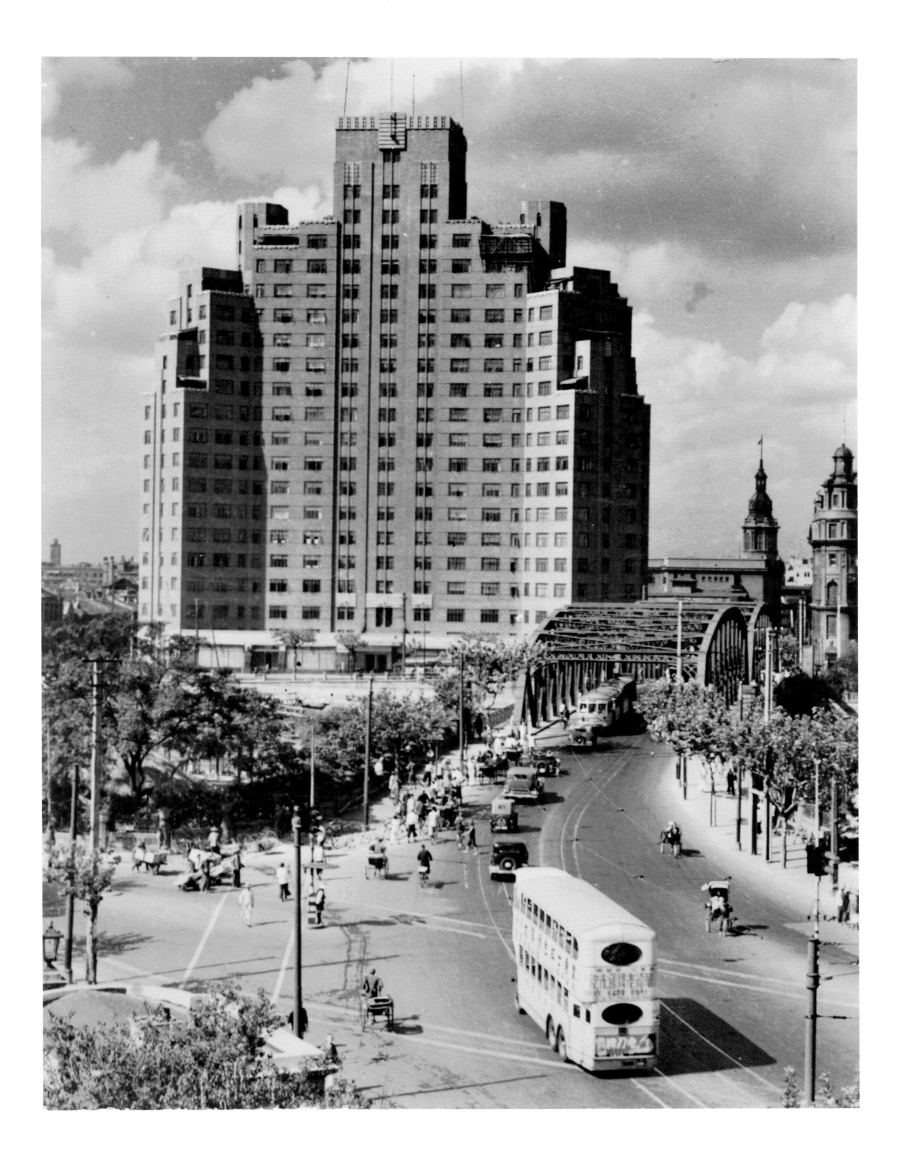

41 An American automobile
service station on the west side
of Shanghai, 1930s

Anonymous
Photograph, silver gelatin
H. 23.0 × w. 28.1 cm
Collection of the Shanghai History Museum

The automobile played an important role as a symbol of prestige in Shanghai during the 1920s and 1930s. It was also a necessity for certain elements of society. Kidnappings were frequent, as were fights between rival gangs. Cars with bullet-proof glass and armed chauffeurs and guards were a common sight (see cat. no. 62). Along with the automobile came service stations—this photograph presents a service station selling Texaco gasoline on the west side of Shanghai.

Many elements of the building show Art Deco influence—from the basic shape of the building to the frieze of triangles along the top, and the elaborate floral elements near the top outside of the doors. All the directional lettering is in English; only the company name in Chinese gives an indication of where the station is located. MK

42 Mingxing Film Studio,
Shanghai, 1930s

Anonymous
Photograph, silver gelatin
H. 18.0 × w. 23.8 cm
Collection of the Shanghai History Museum

Shanghai's long love affair with film began with the first screening of a motion picture in China, which appears to have occurred in Shanghai in 1896. The city was the center of a domestic film industry that began to flourish late in the second decade of the twentieth century. American influence on and interest in the Shanghai film industry was strong from the earliest stages through the 1940s, and all the major U.S. studios maintained offices there. Exchanges between the growing film industries in Hollywood and Shanghai were facilitated by the more rapid travel made possible by changes in maritime technologies.

Mingxing Film Company (Bright Star Pictures) was one of the earliest Shanghai companies. Founded by Zheng Zhengqiu and Zhang Shichuan, the company first produced comic shorts but later added feature-length films and family dramas. They were one of three film companies that dominated the Shanghai industry during the 1930s. This photograph shows filming in action. The elaborate stage set is clearly meant to represent one of the city's high-end restaurants. Its various elements are in Art Deco style—the craze of the time. MK

43 After the horse race, 1930s

Anonymous
Photograph, silver gelatin
H. 23.0 × W. 28.1 cm
Collection of the Shanghai History Museum

When the British settled in Shanghai after the Treaty of Nanjing in 1842, they attempted to re-create as much of their home as possible—including clubs, churches, town halls, and recreation facilities, such as a course for horse racing. Linked to the Bund by Nanjing Road, the race course was a center for much activity in the city for both foreign and Chinese residents. This photo depicts a scene after the horse races. A 1901 account by an Australian adventurer gives a sense of the flavor of the races:

> After the auction everybody settles down to steady drinking, at which the Russians are in a class by themselves. Even the most seasoned soaks of the British Navy will shudder and turn white when asked to go to an official dinner on a Russian warship. . . .
>
> Next morning I am awakened by a booming of gongs and a noise that sounds like rifle-fire. The Chinese grooms are beating gongs and letting off bunches of crackers by way of propitiating Lady Luck before they go out to the course. . . . The track up to the gates is blocked by hundreds of shrieking, howling beggars, with every malformation and disease known to science. They beat their breasts with clubs, and have to be driven out of the way with whips.
>
> Inside the course the place is alive with ponies, for every young officer of the various forces has bought a pony for the meeting and has "trained" him himself. Fields are very large; but most of the runners stop to "stink" half-way through the job, and the finishes are left to a few honest battlers. . . .
>
> At the start of our race, a Japanese officer, in a very neat rig-out, is carried by his pony into an irrigation drain, where the pony rolls on him and then careers away with bridle flying. Covered with evil-smelling mud, and looking like nothing on earth, the Japanese emerges right in front of a Swede civilian, who looks strong enough to hold an elephant, but can make no impression on his pony's iron mouth. The Swede's pony stops dead and its rider is thrown heavily. Mistaking the Japanese for some sort of coolie, the Swede advances on him with a whip. Heaven knows what international complications might have arisen had not a Frenchman's pony, coming along full split, separated the pair and narrowly missed destroying the Swede. By degrees the loose ends are gathered up; unmanageable ponies are held at the post by their grooms; and the field gets away somehow. One race is set apart for ponies ridden by their grooms, and the ponies behave themselves perfectly under their Chinese riders. The white punters, however, get a shock. They all back what appears to be an unbeatable certainty, only to find that the Chinese riders have put their heads together and backed the biggest outsider on the totalizator. The ways of the Chinese are quite inscrutable. They will fix up a racing swindle, gamble like devils, and then go out and pick flowers.[1]

While appealing to all residents of Shanghai, the race course continued to be largely British owned until the Chinese government confiscated it in 1951. The grounds have been converted to People's Park (*Renmin Gongyuan*) and contain a number of public and cultural buildings. The Shanghai Art Museum is in the old clubhouse, and the Shanghai Museum is on what was part of the grounds. MK

1 Paterson, *Happy Dispatches*.

114

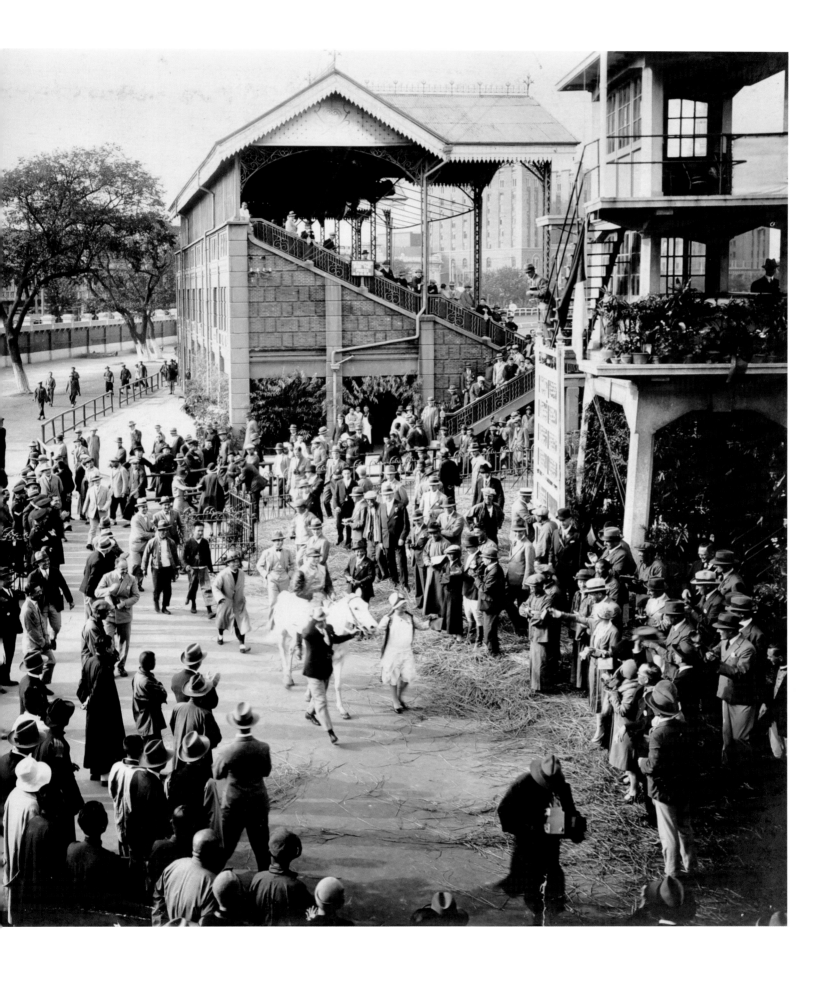

44 Pair of armchairs, 1920–1935

Hardwood (*hongmu*), burl, and fabric
H. 80.0 × L. 66.0 × D. 71.0 cm each
Private collection

Shanghai Deco furniture has recently become a craze
among collectors in Shanghai and elsewhere—for good
reason. The products created for the domestic market
by the furniture makers in and around Shanghai have a
unique character and function well in a contemporary
Western-style environment. This pair of chairs is highly
unusual in that the original fabric has survived more or
less intact. Its bold swirling patterns are matched by the
curvilinear form of the chairs themselves. MK

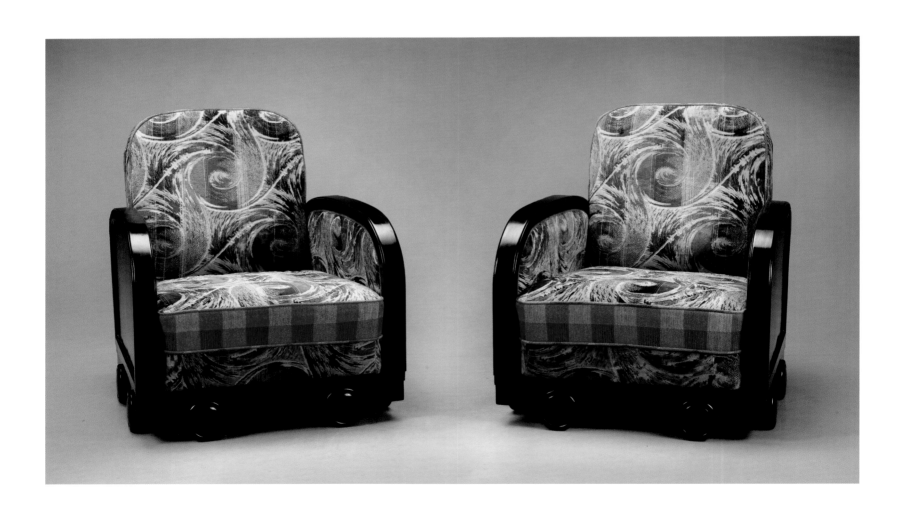

45 Coat tree, 1920–1935
Hardwood (*hongmu*) and metal
H. 202.0 × D. 50.0 cm
Private collection

Certain pieces of furniture in the homes and offices
of "modern" Chinese businessmen living in Shanghai
were by necessity designed to accommodate a Western
lifestyle. Many such businessmen wore Western dress
to work and even on informal occasions (see cat. nos.
62 and 63); coat racks like this one were designed and
arranged to hold their overcoats and hats. Like the
cabinet that follows, this coat tree, with its angular,
multitiered form and fluted decoration, is an example
of Shanghai Deco design. MK

46 Small cabinet (one of a suite
of three pieces), 1920–1935
Hardwood
H. 122.0 × L. 140.0 × D. 44.0 cm
Private collection

As with many examples of Shanghai Deco furniture, this
small cabinet features an angular, multilevel, asymmetri-
cal design and heavy fluting on the surface. In addition,
the main motif on the front of this piece, a sunburst, was
popular in Art Deco architecture, interior design, and
furniture. MK

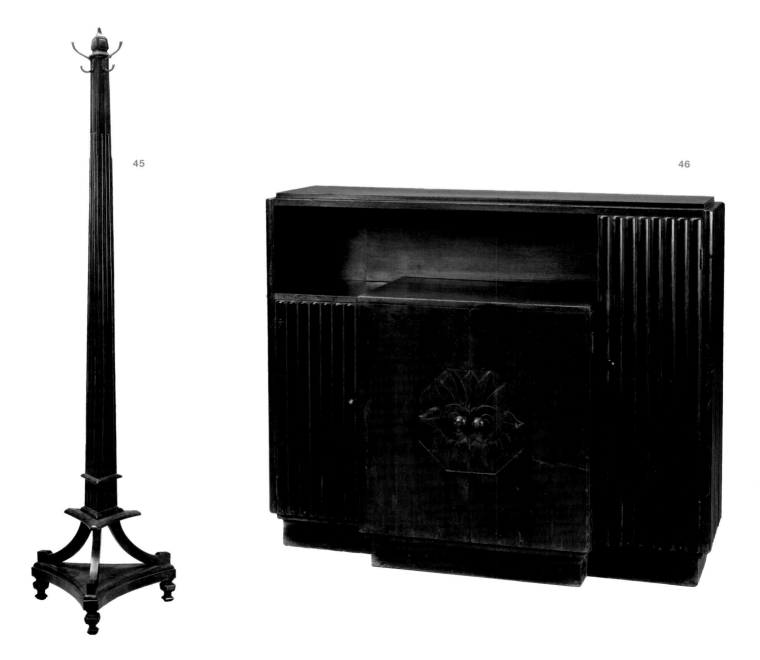

45

46

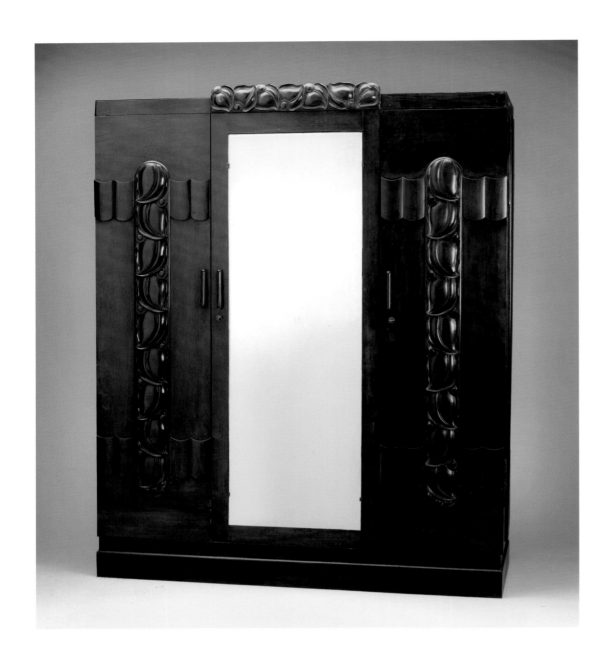

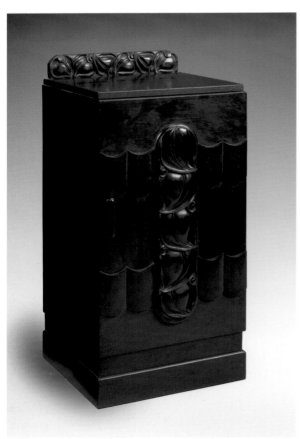

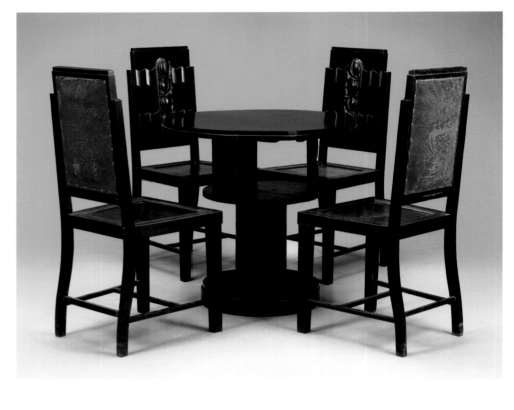

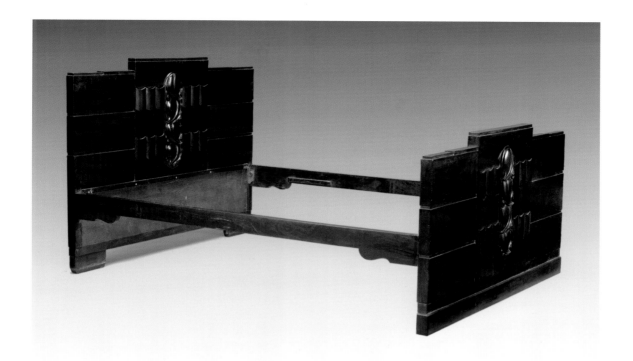

47 Eleven-piece bedroom suite, 1920–1935

Hardwood (*hongmu*)
Dimensions variable
Private collection

This bedroom suite consists of a bed frame with head and footboard, a vanity and stool, a wardrobe, a dresser, a nightstand, and a small table with four chairs—all the pieces that might be found in a "modern" Western bedroom of the 1920s and 1930s. Western influences can be seen in the mirrors on the vanity, wardrobe, and dresser; the asymmetrical forms are based on Art Deco prototypes. However, this furniture is created from *hongmu* (rosewood), a type of tropical hardwood readily available in China, and the bamboo design is based on established Chinese traditions. MK

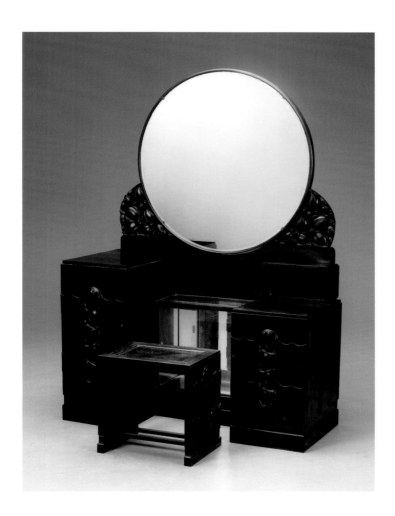

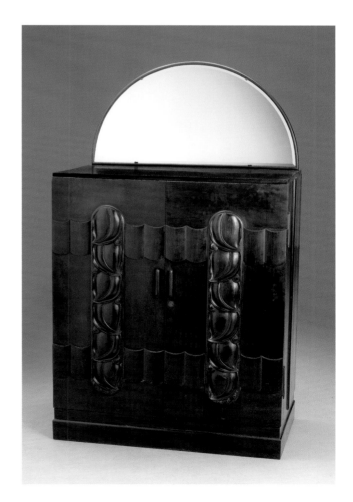

48 Rug, 1920–1935
Wool with "Kangxi" pattern
L. 114.3 × W. 63.5 cm
Private collection

49 Rug, 1920–1935
Wool with *leiwen* pattern
L. 120.7 × W. 59.7 cm
Private collection

While true abstraction did not have a role in traditional Chinese painting, it did have a long history in Chinese ritual and decorative arts—most commonly as background or border patterns. Certain of these patterns translated easily into the "modern" design popular in Deco-influenced arts of the 1920s and 1930s. This was particularly true of the more abstract border and background patterns found in Chinese decorative arts. One such pattern is an ancient Chinese design known as *leiwen*. The earliest known forms of this design appear as early as the Neolithic period, and it is a common background pattern from the early Bronze Age through modern times.

The *leiwen* is also the likely source for the central design on the richly colored dark blue rug. The graduated-bar designs on this rug relate most closely to fluted patterns found on many examples of Shanghai Deco furniture.

The motif on the first rug illustrated here can be seen as an interpretation of border designs that were common during the early years of the Qing dynasty; rug aficionados call this a "Kangxi" pattern, named for the reign of the Kangxi emperor (1672–1722). However, this design is also typical of Art Deco patterns for furniture and other decorative arts created in Shanghai and other Chinese treaty ports. The basic form is an angular, stepped pyramid, which in this case is repeated a number of times across the surface of the rug. MK

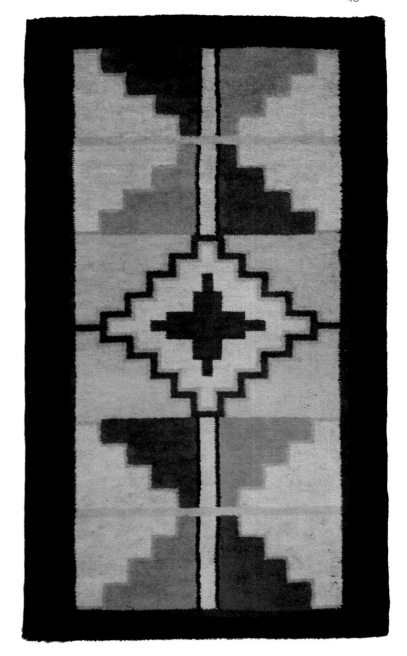

50 Rug, 1920–1935
Wool with abstract pattern
L. 158.8 × W. 91.4 cm
Private collection

This rug is one of a pair of relatively small pieces of different sizes. The pair was likely a suite accompanied by at least one that was much larger. MK

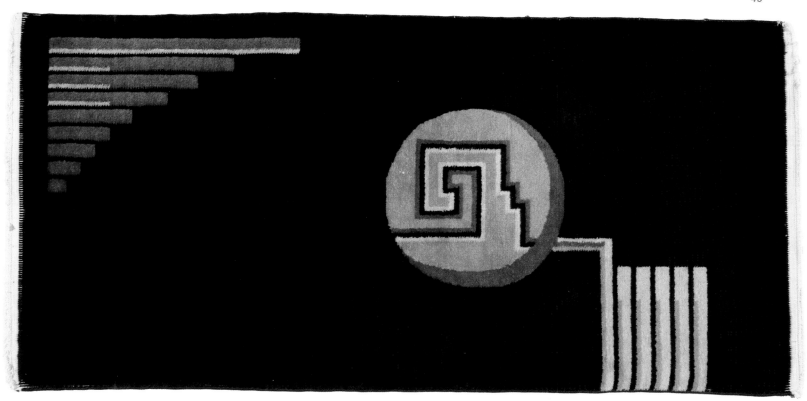

51 Rug, 1920–1935
Wool with yin and yang pattern
L. 350.5 × W. 274.9 cm
Private collection

52 Rug, 1920–1935
Wool with "crested crane" design
L. 350.5 × W. 271.8 cm
Private collection

The large red rug is decorated with a simple yet bold design consisting of a repeated yin and yang pattern along with a box and what appear to be ribbons. It is both very modern in feel and very Chinese. The design on the green rug is more difficult to read. It has been interpreted as the head and wings of a crested crane, another auspicious design found in traditional Chinese arts but here given a modern interpretation. MK

Western-Influenced Painting in Shanghai

During the early twentieth century, China embarked on a period of intense intellectual self-scrutiny and exploration. In the arts, these discussions attracted many active and often contending voices. Because of its economic power and close contact with Japanese, Western, and other world cultures, Shanghai was a center for creative thinking during this time. Shanghai was also one of the leading centers for Western-influenced painting and other arts. Artists grappled with a number of questions: How should the thousand-year-old heritage of traditional Chinese painting be evaluated in light of Western art's powerful new influence? How might traditional Chinese painting best respond to modernity? Should Chinese artists participate in an attack on tradition and adopt Western styles and approaches, or should they preserve their own traditions and resist Western influence? What kind of reform of traditional painting, if any, should Chinese artists attempt? Essentially, the major players in the debates formed two camps: the conservatives, who feared that China was about to lose its national essence; and the reformers, who held that integrating Western elements would add new life to Chinese art.

The Western-influenced paintings under discussion here differed substantially both in purpose and in patronage from the China Trade paintings discussed earlier in this catalogue (see cat. nos. 1–5). Although China Trade paintings were created by Chinese artists in Western styles, the artists were not intent upon revolutionizing Chinese art. Their patrons were Westerners who commissioned commemorative works of the places they had lived, worked, or visited. There appears to have been little, if any, interaction between the artists who created China Trade paintings and those active in traditional Chinese painting and calligraphy. The majority of art thinkers and writers of late-nineteenth-century Shanghai were members of the educated elite and would have considered China Trade painters artisans rather than artists. With the advent of photography, China Trade paintings died out,

and the genre did not survive to impact the early practitioners of "modern" European-influenced oils, most of whom were active after 1910. The works in this section were painted by educated Chinese with a Chinese audience in mind. The intent of these artists was to revolutionize Chinese art, to bring it in line with trends in the broader world.

Patronage

Although a great deal has been written about the artists active in Shanghai during the early twentieth century, less information is currently available about their patrons and the market for their art. No independent commercial galleries for Western-style paintings were established in the city prior to the 1980s, and many of the sales must have been private or as the result of exhibitions or other public showings.[1]

There is some evidence of support from wealthy Westerners living in Shanghai. Michael Sullivan mentions that Xu Beihong was drawn into the artistic circle created by Silas A. Hardoon and his Chinese wife, Luo Jialing. Hardoon was one of a small group of wealthy Iraqi Jews who had settled in Shanghai in the early twentieth century. Today their influence is visible in the many buildings they commissioned around the city, particularly on Nanjing Road. Hardoon first worked as a night watchman in a warehouse owned by the Sassoon family. He moved on to become successful in real estate, opium, and politics. He owned a large complex in Ailing Park, Bubbling Well Road, where he and his wife hosted gatherings that brought together artists and collectors.[2] Most likely Liu Haisu was also involved in this circle; Liu was close to the political reformer Kang Youwei, who was supported by Hardoon early in his career. Sullivan points out that "the foreign settlements [in Shanghai] were more than a refuge. They were the bridgeheads of foreign culture in the city, where artists and writers returning from the West could feel more or less at home. Societies such as the

Association Amicale Sino-Française, founded in November 1933, became meeting places for Sinophile French and Francophile Chinese."[3] The association's bulletin often included articles about the art scene.

The relationship between patron and artist is often easy to trace in Chinese-style paintings for two reasons: a long-standing tradition exists of adding colophons, either by the artist or by others, many of which state the circumstances under which the painting was created and who it was intended for; and collectors often added their seals and inscriptions to the painting. This information and other evidence makes clear the role of wealthy Chinese in traditional Chinese painting and calligraphy in Shanghai. Such traditions did not carry over into Western-style paintings, and the evidence for Chinese patronage of new styles is less direct. Paintings in Chinese mediums and formats are also easy to roll, store, and move and therefore were more likely to survive the turmoil that beset Shanghai for much of the twentieth century than were framed Western-style oils. The entire oeuvre of a number of important early-twentieth-century oil painters has been lost.[4]

In the late nineteenth century a class of Shanghai Chinese commonly known as compradors served as the bridge between China and the West. Working for foreign firms on commission or with fixed salaries, these specialists amassed enormous wealth and power in a very short period of time. Their positions required that they have some degree of fluency in a foreign language, English and Japanese being the most common. Depending on who they were dealing with, they wore either traditional Chinese robes or Western dress. They built huge European-style mansions decorated with imported furniture and fine Chinese decorative arts, paintings, and antiques (see cat. no. 13). According to Wen-hsin Yeh, "In appearance as well as in practice, the comprador merchants drew upon elements of East and West and forged a style that mixed the exotic and the conventional in unprecedented ways."[5] They were the major patrons for Shanghai school (*Haipai*) paintings and calligraphy (see cat. nos. 8–19) and provided support for Chinese who wished to learn Western styles. They also may have purchased the occasional Western-style painting.

During the 1920s a new Chinese elite emerged in Shanghai, many of whom were educated overseas and worked as bankers, industrialists, entrepreneurs, lawyers, accountants, and the like. They joined members of the comprador class and others in forming associations that supported a range of social, political, and charitable activities.[6] A number of these associations were involved in modernization efforts. This elite commissioned Western-style buildings (see cat. nos. 36–41) and supported an entire industry that produced what is now known as Shanghai Deco furniture (see cat. nos. 44–47). They were a likely market for paintings created by Chinese artists working in modern Western styles; their sons and daughters attended the schools that provided the real livelihood for many of these artists; and their financial support made possible vital institutions, societies, and travel opportunities.

Academies and Other Institutions

The support of a small number of wealthy Westerners and Chinese in Shanghai interested in Western-style art was not adequate to make viable a community of Chinese artists working in Western-influenced styles, nor did it serve the larger goals of the more ambitious members of the group. Many of these artists fervently believed that Chinese art and culture had to change and align with international standards. A range of academies, art societies, and related organizations, along with government agencies, provided a supporting framework for these artists, but their members were not necessarily art buyers. Many artists made their living by teaching. Of great importance were schools and private studios, a large number of which existed in Shanghai. Two institutions serve as examples.

One of the first art schools in Shanghai was opened in 1912 by the then-sixteen-year-old Liu Haisu. This was ultimately to become the privately run Shanghai Art Academy (*Shanghai*

Meizhuan). By 1921 the school had begun to build a campus in the Chapei district north of Suzhou Creek.[7] Controversy often surrounded the school; in 1925 the warlord Sun Chuanfang attempted to arrest Liu Haisu for using nude models in class; the academy was closed down and some buildings were destroyed. However, the school continued to thrive, and by its twenty-fifth anniversary in 1937 its powerful board included Wang Zhen (see cat. no. 17), Cai Yuanpei, and a number of influential artists, along with a staff of eighty-one. Of its 329 students, 29 percent studied Western-style painting, 14.5 percent Chinese traditional painting, 32 percent teaching, 8 percent design, 16 percent music, and 0.5 percent sculpture.[8] It is often described as the heart of the Shanghai art scene during the 1920s and 1930s.

The Shanghai Art Academy spun off a number of other academies, some of them quite large. The Xinhua Academy was founded by a breakaway group. Its faculty included Zhang Yuguang, Zhu Qizhan (who had trained in Japan as an oil painter), Pan Tianshou, Wang Yachen, and others. Its buildings were destroyed in 1937.[9]

The studio of Zhang Chongren provides an example of a very different type of art-training institute—small, private, and exclusive. Zhang, who had studied at the Royal Academy in Brussels, was best known as a sculptor; he had won a gold medal in a competition while in Belgium. Before 1949 he won a national competition to create a sculpture of the Nationalist leader Chiang Kai-shek. Zhang's studio, the most prestigious (and expensive) private art-training facility in Shanghai, was also one of the most innovative.[10] While he at times used live models, his main tools for teaching Western sculpture and drawing were a series of full-size plaster casts of famous European sculptures he had had shipped back from Belgium and a copy of *Guide Pratique pour les Différents Genres de Dessins,* an illustrated multivolume manual by Armand Cassagne (1823–1907) published in Paris in 1873. Zhang was also interested in traditional Chinese painting and taught from one of the first histories of the tradition, the *Nanhua dacheng,* which was published in Japan.[11]

Art Societies

Art societies served as a forum for sharing ideas and for mutual support. Such societies were numerous—many had few members and lasted only a brief period, while others were more influential. In 1920 Liu Haisu (see cat. nos. 22 and 79) and several friends organized the Heavenly Horse Painting Society (*Tianma huahui*); its annual exhibitions were part of Shanghai artistic life from 1920 until 1929.[12] In 1928 Lin Fengmian (see cat. nos. 20 and 21) established the National Art Movement Society with the stated goals:

> To introduce Western art
> To reform traditional art
> To reconcile Chinese and Western art
> To create contemporary art.[13]

In the summer of 1931 the oil painter Ni Yide (cat. no. 78), Pang Xunqin (cat. no. 80), and other Shanghai artists trained in Tokyo and Paris met to form a society dedicated to promoting modern art. They named their group the Storm Society (*Juelanshe*) and held their first exhibition in January 1932 in the French Concession. The Storm Society ended in 1935. Its manifesto provides insights into these artists' aspirations and the environment in which they worked.

> The air that surrounds us is too desolate.
> The commonplace and the vulgar enclose us on all sides, numberless feeble wriggling worms, endless hollow clamor!
> Whither has gone our ancient creative talent, our glorious history? Our whole art world today is decrepit and feeble.
> We can no longer be at ease in this atmosphere of compromise. We cannot tolerate this feeble breathing to await our death.
> Release the disturbing power of Realism!
> Let us arise! Summon up the passion of wild beasts, the will of steel, to create an integrated world with color, line, and form!
> We recognize that art is certainly not the imitation of nature, nor is it the inflexible repetition of objective form. We must devote

our whole lives to the undisguised expression of our fierce emotion!

We do not take art to be the slave of religion, nor is it the explanation of a culture.

We want freedom to build up pure creation!

We hate the old forms, the old colors! We hate the commonplace, low-grade cleverness! We want to use the new art to express the spirit of a new era.[14]

Galleries and Exhibitions

Shanghai artists working in Western mediums and styles also faced challenges in finding places to exhibit their art. For most of the period under discussion here, Nanjing was the only city in China that had an art gallery. In Shanghai, exhibitions were held wherever room could be found: university halls, corporate buildings on Nanjing Road that had spare space, hotels, international clubs, and department stores. The Daxin Department Store on Fuzhou Road in the International Settlement had one of the most famous art-showing areas in Shanghai.[15] Societies of various types hosted exhibitions as well; Kuiyi Shen mentions the building owned by the Ningbo Native Place Society as an important private exhibition space in the city.[16]

Exhibitions ranged in size from small displays with works of only one or two artists to shows that were large and ambitious. A few large, influential exhibitions were particularly noteworthy. In October 1922 Chen Baoyi, Yu Qifan, and Guan Liang exhibited their oil paintings at the Ningbo Native Place Society mentioned above.[17] Tickets were sold at the door.[18] Cai Yuanpei opened the first official *National Art Exhibition* in Shanghai in 1929; it featured both paintings in traditional Chinese mediums (*guohua*) and paintings in Western styles and mediums (*xihua*), along with sculpture, photography, architecture, design, and embroidery. It also included works from Japan, which sparked a debate.[19] The Art Wind Society (*Yifeng she*) sponsored the *Art Wind Journal* (*Yifeng*) and in 1931 began to hold important exhibitions, including works by many modern masters. Its third exhibition had no fewer than 931 works.[20]

As the critic Wen Yuanning pointed out in 1936, the exhibitions held in China suffered in comparison to those held in Europe and Japan.

The first point that strikes any visitor to most Chinese Exhibitions of Paintings is the atrocious way in which the pictures are displayed. Nothing is done to show a painting to its best advantage. The exhibits seem to be hung up on no principle that we can discover: short and long, big and small, they are thrown together pell-mell. The result is anything but artistic. Under such circumstances, many beautiful pictures stand precious little chance of catching one's attention. In this respect, we have plenty to learn from the Japanese. With them, every picture, without sacrificing a jot of its claim on the spectator's attention, contributes to the harmonious effect of the whole exhibition. . . . In the West too, they order things better than we do here. What a difference, for instance, between the way we displayed our exhibits for the London Exhibition of Chinese Art at Shanghai last year and Nanjing a few months ago, and the way they were displayed at Burlington House! Our manner of displaying our exhibitions is not even a good shopman's way of displaying his goods.[21]

Artists took advantage of every possible opportunity to display their work overseas. There were frequent exhibitions in Japan and a smaller number in Europe. The *Exposition Chinoise d'Art Ancien et Moderne,* with 485 works, opened at the Palais du Rhin in Strasbourg on May 21, 1924,[22] and an exhibition of 250 contemporary Chinese works was sent to Germany in 1934.[23] Perhaps the most influential European exhibition was the *International Exhibition of Chinese Art,* mentioned by Wen Yuanning above, that was held at Burlington House in London in 1935. This huge exhibition included antiques, traditional arts, and contemporary works.

Journals

Art journals and other periodicals served as another arena in which artists could share ideas and debate new concepts. Such journals were so prevalent and provide so much material for scholars that there is almost more written information available than there are surviving works of art. Printing boomed in Shanghai during the early twentieth century. Wen-hsin Yeh points out that during this period more than two thousand periodicals competed for revenue and attention of a readership of merely five hundred thousand.[24] In addition to journals specific to the field, art exhibitions and happenings were also mentioned in a number of popular publications. As noted earlier, the bulletin of the Association Amicale Sino-française often included articles about the art scene.[25] Even popular and influential magazines like *The Young Companion* (see cat. no. 58) carried reviews and photographs of art exhibitions.[26] Michael Sullivan describes the resulting environment as "civilized, cosmopolitan, stimulating, and confused."[27]

The Influence of Japan

Several scholars have discussed in depth the influence of Japan on Chinese artists seeking to study Western-style painting.[28] A brief summary will suffice here. Japan was a natural first stop for many Shanghai artists seeking an introduction to Western styles. Japan was nearly fifty years ahead of China in establishing strong cultural and economic links with the West. After opening its doors with Perry and the Meiji Restoration in 1868, Japan set upon an ambitious plan to modernize and Westernize its economy, its government, and many of its cultural and social institutions.

In pragmatic terms, Japan is physically close to China and shares a writing system, which made easier the translation of Western concepts and practices. Japan also had strong and direct commercial ties to Shanghai. Tokyo was the main attraction for visiting scholars; the Imperial Academy of Fine Arts, the Tokyo Academy of Fine Arts, and the Kawabata Painting Academy drew most visiting artists.[29] The majority of the painters under discussion here spent some time in Japan.

However, relations with Japan presented philosophical difficulties for Chinese artists, particularly as Japan's territorial ambitions on the continent became more apparent. One of the major events that impacted China's view of Japan came in late April 1919 when, as part of the agreements ending World War I, U.S. President Woodrow Wilson and the British and French transferred all of Germany's rights in Shandong Province to Japan. The agreements were signed in Versailles and led to mass protests in China. The resulting May Fourth Movement has been described as the first mass movement in modern Chinese history.[30] It also served as a catalyst for modernization in China. The resulting New Culture Movement spurred modernization in artistic and cultural spheres. Ironically, Japan was the most immediate place to obtain the tools necessary for modernization.

The situation became even more difficult on January 29, 1932, when the Japanese bombed the poor area of Chapei in Shanghai, killing large numbers of civilians. This bombing was followed by a full-scale attack on Shanghai's Chinese defenders. Relations with Japan changed entirely with the occupation of much of China, including Shanghai, in 1937. On August 1, 1943, the International Settlement and the French Concession were formally handed over to the Shanghai Special Municipality. After one hundred years, "European Shanghai had come to an end and the city was unified under a Chinese government, thanks to Japan's 'friendship.'"[31]

Study in Europe

Travel from China to Europe, in comparison to Japan, was time-consuming and expensive. There were also immense language and cultural barriers to overcome. Nevertheless, a number of influential artists did make the journey—most with the hope of study in Paris. Lin Fengmian (cat. nos. 20 and 21), Xu Beihong (cat. nos. 53 and 54),

Liu Haisu (cat. nos. 22 and 79), and Wu Zuoren all spent considerable time in Europe. Paris was expensive, though, and many continued their studies in Germany or Belgium while also traveling to other countries. Very few artists studied in the Americas. One of those few was Teng Baiye (1901–1980), who studied in Seattle, where he profoundly impacted Mark Tobey and the developing Northwest school.[32]

At this time Europe was undergoing its own artistic revolution, and the choices of where and what to study were many and confusing. Most Chinese artists spent the bulk of their time studying at the various well-established academies. Few Chinese in Europe actually studied with leading modern artists such as Picasso and Braque, who did not teach students. Only the more conservative painters at the academies did.[33] Nevertheless, various leading Chinese artists actively debated about which Western styles were and were not appropriate for study. These debates are introduced briefly in the entries on the individual artists.

Impressionist and Postimpressionist styles appealed to Shanghai artists. Julia F. Andrews points out that "in some cities, such as Shanghai, impressionism became so potent that it was widely practiced by young artists as late as 1980."[34] Still lifes and landscapes in Impressionist styles were popular in China due to their conceptual appeal; they seemed scientific and modern to young Chinese and shared principles with traditional Chinese painting.[35]

Michael Knight

NOTES

1 Sullivan, *Art and Artists,* 58.
2 Ibid., 68.
3 Ibid., 44.
4 Shen, "Lure of the West," 174.
5 Yeh, *Shanghai Splendor,* 16.
6 Ibid., 31.
7 Sullivan, *Art and Artists,* 44–45.
8 Ibid., 46.
9 Ibid.
10 Andrews, *Painters and Politics,* 223.
11 Knight and Li Huayi, *Monumental Landscapes,* 30–31.
12 Sullivan, *Art and Artists,* 45.
13 Danzker, "Cultural Exchange," 23–25.
14 Sullivan, *Art and Artists,* 62n17.
15 Ibid., 60–61.
16 Shen, "Lure of the West," 174.
17 Ibid.
18 Sullivan, *Art and Artists,* 58.
19 Danzker, "Cultural Exchange," 26.
20 Sullivan, *Art and Artists,* 59.
21 Ibid., 61n12.
22 Danzker, "Cultural Exchange," 22.
23 Ibid., 10.
24 Yeh, *Shanghai Splendor,* 127.
25 Sullivan, *Art and Artists,* 44.
26 Shen, "Lure of the West," 175.
27 Sullivan, *Art and Artists,* 65.
28 For example, see Shen, "Lure of the West," 173–176; Crozier, "Post-Impressionists in Pre-War China," 137–138; and Shen, "Modernist Movements in Pre-War China."
29 Shen, "Lure of the West," 173–175.
30 Danzker, "Cultural Exchange," 18–21.
31 Yeh, *Shanghai Splendor,* 158–159.
32 For a full discussion, see Clarke, "Teng Baiye and Mark Tobey," 84–103.
33 Andrews, *Painters and Politics,* 180–181.
34 Ibid., 181.
35 Ibid.

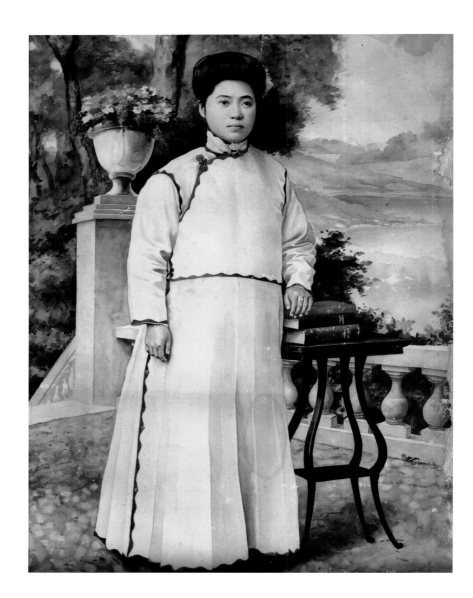

53 Portrait of Kang Youwei's wife

By Xu Beihong (1895–1953)
Watercolors on paper
H. 83.9 × W. 65.0 cm
Collection of the Shanghai Museum

Xu Beihong was a major figure in introducing Western styles into Chinese art during the early and mid-twentieth-century. He also attempted to synthesize Chinese and Western techniques. Born in Yixing, Jiangsu Province, not far from Shanghai, Xu began studying Chinese calligraphy with his father, Xu Dazhang, when he was six and Chinese painting when he was nine. In 1915 he moved to Shanghai, where he studied French language and Western painting, at least in part with Liu Haisu at the Shanghai Art Academy.[1]

Like many ambitious Shanghai artists, Xu longed to study abroad. His first opportunity came in 1917, when he went to Tokyo. After returning to China, he taught in Beijing at the invitation of Cai Yuanpei, China's minister of education. In 1919 Xu made his first trip to Europe, where he studied at the École Nationale Supérieure des Beaux-Arts in Paris. He stayed in Europe until 1927. Upon his return to China, he filled a number of important and influential teaching posts.[2]

Xu was quite conservative in his approach to Western art. He studied with the academies in Paris and returned to China holding a strong opinion that art should focus on realism. He was a harsh and adamant critic of the contemporary movements in Europe and felt they had no place in China.[3] In this he was in direct conflict with artists such as Ni Yide (cat. no. 78) and, even more so, Liu Haisu (cat. no. 79).

In Shanghai Xu Beihong was drawn into the circle of the Hardoons. The famous reformer Kang Youwei was also a member of this circle, and he and Xu may have first made contact there.

This image of Kang Youwei's wife is in watercolors on paper. She is rather stiffly depicted in Chinese dress but in a totally Western setting. The architectural details, small table, potted plants, trees, and landscape all suggest a European setting; even the books appear to have Western titles. Other than the fact that the main subject is a Chinese woman, there is little to indicate that this work is not a Western watercolor. MK

1 Sullivan, *Art and Artists*, 68.
2 Ibid.
3 Ibid., 68 and 73.

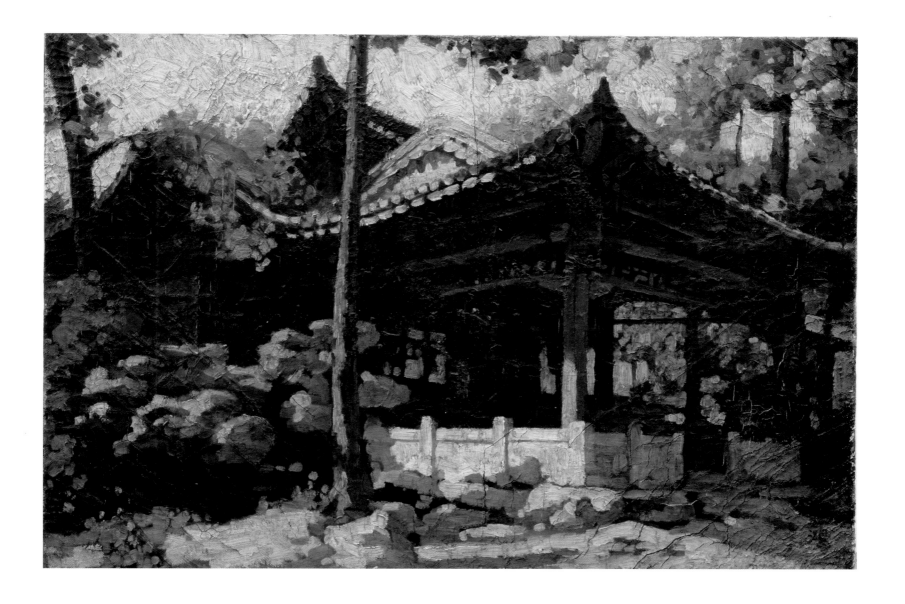

54 *Garden*, 1940s

By Xu Beihong (1895–1953)
Oil on canvas
H. 50.0 × W. 71.0 cm
Private collection

This painting in oil on canvas is in a far more impressionistic style than Xu's portrait of Kang Youwei's wife. Here Xu has chosen to depict a traditional Chinese-style garden and building—thereby combining the extremely different traditions of Western painting and Chinese architecture. The setting resembles one section of the famous Yu Gardens in Shanghai, but it could be from any number of similar-style gardens in nearby Suzhou. The artist has signed the work with the Chinese characters reading *Beihong* in red in the lower right corner. MK

55 *Changde Road*, 1940
By Guan Liang (1900–1986)
Oil on canvas
H. 58.0 × W. 89.5 cm
Private collection

56 *Wharf*, 1940
By Guan Liang (1900–1986)
Oil on board
H. 53.5 × W. 80.0 cm
Private collection

Best known as an oil painter, Guan Liang was
born in Fanyu, Guangdong Province, in 1900.
Like many Chinese artists interested in Western
art practice and theory, he studied at the Tokyo
Academy of Fine Arts, the Kawabata Painting
Academy, and the Pacific Painting Academy in
Japan, staying there from 1917 to 1923. He spent
the decades following his return teaching in
Shanghai and Hangzhou. He was associated with
revolutionary causes from early in his life and in
1926 joined the Northern Expeditionary Revo-
lutionary Troop as a propaganda artist. After the
Japanese invasion in 1937, he left Shanghai and
spent the following years in Hong Kong, Kunming,
and Chengdu. Guan Liang, along with Zao Wou-ki
(Zhao Wuji) and Ding Yanyong, held their own
"Salon des Independents" in Chongqing in 1942

at the same time as the government sponsored the *Third National Art Exhibition* (which Guan and his colleagues considered too conservative).[1] He later taught and served as an administrator at the Shanghai Art Academy, the Shanghai University of Art, and the Chinese Artists' Association. He was one of many artists who traveled to the Soviet Union after China closed its doors to the West in 1950.[2]

Both of these works are dated 1940, when Guan Liang was in exile during the Japanese occupation of Shanghai. In the first he has chosen to depict a quiet residential street overhung with sycamores. A streetcar occupies the center of the painting, while to the left a square raised area appears to contain a large Chinese-style garden rock. The style is generalized, soft, and impressionistic. The artist signed his work in black with the Chinese characters reading *Guan Liang* in the lower left corner.

Wharves (*matou*) are depicted in the second work. The artist has taken a low viewpoint and focuses on the actual wharf; no complete ship and only small strips of water are visible. To the left, smoke billows from a smokestack, and numerous banners flutter from masts. To the right appear buildings of what might be the Bund. They are done in broad, flat planes of color with only cursory detail. No people are shown.

No doubt these paintings are a nostalgic representation of what the Shanghai resident living in exile had lost. MK

1 Sullivan, *Art and Artists,* 97–98.

2 Ibid., 135.

57 Still life, 1943

By Guan Zilan (1903–1986)
Oil on silk
H. 55.0 × W. 75.5 cm
Private collection

Guan Zilan was one of Shanghai's most successful women artists.[1] Born in Guandong Province in 1903, she moved to Shanghai to study painting with Chen Baoyi at the Shanghai Chinese Arts University. She favored Fauvist styles as painted in Japan by Yasui Sotaro, the same styles that fascinated Ni Yide (cat. no. 78) and other avant-garde artists. Guan traveled in 1927 to Japan, where she continued her studies of Western painting theory and practice. In 1930 she was back in China teaching at the Xiyang Academy of Fine Arts. Kuiyi Shen reports that Guan held a large solo exhibition in 1930, apparently in Shanghai. The event was reported in the Shanghai magazine *The Young Companion* (see cat. no. 58), and the artist was photographed with Chen Baoyi and his wife.[2] Guan stayed in Shanghai after 1949, but little is known of her activities. She died in 1986.

This still life, dated 1943, was painted during the Japanese occupation of Shanghai. Guan employs a bright palette to create a scene of a small table supporting two vases filled with exotic flowers. Pieces of fruit are scattered on the table; behind are the wainscoting and wood paneling of a Western-style room. Like the room and the flowers, the fruit (which appear to be lemons, apples, and a banana) and the ceramics are not typical of traditional Chinese painting. Influence of the Japanese Fauvists is evident in the bold colors and simplified forms. Guan signs and dates the work in Chinese in the lower right corner. MK

1 For a brief biography see Zheng Shengtian and Kazuko Kameda-Madar, "Artists' Biographies," 393.
2 Shen, "Lure of the West," 175.

Shortly after the lithographic era of the 1880s and the following two decades, new printing technologies appeared in rapid succession that ultimately established the foundation for Shanghai's printing boom during the first half of the twentieth century,[1] beginning with the copperplate press in the 1910s and followed by the photographic plate in the 1920s.[2] The majority of the important publishers were based in Shanghai and concentrated around Fuzhou Road:[3] Commercial Press Limited (1897, *Shangwu yinshu guan*), Chung Hwa Book Company (1912, *Zhonghua shuju*), Kai Ming Book Company (*Kaiming shudian*), and World Book Company (*Shijie shuju*).[4] Arguably the most influential was the Liangyou Publishing Company (*Liangyou tushu gongsi*), whose flagship magazine, *The Young Companion* (*Liangyou huabao*) (cat. no. 58), had the longest print run for a pictorial in modern Chinese history.[5]

The samples here of graphic arts of this period fall into two broad, but at times overlapping, categories: commercial and social. On the commercial side are posters (cat. nos. 62–72), advertisements, and lifestyle magazines (cat. nos.

58–61); materials with social agendas include cartoons (cat. no. 102), woodcuts (cat. nos. 95–101), and the art periodicals that published them (cat. nos. 91–94). Two fundamental features connect these examples thematically, temporally, and spatially: 1) their intended mass audience and aim at popular appeal, and 2) their emphasis on pictures—the image served as *the* medium of communication. The "pictorial turn"[6] that began in the late 1800s with the *Dianshizhai huabao* intensified during the first half of the twentieth century and characterizes Shanghai printing of the time as a visual enterprise.

Dany Chan

NOTES

1 By 1930 the printing industry was the city's third-largest form of industrial investment, after brocade weaving and cigarette manufacturing. See Reed, *Gutenberg in Shanghai*, 267.
2 Zhang, "Corporeality of Erotic Imagination," 126.
3 Lee, *Shanghai Modern*, 45; and Laing, *Selling Happiness*, 2.
4 Edgren, "China," 109.
5 Lee, *Shanghai Modern*, 64.
6 This term is borrowed from Laikwan Pang in "The Pictorial Turn," 16–36.

58 *The Young Companion*, no. 101
(January 1935)
Published by Liangyou Publishing Company
Bound volume
H. 36.5 × W. 26.5 × D. 3.5 cm
Collection of the Shanghai History Museum

With the longest print run for a pictorial magazine in modern China (1926–1945),[1] *The Young Companion* became a major influence on—and therefore an invaluable source material of—Shanghai urban culture during the first half of the twentieth century. It was published by the Liangyou Publishing Company using the newer offset printing technology,[2] in addition to photography for its cover portraits:[3] the black-and-white photographs were first shot at commercial studios, and color was

later applied by artists before printing.[4] In fact, the faces of women appear on almost every cover of the magazine;[5] they range from neighborhood students to famous movie stars,[6] and each is identified by name[7] and sometimes school or vocation.[8] Scholars have traced the tradition of the cover girl to late-nineteenth-century entertainment journals that often featured "famous flowers," or Shanghai courtesans, on their covers.[9] However, most likely to counter this tradition, every editorial and marketing effort was made to emphasize the respectability of the cover girls of *The Young Companion*.[10]

Browsing through any issue of the magazine, one would most likely encounter, among other features, 1) reproductions of Western and Chinese art;[11] 2) photographs showcasing Shanghai's many attractions;[12] and

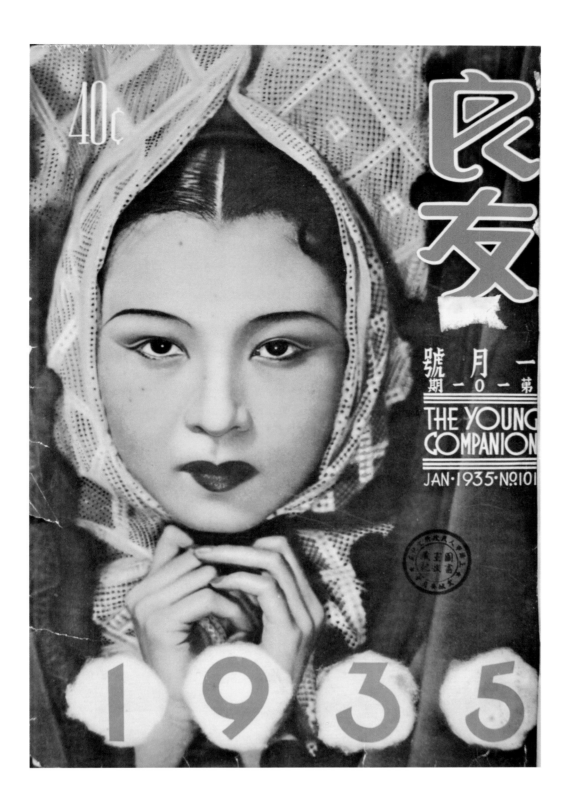

3) advertisements for Western and Chinese products,[13] especially prevalent during the National Goods Campaigns.[14] The legacy of *The Young Companion* lay in its achievement as an arbiter of modernity for the two decades of its run, not only by satisfying public demand for all things *en vogue*, but also by creating such demand at the same time.[15] DC

1 Lee, *Shanghai Modern*, 64.
2 Offset lithography (*jiaoban* or *xiangpi ban*) was introduced into Shanghai in 1915 by Commercial Press Limited. See Reed, "Re/Collecting the Sources," 48n4; Reed, *Gutenberg in Shanghai*, 63; and Dikötter, *Exotic Commodities*, 68.
3 Lee, "Cultural Construction of Modernity," 45.
4 Waara, "Invention, Industry, Art," 75.
5 Ibid.; and Laing, *Selling Happiness*, 59.
6 Lee, "Urban Milieu of Shanghai Cinema," 77; and Waara, "Invention, Industry, Art," 75.
7 Lee, *Shanghai Modern*, 65.
8 Waara, "Invention, Industry, Art," 75.
9 Lee, *Shanghai Modern*, 65 and 358n29.
10 Such as including the editor's message to readers expressing his wish to establish a friendly relationship between magazine and reader: "that the journal serves as a good and constant companion in the daily lives of its readers." See ibid., 66 and 73.
11 Waara, "Invention, Industry, Art," 75.
12 Lee, *Shanghai Modern*, 75.
13 Wu Huating, "Shapeless Wives and Mothers," 11.
14 Waara, "Invention, Industry, Art," 63.
15 Lee, *Shanghai Modern*, 75–76; and Lee, "Cultural Construction of Modernity," 45.

電影世界

THE MOVIE WORLD 13

國泰紅星一周曼華

59 *The Movie World*, no. 13 (1940)

Bound volume
H. 35.7 × W. 26.0 × D. 3.0 cm
Collection of the Shanghai History Museum

Film arrived in China in 1896[1] with the first public viewing in a teahouse in Shanghai,[2] but the first movie magazines did not appear until 1921—with the publication of *The Journal of Film* (*Yingxi congbao*) by the Shanghai newspaper *Shenbao* and the independent *Film Magazine* (*Yingxi zazhi*)[3]—heralding the Chinese film industry boom of the 1920s and 1930s.[4] Not surprisingly, interest in movies was de rigueur for modern living in Shanghai,[5] and the city became the center of Chinese cinema, functioning as "a nexus in the larger matrix of a national, regional, and international film culture"[6] during the first half of the twentieth century. Nearly half of all Chinese films were produced in Shanghai,[7] and the first movie theater there opened in 1908;[8] by 1930, the city housed a total of fifty-three cinemas. In fact, the city offered such favorable circumstances for a burgeoning film culture that one scholar distinguished "Shanghai cinema" from "Chinese cinema" to illustrate its singularity—"just like the city that fostered it . . . Shanghai cinema was neither completely national nor completely international."[9]

The woman on the cover of this issue of *The Movie World* is Zhou Manhua, a popular actress of Shanghai films in the 1940s. Unlike her Hollywood counterpart,

Zhou here exhibits demure femininity rather than loud sexuality,[10] and in many regards, the Chinese actress was the first generation of the "modern girl" both on-screen and off.[11] The color and texture effects of Zhou's rosy face recall the "rub-and-paint" technique employed on the popular posters (cat. nos. 64–72) for which screen actresses often served as models.[12] DC

1 Fu, "Selling Fantasies at War," 187. The first films were predominantly foreign; the first Chinese film appeared in 1905. See Dikötter, *Exotic Commodities*, 253; and Zhang Zhen, *Amorous History*, xviii.
2 Zhang Zhen, *Amorous History*, xviii; and Dikötter, *Exotic Commodities*, 252.
3 Lee, *Shanghai Modern*, 85.
4 Zhang Zhen, *Amorous History*, 38.
5 Lee, *Shanghai Modern*, 86.
6 Zhang Zhen, *Amorous History*, 87.
7 Zheng Dongtian, "Films and Shanghai," 300.
8 Dong, *Shanghai: Gateway*, 21.
9 Zhang Zhen, *Amorous History*, 349.
10 Lee, *Shanghai Modern*, 93.
11 Zhang Zhen, *Amorous History*, 39.
12 Lee, *Shanghai Modern*, 78.

60 *Arts and Life,* no. 22

(January 1936)

Published by K & K Printing Company,
distributed by Xinwen baoguan

Bound volume

H. 38.5 × W. 26.7 cm

Collection of the Shanghai History Museum

Despite its short print run (1934–1937),[1] *Arts and Life,* along with *The Young Companion* (cat. no. 58), has been singled out as exemplary of the aims and strategies of Shanghai's twentieth-century commercial culture.[2] The magazine's editors comprised a virtual Who's Who in Chinese art;[3] the middle class, and especially women, formed its core readership;[4] and it promoted consumerism of arts and entertainment as a desirable activity of modern living.[5] This special New Year's issue has a cover image of Shirley Temple and features on Chinese cartoons (*manhua*), a genre that reached the height of its popularity in the mid-1930s.[6]

The cartoon originated in Europe and entered China via Japan. In fact, the Chinese term was borrowed from the Japanese *manga,* meaning a "spontaneous or impromptu sketch,"[7] and was first used by artist Feng Zikai in a 1925 publication;[8] *manhua* became the official designation for Chinese cartoons thereafter.[9] Touted as an art form for the masses,[10] Chinese cartoons were produced mainly in Shanghai. The first weekly cartoon magazine was published by a local press in 1928,[11] and cartoons gradually became integral to all major publications.[12] By this time, Shanghai residents were already familiar with the art form as seen in Western publications such as the British *Punch* (1841–1992)[13] and the American *New Yorker.*[14] In addition to publishing, cartooning societies were established in the city, such as the Cartoon Association (*Manhua hui*) in 1927[15] and the National Salvation Cartoon Propaganda Corps (*Jiuwang manhua xuanchuandui*) in 1937.[16] The first national conference on cartoons was held in Shanghai in 1927.[17] DC

1 Waara, "Invention, Industry, Art," 63.
2 Ibid., 62–63.
3 Ibid., 63.
4 Ibid., 74–75 and 87.
5 Lee, *Shanghai Modern,* 64.
6 Farquhar, "*Sanmao,*" 145; and Shen, "*Lianhuanhua* and *Manhua,*" 114.
7 Farquhar, "*Sanmao,*" 142.
8 Hung, "Feng Zikai's Wartime Cartoons," 41.
9 Huang Yuanlin, "Chinese Cartoons," 5.
10 Farquhar, "*Sanmao,*" 143.
11 Ibid., 145.
12 Hung, "Feng Zikai's Wartime Cartoons," 42.
13 Reed, *Gutenberg in Shanghai,* 93.
14 Farquhar, "*Sanmao,*" 147.
15 Hung, "Feng Zikai's Wartime Cartoons," 42.
16 Ibid., 44; and Shen, "*Lianhuanhua* and *Manhua,*" 118.
17 Farquhar, "*Sanmao,*" 145.

61 *Chinese Culture,* no. 43 (1933)

Bound volume
H. 34.0 × W. 24.5 × D. 3.5 cm
Collection of the Shanghai History Museum

The cover of this issue of *Chinese Culture* reproduces
a painting by Liang Dingming (1898–1959) depicting
the mausoleum of Sun Yat-sen (1866–1925), founder of
the Nationalist Party in China.[1] Construction of what is
called the Zhongshan Mausoleum (*Zhongshan ling*) was
completed in Nanjing in 1929.[2]

Liang began in portraiture as a staff artist for
the in-house advertising department of BAT (British
American Tobacco Company, based in Shanghai) —
he was there from 1921 to 1925[3]—and later moved to
Guangzhou, where an introduction to Chiang Kai-
shek (1887–1975) would thereafter entrench Liang's
art within the activities of the Nationalist Party,[4] as
this painting intimates. Painted no later than 1933, the
landscape around the mausoleum is awash in a saturated
palette much favored by Liang: "deep crimson, emerald
green, harvest yellow, ultramarine blue, and violet"[5]
—appropriate color choices, since the mausoleum
sits atop the Zijin ("Purple-Gold") Peak of Zhongshan
Mountain. **DC**

1 Schoppa, *Modern Chinese History,* 186.
2 ChinaCulture.org, "Sun Yat-sen Mausoleum."
3 Laing, "British American Tobacco Company."
4 Ibid.
5 Ibid.

Nanjing Road—From *Series of Views of Shanghai*, after 1932

By Zhao Weimin (dates unknown)
Poster, chromolithograph
H. 53.0 × W. 75.8 cm
Collection of the Shanghai History Museum

What is captured in this poster is one of the intersections along Nanjing Road, the hub of Shanghai's commercial power during the early 1900s; in fact, it is still privileged with the name "Number-One Road" (*Da malu*).[1] The imposing structures lining the thoroughfare are three of China's "Big Four" department stores: Sincere Company, Ltd. (*Xianshi*, 1917, right foreground), Wing On Company, Ltd. (*Yong'an*, 1918, left foreground), and Sun Sun Company, Ltd. (*Xinxin*, 1926, behind Sincere),[2] all of which could rival New York's Macy's and London's Selfridges.[3] Their importance in Shanghai's, and China's, history extended beyond mere commerce to advance an emerging ideal that linked "tasteful" consumption with refined modern living.[4] They achieved this end by employing several strategies, some of which were based on Western trends: Sincere set fixed prices to prevent haggling,[5] and Wing On emphasized individual and friendly customer service.[6] An outstanding feature of these department stores was their attention to elegant store and window displays utilizing mannequins, glass cabinets, and gallery rails.[7] One strategy that seemed to be uniquely Shanghai, however, was the addition of entertainment venues:[8] for example, Sincere (followed by Wing On and Sun Sun) installed a roof garden offering such amusements as Cantonese opera,[9] and Sun Sun installed an all-glass radio studio with live performances by famous singers.[10] In these ways, the department store became another form of public space, a nexus of consumerism and recreation. And much like this richly detailed poster that bears their likenesses, they exhibited modernity as an "imagined reality" governed by consumption[11] and attainable either through direct acquisition of goods or via the ancillary form of window-shopping. DC

1 Lee, *Shanghai Modern*, 15.
2 Chan, "Four Premier Department Stores," 23–24; and Lee, *Shanghai Modern*, 13.
3 Dikötter, *Exotic Commodities*, 59–60.
4 Chan, "Four Premier Department Stores," 35–36. For example, a major commercial trend in the United States during the 1930s was the emergence of industrial design, a movement that aimed to enhance consumer choice and elevate middle-class sensibility with goods that were both utilitarian and stylish, thereby merging art and life. See Cogdell, *Eugenic Design*, 219.
5 Chan, "Four Premier Department Stores," 26.
6 Dikötter, *Exotic Commodities*, 59.
7 Ibid., 61; Zhao and Belk, "Advertising Consumer Culture," 46; and Chan, "Four Premier Department Stores," 35.
8 Lee, *Shanghai Modern*, 13.
9 Zhang Zhen, *Amorous History*, 61.
10 Lee, *Shanghai Modern*, 15.
11 The term in this context is borrowed from ibid., 74.

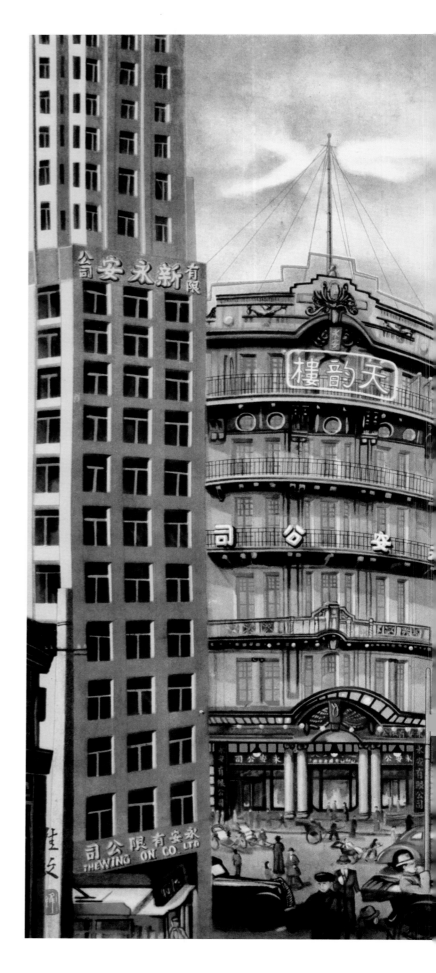

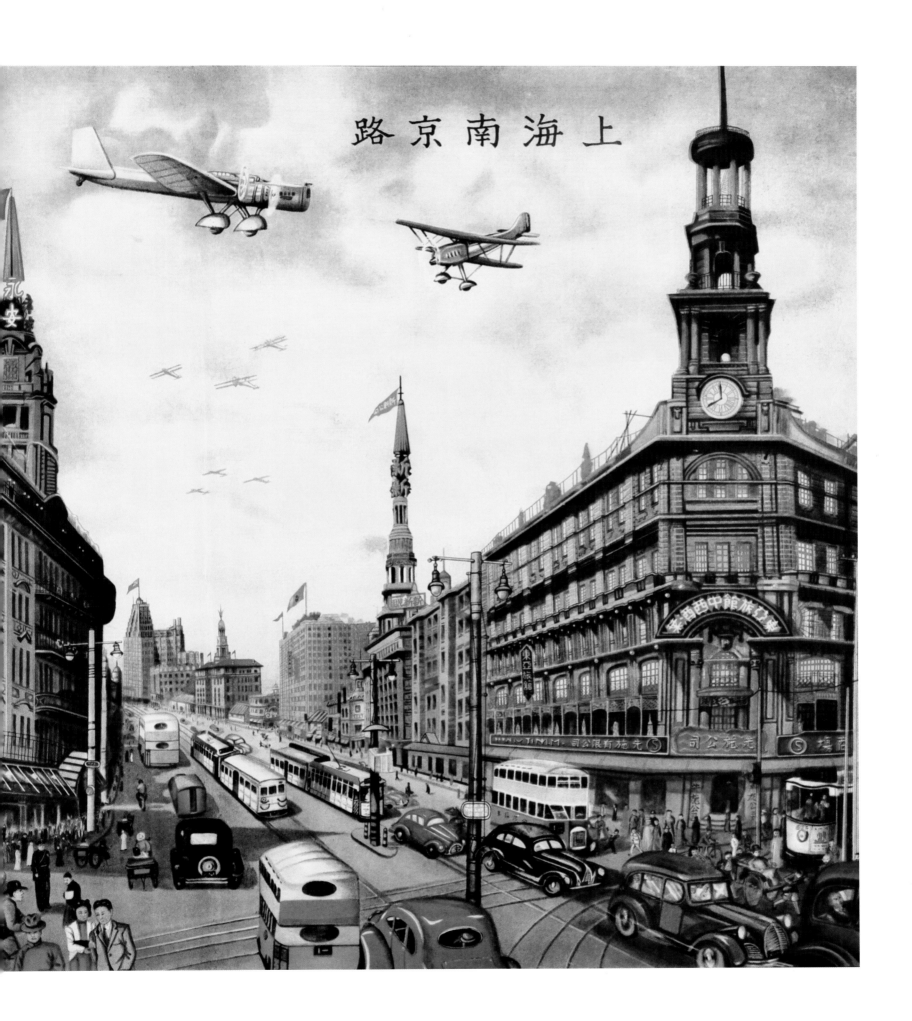

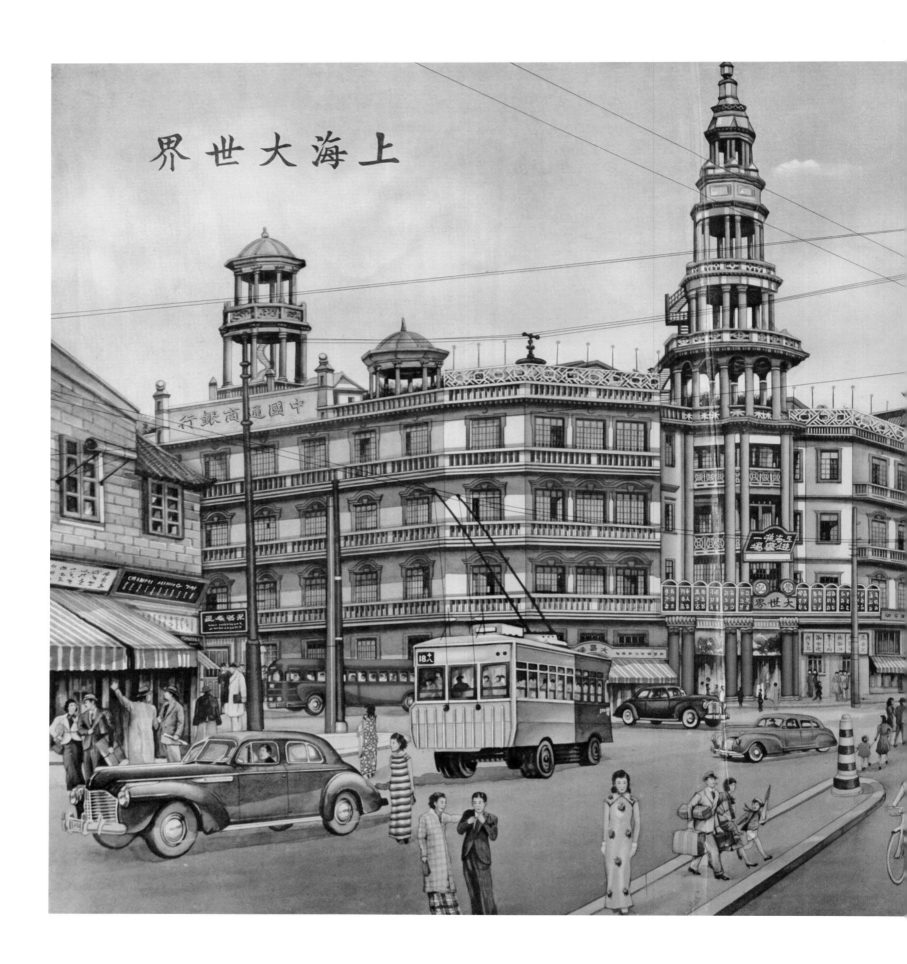

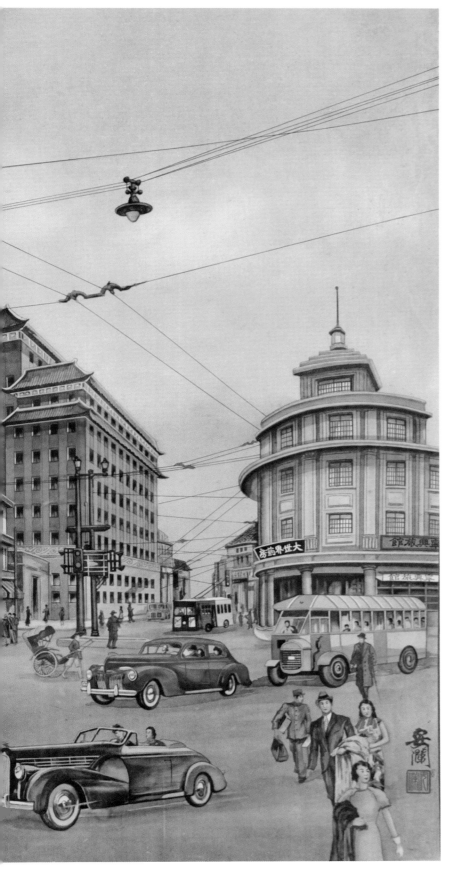

Great World Entertainment Center, 1941

Signature of An Lan (dates unknown)
Published by Global Heji Poster Company
Poster, chromolithograph
H. 53.0 × W. 77.0 cm
Collection of the Shanghai History Museum

This poster advertises the Great World Entertainment Center, the most famous amusement hall (*youlechang*)[1] in Shanghai during the early decades of the 1900s. Defined as a resort of entertainment catering to patrons of "moderate means,"[2] the center offered, among other things, a mini zoo, variety shows, cinemas, food shops, and garden "scenic spots."[3] In addition, Great World provided a convenient twenty-four-hour bank and its own daily newspaper.[4]

Aside from recreation, Great World came to serve many commercial functions. The original building was erected in 1917 in the French Concession at the corner of Tibet Road and Avenue Edouard VII, a densely populated crossroads of the different concessions.[5] The structure pictured here is the one renovated in 1925, composed of a four-story circular facade and a pagoda-like tower that mixes Baroque features. Other architectural inspirations were drawn from late–imperial Chinese gardens and teahouses and the various international world fairs.[6]

The building also had great advertising value for its owner, the pharmaceutical industrialist Huang Chujiu (1872–1931), who plastered its interior walls and outer facade with advertisements for his medicines; promotional stunts were launched from the tower. For these and other reasons, Huang had been dubbed by his contemporaries as the "King of Advertising" (*guanggao da wang*).[7] DC

1 Zhang Zhen, *Amorous History*, 58.
2 Ibid.
3 Information was compiled from Lee, *Shanghai Modern*, 13–14; and Zhang Zhen, *Amorous History*, 60 and 63.
4 Zhang Zhen, *Amorous History*, 60.
5 Cochran, "Marketing Medicine and Dreams," 79; and Zhang Zhen, *Amorous History*, 60.
6 Zhang Zhen, *Amorous History*, 62–63.
7 Information was compiled from ibid., 63; and Cochran, "Marketing Medicine and Dreams," 63 and 79.

Visualizing Women and Shanghai Modernity

The faces of beautiful Chinese women appear often in visual products exhibiting Shanghai modernity in the 1920s and 1930s, including magazines, film, fashion, advertising, and commercial posters such as the substantial group featured in the following pages. Each of the examples pictured here (cat. nos. 64 and 65) presents a woman, garbed and coiffed in the latest styles, lounging before a backdrop of the city's skyline. Such a composition exemplifies the successful marketing strategy that created a triangular association linking 1) Shanghai with 2) modernity with 3) the Chinese woman. This association was so prevalent in the city's visual culture at the time that it compelled the claim "*Haipai* is like a modern girl."[1]

This statement, made in the early twentieth century, echoed both the local past and the global present. When the term *haipai* first appeared in the late 1800s, referring to the Shanghai school of painting, it was intended as a negative characterization.[2] However, throughout the early 1900s, the epithet was consciously manipulated by local artists and entrepreneurs in all forms of media to redefine *haipai* as "Shanghai style" and glorifying it as "refined, dashing, cosmopolitan, and, above all, 'modern' [*modeng*]."[3] The appearance of the Chinese modern girl coincided with the emergence of the "modern girl" icon in popular cultures of such nations as the United States, Germany, and Russia.[4] A survey of graphic design in Europe and America during these years suggests two broad societal trends regarding women also seen in Shanghai: 1) greater accessibility for women in the public domain, and 2) more focus on the private lives of young women.[5] Although she arguably shared numerous similarities,

what distinguished the Shanghai modern girl in particular from her international sisters was the unique character of her city.

The posters in this group offer portrayals of the multiple roles utilized in advertising women in general, such as wife and mother (cat. no. 71), sexual referents (cat. no. 72), and sex objects (cat. no. 66),[6] underscoring the paradoxical nature of the tripartite association of Shanghai, modernity, and the Chinese girl: how "modern" could the Chinese modern girl be when she was still trapped in a predominantly male gaze?[7] The difficulty of defining women's roles in a modernizing Shanghai society has been explored by scholars through the appearance of women's images in various sites, including cinema, commerce, advertising, print, industrial design, and fashion.[8]

Dany Chan

NOTES

1 This statement was made by writer Cao Juren (1900–1972) and quoted in Waara, "Invention, Industry, Art," 63.
2 Ibid., 61n1; and Chung, "Reinterpreting the Shanghai School," 43.
3 Cochran, "Commercial Culture in Shanghai," 9–10; and Waara, "Invention, Industry, Art," 61.
4 A comprehensive study focuses on the development of the "modern girl" icon on a global scale. See Modern Girl Around the World Research Group, *Modern Girl*.
5 Eskilson, *Graphic Design*, 53–54.
6 Cohen and Kennedy, *Global Sociology*, 354.
7 Ibid.
8 See Zhang Zhen, *Amorous History*, 245–297; Cochran, *Inventing Nanjing Road*; Laing, *Selling Happiness*; Lee, *Shanghai Modern*; Dikötter, *Imperfect Conceptions*; Cogdell, *Eugenic Design*; and Finnane, "What Should Women Wear?"

Moonlight over
Huangpu River, 1930s

By Yuan Xiutang (dates unknown)
Poster, chromolithograph
H. 53.4 × W. 77.2 cm
Collection of the Shanghai History Museum

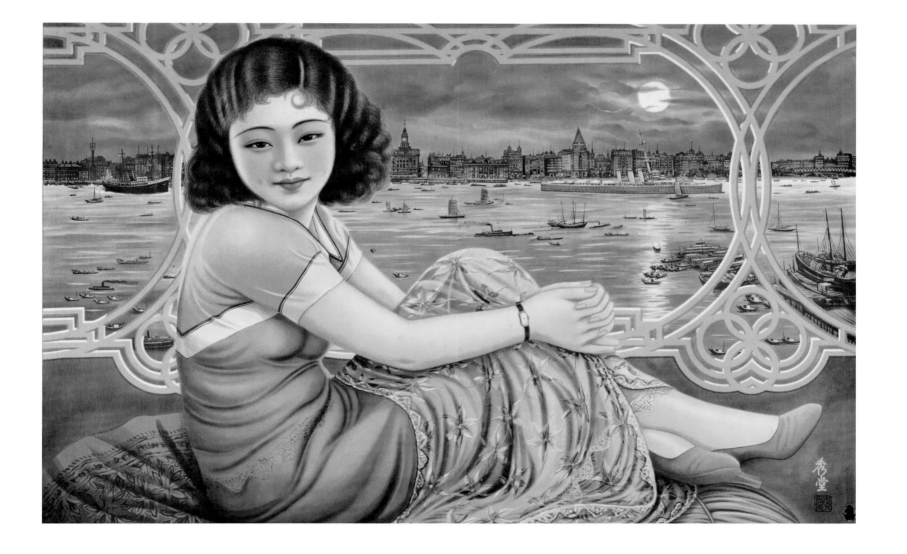

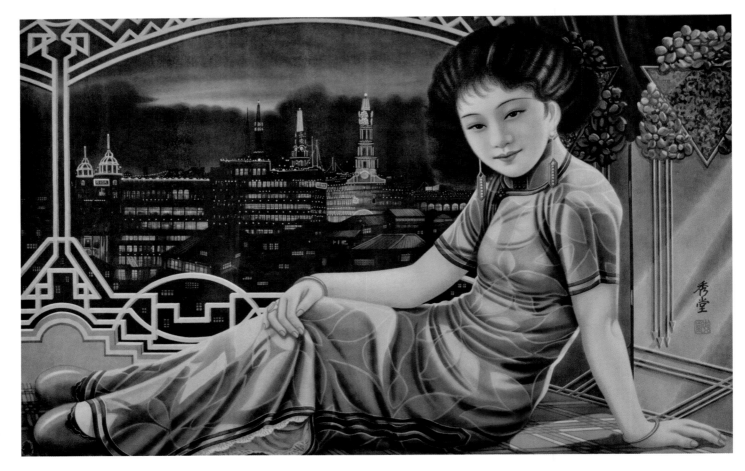

65

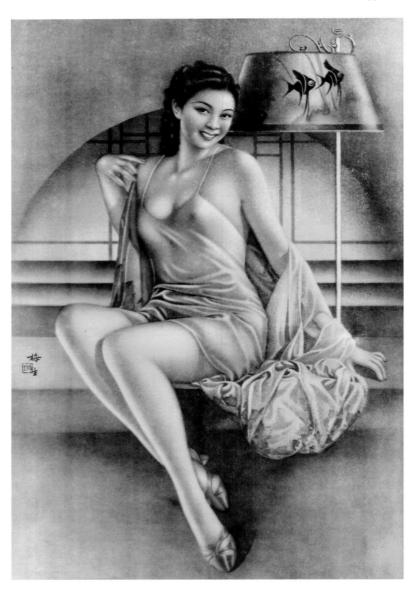

65 *A Prosperous City That
Never Sleeps*, 1930s

By Yuan Xiutang (dates unknown)
Poster, chromolithograph
H. 53.5 × W. 76.8 cm
Collection of the Shanghai History Museum

66 *It Often Begins with a Smile*, 1930s

By Jin Meisheng (1902–1989)
Poster, chromolithograph
H. 77.6 × W. 53.7 cm
Collection of the Shanghai History Museum

The Course of a Marriage, 1930s

Signature of Zhao Fang (dates unknown)
Poster, chromolithograph
H. 71.2 × W. 51.6 cm
Collection of the Shanghai History Museum

This poster is rich not only in details but in their connotative messages as well. In keeping with the title, *The Course of a Marriage*, the outer four scenes capture the idealized life stages of a happy couple, whose wedding is pictured in the center. From top to bottom starting at top right, the images depict:

- Childhood years: the boy and girl are already in love with each other.

- School days: they continue to help each other.

- After marriage: they have children, referred to as "love's reward."

- In retirement: the couple will enjoy a happy life.

An outstanding feature of the poster's visual narrative is its focus on the nuclear family (*xiao jiating*): mother, father, and unmarried child (or children),[1] a concept in opposition to the traditional ideal of multiple generations living under one roof. However, it has been suggested that a preference for the nuclear family type, as seen in Shanghai advertising, reflects the interests and ideology of capitalism,[2] since by the 1930s the city had become in its own right an industrial, market-economy society. DC

1 Yeh, *Shanghai Splendor*, 111.
2 Wu Huating, "Shapeless Wives and Mothers," 16.

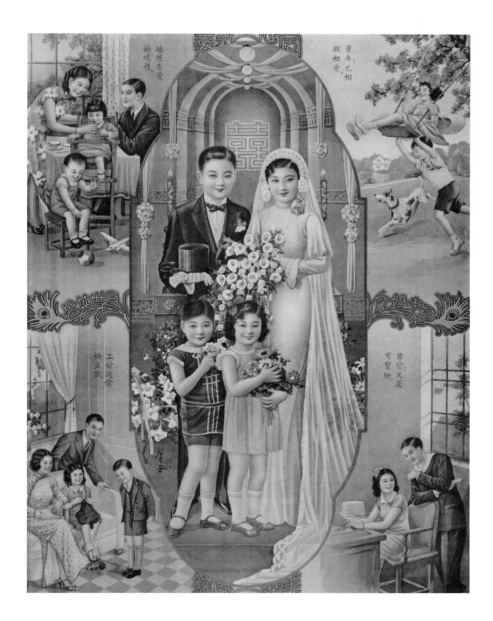

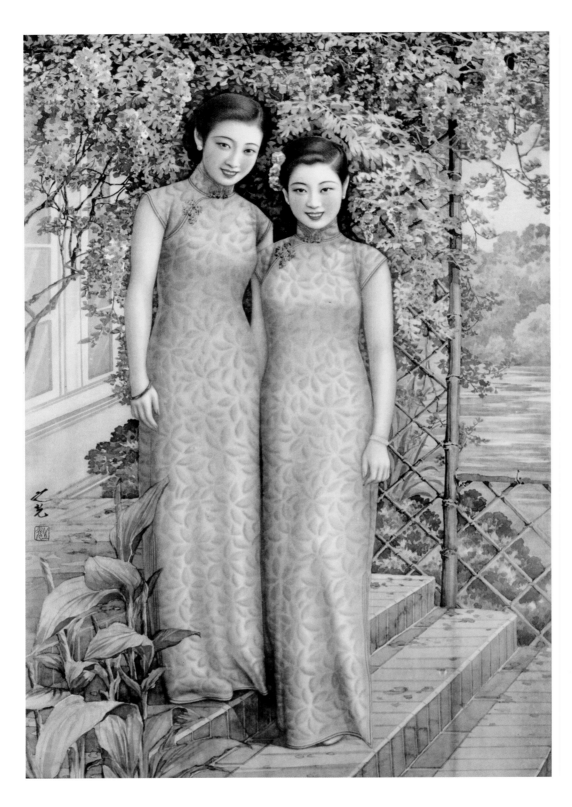

68

68 *Sightseeing Arm-in-Arm*, 1930s

By Xie Zhiguang (1900–1976)

Poster, chromolithograph

H. 75.7 × W. 53.2 cm

Collection of the Shanghai History Museum

69 *Facing One's Reflection in Vanity*, 1930s

By Xie Zhiguang (1900–1976)

Poster, chromolithograph

H. 77.5 × W. 53.8 cm

Collection of the Shanghai History Museum

These two images are exemplary of a technique used for the original paintings from which these prints were made. The technique revolutionized the look of Chinese posters and elevated their commercial popularity.[1] Known as the "rub-and-paint" technique (*cabi shuicai*, or *cabi dancai*), it was supposedly invented in 1915 by the artist Zheng Mantuo (1885/88–1961).[2] Put simply, the technique involves applying a thin layer of carbon or charcoal powder over a base drawing. On areas where shadow or shading is desired, the powder is gently rubbed into the paper. Watercolor is then applied to

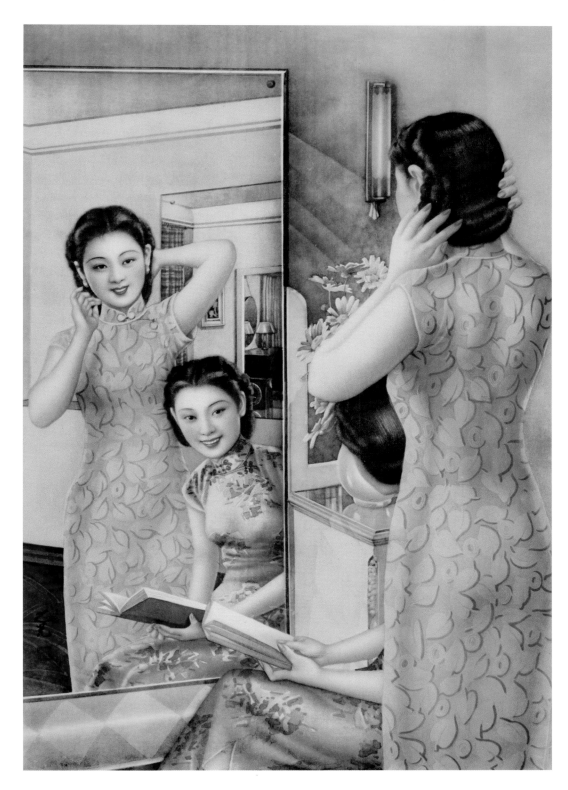

69

finish the image. The overall look, with its graded tones, is soft and veiled.[3]

The rub-and-paint technique was a major factor in the success of Xie Zhiguang, a student of Zhou Muqiao (cat. nos. 33 and 34) and leading master of these commercial posters.[4] Xie was said to have excelled in creating volume in his female figures, in addition to rendering their "glossy lips and saucy eyes."[5] The two posters presented here also highlight Xie's talents in detailing textile patterns and Western interiors.[6] DC

1 Tong, "A History of Calendar Posters," 11.
2 Lee, *Shanghai Modern*, 77; Cochran, "Marketing Medicine and Dreams," 73; and Laing, *Selling Happiness*, 115.
3 Information was compiled from Tong, "A History of Calendar Posters," 11; Lee, *Shanghai Modern*, 77; and Laing, *Selling Happiness*, 116.
4 Laing, *Selling Happiness*, 113.
5 Ibid., 158.
6 Ibid., 152–153 and 158.

70 *Southern Beauty*, 1930s

 By Hang Zhiying (1899–1947) or Zhiying Studio
 Poster, chromolithograph
 H. 78.0 × W. 54.0 cm
 Collection of the Shanghai History Museum

71 *Finishing an Orchid-Water Bath*, 1930s

 By Hang Zhiying (1899–1947) or Zhiying Studio
 Poster, chromolithograph
 H. 78.0 × W. 54.0 cm
 Collection of the Shanghai History Museum

The messages advertised in these two posters are perhaps the least sexually provocative of the group included in this exhibition. Rather, they are representative of the tenets of the short-lived New Life Movement, launched in 1934 by the Nationalist Party in hopes of revitalizing a virtuous Chinese society.[1] Emphasis was placed on 1) physical fitness for both men and women, and 2) a traditional homemaker role for women.[2] Advertising posters such as these were produced en masse to visualize and promote the campaign's platform.

 The poster of the woman lounging seaside (cat. no. 70) falls into the category of sports advertising, as she gives off an air of one at the peak of vitality. She is happy, relaxed, and confident of herself and her station in life—all that can be achieved through a healthy lifestyle. Although such posters were intended to advertise sports and fitness, the women in them are rarely in motion; rather, they are stationary—sitting on the beach or

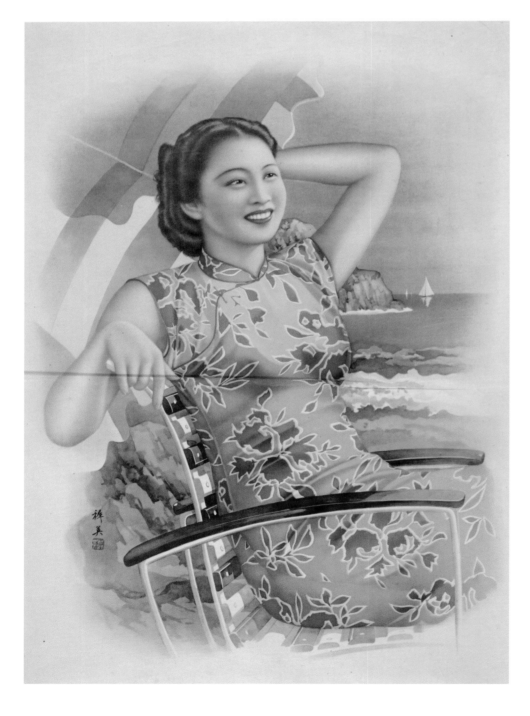

posing poolside[3]—and their "fitness" is implied through physical proximity to the activity. The poster of the woman and child (cat. no. 71) exemplifies advertisements that championed homemaking as the suitable profession for "modern" women.[4] Recalling Confucian ideals, the New Life Movement's message was thus: women had the power to shape the future of the country through keeping a happy home. Such nationalistic sentiments were also echoed in commerce, as women were encouraged to consume (household goods and art, for example) for the good of the country.[5]

The broad, teeth-baring smiles on the women's faces are characteristic of Hang Zhiying's modern beauties.[6] However, although the posters bear his signature, they were just as likely to have come out of his own Zhiying Studio (established in 1925), the most prolific center in Shanghai then for the production of advertisements.[7] The studio was unique in following the purported

business model of Walt Disney's studio: artists were organized into teams that collectively worked on paintings (one artist on the figures and one artist on the setting, for example), and Hang signed his name on the finished pieces.[8] In this way, quality and delivery could be controlled.[9] DC

1 Schoppa, *Modern Chinese History*, 84 and 160.
2 Laing, *Selling Happiness*, 218.
3 Ibid., 219.
4 Ibid.
5 Waara, "Invention, Industry, Art," 78.
6 Cochran, "Marketing Medicine and Dreams," 75–76.
7 Bong, Tong, Ying, and Lo, *Chinese Woman and Modernity*, 163; and Laing, *Selling Happiness*, 203.
8 Cochran, "Marketing Medicine and Dreams," 75.
9 Bong, Tong, Ying, and Lo, *Chinese Woman and Modernity*, 162–163.

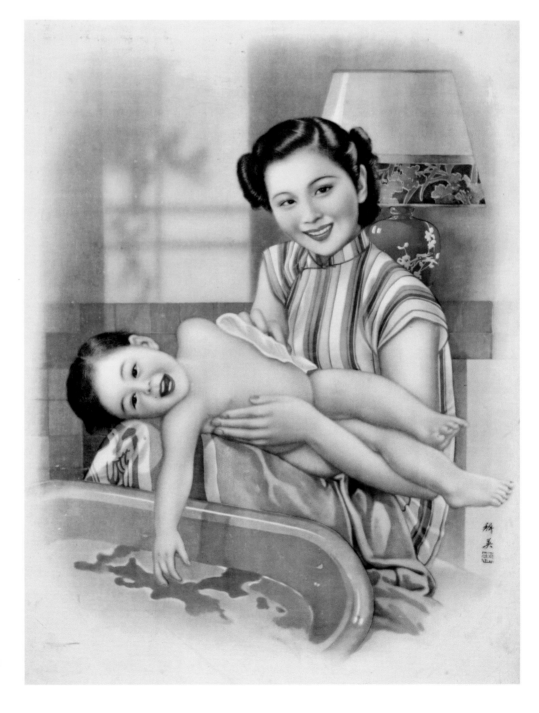

72 *Gliding Like Celestial Beings*, 1930s

Signature of Zhi Yin (dates unknown)

Poster, chromolithograph

H. 77.5 × W. 53.8 cm

Collection of the Shanghai History Museum

A Tianjin newspaper report in 1929 claimed that female same-sex dancing such as the one depicted in this poster was all the rage in Shanghai.[1] Whether or not such a trend existed, a social dancing craze did indeed sweep the city during the 1920s and 1930s. A Western import, social dancing was first regarded as an exotic practice associated with sex;[2] it rapidly gained popularity, particularly in Shanghai. Dance halls (*wuting* or *wuchang*) began to appear in the city in the late 1910s—at the same time as American ones—followed by a surge of new establishments throughout the Foreign Settlements in the 1920s.[3] However, only after 1922 did halls start to accept Chinese clientele.[4] An average dance hall had a small band and "taxi dancers" (*wunü*) or dance hostesses,[5] women such as the four pictured here, who were employed as dancing partners[6] for patrons who had purchased tickets redeemable for dances.[7] Often featured in advertising,[8] the hostesses—the most famous being the MGM Ballroom's Five Tigresses and the Paramount's Lilac Lady[9]—became the public face and the public draw for these establishments, appealing not only to those seeking this new form of entertainment but also to men who sought their sexual favors.[10] DC

1 Laing, *Selling Happiness*, 136.
2 Field, "Selling Souls in Sin City," 104.
3 Henriot, *Prostitution and Sexuality in Shanghai*, 103.
4 Laing, *Selling Happiness*, 135. However, Field gives the later date of 1927 in "Selling Souls in Sin City," 105.
5 Lee, *Shanghai Modern*, 23.
6 Henriot, *Prostitution and Sexuality in Shanghai*, 107.
7 Field, "Selling Souls in Sin City," 109.
8 Laing, *Selling Happiness*, 135.
9 Honig, *Sisters and Strangers*, 21.
10 Laing, *Selling Happiness*, 136; and Zhang Zhen, *Amorous History*, 281.

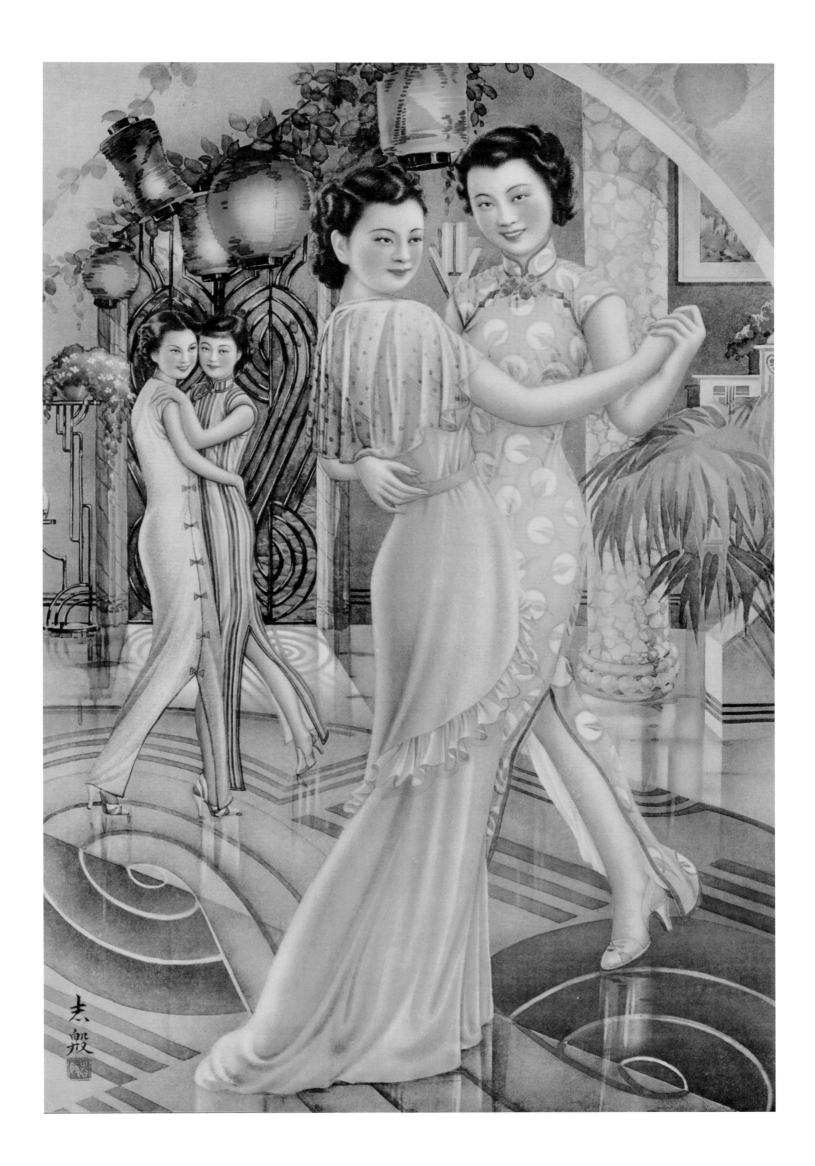

73 Blue-gray medium-sleeved
qipao, 1920s

China
Silk with camel-hair felt lining
H. 123.0 × W. 80.0 cm
Collection of the Shanghai History Museum

74 Rose medium-sleeved *qipao*, 1920s

China
Silk
H. 123.0 × W. 80.0 cm
Collection of the Shanghai History Museum

75 *Qipao*, 1920s

China
Silk
H. 134.0 × W. 42.0 cm
Collection of the Shanghai History Museum

76 Orange short-sleeved *qipao*, 1930s

China
Silk
H. 132.0 × W. 72.0 cm
Collection of the Shanghai History Museum

77 *Qipao*, 1930s

China
Silk georgette and silk cut-velvet
H. 135.0 × W. 61.0 cm
Collection of the Shanghai History Museum

73

The *qipao* (Cantonese: *cheongsam*) was emblematic of "Shanghai style" in the international fashion world from the 1920s to the 1940s, at a time when being "fashionable" (*shimao*) and "modern" (*modeng*) in Shanghai was one and the same.[1] Worn then by wives, mothers, students, workers, and celebrities alike, it remains iconic in present-day imaginations of the city. Although brief (beginning in the 1920s),[2] the garment's history is a complex tapestry of the historical, political, social, and commercial impetuses that similarly shaped other aspects of Shanghai's visual culture. The *qipao* (literally, "banner robe") had Manchu origins[3] but underwent constant style changes within the twenty years of its popularity. In fact, scholars debate on the motivations behind these changes: were they local or global, political or social in nature, or merely driven by capricious whims of fashion and taste?[4] After all, Shanghai was the fashion leader for China, with new trends arriving from Europe and America within a mere two months[5] before eventually filtering into the interior.

The five garments in this exhibition illustrate the variety afforded to shape, pattern, hemline, and sleeve length. Art Deco sensibilities, such as the motifs of bold geometrics, made their way into textile designs[6] as well as architecture (see Nancy Berliner's essay in this volume), and furniture (cat. nos. 44–47); the influences of

Japanese patterns can be discerned in the stylized florals.[7] In shape and fit, there was a marked difference between a 1920s- and a 1930s-style *qipao*: in the 1920s the *qipao* hung from the body in a square, straight line; in the 1930s the *qipao* hugged the figure and often came with one or two slits of varying lengths.[8] DC

1 Lee, *Shanghai Modern*, 5; Ye Xiaoqing, *Dianshizhai Pictorial*, 130; and Dikötter, *Exotic Commodities*, 191.

2 Finnane, "What Should Women Wear?," 9 and 11.

3 Ibid., 9.

4 For example, Antonia Finnane intimates the popularization of the *qipao* with policies of the Chinese Nationalists (Guomindang). See ibid. An association can also be made between the linearity of the *qipao*'s shape and American eugenic design principles of the 1920s–1940s. See Cogdell, *Eugenic Design*.

5 Bao Mingxin, "Shanghai Fashion in the 1930s," 320–321; and Yeh, *Shanghai Splendor*, 62.

6 Erh, *Shanghai Art Deco*, 14; and Yeh, *Shanghai Splendor*, 64.

7 Yeh, *Shanghai Splendor*, 233n38. Japanese silk became the preferred material during the early decades of the 1900s as silk production in Japan became "modernized" and reliably produced superior-quality silks. See Li, *China's Silk Trade*, 83–84.

8 Summarized from Finnane, "What Should Women Wear?," 18–19; Wu Huating, "Shapeless Wives and Mothers," 17–18; and Dikötter, *Exotic Commodities*, 200.

74

75

76

77

Western-Influenced Painting in Shanghai 1945–1980

Chinese artists who returned to Shanghai from their places of refuge following the end of the Japanese occupation in 1945 set about reestablishing as many of the old systems as possible. They brought with them large numbers of artworks created during their years away and were soon busy creating even more.[1] Foreigners also returned, but not in the numbers that had existed prior to 1937. The International Settlement and the French Concession were not reestablished, and Shanghai became a city governed by Chinese.

The period of new hope was brief. By 1946 China had begun to suffer from widespread corruption and rampant inflation. In 1949 these ills and others brought about the establishment of the People's Republic of China. In the first years after the establishment of the People's Republic, Shanghai remained relatively cosmopolitan. According to Li Huayi, who grew up in Shanghai in those years,

> Like now, many foreigners lived there [in Shanghai], but nobody paid much attention to them. The Communist Party did not control things as strictly as they did elsewhere in China. My father even went back and forth from Hong Kong until 1952. We went to church on Sundays and many priests were still in the city. There was bowling at church, and we could play baseball there on Sundays. This situation continued through 1955. Other places had changed long before then, but Shanghai was different.[2]

However, Shanghai's reprieve came to an end. By 1953 many of the city's teaching academies and other institutions dedicated to the visual arts had been moved to Beijing, Hangzhou, or other cities.[3] For most of the three decades that followed Shanghai was subject to the whim of political movements. Even though Mao Zedong spent a considerable amount of time in the city, he seemed particularly intent on destroying its artistic and cultural legacy.

Decentralization of education as part of the Great Leap Forward (1958–1961) gave Shanghai

another chance to be influential in the art world, but this also was short-lived. In September 1965 Mao was in Shanghai establishing a base for his assault on the Chinese Communist Party. He returned to Beijing in 1966 as the Cultural Revolution came into full play. What ensued were "two years of violent change, then eight years of misery."[4] Many artists did not practice; others did and either hid or destroyed their works. Officially the Cultural Revolution promulgated a populist and therefore antitraditional approach to Chinese painting; it also rejected professionalism in many fields, an attitude that had a profound impact on the arts. Art created in Shanghai during the period consisted almost entirely of ephemeral propaganda works.

Li Huayi provides a personal account of being an artist in Shanghai during this period:

> Everything changed; the entire structure of society was different. It was terrifying to own or even to read books since no one knew for certain if any particular book was acceptable to the Red Guard or not. Even if it was, the next day it might be decided that it contained some commentary against the government and possessing it could be disastrous.
>
> During the Cultural Revolution I was a worker artist. I was part of a group of artists who painted what the Party wanted us to paint. Mostly we worked in Soviet Realistic styles using Western media. . . . We didn't receive any training, just a lot of practice. The Party or the Red Guard handed us posters and we reproduced them. Sometimes they wanted us to create new artworks. Of course everything had to be approved by the leadership first. Enormous numbers of paintings were needed and we often did works from the same poster or about the same subject over and over again. Some of the paintings were very large. I soon became very familiar with how the Party wanted the main images to appear—strong and positive for the workers and peasants; cartoon-like and evil for

intellectuals and the targets of the current movement—so the work was routine. . . . As a worker painter I was expected to improve my style through study, even though I was not in school. Every time there was a big propaganda exhibition and we were required to create something new, there was chaos.

One of the ironic things about the Cultural Revolution was, because Western-style painting was used so much for propaganda purposes, many artists began to react against it and to look back to traditional Chinese styles. It seems that during the Cultural Revolution we saw Western-style art everywhere, but usually in association with propaganda or some government project. It did not seem like fine art. Chinese painting seemed like fine art; the only fine art we could turn to.[5]

Even after the end of the Cultural Revolution and the death of Mao, Shanghai remained isolated from most artistic movements; this continued to be true for much of the 1980s.[6] The picture has changed dramatically in the last two decades.

Patronage

Direct commissions of works of art were a rarity for Shanghai painters working in modern Western-influenced styles; most relied on teaching or other forms of employment for their livelihood. This remained true between 1945 and 1949. The changes in 1949 meant that, directly or indirectly, the government became the main patron for the arts and private patronage was virtually nonexistent.

From 1949 to 1980 the publishing industry was one of the main patrons of the arts in Shanghai (see cat. nos. 106–111). On December 31, 1955, the New Art and Shanghai People's Fine Art Publishing House were combined under government control, and private publishers ceased to exist in Shanghai.[7] For the remainder of the period under consideration here, this industry

was an arm of the propaganda bureau of the central government.[8] The commissioned works served purposes other than artistic expression. Nevertheless, many Shanghai artists continued to create views of their city that were not, at least obviously, intended as propaganda. Examples in this exhibition include works by Ni Yide (cat. no. 78), Liu Haisu (cat. nos. 22, 79, and 112), and Ren Weiyin (cat. no. 90).

Academies and Other Teaching Institutions

Art teaching institutions in Shanghai were severely impacted by changes in the political environment during this time. By 1953 the private Shanghai Art Academy and the Suzhou Art Academy (which had moved to Shanghai during the Japanese occupation) were moved out of Shanghai and combined in Wuxi. Several smaller private studios did continue to operate in Shanghai during the 1950s and 1960s.[9] They came to an end with the Cultural Revolution of 1966–1976.

During the Great Leap Forward (1958–1961), oil painting and other forms of Western-influenced art were the most common practiced in Shanghai. Decentralization also allowed for the reemergence of some teaching institutions. The Shanghai Art School is an example; it was founded in March 1959 as part of the Bureau of Light Industry as a technical high school. In 1960 junior college and college programs were added, and the academy was reorganized under the Shanghai Department of Education. However, it did not thrive and was forced to move at least four times in its brief existence.[10] The school was closed after its first college class graduated in 1965.[11] Instruction in the visual arts was extremely limited in Shanghai from the beginning of the Cultural Revolution until the establishment of an art department at Shanghai University in 1983.[12]

Art Societies and Associations

While many of the old art societies had dissolved during the war years, they began to re-form almost immediately after 1945, and others joined them. Before the end of August 1945 members of the Shanghai Industrial Arts Society along with other artists who had worked on propaganda during the war created the Shanghai City Artists' Society (*Shanghai shi huaren xiehui*). During this same period, the Shanghai Society of Nine Artists (*Jiuren huahui*) met monthly to discuss Chinese and Western art; its members included Ni Yide (cat. no. 78) and Guan Liang (cat. nos. 55, 56, and 81).[13] These associations slowly died out after 1949.

Beginning in 1949, the Chinese Artists' Association (CAA) became a primary artistic organization throughout China; Shanghai was no exception. The CAA was a "voluntary" professional organization; most often the salaries of its members were paid by work groups that were directly or indirectly sponsored by the propaganda bureau of the Communist Party.[14] An extreme example of indirect demands on Shanghai members of the CAA occurred during the Great Leap Forward. On March 8, 1958, the Shanghai branch of the association announced it was raising its production plan from 10,000 to 20,000 works. On March 10, fifty-five members who had not gone to labor in the countryside pledged to increase their annual output to 9,200 works and 25 books.[15] These paintings and other works of art were needed for the massive and ever-changing propaganda campaigns of the day. The CAA was a victim of political infighting and was largely destroyed during the first years of the Cultural Revolution.[16]

Galleries and Exhibitions

After the occupying Japanese forces left in 1945, Shanghai artists were hungry to show their works following nine years of exile. They made an effort to recreate the gallery and exhibition scene as it had existed in 1937. The Shanghai Municipal Art Gallery opened in 1947 and hosted two exhibitions that year; most of the featured works were in traditional Chinese mediums.[17] Other galleries showed both Western- and Chinese-style works. Change was evident once the Communist Party took control of Shanghai after 1949. Exhibitions remained popular, but they often served purposes other than artistic expression. In 1950 party officials set up the Shanghai municipality's New Chinese Painting Research Society (*Shanghai shi xinguohua yanjiu hui*), which held its first exhibition in 1951.[18]

Large-scale public exhibitions frequently occurred during the Cultural Revolution. One of the largest and most influential hosted in Shanghai was the 1967 *Long Live Mao Zedong's Thought*. The national exhibition *Long Live the Victory of Chairman Mao's Revolutionary Line* opened at the Chinese National Art Gallery on October 1, 1967, and toured the country. It featured sixteen hundred works; 60 percent were by workers, peasants, and soldiers, the other 40 percent most likely by professional artists.[19] For the exhibition and the years immediately following, Mao became the central figure in innumerable paintings (see cat. no. 84).[20] Certain paintings created during this period, usually anonymously, served as models for popular posters (see cat. nos. 106–111). These posters were distributed throughout China and served as models for paintings done by local worker units. It is estimated that one such painting served as a model for as many as 2 billion works.[21]

Where Artists Studied

Beginning in June 1950, opportunities for Chinese artists to study in the West were severely limited following China's participation in the Korean War. This development coincided with closer philosophical and political ties between China and the Soviet Union. In 1955 the Chinese officially adopted Soviet Socialist Realism as the style to be taught at the national art schools.

This style, based on the teachings of the Russian artist Pavel Petrovich Chistiakov (1832–1919), focused on "the ability to create a believable representation of a three-dimensional subject on paper through observation of its planes and tonalities of dark and light."[22] During the years that followed, numerous Chinese artists traveled to Russia, including a small number of Shanghai-based artists, Guan Liang (cat. nos. 55, 56, and 81) among them. Others, such as Yu Yunjie (cat. nos. 82–85), trained at the National Central Art Academy under the Soviet artist Konstantin Maksimov.[23] In general, the major centers for art education were outside of Shanghai and few Shanghai artists had national influence during this period; therefore relatively few traveled abroad.

The years 1959–1961 have been called the "Three Disaster Years," as much of China suffered from famine, drought, and flood. Border disputes also broke out with Russia and India, and China became even more isolated. During the period of nationalism that followed, few Chinese artists had the chance to study in foreign countries.[24] This lack of opportunity remained the case through most of the Cultural Revolution.

Michael Knight

NOTES

1 Sullivan, *Art and Artists*, 115.
2 Knight and Li Huayi, *Monumental Landscapes*, 29.
3 Sullivan, *Art and Artists*, 238.
4 Ibid., 151.
5 Knight and Li Huayi, *Monumental Landscapes*, 37–40.
6 Sullivan, *Art and Artists*, 238.
7 Andrews, *Painters and Politics*, 129.
8 Ibid., 202.
9 Ibid., 216.
10 Ibid., 222–223.
11 Ibid., 224.
12 Sullivan, *Art and Artists*, 238.
13 Ibid., 114.
14 Andrews, *Painters and Politics*, 227.
15 Ibid., 226.
16 Ibid., 319.
17 Sullivan, *Art and Artists*, 115.
18 Ibid., 132.
19 Andrews, *Painters and Politics*, 337.
20 Sullivan, *Art and Artists*, 152.
21 Pollack, "Art and China's Revolution," 82.
22 Andrews, *Painters and Politics*, 136.
23 Ibid., 224.
24 Ibid., 203.

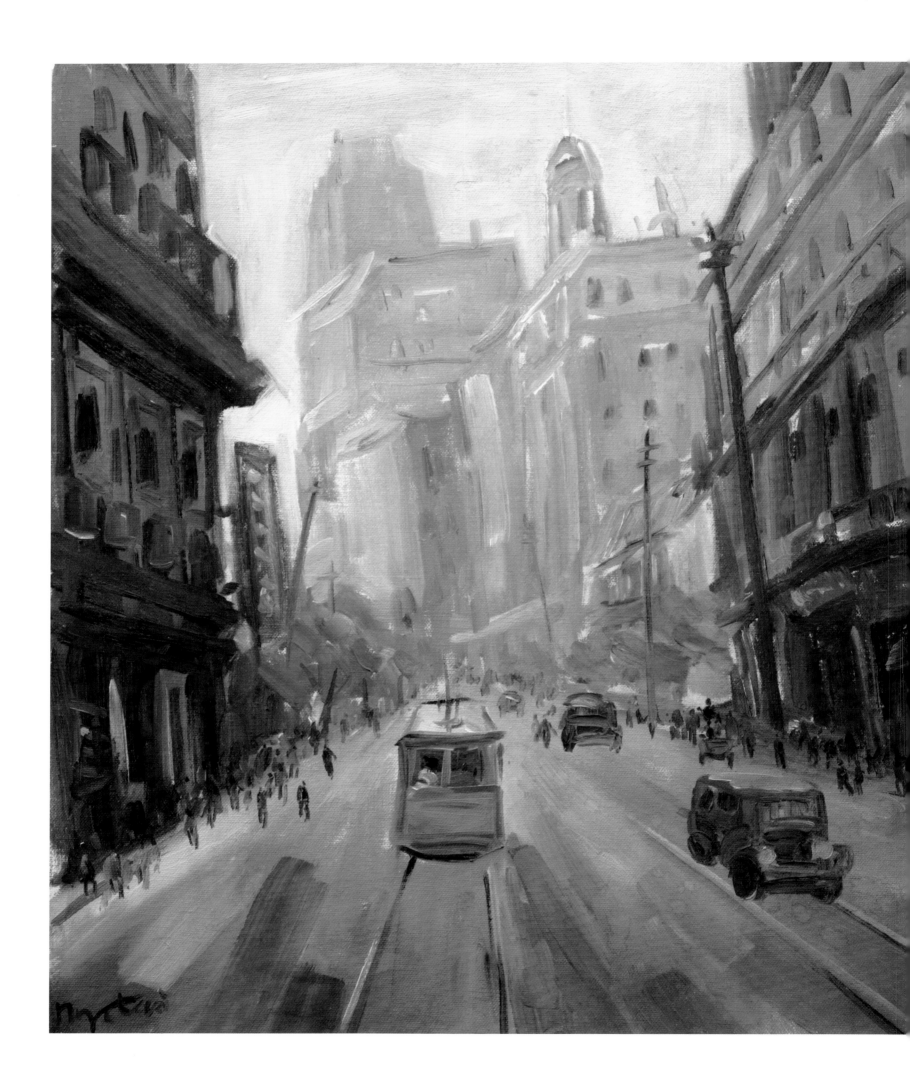

Nanjing Road, 1947

By Ni Yide (1901–1970)
Oil on canvas
H. 44.5 × W. 53.3 cm
Private collection

Ni Yide was among the most avant-garde Chinese painters work-
ing in Western-influenced styles in the early twentieth century.
Born in Hangzhou in 1901, he began his study of Western art
theory and practice at the Shanghai Art Academy in 1919. He
later studied at the Tokyo Academy and the Kawabata Academy
in Japan. Upon his return to Shanghai, Ni met with other art-
ists trained in Tokyo and Paris to form the Storm Society, whose
stated purpose was to introduce a modern art movement.[1]

The Storm Society ended in 1935, but Ni remained influ-
ential in pro–Western art movements. He was also involved in
political reform and eventually the Communist Party. Ni was
one of the artists who worked on anti-Japanese propaganda art
during the occupation, and in August 1945 he became a member
of the Shanghai Industrial Arts Society, the Shanghai City Art-
ists' Society, and the Shanghai Society of Nine Artists. The latter
met monthly to discuss Chinese and Western art; Guan Liang
(cat. nos. 55, 56, and 81) was another member.[2] By 1949 Ni was
among the group of artists who ran the East China Division of
the National Academy of Arts in Hangzhou,[3] and in 1953 he was
assigned to a teaching post at the Central Academy of Fine Arts
in Beijing.[4] Despite his long-term ties to the Communist Party,
Ni suffered during the Cultural Revolution and died in 1970 as a
result of mistreatment.[5]

This work is dated 1947, two years after the end of the
Japanese occupation of Shanghai, a time when Shanghai's (and
China's) hope of regaining its past glory was beginning to dim.
It shows a scene along Nanjing Road, the center for shopping
and entertainment in Shanghai. Known in the 1930s as one of
the World's Seven Great Roads, Nanjing Road connected the
Bund to the racetrack (now People's Park) and points beyond
and had come to equal the Bund as one of the most frequently
represented scenes in Shanghai (see also cat. no. 62).

Ni chose a low point of view and a somber palette to depict
this scene. A truck and streetcar are coming straight down the
street. The truck is of a type that must have been common fol-
lowing the end of the Japanese occupation. People are shown as
dark, solitary silhouettes, and the buildings seem to close in over
the street. The overall feel is much darker than in earlier scenes of
Shanghai painted by this artist. MK

1 Andrews, *Painters and Politics,* 62.
2 Sullivan, *Art and Artists,* 114.
3 Ibid., 131.
4 Andrews, *Painters and Politics,* 56.
5 Sullivan, *Art and Artists,* 154.

The Bund, 1956

By Liu Haisu (1896–1994)
Oil on canvas
H. 46.3 × W. 69.0 cm
Private collection

Liu Haisu was perhaps the leading innovator in Western-influenced
art in China during much of the twentieth century. Born to a wealthy
family in Wuxing, Jiangsu Province, in 1896, he first attended a private
school that provided classical Chinese education. At the age of fourteen
he enrolled in an oil painting school in Shanghai run by Zhou Xiang and
began a lifelong love affair with Western-style art.[1] Liu was close to the
great reformer Kang Youwei (see the text of cat. no. 53) and was able to
see copies of important early European masters in Kang's collection.[2]

Liu's first opportunity to study abroad came with a trip to Tokyo in
1918. Upon his return the following year, Liu helped found the Heavenly
Horse Painting Society (*Tianma huahui*), one of the earliest societies in
Shanghai dedicated to promoting modern art. The society held annual
exhibitions from 1920 to 1929.[3] Liu visited Japan again in October 1920
to attend the opening ceremony of the Imperial Academy of Fine Arts.
Upon his return to China he wrote the *Biography of Jean François
Millet* and the *Biography of Paul Cézanne*. He returned to Japan in both
1927 and 1928 and in 1929 went to Europe. After visiting the art scenes
in France, Germany, Italy, and Belgium, he returned to Shanghai in 1932.
He was in Europe again between 1933 and 1935.

Liu Haisu was a great educator; he started his first art school with
two companions in 1912 when he was only sixteen. It came to be known
as the Shanghai Art Academy and is considered by some to be the first
school of fine arts in modern China. Until it was moved from Shanghai
in 1953, Liu was actively involved with the private academy, where he
introduced such "radical" Western practices as the use of nude models.
As head of this academy, Liu was the leader of the Shanghai art scene in
the 1920s and 1930s.[4]

In 1953 Liu was named head of a new school in Wuxi. This school
was a combination of the Shanghai Art Academy and the Suzhou
Academy of Art, both of which were forced to move to Wuxi, and the
art department of Shandong University. Liu ultimately ended up in the
art department of the Nanjing Academy of Arts. While Shanghai did
not regain its position as a leader in modern Chinese art, Liu remained
a great fan of the city. In 1957 he was condemned at a meeting of the
Jiangsu Federation of Literary and Art Circles; his primary offense was
refusing to move the East China Arts Academy from Nanjing to the
northwest city of Xi'an. In May 1957 he spoke in favor of moving the
school back to Shanghai, stating, "The best art in the world is not Soviet
art; Soviet art has no stature on the world art scene."[5]

Always irrepressible, Liu naturally found himself in trouble during
the Cultural Revolution. His main crime: on the back of one of the clip-
pings he had saved about his past, Red Guards found an article critical of
Jiang Qing when she had been a Shanghai starlet. He survived, however,
and was ninety-eight years old when he died in 1994.

For much of his career, Liu was a competitor of the more conser-
vative Xu Beihong. Liu liked Cézanne, Picasso, and other innovative
European artists of the time; Xu did not. Liu believed in modernism;
Xu was strictly academic in his choices of European styles.

Artistically, Liu was a fan of van Gogh and much influenced by
his styles,[6] but he was also accomplished in the traditional Chinese

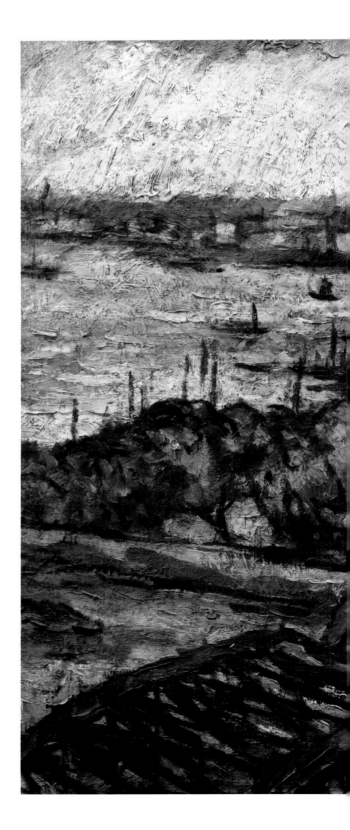

medium of ink on paper, following the manner of the great seventeenth- and early eighteenth-century eccentrics Shitao and Bada Shanren[7] (see cat. no. 22). This work is dated 1956, when Liu was in constant trouble but busy painting as well.[8] Its twisting, dynamic forms and vibrant colors reveal the artist's continued interest in van Gogh.

Liu has chosen to show a view across what is now known as the Garden Bridge and down the length of the Bund. In 1906 the Shanghai Municipal Council replaced the wooden bridge over Suzhou Creek with one made of the most modern material available—steel. Deeper in the painting are the towers of the Bank of China Build-

ing and Sassoon House. A few small craft appear moored along the Bund. In the lower right corner the artist has signed the work with the Chinese characters *Haisu* and the date 1956. MK

1 Sullivan, *Art and Artists*, 72.
2 Ibid., 73.
3 Ibid., 45.
4 Andrews, *Painters and Politics*, 53–54.
5 Ibid., 198–199.
6 Sullivan, *Art and Artists*, 73.
7 Ibid., 74.
8 Ibid., 74–75.

80 *Shanghai Street*, 1959

By Pang Xunqin (1906–1985)
Oil on canvas
H. 52.5 × W. 67.5 cm
Private collection

Like Ni Yide (cat. no. 78), Pang Xunqin was a leader among avant-garde artists in Shanghai. Born in Changshu, Jiangsu Province, in 1906, he began to study oil painting at an early age and was one of the fortunate few who were able to study in Europe, spending the five years from 1925 to 1930 in France. In 1930 he returned to Shanghai, where he became an active member of a number of art societies promoting Western styles. He and Ni Yide were among the founding members of the Storm Society in 1931. In 1936 Pang accepted a teaching post at the National Academy of Arts in Beijing; he escaped the Japanese invasion of that city in 1937 with his family and a few paintings. During the Japanese occupation he spent time in Kunming, Yunnan Province—where he studied the art of the local minority people—and in Chengdu. After the occupation ended he taught in Canton and in 1949 was given a post at the East China Division of the National Academy of Arts in Hangzhou. By 1953 he was back in Beijing at the Central Academy of Fine Arts and was involved in the founding of the Central Academy of Arts and Crafts.[1]

During his later career Pang was beset by issues stemming from political movements. Like many influential and highly visible artists, he was singled out during the anti-rightist campaigns of 1957. He attempted to hide the severity of his situation from his wife, who at the time was recovering from heart problems. Unfortunately, she overheard a broadcast denouncing him and suffered a fatal heart attack.[2] Although he continued to teach in the following years, he was barred from official exhibitions.

Perhaps fearing similar reprisals, Pang destroyed many of his own works at the beginning of the Cultural Revolution in 1966.[3] He was "rehabilitated" in 1972 and provided a painting for export under Zhou Enlai's attempts to improve China's image and to bolster foreign exchange. Unfortunately, the artists involved became embroiled in political maneuvers by Jiang Qing, and many of Pang's remaining works were destroyed by the Red Guard.[4] He survived until 1985.

This quiet scene of a Shanghai street in winter was painted during the time Pang was labeled as a rightist and only two years after his wife's death. Perhaps tellingly, the painting features an adult who appears to be male and two children on a snow-covered street outside a gated compound. Unlike many of his earlier works, which often were in Cubist, Fauvist, or other leading contemporary European styles, this one shows a fairly conservative Impressionist manner. The artist dated the painting and added a version of his seal in black at the lower right. MK

1 Shen, "Lure of the West," 173.
2 Andrews, *Painters and Politics*, 197.
3 Shen, "Lure of the West," 173.
4 Andrews, *Painters and Politics*, 154.

Bridge on Henan Road, 1950s

By Guan Liang (1900–1986)
Oil on canvas
H. 26.0 × W. 33.5 cm
Private collection

In this work Guan Liang (see also cat. nos. 55 and 56)
has chosen a view of Suzhou Creek near the Henan
Road Bridge, with the Shanghai General Post Office in
the background. Suzhou Creek runs through much of
Shanghai before joining the Huangpu River at the Bund.
In the past it was crowded with small boats, many of
which served as residences; a few of these boats appear
in the foreground. First built in 1875, the Henan Road
Bridge is one of many that crossed Suzhou Creek. To the
east is the Sichuan Road Bridge, and on the north bank
between the two is the Shanghai General Post Office.
Designed by Stewardson and Spence, and built between
1922 and 1924, the post office is in classical Beaux-Arts
style; the artist has shown the building's two main
facades with their three-story Corinthian columns and
the clock tower. Fauvist styles influenced his simplified
and expressive forms, broad, flat strokes of color, and
bold palette. MK

82 *Our Land, Our People*, 1948

By Yu Yunjie (1917–1992)
Oil on canvas
H. 65.0 × W. 95.0 cm
Collection of the Shanghai Art Museum

83 *Peeling Corn*, 1963

By Yu Yunjie (1917–1992)
Oil on canvas
H. 80.0 × W. 120.0 cm
Collection of the Shanghai Art Museum

84 Mao Zedong, 1968

By Yu Yunjie (1917–1992)
Oil on canvas
H. 103.3 × W. 71.6 cm
Collection of the Shanghai Art Museum

85 *Studying Industry*, 1974

By Yu Yunjie (1917–1992)
Oil on canvas
H. 190.0 × W. 113.0 cm
Collection of the Shanghai Art Museum

Born in Changzhou, Jiangsu Province, and a long-time resident of Shanghai, Yu Yunjie is best known for his work as a staff artist at the Shanghai People's Fine Art Publishing House.[1] He completed his schooling during the Japanese occupation and graduated in 1941 from the art department of the National Central University while it was temporarily located in Chongqing. In 1945 he began his teaching career at the Shanghai branch campus of the Suzhou Academy of Art. He remained there until 1953, when the academy, the Shanghai Art Academy, and the art department of Shandong University were combined as the Huadong Art Academy and moved to Wuxi.[2]

In 1956 Yu enrolled as a special student in a refresher course in the oil painting department of the National Central Art Academy, studying under the Soviet artist Konstantin Maksimov; he was the only student from Shanghai given this honor. He later served as an advisor with the Shanghai Institute of Oil Painting and Plastic Arts and the art department of Shanghai Jiaotong University.[3] Yu was one of many artists singled out during the anti-rightist campaigns and as a result would have been barred from official exhibitions until 1962.[4] Once "rehabilitated," Yu remained active in Shanghai throughout the Cultural Revolution.

83

The first work illustrated here was completed in 1948, early in Yu's career while he was teaching at the Suzhou academy. *Our Land, Our People* depicts a row of older men in traditional Chinese garb who are clearly lamenting something; since many have their eyes directed to a point below and in front of them, the object of their grief may be there. Although the painting contains no setting other than the men themselves, Yu captured the details of their faces and their robes and effectively communicated their sorrow.

Peeling Corn, the second work, is dated 1963, after Yu had completed his refresher course with Maksimov and after he had been "rehabilitated" from being a rightist. During this time of the Great Leap Forward, oil painting in Soviet Socialist Realist styles dominated the art scene in China's major cities. This work shows a group of peasant women sitting on the ground, stripping the shucks from their crop of corn. As dictated by the tenets of Soviet Socialist Realist paintings, this work clearly tells a story. Although the figures are not heroic in stance, as are many in this genre, they are clearly happy. Certain policies of the Great Leap Forward, combined with a string of natural disasters, led to widespread famine in many parts of China. The "Three Disaster Years," 1959–1961, were particularly difficult.

Scenes of well-fed peasants with bountiful crops were a response.

After Mao Zedong staged his comeback to power within the Chinese Communist Party in 1965, the Cultural Revolution forcefully took hold of China. Having found that art could serve as a powerful propaganda tool, Mao and his supporters had exhibitions organized around the country extolling his virtues, including the 1967 *Long Live Mao Zedong's Thought*. In the years that followed, the "immaculate" Mao became the central figure in innumerable paintings.[5] The third work by Yu Yunjie, a portrait of Mao, is from this period. Juzi Zhoutou, a small island in the Xiang River near Changsha in Hunan Province, serves as backdrop. Much of the painting is impressionistic, with the focus on Mao's smiling and benevolent face.

"Students" were primary players in many of the events of the Cultural Revolution and frequently served as the theme for artworks of the period. In the fourth Yu Yunjie painting shown here, which is dated 1974, the artist used the low point of view and dramatic lighting he learned from his studies of Soviet Socialist Realism to create a heroic image of two such students. The dark environment with a single source of glowing light, the students' hats and heavy clothing, and the tools

they hold along with the sketchy background scene indicate their involvement with the urban working class—perhaps in a smelter or iron mill. The red characters on the jacket of the nearer figure read, *anquan shengchan*, which means "safety in production." Seeking self-reliance through the development of heavy industries such as steel played an important role in both the Great Leap Forward and the Cultural Revolution. MK

1 Andrews, *Painters and Politics*, 433n130.
2 Ibid., 54–55. Additional biographical information was provided by the Shanghai Art Museum.
3 Andrews, *Painters and Politics*, 224.
4 Ibid., 198.
5 Sullivan, *Art and Artists*, 152.

84

85

86 *Power Distribution Worker*, 1957 or 1959

By Zhang Longji (born 1929)
Oil on canvas
H. 99.0 × W. 89.0 cm
Collection of the Shanghai Museum

Born in Shengxian, Zhejiang Province, in 1929, Zhang Longji began his art studies in Shanghai and then graduated from the drawing department of Huadong (East China) Art Academy in 1953, the year after the academy had come into existence. Located in Wuxi, the Huadong was a combination of the previously private Shanghai Art Academy and Suzhou Academy of Art and the art department of Shandong University. For many years after graduation Zhang taught at the Huadong and at the Shanghai Fine Arts Training School. He was later attached to the Shanghai Institute of Oil Painting and Plastic Arts.

Like many works of the period leading up to and during the Cultural Revolution, this painting presents an image of a common laborer, in this case someone working at a power distribution plant. However, rather than showing the heroic peasants and workers that were then a staple (see Yu Yunjie's *Studying Industry*, cat. no. 85), Zhang has chosen to portray a sympathetic and physiologically believable woman. Looking rather tired, she sits staring into a source of light—perhaps the furnace that provides the power. The image is not idealized and is depicted with a dark palette, which enforces its somber, reflective tone. Many of the details are developed with broad, impressionistic applications of pigment, drawing the viewer's eye to the figure and the texture of the rough wood railing that frames her. MK

Celebrating National Day, 1959

By Feng Zikai (1898–1975)

Hanging scroll, ink and colors on paper

H. 67.2 × W. 33.3 cm

Collection of the Shanghai Museum

Feng Zikai is best known as a printmaker but was also an accomplished painter in ink and colors. Born north of Hangzhou, Zhejiang Province, Feng graduated from Hangzhou First Normal School and then studied music and art in Japan. Like many of his contemporaries, he studied at the Kawabata Academy of Painting in Tokyo, but his career went in an entirely different direction than most. While in Japan he discovered *manga*, Japanese comics, and developed his *manhua* from that concept. As a painter, he sought "a painting style that employs a simplified brushwork to express meaning."[1]

When Feng returned to Shanghai from Japan, he served as an editor at the Kaiming Book Company in Shanghai, and his works began to be published. He continued teaching and publishing and after 1949 held various posts, including chairman of the Shanghai City Artists' Society.

This painting, which shows a peasant family enjoying fireworks, exemplifies Feng's approach of seeking childlike simplicity in his work.[2] Minimal strokes outline the figures and provide only essential details; solid colors fill the family's clothing. The painting was completed in 1959 to celebrate the tenth anniversary of the founding of the People's Republic of China. The calligraphy at the top is an eighteen-sentence poem entitled "Celebrating a Thousand Autumns—Grand Ceremony on National Day for Tenth Anniversary" that describes spectacular affairs on October 1, 1959. Most likely the description is highly exaggerated. The "Three Disaster Years," which began in 1959, saw drought, flood, and mismanagement as well as border disputes. It was a period of strident Chinese nationalism,[3] but also of extremely curtailed means. The *Third National Art Exhibition*, scheduled to open in October 1959 as part of the tenth anniversary, had to be postponed. Finally held in the summer of 1960, it was called the *Great Leap Forward Exhibition*.[4] MK

1 Fong, *Between Two Cultures*, 122–129.

2 Ibid., 129.

3 Andrews, *Painters and Politics*, 203.

4 Ibid., 205.

174

88　*Early Dawn Illuminates
Military Exercises*, 1964

By Qian Shoutie (1896–1967)
Ink and colors on paper
H. 105.0 × W. 69.0 cm
Collection of the Shanghai Art Museum

Qian Shoutie is best known for his works in traditional
Chinese mediums and formats (*guohua*). Born in
Wuxi in 1896, he spent much of his early career at
the Shanghai Art Academy. Like many of the artists
discussed here, Qian studied and spent a number
of years in Japan. He was among a group of twenty
traditional Chinese artists who made a visit in 1931
organized by Wang Zhen (cat. no. 17).[1] He also lived
and worked in Japan between 1935 and 1942—years
when Japan's territorial ambitions led it to occupy
much of China, including Shanghai. By 1949 he
was back in Shanghai painting at the Shanghai Art
Academy.

　　Dated 1964, three years before Qian's death, this
work presents a scene of Shanghai from a very high
perspective. In the foreground is a section of residential
buildings with the red roofs and whitewashed walls
typical of architecture built during the years Shanghai
was a treaty port—perhaps the old French Concession.
Beyond are the large commercial and office buildings
of the Shanghai core. A wide avenue that supports an
enormous crane separates the two areas. On the avenue
march rows of tiny figures representing the military
exercises that are the theme of this painting. The title
of the work along with the artist's signature and date
appear in the upper right-hand corner.　MK

1　Sullivan, *Art and Artists,* 14.

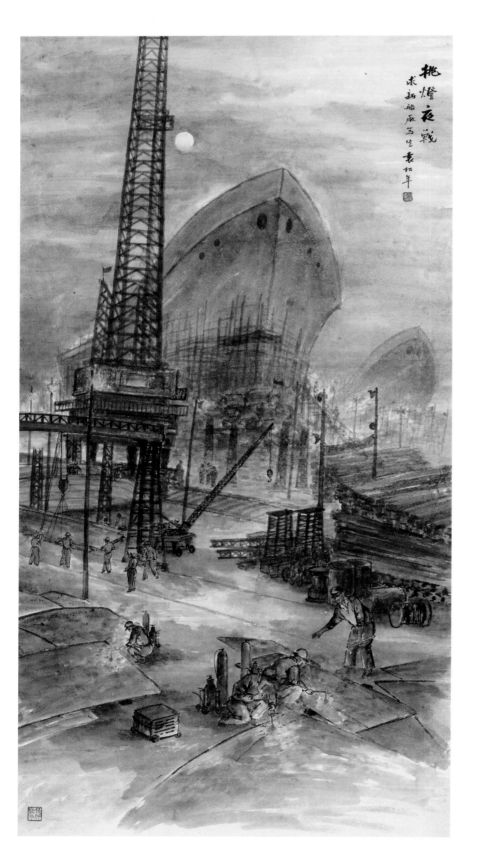

89 *Working by Lamplight,* 1950–before 1966
By Yuan Songnian (1895–1966)
Hanging scroll, ink and colors on paper
H. 126.0 × W. 65.8 cm
Collection of the Shanghai Museum

Born in Fanyu, Guangdong Province, in 1895, Yuan Songnian graduated from St. John's University in Shanghai. St. John's, a missionary school founded by Americans, was known to be a place only the very wealthy could afford to attend. Although his background as a graduate of an American Christian university would have made him unacceptable for many positions in the art organizations of the People's Republic of China, he continued to be a force in the Shanghai art scene after 1950, teaching at the Shanghai Chinese Painting Academy and serving as a member of the Shanghai branch of the Chinese Art Institute and as a fellow at the Shanghai Culture and History Library. He died in Shanghai just prior to the beginning of the Cultural Revolution.

Yuan began his artistic career as a Western-influenced oil painter but later focused on traditional Chinese mediums and formats (*guohua*). He is one of many artists who sought to combine elements of both in a new style. He was also known for his fountain-pen calligraphy and for a new form of poetry.

Although it is not dated, this work must have been completed in the late 1950s or early to mid-1960s and reveals Yuan's efforts at blending Chinese and Western styles. The work is in the traditional Chinese medium of ink and light colors on paper and is in the hanging-scroll format. However, rather than the timeless landscape of Chinese tradition, this painting shows workers at a shipyard and is very much about its time. It also incorporates a Western sense of three-dimensionality and depiction of forms showing the effects of natural light.

Shanghai was a major center of ship production beginning in the 1950s, and this scene shows shipbuilders working through the night to complete their enormous craft. Yuan made a close observation of detail, including both arc and acetylene welders, various types of cranes and scaffolds, and the general clutter of a large working shipyard. The Shanghai shipyards are being moved, and the land they occupied is currently being prepared to accommodate the World Expo of 2010. **MK**

90 *Huaihai Road,* 1970s–1980s

By Ren Weiyin (born 1918)
Enamel on board
H. 25.0 × W. 36.0 cm
Collection of the Shanghai Art Museum

Ren Weiyin was born in Kunming, Yunan Province, in 1918 and started to study at the Shanghai New China Arts School (*Shanghai xinhua yishu zhuke xuexiao*) in 1936.[1] After teaching at the Lu Xun Academy in Shenyang, Liaoning Province, he returned to Shanghai in the 1950s and early 1960s to manage a private teaching studio.[2]

The artist has chosen to depict a sunny corner of Huaihai Road, one of Shanghai's major thoroughfares. The street is lined with a mix of residential buildings and shops with awnings, carryovers from the time of the foreign concessions. The red leaves and bare branches of the ubiquitous sycamores and the low angle of sunlight, along with the yellowish tones, indicate a late autumn setting. The Impressionist-influenced style of this work was popular with oil painters in Shanghai from the 1920s to the 1980s. The artist's name appears on the seal in the lower left corner of the painting.

Clues to the date of this painting are to be found in the content. It clearly shows a time before the beginning of the frenetic rate of development in Shanghai; Huaihai Road now has multiple car-filled lanes and is lined with large modern buildings. However, this quiet scene with its mix of small businesses and homes would not have been a suitable subject for painting during the Cultural Revolution. The most likely date therefore is around 1980. MK

1 Biographical information was provided by the Shanghai Art Museum.
2 Andrews, *Painters and Politics*, 449n59.

A Public Art Movement in Shanghai

While arguably the painted mural was synony-mous with New Deal art in Depression-era Amer-ica,[1] the woodcut (*muke*)[2] became *the* medium propelling a public art movement in China in the 1930s. Centered in Shanghai, the Chinese mod-ern woodcut movement was spearheaded by the renowned writer and editor Lu Xun (1881–1936), who upheld it as a modern "public art" (*dazhong yishu*).[3]

Woodblock printmaking has a long history in China, but it was not traditionally regarded as an art form, since its production process involved different artisans executing design, cut, and print.[4] The woodcut form of the 1930s, how-ever, was regarded as art primarily due to craft: the individual artist now executed all the steps of designing, cutting, and printing[5]—hence its official name of "creative woodcuts" (*chuangzuo muke*), a term bespeaking Japanese inspiration.[6] In Japan the creative print (*sōsaku-hanga*) move-ment began in 1904[7] with artists who embraced the Western art ideal of the print's capacity for personal expression.[8] It reached Shanghai around 1930 through Lu Xun,[9] who also introduced to Chinese audiences woodcuts from England, France, Germany, Russia, and the United States.[10]

Influenced by such contemporary trends as German Expressionism, American Regionalism,[11] and Russian Socialist Realism,[12] the Chinese woodcut garnered a similar mission for captur-ing societal ills and furthering a public cause. Encouragement was found domestically as well; beginning in 1912, the Nationalist government adopted the discourse of "aesthetic education" (*meiyu*) and subsequently sponsored develop-ments of the fine arts.[13] Within this supportive environment, woodcut artists increasingly pur-sued Socialist agendas in their prints. The nature of the medium also enabled public appreciation: it was reproducible, affordable, and mobile. In opposition to the concurrent Western-style oil-painting movement (see the essay "Western-Influenced Painting in Shanghai, 1910–1945" in this volume), artists of the modern woodcut movement asserted that the woodcut could best serve "the people," the urban proletariat and illiterate peasantry[14] who suffer the most in a modernizing society such as Shanghai.

Dany Chan

NOTES

1 Taylor, *American-Made,* 273–274.

2 There is a technical difference between a "woodcut" and a "wood engraving": a woodcut is carved along the natural grains of the wood, while an engraving utilizes the cross-cut end grain. See Tang, *Origins of the Chinese Avant-Garde,* 84.

3 Ibid., 1.

4 Barker, "Muban Foundation," 17.

5 Ibid., 17; and Shen, "Modernist Woodcut Movement," 266.

6 Tang, *Origins of the Chinese Avant-Garde,* 82.

7 Merritt, *Modern Japanese Woodblock Prints,* 109; and Tang, *Origins of the Chinese Avant-Garde,* 82.

8 Merritt, *Modern Japanese Woodblock Prints,* 3.

9 Shen, "Modernist Woodcut Movement," 268. Print-making exchanges between China and Japan ceased after the Japanese invasion of Shanghai in 1936–1937. See ibid., 264; and Tang, *Origins of the Chinese Avant-Garde,* 261n63.

10 Tang, *Origins of the Chinese Avant-Garde,* 84.

11 Taylor, *American-Made,* 273.

12 Sullivan, *Meeting of Eastern and Western Art,* 183.

13 Tang, *Origins of the Chinese Avant-Garde,* 3 and 12.

14 Sullivan, *Meeting of Eastern and Western Art,* 182–183.

91 *Sprouts Monthly* 1 (1930)

Edited by Lu Xun (1881–1936) and Feng Xuefeng
 (1903–1967); published by Guanghua Book Company,
 Shanghai
Bound volume
H. 20.7 × W. 15.3 × D. 1.3 cm
Collection of the Lu Xun Memorial Hall

Established and coedited by Lu Xun,[1] *Sprouts Monthly* was a publication of the League of Left-Wing Writers (*Zuolian*). The league was inaugurated in Shanghai in March 1930[2] and comprised nearly three hundred experienced and popular writers and editors. So influential were the league's publications that the Nationalist government created a new code of censorship in December 1930 in order to temper their influence.[3] *Sprouts Monthly* primarily served as a vehicle for league members' own work and offered space for translation of Marxist and Soviet texts.[4] This inaugural issue includes a report on

the February 16th meeting that eventually led to the formation of the league. It was described as a "seminar of the participants of the modern literary movement in Shanghai."[5] DC

1 Wong, *Politics and Literature in Shanghai*, 62; and Tang, *Origins of the Chinese Avant-Garde*, 100.
2 Wong, *Politics and Literature in Shanghai*, 51.
3 McDougall and Louie, *Literature of China*, 25.
4 Ibid.
5 Wong, *Politics and Literature in Shanghai*, 51.

92 *October*, 1933

Translated by Lu Xun (1881–1936); published by
 Shenzhou Guoguang Press, Shanghai
Bound volume
H. 18.8 × W. 13.1 × D. 1.2 cm
Collection of the Lu Xun Memorial Hall

The renowned bookbinder and cover designer Qian
Juntao (1906–1998)[1] adapted one of his prints for the
cover of this translation of a Russian novella. Translated
by Lu Xun, *October* was written by A. S. Yakovlev (1886–
1953) and first published in 1923.[2] The story is a fictional
account of the Socialist revolution of October 1917 in
Moscow as seen through the eyes of a confused young
worker. After the overthrow of the Romanov dynasty,
the conflict ensued between the Whites (capitalists)
and Reds (socialists), resulting in the victory of the
Reds and the beginning of a Lenin Soviet Russia.[3]
 Qian's print for the novella's cover captures this
class-based conflict through choice details. Within a
spare setting, two men are figured: one in a hard hat, rep-
resenting the Whites (the capitalists and the traditional
elites), peers from his hiding place, waiting to surprise
the second man, who with his soft hat represents the
Reds (the socialists, the "industrial proletariat,"[4] and the
poor peasantry). The men appear equally armed. DC

1 China Guide Corporation, "Qian Juntao."
2 Freeborn, *Russian Revolutionary Novel*, 129.
3 Ibid., 65–67.
4 Ibid., 65.

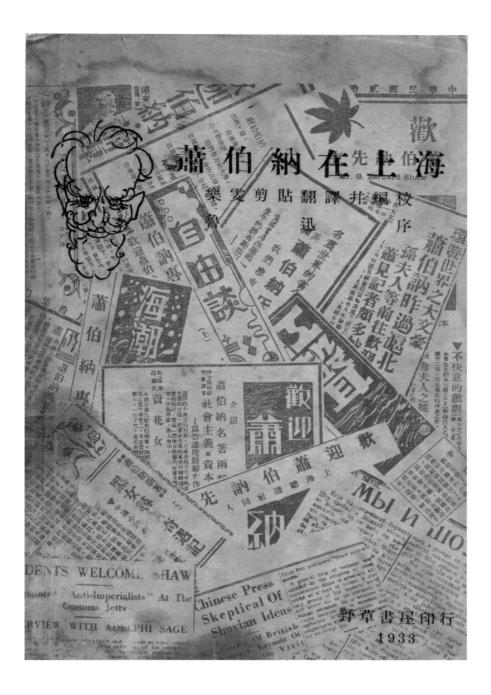

93 *George Bernard Shaw in Shanghai*, March 1933

Compiled by Lu Xun (1881–1936) and Qu Qiubai
 (1899–1935); published by Wild Grass Publishing
 House, Shanghai
Bound volume
H. 20.8 × W. 13.5 × D. 0.7 cm
Collection of the Lu Xun Memorial Hall

For this publication, Qu Qiubai assisted Lu Xun in compiling
numerous publications relating to the visit of George Bernard
Shaw (1856–1950) to Shanghai in February 1933.[1] The cover
appropriately reproduces a montage or collage of the various
headlines. So popular was the British playwright (and Fabian
Society member) among Shanghai's left-wing society that his
visit turned into a major cultural event, bringing together
such names as Cai Yuanpei, Song Qingling, Lu Xun, and
the widow of Sun Yat-sen.[2] DC

1 Gongyi Shuku, "Lu Xun."
2 Tang, *Origins of the Chinese Avant-Garde*, 146.

94　*Woodcut World* 1 (April 15, 1936)

Edited by Tang Yingwei (born 1915);
　　published by Modern Prints Society, Guangzhou
Bound volume
H. 26.1 × W. 19.2 × D. 0.5 cm
Collection of the Lu Xun Memorial Hall

This copy of the inaugural issue of *Woodcut World* has a handwritten inscription by the journal's editor, Tang Yingwei, dedicating it to Lu Xun. The journal was published by the Guangzhou-based Modern Prints Society (*Xiandai banhua hui*), the leading woodcut group of the modern woodcut movement in China,[1] and a review of the format and content reveals its pursuit of broadening the audience of the woodcut movement.[2]

　　The issue opens with a series of essays (*lunwen*), short features (*jieshao*), and news items (*xiaoxi*). The essay section contains an introduction ("Remarks on the Publication of the Journal") by the editor in which he designates the woodcut as a tool for national mobilization during these critical times,[3] with the country facing internal conflicts between Nationalists and Communists and external Japanese aggression that culminated in the Sino-Japanese War (1937–1945).[4] Tang's regard for the woodcut is reinforced by two succeeding articles: "The Value of Woodcuts During the National Crisis" by Li Hua (1907–1994) and "Notes on the Woodcut" by Lai Shaoqi (1915–2000). The news section is reserved for

updates such as exhibition openings and the activities of various groups that were pertinent to the national woodcut community.[5]

　　The latter part of the journal features new original woodcuts by five artists: German-American Fritz Faiss (1905–1981) and Chinese Li Hua, Tang Yingwei, Lai Shaoqi, and Hu Qizao (1915–1965). A second woodcut by Tang decorates the journal's cover and sets the tone for the other works by focusing on the destitute family in the foreground; in the left background is a group of armed soldiers. Tang also employed the technique of line drawing then favored by woodcut artists.[6]　DC

1　For more information on the Modern Prints Society, see Tang, *Origins of the Chinese Avant-Garde*, 182–210.

2　Andrews and Shen, "Modern Woodcut Movement," 220.

3　Tang Yingwei, "Fakan de hua," trans. by Xiaobing Tang, in Tang, *Origins of the Chinese Avant-Garde*, 197n68.

4　Summarized from Schoppa, *Modern Chinese History*, 155–161.

5　Tang, *Origins of the Chinese Avant-Garde*, 200.

6　Ibid., 192.

95 *To the Front!*, 1932

By Hu Yichuan (1910–2000)
Woodcut
H. 23.2 × W. 30.0 cm
Collection of the Lu Xun Memorial Hall

Hu Yichuan created this print in response to the Shanghai War of 1932,[1] when the Japanese attacked greater Shanghai as part of an expansionist campaign into China. Many cultural and commercial buildings were decimated, leaving much of the city in ruins. Hu's print surges with motion and emotion, befitting the social charge of woodcut art during this period.

 A visual analysis by Xiaobing Tang highlights the print's kinetic-emotional effect: Movement emerges from a composition dominated by diagonals pulling in opposite directions, creating visual tension within the confines of the frame. The male figure in the foreground leans right with one hand extending left. Behind him on either side, brick columns topple toward opposite ends as the mob bowls through them. Contributing to the print's animation is a collective voice from the central figure and the rushing multitude behind him that seems to reverberate within the piece. In these ways, the outstretched hand visually extends the man's impassioned rallying call to the anonymous viewer in front of him, demanding a response, achieving a viewer-picture interaction that fulfills the artist's aim to inspire his audience.[2] DC

1 Tang, *Origins of the Chinese Avant-Garde*, 208.
2 Summarized from ibid., 128 and 218.

Youth, 1933–1935

By Lai Shaoqi (1915–2000)
Woodcut
H. 13.4 × W. 12.0 cm
Collection of the Lu Xun Memorial Hall

Lai Shaoqi's *Youth* is a pure celebration of modernism. In both form and function, this print is part and parcel of art movements originating in Europe, such as Impressionism, Fauvism, and Romanticism. By Lai's time, Western art had become more accessible to Shanghai artists in the forms of travel, education, publications, and exhibitions, resulting in their greater awareness of, and greater ease of interpretation within, the Western idiom.[1]

A major influence for Lai's image was most likely the arabesque nude favored by the French artist Henri Matisse (1869–1954). In painting, print, and sculpture, Matisse played with sinuous lines to create female nudes lounging in serpentine postures.[2] A similarly graceful, curvilinear nude stands as the focus of Lai's print. The linear rhythm continues in the background as swirling currents in the water and arcs of light off the sunset. The nude's appearance in this context already bespeaks Western influence, since before then, figurative representation of the nude was absent in Chinese art.[3]

Lai, however, created at least one other image of the nude in his print *On the Beach* (1934). It shares *Youth*'s subject matter (the nude on a waterfront) but is more abstract.[4] Furthermore, the figure in either print is indistinguishable as Chinese. This may have been by choice, but it also may have been a matter of training and exposure; according to one scholar, "the task of making a detailed, credible, and sensitive rendition of Chinese subjects on a woodblock was far from easy [for a modern Chinese woodcut artist]."[5] We do know that Lai Shaoqi eventually became the leading advocate for the creation of a distinctly Chinese style for the woodcut medium.[6] DC

1 Sullivan, *Meeting of Eastern and Western Art*, 181.
2 Watkins, "Matisse, Henri," 824 and 829.
3 Jullien, *The Impossible Nude*, 30.
4 Tang, *Origins of the Chinese Avant-Garde*, 184.
5 Ibid., 184–185.
6 Ibid., 185–186.

Against the Current, 1935

By Luo Qingzhen (1904–1942)
Woodcut
H. 17.6 × W. 19.4 cm
Collection of the Lu Xun Memorial Hall

The labor of the six boatmen is the focus of Luo Qingzhen's *Against the Current.* Bodies bent, they strain to pull a boat lying outside the picture's frame.[1] They are bent not only against the supposed weight of the boat but also against the opposing current of the river. The artist depicts this by extending the black outlines of the first two figures into tendrils fusing with the wavy lines of the water's currents, creating a visual link between the two forces. The men's strenuous effort is further emphasized by their contrast with the scenery: whereas bank, water, trees, and hills are full of surface details, the six figures are faceless and nondescript, and therefore indistinguishable;[2] theirs is a collective toil.

By the time this print was created, the woodcut movement was pushing to cement its place as a public art. It succeeded in the several ways exemplified by Luo's print. First, the artist focuses on human subjects and their roles as social beings—as the poor, the injured, and the exploited. Second, such human-centrism determined a more realistic style of representation that had broader appeal. Third, *Against the Current* was part of the first national traveling exhibition (*National Joint Woodcut Exhibition, Quanguo muke lianhe zhanlanhui*) that promoted greater public accessibility to art.[3] DC

1 Tang, *Origins of the Chinese Avant-Garde,* 181.
2 Ibid.
3 Summarized from ibid., 166, 175, and 179.

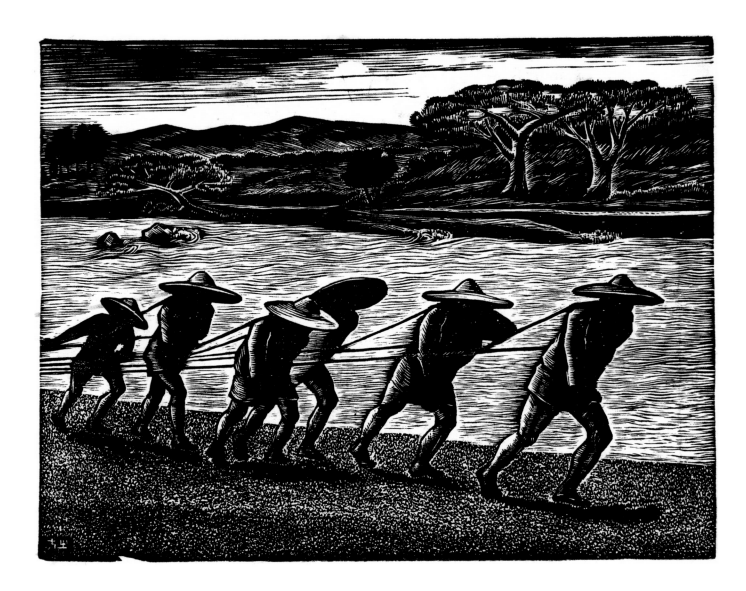

Roar, China!, 1935

By Li Hua (1907–1994)
Woodcut
H. 27.3 × W. 13.7 cm
Collection of the Lu Xun Memorial Hall

By the time this Chinese print appeared in late 1935, "Roar, China!" had become an international rallying call for the emancipation of all oppressed people.[1] The phrase was representative of the anti-imperialist mood gripping many countries in the 1920s and 1930s, and it highlighted China as the focus of this global mobilizing effort.

"Roar, China!" was manifested in several media, including theater, poetry, and print. The Russian poet and playwright Sergei Tret'iakov (1892–1939) first composed a poem and later a play (Russian: *Rychi, Kitai!*) that premiered in Moscow in 1926.[2] Based on a contemporary incident in the Chinese town of Wanxian (near the upper Yangzi River),[3] the play dramatizes the clash between a group of Chinese boatmen and Western "imperialists": two of the boatmen were wrongly accused of the death of an abusive American trader.[4] The play went on to tour in New York, London, and Berlin.[5]

The renown of Tret'iakov's play was due in part to international sympathies directed toward China during the early decades of the 1900s. Around the same time that the Chinese Communist Party held its First National Congress in Shanghai in 1921, Communists in several different countries united to found the "hands off China" movement, lending their support to China's revolutionary aims in numerous ways.[6] One of their most remarkable manifestations of solidarity was the congress held in 1925, which nearly eight hundred international representatives attended.[7] Much later, a poem also titled "Roar, China!," by the American Langston Hughes (1902–1967), appeared in the British publication *Volunteer for Liberty: Organ of the International Brigades* (September 1937). Hughes was inspired by what he saw during his visit to Shanghai in 1933 and, like his peers, found no better expression for China's condition than this phrase.[8]

Within China, the phrase circulated among the prominent left-wing societies and organizations. Tret'iakov's poem garnered attention in 1929 with its first Chinese translation.[9] Then the play premiered in Guangzhou, China, in 1930;[10] it eventually was performed in Shanghai in the fall of 1933 to mark the second anniversary of the Japanese occupation of Manchuria.[11] In the visual arts, Hu Yichuan (1910–2000) created a 1931 print with the title *Roar, China!* (no longer extant), and Liu Xian (1915–1990), in 1934, created a series of illustrations for the Tret'iakov play.[12]

Li Hua's print, therefore, appeared as one of the latest in a long line of manifestations of "Roar, China!," but it perhaps captured best the universal relevance of the phrase. The male figure is naked, removed of all markers of nationality, culture, or class[13]—all that remains is a human being in pain. DC

1 Tang, *Origins of the Chinese Avant-Garde*, 226.
2 Patterson, *Oxford Guide to Plays*, 351.
3 Berg-Pan, "Mixing Old and New Wisdom," 208.
4 Patterson, *Oxford Guide to Plays*, 351.
5 Ibid., 352.
6 For example, in Germany, left-wing writers and intellectuals made their declarations heard through manifestos, articles, and plays. See Berg-Pan, "Mixing Old and New Wisdom," 207; and Piazza, "Anti-Imperialist League," 167.
7 Piazza, "Anti-Imperialist League," 167.
8 Tang, *Origins of the Chinese Avant-Garde*, 226–227.
9 Two subsequent translations of the poem into Chinese appeared in 1930 and 1935. See ibid., 224 and 226.
10 Ibid., 224.
11 Ibid., 151 and 225.
12 Ibid., 222–223.
13 Ibid., 226.

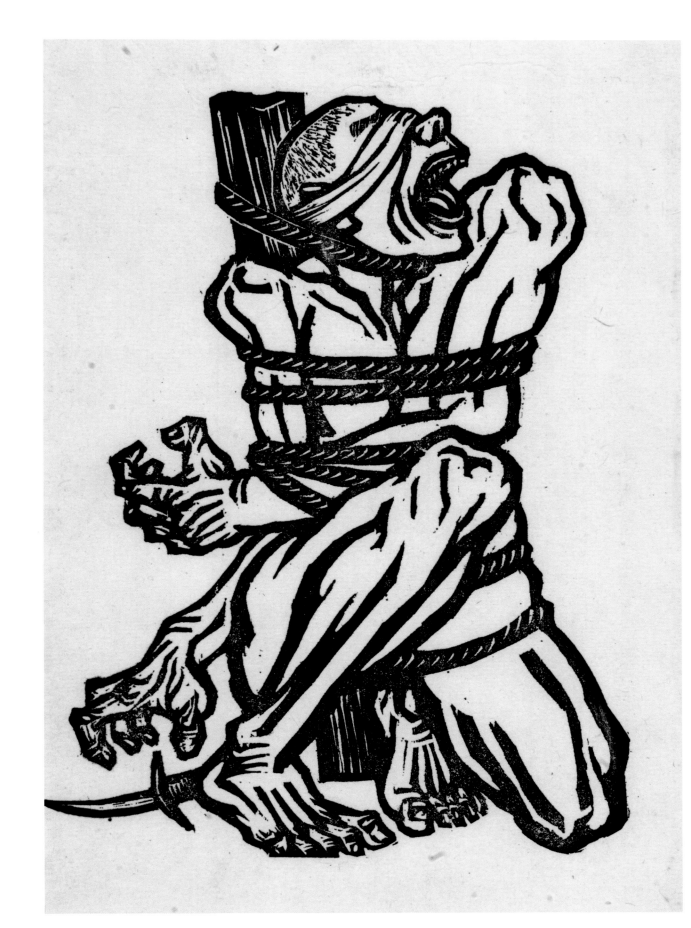

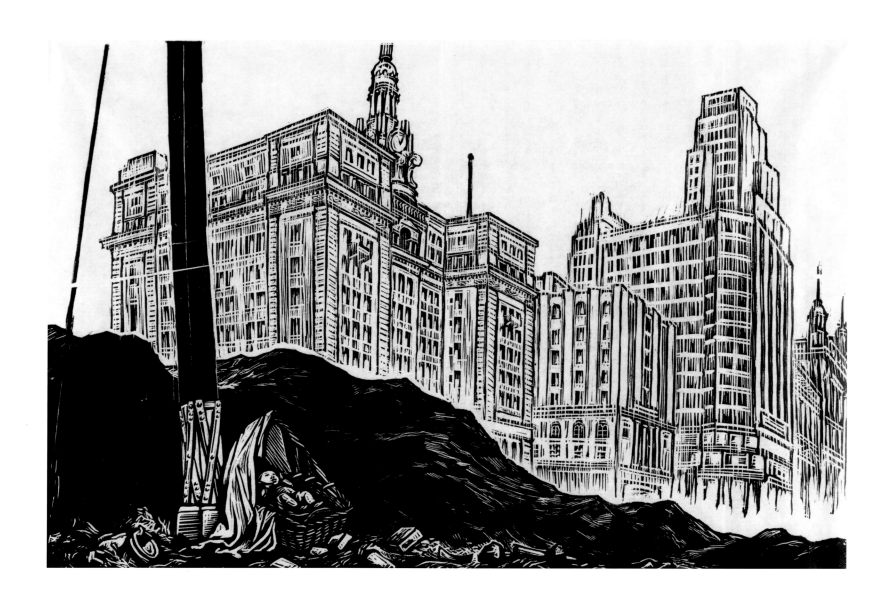

99 *A Corner of the City*, 1947

By Li Hua (1907–1994)
Woodcut
H. 24.0 × W. 36.0 cm
Collection of the Lu Xun Memorial Hall

In the background of this image are several buildings
along the Bund waterfront: they appear grand, pristine,
and float as if in a dreamland or illusion. However, con-
fronting the viewer in the foreground is an organic black
mass of dirt and debris that slashes across the picture
plane. Amid the dark bulk is a basket holding an infant,
who in all likelihood has been abandoned on this titular
corner of the city. DC

188

100 *On the Streets of Shanghai*, 1947

By Shao Keping (born 1916)
Woodblock print
H. 22.0 × W. 16.0 cm
Collection of the Shanghai Art Museum

101 *Street Corner*, 1947

By Shao Keping (born 1916)
Woodblock print
H. 21.0 × W. 16.0 cm
Collection of the Shanghai Art Museum

The social agenda for the woodcut movement intensified during the 1940s. As reflected in these two prints, societal ills in Shanghai were choice subject matter, and an even more realistic, more readable pictorial style was preferred to capture the harsh realities:[1] honest labor goes unnoticed amid vice and corruption (cat. no. 100); and postwar life in cosmopolitan Shanghai seemed to benefit only the rich, with little hope and promise for the downtrodden (cat. no. 101). DC

1 Shen, "Modernist Woodcut Movement," 265.

100

101

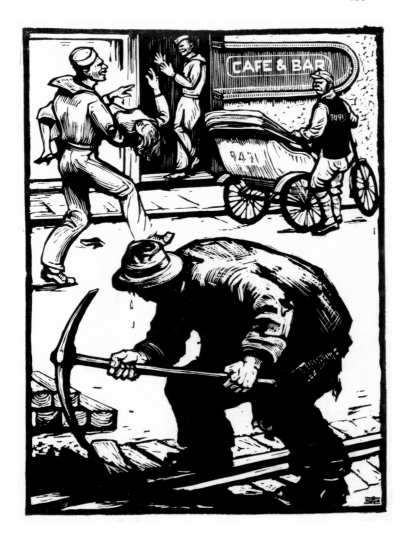

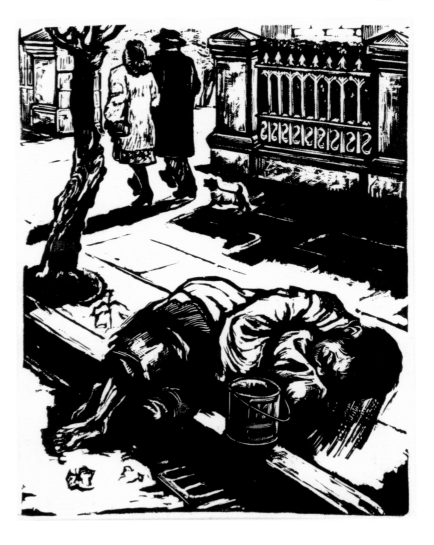

102 *Sanmao Follows the Army*, 1946

By Zhang Leping (1910–1992)
Original cartoon, ink on paper, three sheets
H.29.5 × W. 40.0 cm each
Collection of the Shanghai Art Museum

The *Sanmao* series is the longest-running comic strip (*lianhuan manhua*)[1] in China. First published in Shanghai newspapers in 1935, the series appears in China now as a televised cartoon. The story follows the life of an orphan boy, Sanmao, trying to survive on the streets of Shanghai during the 1930s and 1940s. This series in particular, *Sanmao Follows the Army*, came out of the 1945 version of the comic strip (published in Shanghai's *Shenbao*), one of four incarnations by Zhang Leping that has been identified.[2] When Japan invaded Shanghai in 1937, Zhang, along with many other artists, fled the city. During the ensuing war, he participated in an anti-Japanese propaganda team (National Salvation Cartoon Propaganda Corps, *Jiuwang manhua xuanchuandui*). Upon his return to Shanghai in 1945, Zhang resurrected his *Sanmao* cartoon to reflect upon both the wartime experience and the postwar "greed" of Shanghai officials.[3]

 The continuing popularity of the *Sanmao* series owes much to the original cartoon format itself and

to favorable conditions in Shanghai for cartoon publication at the series' inception (see also cat. no. 60). In general, the cartoon format relies on directness and common imagery for presenting ideas in "humorous, spontaneous, and often biting images";[4] Zhang himself wrote that many situations in *Sanmao Follows the Army* "border on the absurd."[5] Yet these situations were intended to be easily comprehensible without explanatory text, as the majority of China's population was illiterate. So each comic strip is paired with only a four-character phrase that serves as a title and thematic guide. Zhang Leping was a proponent of the modern movement that sought to align visual art with populist concerns: *Sanmao* was not only accessible to China's masses but also sympathetic to them.[6] The situations were presented through their perspective, as embodied by the orphan boy. DC

1 Farquhar, "*Sanmao*," 149.
2 Based on plot and theme, Farquhar distinguished four discrete versions of *Sanmao* that appeared in Shanghai publications: 1935, 1945, 1947, and post-1949. See ibid.
3 Ibid., 149–150.
4 Hung, "Feng Zikai's Wartime Cartoons," 40.
5 Farquhar, "*Sanmao*," 150.
6 Ibid., 151.

Shanghai Graphic Arts 1950–1976

Along with other aspects of life, artistic production from 1950 to 1976 was dictated by the government.[1] In touting an art policy not dissimilar to Lu Xun's modern woodcut movement (see "A Public Art Movement in Shanghai" in this volume), art in the People's Republic of China was solely for public consumption[2] and mass mobilization. Numerous mediums (both native and foreign-inspired) remained in use, including oils (cat. nos. 82–86), watercolors, inks (*guohua*; cats. nos. 87–89), and woodblocks (cat. no. 103),[3] but all content was censored for Party propaganda. And in fulfilling the Party credo of "art for the people by the people," laypeople in workers' units created art along with professional artists in state-owned presses, such as the Shanghai People's Fine Art Publishing House (cat. nos. 108–111). Furthermore, the government maintained robust exhibition programs such as the famous *Shanghai, Yangquan, Lü Da Workers Art Exhibition* (1974).[4]

In the graphic arts, perhaps the most ubiquitous products of the government's visual enterprise were the large-format, colorful propaganda posters such as cat. nos. 106 and 107, which depict celebrations in Shanghai of the new Communist regime. Shanghai was reduced to being a minor player in artistic production during these years.[5] From the examples presented in this exhibition, famous landmarks of the Bund and Nanjing Road often appeared in propaganda posters as sites of new revolutions and campaigns against all that the city had symbolized: imperialism, colonialism, and capitalism.

Dany Chan

NOTES

1 Wood, "Political and Literary Context," 20.
2 Andrews, *Painters and Politics*, 37.
3 Ibid., 110.
4 Galikowski, *Art and Politics,* 154–155.
5 However, Shanghai became the country's principal producer of comic strips (*lianhuanhua*), and the Shanghai People's Fine Art Publishing House was a major publisher of the propaganda posters. See Andrews, *Painters and Politics,* 67.

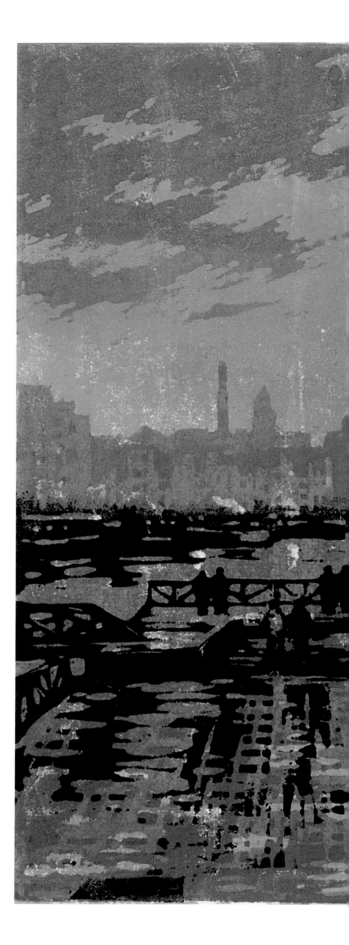

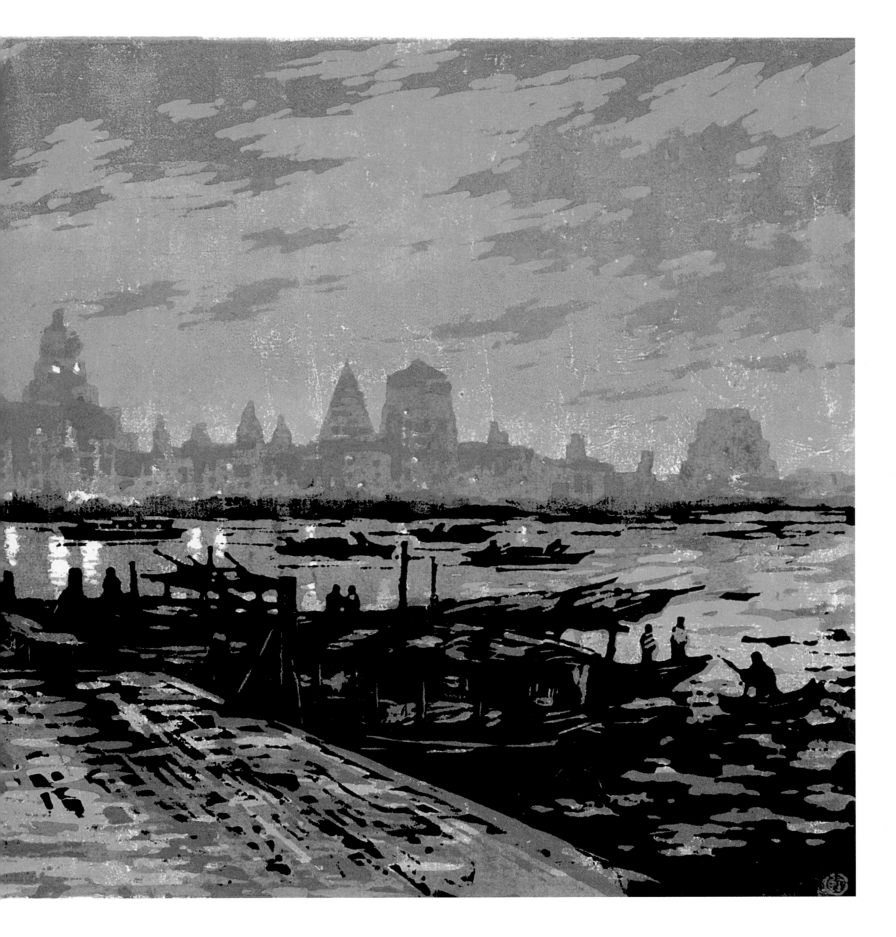

103　*Evening Glow on the Huangpu River*, 1955
By Shen Roujian (1918–1998)
Woodblock print with oil-based ink and watercolors
H. 26.0 × W. 37.0 cm
Collection of the Shanghai Art Museum

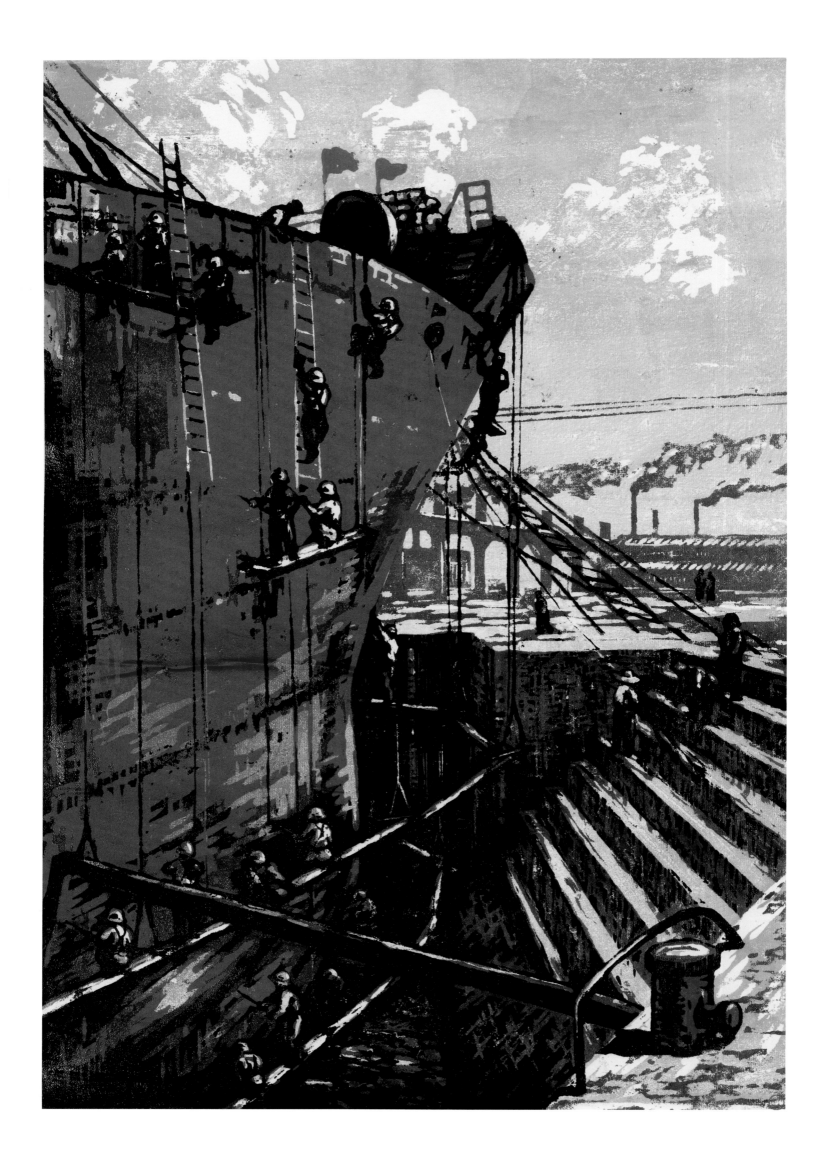

104 *During the Great Leap Forward,* 1958

By Shen Roujian (1918–1998)
Chromolithograph on paper
H. 45.4 × W. 30.7 cm
Collection of the Shanghai Museum

Industry, both as subject matter and as process, was an important aspect of printmaking during the Great Leap Forward (1958–1961),[1] an accelerated economic development campaign launched by Mao Zedong aiming to catch up with the West within a mere fifteen years.[2] As subject matter, a new spate of construction scenes appeared in print, such as this one depicting ship building. Since the 1930s, Shanghai had housed several of the largest and most active industries in the country, including arsenals, ironworks, and shipyards; for example, the Jiangnan Dock and Engineering Works (at the Huangpu River) produced 10,000-ton cargo ships.[3] Shanghai's shipyards saw renewed activity during the Great Leap Forward when China raced toward modernization.

As process, artists were expected to match the speed of the nation's industries by increasing their output—producing better works at a faster pace.[4] And the favored style evoked the energy and frenzy of the Great Leap Forward,[5] through "the combination of revolutionary realism and revolutionary romanticism" (*geming xianshizhuyi yu geming langmanzhuyi xiangjiehe*),[6] an exaggeration of the earlier Socialist Realism model (see "Western-Influenced Painting in Shanghai, 1945–1980" in this volume). Shen Roujian's print adheres to this artistic rubric by effectively capturing the monumentality of the workers' task: the brilliant hull of the ship towers above their minuscule forms.[7] DC

1 Farrer, *Chinese Printmaking Today,* 74.
2 Schoppa, *Modern Chinese History,* 157.
3 Dikötter, *Exotic Commodities,* 115–116.
4 Laing, "Woodcuts in the People's Republic of China," 50.
5 Ibid., 55.
6 Clark, *Chinese Cinema,* 63.
7 Laing, "Woodcuts in the People's Republic of China," 56.

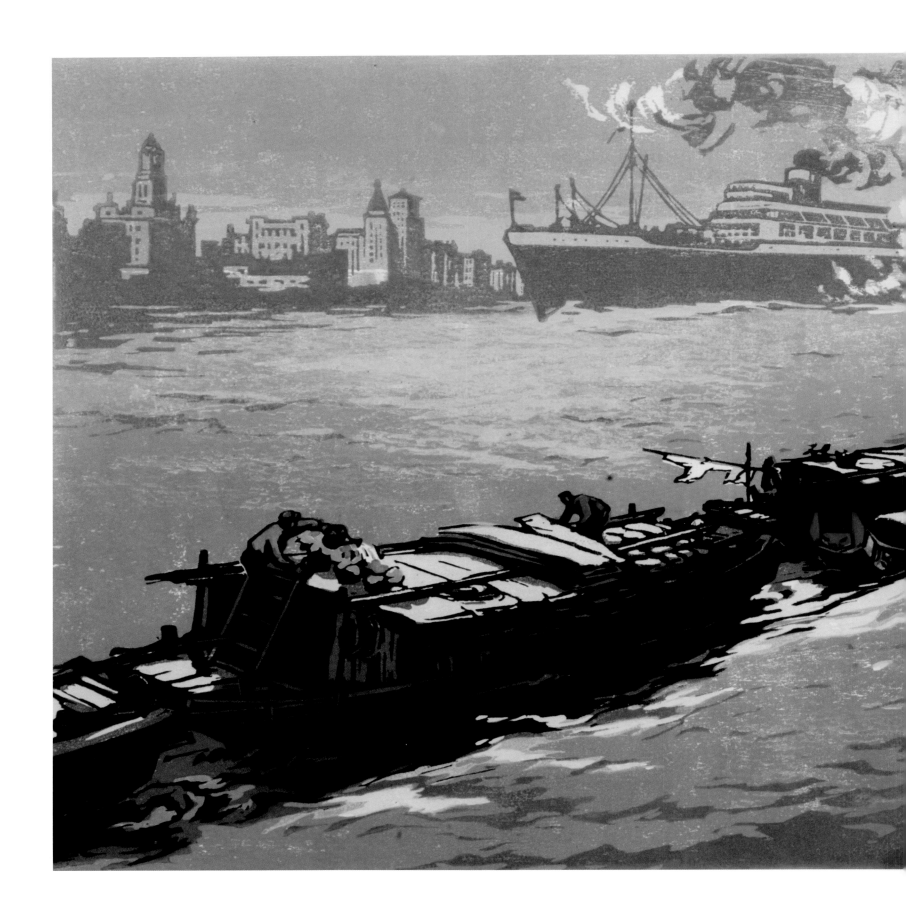

105 *Morning Toilet on the Huangpu River*, 1961

By Shao Keping (born 1916)
Woodblock print with oil-based inks
H. 28.5 × W. 45.5 cm
Collection of the Shanghai Art Museum

The look and feel of this print by Shao Keping differs
substantially from that of his earlier ones: the two
prints created in the 1940s (cat. nos. 100 and 101)
had an intentional social function, to comment on
and contribute to social change;[1] this 1961 work does
not necessarily share that aim. Rather than actively
provoking, it focuses on atmosphere, on capturing the
details of a morning scene on Shanghai's Huangpu River.
Shao utilized to great effect the intensity of pigment
in oil-based inks introduced in the 1950s.[2] In deep
black and dots of brilliant blue, green, and orange, the
foreground boats and their attendants become the focus
of the print, against the muted receding background
skyline of the Bund. DC

1 Qi Fengge, "New Outlook for Chinese Prints," 24.
2 Ibid.

106 *Parade for the Founding of the People's
Republic of China (Shanghai),* 1950
By the Hangzhou National Art School;
 published by Mass Fine Art Publishing House
Poster, chromolithograph
H. 53.0 × W. 40.0 cm
Collection of the Shanghai Propaganda Poster Art Centre

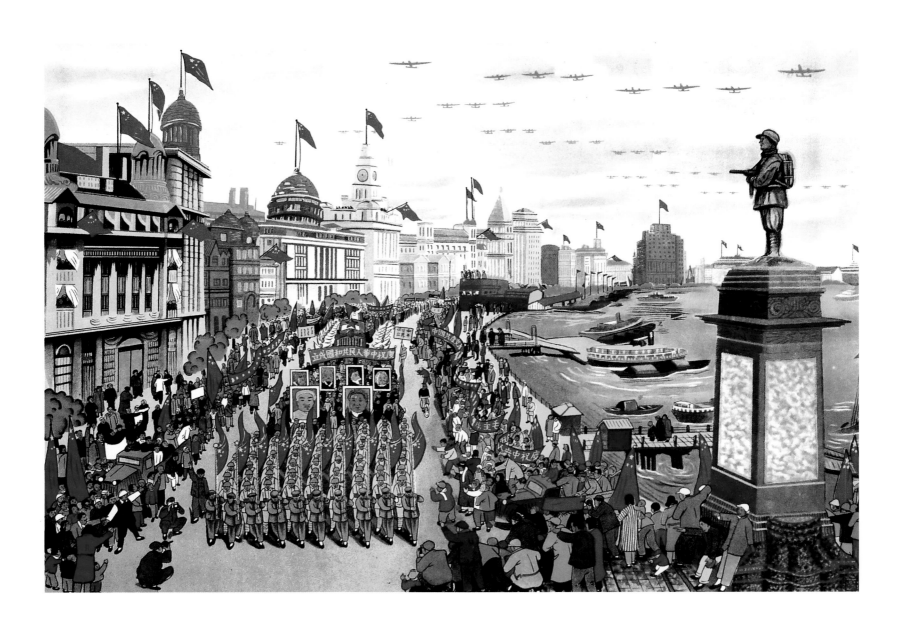

107 *Parade on Huangpu River (1)*, 1950
Published by Da Hua Printing Company
Poster, chromolithograph
H. 40.0 × w. 53.0 cm
Collection of the Shanghai Propaganda Poster Art Centre

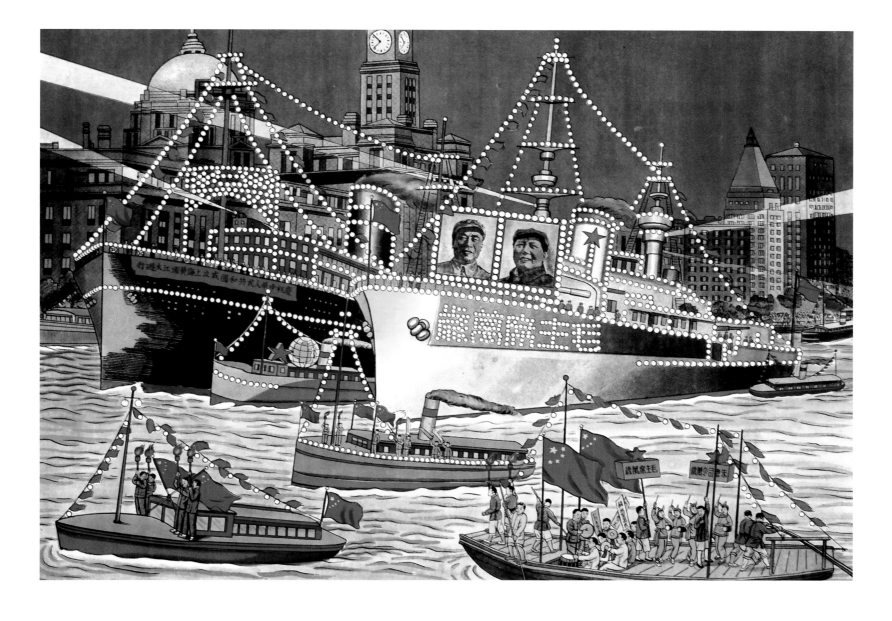

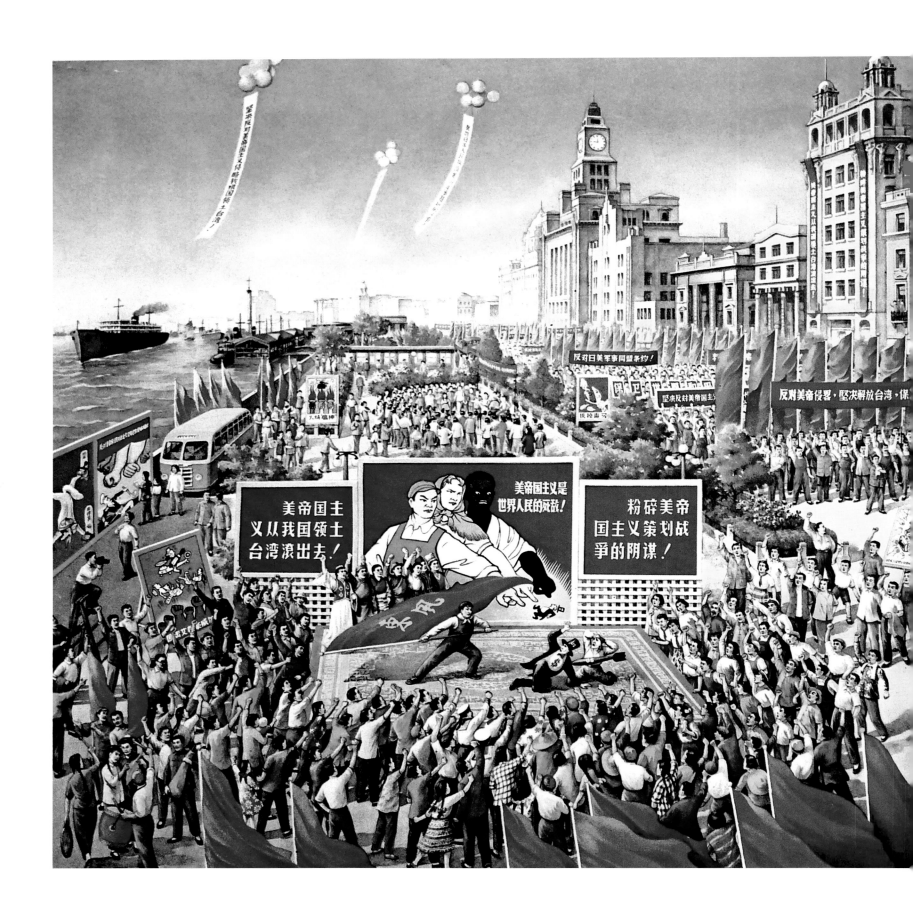

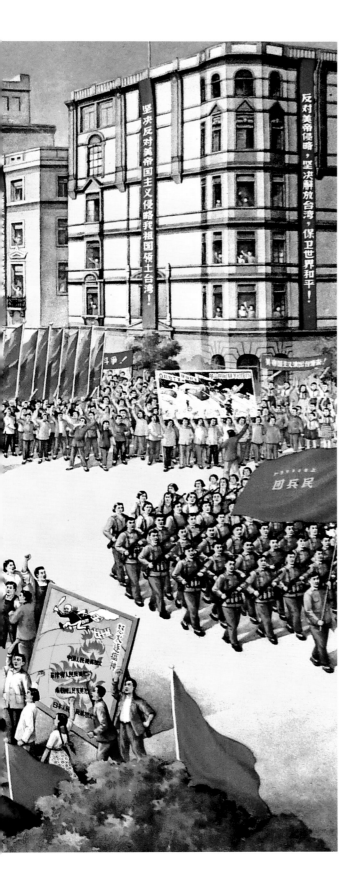

Waves of Anti-American Anger Along the Bund, 1961

By Zhang Yuqing (1909–1993); published by
 Shanghai People's Fine Art Publishing House
Poster, chromolithograph
H. 53.0 × W. 77.0 cm
Collection of the Shanghai Propaganda Poster Art Centre

The focus of cat. no. 108 is a public criticism, described as a mob converging upon a small arena where two figures kneel on the ground, trying to shield themselves from their accuser. Who or what is under attack? Specifically, American imperialism is under attack: one of the kneeling figures is dressed in a Western suit (emblazoned with the dollar sign) and top hat (labeled "US") and has a miniature missile (also labeled "US") attached to his arm. This figure often appears in similar posters representing the targeted "capitalists" and "industrialists"; his kneeling companion resembles a soldier.

One remarkable feature of this poster is its referentiality, in that the large billboards depicted here were in fact displayed in public spaces at this time. For example, the central billboard of the three pointing figures in this poster compares to contemporary posters of these figures representing the workers and laborers of various nations such as Vietnam, Congo, and Panama that fell victim to imperialist aggressors. Opposition to colonialism was the primary focus of Chinese propaganda art during the 1950s and 1960s—with the United States regarded as "the world's foremost imperialist nation"[1]—and often came in the form of these workers standing side-by-side to symbolize unity in the fight for independence. Considering Shanghai's internationalized history, staging such opposition on the Bund (in the former International Settlement) puts into sharp relief the city's precarious new position within the Communist regime.

This poster was created by Zhang Yuqing, one of the most prolific artists of the 1950s and 1960s, and an in-house artist of the Shanghai People's Fine Art Publishing House.[2] As part of the new Communist art publishing system, this publishing house (established in 1954) stemmed from a reorganization of the major private publishers in Shanghai now controlled by the state. In-house artists such as Zhang assembled into "creation studios" to collaborate on commissions that commonly included propaganda posters, oil paintings, and *nianhua* (New Year's) paintings.[3] DC

1 Schoppa, *Modern Chinese History*, 109.
2 Landsberger, "Zhang Yuqing."
3 Andrews, *Painters and Politics*, 4 and 72.

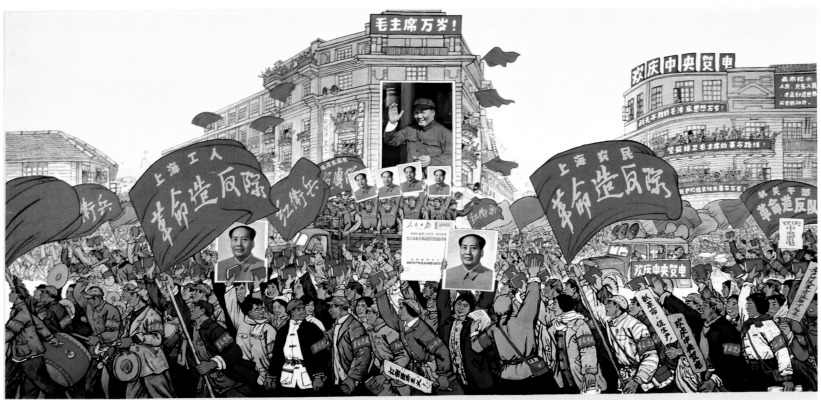

109 *Long Live Victory of the Great January Revolution*, 1967

Published by Shanghai People's Fine Art Publishing House
Poster, chromolithograph
H. 53.0 × W. 77.0 cm
Collection of the Shanghai Propaganda Poster Art Centre

A crowd representing Shanghai's various workers' units is shown here sweeping through an intersection of Nanjing Road swathed in Communist Party banners and portraits of Mao Zedong. This poster appeared at the rocky start of the Cultural Revolution (1966–1976) as the party sought to consolidate power. The so-called "January Revolution" (*yiyue geming*) refers to the party's takeover of Shanghai during that month in 1967[1] and the subsequent formation of the Shanghai People's Commune;[2] this campaign inspired later power seizures throughout China.[3] The campaign was carried out by local workers rather than Mao's Red Guards, and it was led by two members of the political powerhouse Gang of Four, Zhang Chunqiao (1917–2005) and Yao Wenyuan (1931–2005), who became first- and second-in-command of the commune, respectively.[4] DC

1 Communist Party of China, "Storm of the January Revolution."
2 The people's communes functioned as the Communist Party's political and economic administrative units during the Cultural Revolution. See Schoppa, *Modern Chinese History*, 170.
3 MacFarquhar, "The Cultural Revolution," 44. Andrew G. Walder provides an in-depth review of the particulars of the campaign in *Chang Ch'un-Ch'iao and Shanghai's January Revolution*.
4 Landsberger, "Shanghai People's Commune (1967)"; and Communist Party of China, "Storm of the January Revolution."

202

Criticizing Lin Biao and Confucius to Prevent Revisionism, 1976

By Shanghai People's Fine Art Publishing House
Gouache on paper
H. 75.0 × W. 108.0 cm
Collection of the Shanghai Propaganda Poster Art Centre

The anti-Lin, anti-Confucius campaign (1973–1974) branded Communist Party member Lin Biao (1907–1971) and sixth-century-BCE philosopher Confucius as "embodiments of feudal Chinese society."[1] The ideological link was cryptic at best—Lin had been the second-ranking member of the Party and even had been named Mao's successor[2]—but this backlash partly stemmed from Lin's failed coup against Mao in 1971.[3] Furthermore, the campaign was directed by the Gang of Four in their efforts to position themselves as Mao's successors.[4]

The painting (cat. no. 110) was the eighth in a series of ten commissioned in celebration of the tenth anniversary of the Cultural Revolution (before Mao's death that year). The Shanghai People's Fine Art Publishing House organized their best in-house artists to collaborate on the series, and each was signed, "the collective artists of the publishing house." Exemplary of propaganda art at this time, the painting was then mechanically reproduced into the large-format posters (cat. no. 111). In addition to gouache and watercolor, other mediums such as woodcuts and oil paintings were popular as models for these posters.[5] DC

1 Schoppa, *Modern Chinese History*, 155 and 191.
2 Ibid., 192.
3 Ibid., 125.
4 Ibid.
5 Andrews, *Painters and Politics*, 60; and Landsberger, *Chinese Propaganda Posters*, 44.

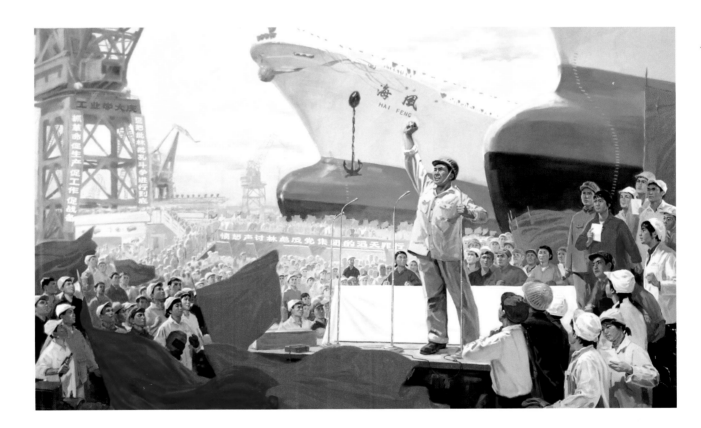

Criticizing Lin Biao and Confucius to Prevent Revisionism, 1976

By Shanghai People's Fine Art Publishing House
Poster, chromolithograph
H. 77.0 × W. 106.0 cm
Collection of the Shanghai Propaganda Poster Art Centre

A Concise Introduction to Modern Shanghai Painting

As China's most important modern city, Shanghai has been the epicenter of burgeoning culture since the late nineteenth century. The city's excellent infrastructure, multiethnic residents, and booming industry and service sectors, as well as its modern, open lifestyle, all combine to provide a favorable environment for cultural development. At every important stage in modern Chinese history, Shanghai has had its unique developments, and its painting scene, much like fast-paced city life, has been complex and brimming with vitality.

Early modern Chinese painting is intricate. It is an exchange of the old and new, a fusion of East and West. It is independent and innovative, full of change and transition. Oil painting, print art, illustrated storytelling small books, and comic and promotional art, which are separate from the traditional painting forms, largely found their beginnings in Shanghai. The stages of the development of painting in early modern Shanghai can generally be dated as follows: around the time of the 1911 revolution, from the revolution to the early 1930s, from the late 1930s to the establishment of the People's Republic, from the establishment of the PRC to the 1980s, and from after the 1980s to the present.

During the late Qing, the style of the Four Wangs, which had been promoted by the more orthodox educated elite, went into decline, and a new style influenced by the aesthetic preferences of the city's inhabitants emerged and formed a new market for painting in Shanghai. This change attracted artists from all over the Jiangsu and Zhejiang area. The resulting "Shanghai school" of art embodied the spirit of diversity and dynamism of the modern city. By combining traditional poetry, calligraphy, and folk art and employing the methods based on ancient calligraphy, known as bronze-and-stone art, the Shanghai school created themes that reflected the curious, bustling, life-loving nature of the common people. Major practitioners of this style include the "Three Xiongs" (Zhang Xiong, Zhu Xiong, and Ren Xiong) and the "Three Rens"

(Ren Xiong, Ren Xun, and Ren Yi) of the earlier period and Wu Changshuo and others of the later period. Artists combined the greater freehand technique (*daxieyi*) of the Ming and Qing with vibrant colors, including the heavy use of magenta, pink, and rose (*xiyang hong*), and created works with bold color and vivid contrast. This innovation resulted in the further development of the greater freehand tradition and formed a style enjoyed by both refined and general audiences.

The early twentieth century brought a surge in modern art. As a large number of Chinese art students studied abroad in Japan and Western countries such as France, new ideologies of the Western world made their way into people's field of vision. The students who studied abroad in the West also became the pioneers of and main force behind the teaching and creation of early modern art in China, thus establishing a foundation for the development of modern art in China. At the same time that the Shanghai school pursued the expansion and development of traditional Chinese painting, those pioneers of art who returned from their studies abroad adopted certain Western ideas in a quest to improve it. From this juncture the idea of "Chinese painting" and "Western painting" truly emerged. Although these terms existed as early as the Ming dynasty, they were not truly accepted by the populace until the twentieth century, and coastal cities, especially Shanghai, were the main centers for this development. The result of the influx of Western culture and numerous ideological movements were twofold: first, the realms of Western oil painting, watercolors, and print and poster art became active in Shanghai and the coastal cities in Zhejiang and Jiangsu; on another front, the movement to reform and revamp traditional Chinese painting began to gain momentum. During this period important artists such as Huang Binhong, Xu Beihong, Lin Fengmian, Liu Haisu, Yan Wenliang, Pan Tianshou, and Li Keran came to the fore.

At the same time, various art schools and

organizations began to settle in Shanghai. According to historical sources, more than 107 art schools and organizations existed in the Shanghai area from the end of the Qing and early Republic era to May 1949. These included many institutions that were significant in the history of Chinese art. Among them were the Tushanwan Art School, China's earliest place of Western art instruction, which was established in 1862 in the Xujiahui district of Shanghai; and Duoyunxuan, which was also a publishing house. Established in Shanghai in 1900 and rebuilt in the 1960s, Duoyunxuan merged with the Shanghai Painting and Calligraphy Press and is still in existence today. The Shanghai Oil Painting Academy and the Chinese and Western Art Correspondence School, which provided professional oil painting instruction and watercolor instruction, respectively, were both founded in 1910. In 1912 the Shanghai Art Academy, the first modern fine art school in early modern China, was established by Liu Haisu and his colleagues at 7 Zhapu Road in Shanghai. The school not only adopted the Western educational system and methods of instruction, it also started hiring models in 1914. Because nude models had never been employed in China up to that point, their appearance caused a considerable sensation, and the debate among supporters and opponents of figure painting lasted decades.

From the 1930s to the 1940s, "left-wingers" started promoting the idea of "art for the people." Some artists took to the streets and, borrowing from Western methods, painted various scenes of laborers, both in the city and in the countryside. During the Japanese invasion, the art world focused on anti-invasion promotional materials. Accordingly, there emerged a new woodcut movement as well as comics and oils depicting war and societal realities. Print, promotional, and comic art showed unprecedented development, and multidimensional art forms came into vogue, such as Shao Keping's *Street Corner* and Zhang Leping's Sanmao comic series. The art of Shanghai in the late nineteenth and early twentieth centuries developed along with the spread of democratic revolution, Enlightenment thinking, and Marxist theory in the political, economic, and cultural sectors. These factors contributed to Chinese art's expansion into new territories, undoubtedly one manifestation of the desire and efforts of the Chinese people to modernize an age-old culture.

After the establishment of the People's Republic of China, under the general principle that "art and literature serve the people and serve socialism," painting began to regularly depict scenes from everyday life. In Shanghai a new group of emerging artists included Qian Shoutie, Yu Yunjie, Cheng Shifa, and Fang Zengxian. Artists ventured deep into the countryside, into factories, and into the armed forces to create works celebrating laborers, farmers, and PLA (People's Liberation Army) soldiers. Consequently, figure painting advanced by leaps and bounds. Landscape and flower-and-bird paintings started to move toward realistic portrayal rather than being copies of the masters, as in the old tradition. Promotional and comic art and even folk art came into their own. In major urban centers such as Beijing, Shanghai, and Guangzhou, Chinese art was popularized to an extent never before seen. Thus began a period of extreme prosperity for Chinese art.

Amid the economic reforms of the 1980s, life and people's way of thinking underwent profound changes, changes that were accelerated by cultural and artistic influences from the West. Individualism and subjectivity became more evident in artwork. The infiltration of modern aestheticism gave rise to many new types of painting, such as abstract, ultra-realistic, folk, "neo-literati freehand" (*xinwenren xieyi*), and multimedia art. As economic reforms deepened and the Chinese-Western exchange advanced, Shanghai began to move ahead with cultural and artistic developments on the international front, and all types of contemporary art exhibitions and art galleries opened. Artists drew upon historical experience to ponder anew the relationship

between painting and reality; younger and middle-aged artists appeared who dared to create and at the same time undertake intensive study of tradition. A brand-new atmosphere took hold in the art world of Shanghai.

From the manifesto of the Storm Society (see "Western-Influenced Painting in Shanghai, 1910–1945" in this volume) to the "New Wave " art movement of 1985 to art's multidimensional development of today, as China's largest industrial and commercial city, Shanghai has long been a place where Chinese and Western cultures have gathered, collided, and merged. It has also been a passageway for the movement and exchange of various types of Chinese and Western art. The romantic, refined aesthetic that emerged as a result of immigration culture and Jiangnan culture unique to Shanghai

combined with Western influences to create the multidimensional tradition of the Shanghai school. The school has continued to be a driving force behind the development of the art and culture of Shanghai.

This exhibition has given us the opportunity to display the various scenes along the path of Shanghai's artistic development. It allows us to recall the art movements of old and the academies, organizations, and exhibitions that built them. As we admire the artworks and experience the history they invoke, we are also paying tribute to the artists who were and are active in this city; this exhibition is a miniature of Shanghai's culture.

Li Lei
Translated by He Li

Unfettered Dynamic Imagination

Since Shanghai's inception, the city has through accident and design generated a uniquely innovative cultural environment. This is attributable to the historical circumstances that led to its initial rapid growth in the mid-nineteenth century, followed by the twentieth-century twists of fate that shaped its development. It is a short history compared to that of China's other major cities, not so long as to constitute a weighty encumbrance, yet rich and characterized always by flux. From the start, Shanghai has been (aside from the mid-twentieth-century hiatus) a place of wealth, opportunity, and international congress. In the nineteenth century the population exploded in part due to the city's importance as a treaty port, and in part because China's internal strife compelled hundreds of thousands of people—a disproportionate number of whom were wealthy or well-educated, including many artists—to flee to the safety of Shanghai. This, combined with the distance from the orthodox art center of Beijing, resulted in an enormous outburst of creativity. Shanghai is in a similar situation today: it is a wealthy trade and banking center rather than a political center, poised on the Pacific Rim and looking outward with aspirations of world prominence, and thus presenting opportunities that attract people, including artists, from throughout China and beyond.

That Shanghai's current status is one of wealth, growth, and cultural prominence is testimony to the city's quick recovery from the isolation and restriction of the mid-century political movements, ending with the Cultural Revolution (1966–1976). When Deng Xiaoping (1904–1997) came to power in 1978, implementing a policy of practical economic development over dogma, Shanghai did not hesitate to race toward a new modernism. Throughout China, government control of the arts relaxed, contact with the outside world was reestablished, and a flood of information about trends in art and philosophy became available. While an older generation of Shanghai artists had maintained the local understanding of earlier Western art movements (for example, Liu

Haisu [1896–1994] continued painting in a manner indebted to Postimpressionism; see cat. nos. 22 and 112), many twentieth-century Western art movements, such as Pop and Dada, were newly imported.

Art Education

In general, over the past three decades Shanghai's climate for art creation and exhibition has been more relaxed than that of the city's chief cultural rival, Beijing. The most obvious reason for this is that distance from China's administrative center leads to relative freedom. A less apparent reason may be that no nationally administered art academy is based in Shanghai, bringing with it the concentrated competitiveness and political underpinnings generally associated with the academies.

A century ago Shanghai was home to one of China's most important art schools, the Shanghai Art Academy (also known as the Shanghai Painting and Art Institute), founded in 1912 by Liu Haisu.[1] For political reasons the school was moved to Wuxi in 1952, becoming part of the East China Arts Academy; since then, although there has been a succession of art schools and nonteaching art institutes, there has not been a major art academy in Shanghai.[2] For decades, private lessons and art clubs for young artists were key steps in an art education and, because their instruction was not regulated in the way of major art academies, they tended to foster the perpetuation of styles that were less prominent elsewhere in China.[3] Many contemporary mid-career Shanghai artists began their education with private lessons and art club activities, completing it in one of the Shanghai institutes of higher education that established an art department: Shanghai University, Shanghai Normal University, East China Normal University, and the Shanghai Drama Institute (Theater Design Department).[4] These schools afford Shanghai a variety of educational opportunities and, because of Shanghai's unparalleled ambience, are able to attract important artists to serve as professors.

Activities in the 1980s

Shanghai has proven consistently to be particularly fertile ground for innovative exhibitions—innovative in terms of content, location, and format. Seemingly setting the tone for Shanghai's post–Cultural Revolution leadership in the arts, an exhibition of watercolor landscapes and still lifes daringly void of political content was held at the Xuhui District Cultural Palace in December 1976, just three months after the death of Mao Zedong (1893–1976).[5] More exhibitions followed, including those organized by artists' groups, notably *The Twelve-Man Painting Exhibition* at the Huangpu District Youth Palace in February 1979[6] and the Grass Painting Society's early 1980 *Painting Exhibition for the '80s* at the Luwan District Cultural Palace, where the organizer, Qiu Deshu (born 1948), was an artist-worker.[7] Although the group self-censored, withdrawing a nude painting prior to the opening, the exhibition included works influenced by cubism and expressionism, as well as ink paintings in new experimental modes.[8]

The frequency of such quasi-official exhibitions organized by groups with no official status burgeoned through the early 1980s, and artists seemed free to explore unsanctioned directions in private, albeit with occasional crackdowns. In the winter of 1983, ten artists—most from the Shanghai Drama Institute—participated in the *'83 Experimental Painting Exhibition* at Fudan University (fig. 1). Although they had permission to hold the exhibition there, it was closed after a day and a half: the Anti-Spiritual Pollution campaign was beginning.[9] The works Zhang Jian-Jun (born 1955) had contributed to the exhibition were particularly targeted: four out of his five paintings were criticized for being abstract, including one described as "strange." Zhang was the first mainland Chinese artist to employ mixed media on canvas, and the "strange" painting was in that mode.[10]

As liberalization succeeded the Anti-Spiritual Pollution campaign, increasingly unorthodox activities were organized with seeming impunity throughout China—until the crackdown that came in the wake of the June 1989 Tiananmen Square massacre. This florescence, known as the New Wave or the '85 Art Movement, involved over two thousand avant-garde artists who participated in more than eighty unofficial art

FIG. 1
Zhang Jian-Jun at the *'83 Experimental Painting Exhibition* at Fudan University, standing in front of his painting *Time/Space* (1983), for which he was criticized. (Photograph courtesy of Zhang Jian-Jun)

groups and over one hundred fifty exhibitions and meetings.[11] Although Shanghai activities from this era have not received as much attention as those in other parts of China, Shanghai continued as a site of experimental exhibitions. In addition, a small number of artists of the generation who entered art schools soon after the end of the Cultural Revolution ventured to produce performance works and public interventions. In 1986, for example, Shanghai University art students Ding Yi (born 1962), Zhang Guoliang, and Qin Yifeng (born 1961) wrapped themselves in yellow fabric and then stationed themselves in various locations, including in a restaurant, on the street, and in a field, calling their work *Cloth Sculptures on the Street* (fig. 2).[12] During the same year "M" Art Group, founded by Song Haidong (born 1958), realized several performances at the Shanghai Workers' Cultural Palace, generally characterized by acts of symbolic violence against the artists, including Zhou Tiehai (born 1966), in the performance *Violence*.[13]

The 1990s and Beyond

The 1980s can be thought of as a gestation period, a valuable time of wide-ranging experimentation that opened the way for an expansive maturing art scene. Li Shan (born 1944), whose abstract and expressionist paintings had been criticized during the Anti-Spiritual Pollution campaign, found international acclaim for his works in the Political Pop mode.[14] Other leading Political Pop practitioners are Shanghai painters Wang Ziwei (born 1963), Yu Youhan (born 1943), and Liu Dahong (born 1962; not a Shanghai native, but now thoroughly ensconced there). Influenced by Andy Warhol (1928–1987) in their brightly colored renditions of an iconic figure (Chairman Mao), they had begun their

deconstruction of Mao in the late 1980s, continuing into the 1990s. The love of color and sense of fun inherent in Political Pop suited the spirit of Shanghai, unlike the comparably celebrated painting trend of the early 1990s, Cynical Realism, which was the expression of a Beijing zeitgeist. The appreciation of color also extends to Shanghai's unusual concentration of artists producing abstract works of art in oils or other non-ink mediums, including Ding Yi, Shen Fan (born 1952), Yu Youhan (despite the detour to Political Pop), and Li Lei (born 1965). Other dominant Shanghai artists found their stride at this time: Zhou Tiehai took a judicious taunting of the

FIG. 2 Ding Yi, Zhang Guoliang, and Qin Yifeng, *Cloth Sculptures on the Street*, 1986, performance. (Photographs courtesy of Ding Yi and ShanghART)

FIG. 3 Zhou Tiehai, *Un/Limited Space (4): The Shower*, approx. 1998. Installation in progress, German Consulate General, Shanghai. (Photograph: Graham Earnshaw; courtesy of Zhou Tiehai)

international art world as his modus operandi; Yang Fudong (born 1971) established himself first as a witty commentator on the dilemmas facing Shanghai's youthful "intellectuals" and later as a master filmmaker; Shi Yong (born 1963) was the first mainland Chinese artist to produce a work of art distributed by the Internet; Wang Tiande (born 1960) pushed ink painting beyond its basic ink-on-paper existence to create ink installations; Zhao Bandi (born 1966) established his loving relationship with a toy panda as central to his oeuvre;[15] and so on. The sense of fun and appreciation of color so obvious in Political Pop emerge as prevalent factors in Shanghai art, leavening an underlying seriousness of purpose.

Photography, video, and installation became important modes of art production in Shanghai, as throughout China, increasingly dominating exhibitions. At the beginning of the decade they featured prominently in the 1991 *Garage* exhibition curated by Song Haidong and held in the underground parking garage of the Shanghai Education Hall.[16] A decade later, installations were taken for granted as the only means of filling large-scale exhibitions such as *Home* (2000), curated by Wu Meichun (born 1969) and Qiu Zhijie (born 1969) and held in the enormous empty halls of the soon-to-open Star Moon Home

Furnishing Company.[17] Other exhibitions taking place in unconventional spaces or in the public domain include *Un/Limited Space* (fig. 3), a series of small radical exhibitions held during the 1990s on the German Consulate's outer wall, where Chinese and foreign space physically intersect. A supermarket on Huaihai Road was the site of *Art for Sale* (1999), an exhibition curated by artists Xu Zhen (born 1977), Yang Zhenzhong (born 1968), and Alexander Brandt (born 1971), where small works of art could be purchased in a supermarket setting, at supermarket prices, highlighting the transition of avant-garde contemporary Chinese art to marketable commodity.[18] Zhao Bandi, whose public-service-announcement-style images, *Zhao Bandi and the Panda,* had been displayed as light boxes at the Shanghai Pudong International Airport, brought those images to life in his street-theater piece, *Come and Meet the Panda* (2000). His latest theatrical productions are fashion shows of his *Panda Fashion* (2007–2008)—panda-inspired couture conjuring such readily recognizable types as bride, corrupt official, property saleswoman, migrant worker, street sweeper, and so on (fig. 4). The largest-scale effort to bring art to public notice has been *Intrude: Art & Life 366*, a Zendai Museum of Modern Art project in which

FIG. 4 Zhao Bandi, Panda Couture, ShanghART Night—Shanghai Jinmao Shengrong Yacht, the Bund, Shanghai, 2008. (Photograph courtesy of ShanghART and Zhao Bandi)

every day during 2008, a public cultural event took place in Shanghai, with the aim of bringing "global perspectives on art and culture . . . closer to the people of the city."[19]

Galleries

Just as the lack of an art academy contributed to the shape of the Shanghai art world, so too has the emergence of strong commercial galleries as well as noncommercial public art galleries. Zheng Shengtian opened the first commercial space to promote Shanghai contemporary art, the Gallery of the Shanghai Drama Institute, but it lasted only a year due to unfortunate timing: it opened on June 6, 1989 (fig. 5).[20] Lorenz Helbling established ShanghART Gallery, the earliest such gallery to remain in operation, in 1996: it has grown from a small venture in the Portman Ritz Carlton Hotel to a major enterprise with galleries in both Shanghai and Beijing, consistently the most important venue for Shanghai artists and offering invaluable support for their projects.[21] Two of ShanghART's current spaces are at the Moganshan Road Art District, a cluster of old factory buildings converted to art galleries and artists' studios. Also at Moganshan is BizArt, run by Davide Quadrio (born 1970) and Xu Zhen as one

of the pioneering nonprofit art spaces in Asia. In addition to supporting and promoting artists, BizArt has recently completed an ambitious series of interviews documenting the state of art in Shanghai.[22] Numerous commercial galleries have opened since the later 1990s, including the relatively long-lived Eastlink Gallery and the Shanghai Gallery of Art, the latter located in a hyper-elegant space on the Bund.[23] Shanghai also is home to the Duolun Museum of Modern Art, to two newly established private museums that aim to adhere to international standards—the Museum of Contemporary Art Shanghai (MOCA Shanghai) (fig. 6); and the Shanghai Zendai Museum of Modern Art[24]—and to two art fairs, Shanghai Art Fair and ShContemporary.

In 1996 the Shanghai Art Museum inaugurated its biennial program with the first Chinese periodical exhibition of contemporary art.[25] Although the first two Shanghai Biennales showcased works by Chinese artists, all subsequent biennials have been international, and from the beginning the plan was to use the biennial as a means to achieve equal footing in the international art realm: Shanghai would "open the gate for China's modern art to make its way into the world arena."[26] Since the 2000 exhibition, the biennial has achieved prominence in a way

China's other biennials have been unable to match, consistently drawing throngs of international art aficionados. In addition, a cluster of particularly lively and challenging privately organized exhibitions coincided with the 2000 biennial, firmly establishing Shanghai's reputation as a premier locale for exhibiting cutting-edge art.

Conclusion

Shanghai grew from a village to a major metropolis in very short order. Without a master plan, it developed as a livable and beautiful city. Now the past symbolically meets the future across the waters of the Huangpu, as the elegant buildings along the Bund—considered quite grand for their time—face the massive towers of record-breaking height that populate Pudong: the Jinmao Tower, the tallest building in China until the completion of the Shanghai World Financial Center,[27] with both soon to be dwarfed by the Shanghai Tower under construction next to them, planned to rise 632 meters.[28] Compared to such supertowers, architectural projects like Dongtan

Eco-city, being developed as a possibly carbon-neutral city on Dongtan Island in the mouth of the Yangzi River, are no less an achievement.[29] It is a strength that Shanghai plays host to varieties of imaginative daring. It thus benefits from the readily observable leaps of faith, such as Pudong's mega-towers, or the Shanghai Art Museum's initiative to launch Chinese art onto the world stage through a new series of biennial exhibitions, or the construction of ambitious private museums. And it also benefits from the lower-key initiatives, such as the construction of an eco-city on a mud flat (just as Shanghai began on a mud flat), or the green initiatives built into the original Expo 2010 Master Plan;[30] the perpetuation of early-twentieth-century painting styles by such artists as Liu Haisu, early artists' groups' exhibitions of works beyond the pale, the establishment of commercial galleries when there was hardly a market for contemporary art, early performance art witnessed by few, and the production of ambitiously scaled, short-lived exhibitions in temporary spaces, such as *Home* or the exhibitions ancillary to the 2000 Shanghai Biennale. The variety creates the dynamic that keeps Shanghai visual culture fresh and exciting.

Britta Erickson

NOTES

1 Sullivan, *Art and Artists,* 30.
2 Andrews, *Painters and Politics,* 55.
3 Ibid., 384.
4 The Shanghai School of Design, a branch of the China Academy of Art, is located in Pudong.
5 Andrews, *Painters and Politics,* 384–385.
6 Li Chao, *Shanghai youhua shi,* 314.
7 Cohen, *New Chinese Painting,* 67.
8 Ibid.
9 E-mail correspondence between the author and Zhang Jian-Jun, April 9, 2009; and Cohen, *New Chinese Painting,* 85.
10 E-mail correspondence between the author and Zhang Jian-Jun, April 9, 2009.
11 Gao Minglu, "Conceptual Art with Anticonceptual Attitude," 131.
12 Song Dong et al., *Yesheng 1997 nian jingzhe shi,* 112.
13 Berghuis, *Performance Art in China,* 70.
14 Li Shan's paintings can be seen in fig. 5, a photograph of the opening of the Gallery of the Shanghai Drama Institute.
15 Although Zhao Bandi lives in Beijing, his work is associated with Shanghai. For links to images and video footage, see ShanghART, "Zhao Bandi."
16 Zhang Qing, "Shanghai Modern," 354.
17 For more on this exhibition, see Wu Hung, *Exhibiting Experimental Art,* 196–203.
18 For more on this exhibition, see ibid., 172–179.
19 Zendai Museum of Modern Art, "*Intrude: Art & Life 366.*"
20 Erickson, "Interview with Shengtian Zheng," 30.
21 ShanghART Gallery, http://www.shanghartgallery.com.
22 *Art hub,* "40+4, Art is not enough! Not enough," March 1, 2008. http://www.arthubasia.org/archives/404-art-is-not-enough-not-enough.
23 Eastlink Gallery, http://www.eastlinkgallery.cn/Exhibition.aspx?lan=en&c=sh; Shanghai Gallery of Art, http://www.shanghaigalleryofart.com/en/home.htm.
24 MOCA Shanghai, http://www.mocashanghai.org; Shanghai Zendai Museum of Modern Art, http://www.zendaiart.com.
25 By this I mean the first Chinese periodical exhibition aside from the conservative annual national exhibitions held in Beijing or regionally: they are of a character entirely different from that of international periodical exhibitions. For more information, see Erickson, "Periodical Exhibitions in China," 41–46.
26 Fang Zengxian, "Preface," *Shanghai Biennale* n.p. For more on the biennial, see Shanghai Biennale, http://www.shanghaibiennale.org/.
27 Dawson, *China's New Dawn,* 74.
28 Wikipedia, "Shanghai Tower."
29 *Arup,* "Dongtan Eco-city"; Kane, "Shanghai Plans Eco-metropolis."
30 Dawson, *China's New Dawn,* 50.

112 *Fuxing Park,* 1981
By Liu Haisu (1896–1994)
Oil on canvas
H. 71.0 × W. 90.0 cm
Collection of the Shanghai Art Museum

For a discussion of Liu Haisu's life and career,
see cat. no. 79.

By the time Liu Haisu painted *Fuxing Park* he was in
his mid-eighties. Having been condemned as a rightist
during the Great Leap Forward and then rehabilitated
in 1979, he finally enjoyed an extended period when he
could paint free of political concerns.[1] He continued to
work with equal enthusiasm in both oil painting and
ink painting, employing splashed ink and bold splashed
color in his brush paintings. As is evident in *Fuxing Park,*

his oil painting manner was similarly bold and loose,
and maintained the ties to the Postimpressionists he
had favored in his youth.

Liu Haisu lived for a time in Shanghai's Luwan
district, home to Fuxing Park.[2] Established in the early
twentieth century, the park belonged to the French
Concession and was laid out after the manner of French
public parks, with beds of flowers and wide, tree-shaded
paths. Although the park was later modified to suit Chi-
nese tastes, the area represented in Liu Haisu's painting
resembles a European-style park. Liu peopled it with
numerous figures wearing the white shirts and dark
pants common in the 1980s. The park remains a favorite
gathering place for locals. BE

1 Sullivan, *Art and Artists,* 217.
2 Andrews, *Painters and Politics,* 385.

Morning on the Long Canal, 1995

By Chen Yifei (1946–2005)
Oil on canvas
H. 198.8 × W. 198.8 cm
Collection of Chong-Moon and Reiko T. Lee

Born in Zhenhai, Zhejiang Province, Chen Yifei studied at the Shanghai Art Academy and, in 1965, was a founder of the Shanghai Oil Painting and Sculpture Institute. An artist with great technical facility, he trained in the Socialist Realist manner, which afforded him an understanding of the use of color and lighting to create a heightened sense of drama. He was remarkably attuned to his times, utterly responsive to the visual arts needs of a variety of cultural moments and settings. During the Cultural Revolution he produced propaganda paintings and portraits of Mao. His talent as a history painter was such that the Military Museum in Beijing commissioned him and Wei Jingshan (born 1943) to paint one of the last major highly political works in this genre, *The Taking of the Presidential Palace* (1977). Travel-

ing to the United States to study, Chen earned an MFA from Hunter College in 1985 and then remained in New York, where his polished portraits, paintings of beautiful young Chinese women, and Jiangnan canal village landscapes were in demand. He was the most financially successful mainland Chinese artist of the time, with paintings fetching record prices at auction. Returning to China in 1991, he established an entrepreneurial cultural empire based in Shanghai, with the Leyefe fashion and housewares lines, Yifei Modeling Agency, and other enterprises. In 1993 he became involved in filmmaking. The sense of color and dramatic staging that he acquired as a youth served him well in his wide range of roles, from propaganda painter to portrait artist to fashion designer to film director.

When Chen Yifei painted *Morning on the Long Canal,* he had been creating scenes of Suzhou or similar canal villages for well over a decade. The restrained color palette and stable composition combine with the sense of the age of the buildings and quiet movement of the boatman to capture the peace of early morning. BE

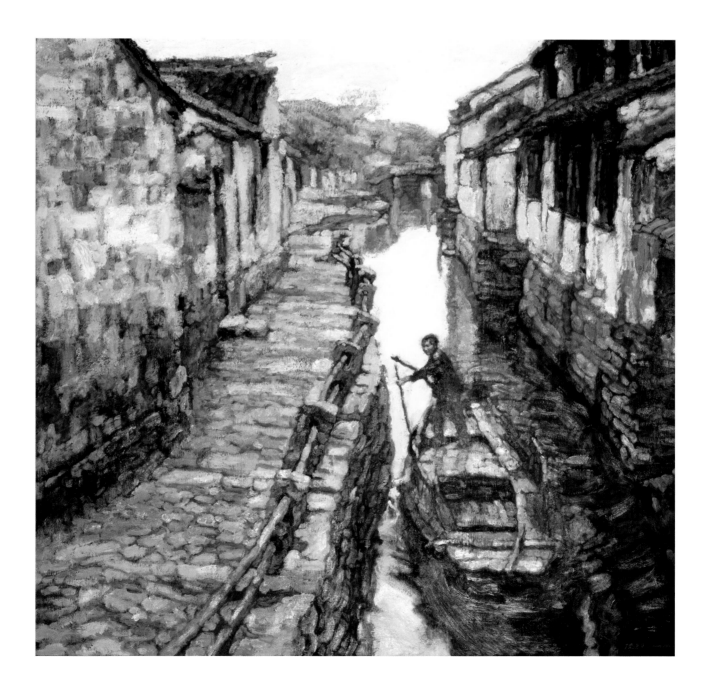

A Series of Shanghai Alleyways 18, 2002

By Liang Yunting (born 1951)
Oil on canvas
H. 99.5 × W. 83.5 cm
Collection of the Shanghai Art Museum

Liang Yunting graduated from East China Normal University in Shanghai. His works depict rapidly vanishing prerevolutionary forms of architecture, including Shanghai's characteristic residential lanes, which he began painting as early as 1993. *A Series of Shanghai Alleyways 18* was included in the *Shanghai Oil Painting Exhibition* of 2003.[1]

Longtang housing (also called Lilong) developed in Shanghai as a blend of European row housing and Chinese courtyard dwellings; it was built from the late nineteenth century until the early 1940s. The essential feature of this form of housing is the neighborhood layout: a lane faced with closely packed houses extends perpendicular to the main street, and narrow ancillary lanes lead off from the primary lane. The entrance to that lane, which may be marked by an arching gate, is the locus of commercial activity, with small vendors clustered close at hand to serve the needs of those dwelling within the network of lanes. The lanes themselves form a quiet neighborhood, acting as an extension of the interior living space, and can be a hive of activity. By omitting the residents from his painting, Liang has created a timeless image of a classic, elegantly proportioned Shanghai neighborhood, enhanced by the restrained tones of the weathered red brick facade. Only two benches and a laundry-hung pole suggest the human presence.[2] BE

1 Shanghai Art Salon, Chinese Arts, "Liang Yunting," *Art Shanghai,* March 11, 2009. http://www.cnarts.net/artsalon/2004/eweb/gallery/index.asp?mid=31.
2 Qian Guan, "Lilong Housing"; and Novelli, "Longtang Housing," 36–65.

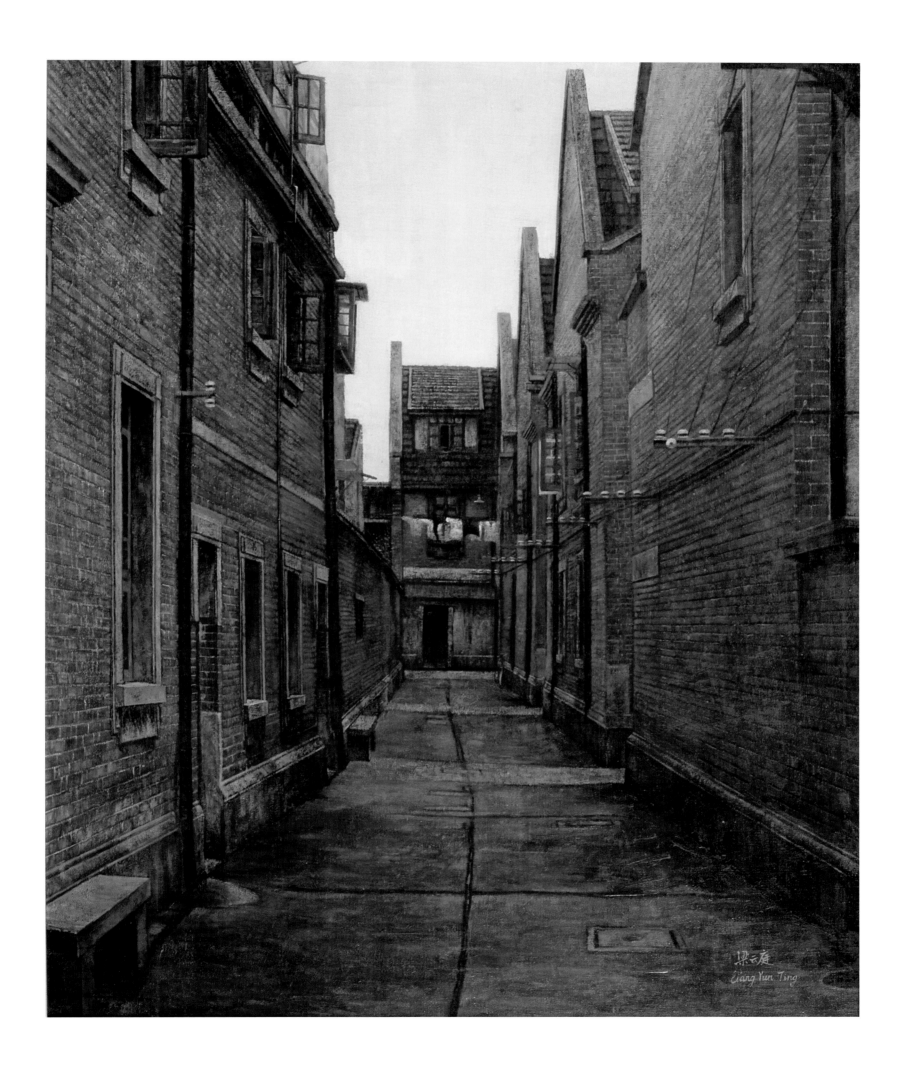

Appearance of Crosses 1991–3, 1991
By Ding Yi (born 1962)
Acrylic on canvas
H. 140.0 × W. 180.0 cm
Courtesy of the artist

Ding Yi's paintings are a synthesis of the abstract
qualities inherent in traditional Chinese calligraphy
and brush painting with an understanding of Euro-
pean abstract painting, further reduced in accord with
the artist's desire to create works of art that provide
a pure visual experience and thus can be universally
appreciated, regardless of the viewer's background and
education. As such, they are a sophisticated personal
manifestation of the Shanghai appreciation for color
and line. Having been born and educated in Shanghai,
and living there still, Ding Yi is a product of that city.
He graduated from the Shanghai Arts and Crafts
Institute in 1983 and from the Fine Arts Department
of Shanghai University in 1990. Although he began
creating abstract paintings in 1983, at Shanghai Univer-
sity he studied traditional Chinese painting. Outside
of his studies, he experimented with straight lines
produced with a T-square, and he tried pens, airbrush,
and digital media in his search for a dispassionate and
accurate mode of creativity.[1] In 1988 he embarked on
his major project, the ongoing painting series *Appear-
ance of Crosses*. Each painting in the series is built up
from a single basic unit, the cross form, which is also
the Chinese character *shi* (meaning ten). The extreme
self-imposed restriction to the cross form is related
to the (much less) limited vocabulary of brushstrokes
employed in Chinese brush painting, as well as to the
de Stijl painters, who restricted their vocabulary to pure
geometric forms. While the latter group employed a
color palette confined to the primary colors plus black
and white, Ding Yi has experimented with a wide range
of color combinations, resulting in images that may be
elegantly restrained or wildly exuberant. In addition,
layering crosses in different colors can create a sense of
depth, and the slight irregularities in the lines produce
a sense of movement. The small linear irregularities in
Appearance of Crosses 1991–3 cause certain diagonals and
plane figures to stand out from the apparently evenly
articulated all-over pattern. BE

1 Pederson, "Contemporary Art with Chinese
 Characteristics," 38.

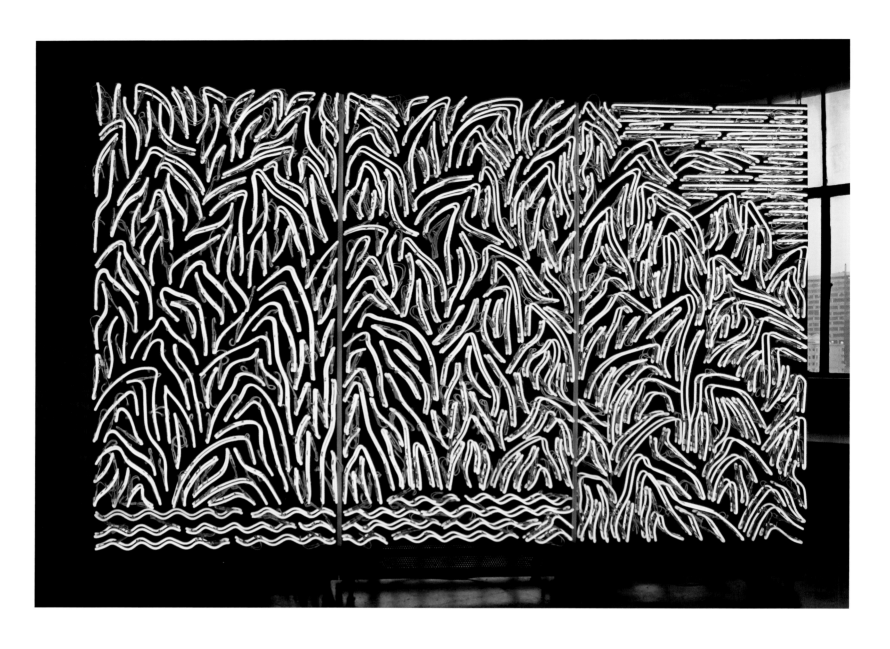

116 *Landscape—Commemorating Huang Binhong—Scroll*, 2007

By Shen Fan (born 1952)
Installation with lights and sound
H. 222.0 × W. 302.0 × D. 70.0 CM
Courtesy of the artist

Shen Fan was born and grew up in and around Shanghai, receiving an education in the city and farming in the countryside during the Cultural Revolution. He graduated from the Fine Arts Department of the Shanghai Light Industry Institute in 1986 and has been living in Shanghai ever since. He is one of a group of internationally acclaimed Shanghai artists working primarily in an abstract idiom that is conceptually based in the abstract qualities inherent in Chinese traditional brush painting and calligraphy as well as in twentieth-century European abstraction. *Landscape—Commemorating Huang Binhong—Scroll* is a logical progression from his painting oeuvre, an expression of his aesthetic and interests in a new medium.

Over the years Shen Fan has produced increasingly minimalistic monochromatic abstractions, working with primary colors, black, and white. Applying paint with a palette knife, he creates arrangements of three-dimensional geometric forms atop the paper or canvas. Recently he has chosen to move from pure abstraction to hint at landscape forms, referencing traditional landscape paintings through placement of those forms and through the proportions of his canvases. When he was invited to contribute a work to the 2006 Shanghai Biennale, he considered that to translate his work into neon would be appropriate, given that the biennial site, the Shanghai Art Museum, is situated on Nanjing Road, known for its abundance of neon signs.[1] *Landscape—Commemorating Huang Binhong—Scroll* is a smaller variant on the biennial work *Landscape—Commemorating Huang Binhong*. The neon tubes can be equated to brushstrokes and approximate the idea of

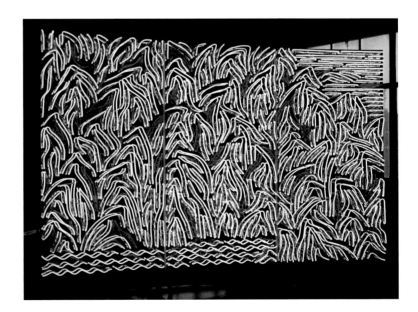

Huang Binhong's (1865–1955) late works, masterpieces of Chinese landscape painting built up from "raw" brushstrokes in uniformly dark ink. A musical composition played on the *qin* forms an integral part of the neon installation: the length, shape, angle, and location of the neon tubes decide the length and tone of the musical notes. As Shen Fan describes the music, "There is no melody, no rhythm, no harmony. . . . Who would care about the source of the music? Maybe, that is the sound of nature."[2] BE

1 Shen Fan and Christopher Phillips, "Shen Fan: Interview by Christopher Phillips," *ShanghART Gallery*, May 2008, http://www.shanghartgallery.com/galleryarchive/texts/id/1067.
2 E-mail communication with the artist, March 31, 2009.

Shanghai Lily, 2009

By Zhou Tiehai (born 1966)
Acrylic (airbrush) on canvas
H. 250.0 × W. 150.0 cm
Courtesy of the artist

A lifelong Shanghai resident, Zhou Tiehai is the city's best-known conceptual artist. He established the direction of his oeuvre in 1994, a year that marked a turning point in his career: prior to that he had participated briefly in the Shanghai-based performance group "M" Art Group (1986) and studied at the Fine Arts Department of Shanghai University (1987) where, although he did not complete the program, he nevertheless gained a grounding in representational modes that remained somewhat Socialist Realism–inflected. Like many artists of China's 1980s New Wave Movement, he became discouraged by the difficulty of establishing relations with the art world outside China. Identifying the artist's ability to convince others of his importance as the crucial career-making factor, from 1994 he resolved to devote his time to liaising with curators, critics, and other art-world figures, while assistants produced work for him based on his conceptions, including creating paintings for him using an industrial tool, the airbrush. He embarked on his signature series *Placebo* in 2000, irreverently replacing the heads on masterpieces of European figural painting with that of Joe Camel. The latter sports dark glasses and a smug grin as if content in his role of stripping away the artifice of the privileged art world. Zhou's remakes of Western film images belong to the *Placebo* series, with Joe Camel's head substituted for that of one of the actors depicted, including Marlene Dietrich in *Blond Venus* (2007) and supporting actors in *Mata Hari* (2007) and *The Great Dictator* (2008).[1]

Shanghai Lily is based on a promotional still for the 1932 Joseph von Sternberg film, *The Shanghai Express,* starring Marlene Dietrich as Shanghai Lily, the notorious White Flower of China who has "wrecked a dozen men up and down the China coast."[2] She became a seductress only after the man she loved left her: as she remarks, "It took more than one man to change my name to Shanghai Lily." Her true personality is revealed when a rebel warlord captures the train she is traveling on, and she proves willing to sacrifice herself to save her former love, who happens to be traveling on the same train. Both Shanghai Lily and the actress herself were constructs that satisfied a craving for exoticism, glamour, and sensuality. As such, they are ripe targets for Zhou Tiehai's brush, the amusingly jarring substitution of Joe Camel's head for one of great beauty underscoring Hollywood's role as generator of illusory, self-satisfied myths. BE

1 Zhou Tiehai's first movie-related images were *Stars of the '80s*, idealized portraits of youthful early–Cultural Revolution movie stars.
2 The Reverend Carmichael made this statement to fellow Shanghai Express passenger Captain Donald Harvey.

118 *Mawangdui 2009*, 2009

By Liu Dahong (born 1962)
Embroidered silk
H. 240.0 × W. 100.0 cm each, two pieces
Collection of the artist

After receiving his undergraduate degree from the Zhejiang Academy of Fine Arts (now the China National Academy of Fine Arts) in Hangzhou, Liu Dahong moved to Shanghai, where he is a professor in the Fine Art Department of Shanghai Normal University. He has developed a highly idiosyncratic painting style that reflects influences as diverse as the Northern Renaissance masters and Chinese New Year prints. Fascinated by detailed observations of vernacular life, of history and fantasy, he absorbs the full spectrum of visual culture as fodder for his fanciful creations, recombining familiar imagery with his own imaginings to produce commentary on both historical and contemporary society. Both contemporary Shanghai and Cultural Revolution China have proven to be particularly rich sources of visual information. Having been born in 1962, Liu Dahong witnessed the effects of the Cultural Revolution as a child, and that era appears frequently with a satiric twist in his work; because of this he was grouped with the highly acclaimed Political Pop artists during the early 1990s.

Liu Dahong's *Mawangdui 2009* is an embroidered version of his oil-on-canvas *Mawangdui Silk Painting—Red and White Diptych* (2001), supposedly "designed for the Memorial Hall of the Cultural Revolution."[1]

It, in turn, was based on the painted silk funerary banner (approx. 168 BCE) found atop the innermost coffin in the tomb of Lady Dai, Mawangdui Tomb No. 1.[2] The tomb, discovered and excavated near Changsha during the Cultural Revolution, dates from the Western Han dynasty (206 BCE–25 CE).

The embroidery of Liu Dahong's *Mawangdui 2009* was accomplished in Zhenhu, a small town near Suzhou famed for its embroiderers. The artist estimates that four women will have worked more than ten hours each day for over six months to complete the banners, working in the laborious, delicate style known as Su (short for Suzhou) embroidery, whereby images are built up via small, flat stitches of fine silk thread.

Both embroideries composing *Mawangdui 2009* follow the layout of the original banner closely, but one mirrors the composition (the composition is flipped around a vertical axis), and the artist has substituted Cultural Revolution–related iconography for that of the Western Han. The fact that the Maoist pantheon is sufficiently abundant to provide iconographic parallels to the Mawangdui banner twice over underscores the extent to which the Cultural Revolution provided quasi-religious objects for fervent believers.

224

Although the exact meaning of the original Mawangdui banner's iconography cannot be known, the general consensus is that the banner represents the journey of the deceased. Horizontal bars divide the vertical structure into four areas, the lowest representing hell, the highest being heaven, and the middle two portraying stages in Lady Dai's afterlife. Liu Dahong follows this pattern, substituting for Lady Dai a peasant girl heroine from a Cultural Revolution ballet as the central figure for each banner, one being Wu Qinghua from *The Red Detachment of Women* and the other Xi'er of *The White-Haired Girl*. In the top center of the Red banner, based on *The Red Detachment of Women*, a woman appears clad in red; the White banner, based on *The White-Haired Girl*, features a woman in white.

In the lowest division of the compositions, the villainous landlords from the two ballets—Tyrant of the South (from *The Red Detachment of Women*, set in Hainan Island in the south of China) and Tyrant of the North (Huang Shiren, from *The White-Haired Girl*, set in the northern province of Hebei)—assume the role of lord of the underworld. In the next level up, the original banner features two ritual objects, a *bi* or disk and a chime shaped like an inverted "V": for these,

225

Liu has substituted a straw peasant hat inscribed with "Red Army" (the dragon's body crossing over the hat is inscribed with the ballet title); and a bridge grouped with two pagodas such as are found at West Lake. Where the original depicts the corpse and attendant mourners, Liu captures the heroines in their most dire moments, shackled and observed by their tormentors. In the next section up, where the original is thought to portray Lady Dai in eternity (the "body in its eternal home"[3]), Liu shows the heroines in their moments of liberation: Wu Qinghua is rescued by Hong Changqing, Commissar of the Red Detachment of Women, and Xi'er is saved by her fiancé, Wang Dachun, who had left to join the Eighth Route Army but then returned to liberate the area. Suspended above their epiphanies is a winged Mao Zedong. The third and final horizontal divider is supported by walls of cave dwellings such as were found in the Communist base area of Yan'an, and seated atop the pointed roof in the center are Liu Shaoqi (1907–1971), who rose to the position of vice premier but died mysteriously in a plane crash after a supposed failed coup, and Deng Xiaoping (1904–1997), who was twice purged during the Cultural Revolution but survived to become China's leader from 1978 into the 1990s, the pair flanked

by additional figures from the ballets. Above them, ironically centered in the double fish symbol of good fortune, is the head of Peng Dehuai (1898–1974), a prominent military commander who fell from grace and was arrested and tortured during the Cultural Revolution.

The top segment of each image represents heaven. Centered above in place of the original mythical human-headed snake, Liu has placed female Communist martyrs, Zhang Zhixin (1930–1975) in the Red banner (dressed in red) and Sister Jiang (Jiang Zhujun, 1920–1949) in the White banner (dressed in white). Zhang was executed but posthumously rehabilitated for having opposed the extremism of the Cultural Revolution, including the cult of personality surrounding Mao.[4] Sister Jiang was a Communist Party member who was captured by Nationalist forces and executed after refusing to reveal secrets to the enemy.[5] The martyrs glow with a light equal to that of the flanking sun and moon, the sun occupied by Mao (commonly referred to as the Red Sun) and the moon by Zhou Enlai, as well as by the raven and rabbit traditionally associated with those celestial bodies, and also depicted in the original. Mao's extended hand supports the central martyr. Where the original banner featured small suns below the large sun,

in reference to the legend in which Archer Yi shot nine superfluous suns out of the sky to save the earth from scorching, Liu has inserted red disks resembling sunflowers and inscribed them with a saying that the flowers turn toward the sun, a common reference to Mao's followers turning to him for light. Humorous details include Shanghai's Oriental Pearl TV Tower and the Monkey King behind and below the moon, as well as small semi-naked women and women-beasts appearing throughout the composition.[6] BE

1 Liu Dahong, *Liu Dahong's Textbook*, 58.

2 For images of the original banner, see Hunan Provincial Museum, "The Exhibition of Mawangdui Han Tombs: Treasure on Silk and Inscribed Slips," http://www.hnmuseum.com/ hnmuseum/eng/whatson/exhibition/mwd_2_5.jsp#.

3 Wu Hung, "Origins of Chinese Painting," 24.

4 Wikipedia, "张志新" (Zhang Zhixin), http://zh.wikipedia .org/wiki/张志新.

5 Wikipedia, "江竹筠" (Jiang Zhujun), http://zh.wikipedia .org/wiki/江姐.

6 Information concerning the iconography was drawn from e-mail correspondence with the artist as well as from Liu Dahong, *Liu Dahong's Textbook*, 58.

119 *Forest*, 2004

By Li Huayi (born 1948)
Ink and colors on paper
H. 120.0 × W. 368.0 cm
Private collection

While the fastidious brushwork characterizing Li Huayi's paintings hints that they belong to a conservative lineage of China's great landscape painting tradition, they are much more. Li has found in the Chinese landscape a protean form that can be molded to accommodate all manner of artistic influence and experience. Born in Shanghai before the revolution and educated in both China and the United States, he has lived through art movement extremes. His initial training was in traditional painting and calligraphy, as he was tutored by Wang Jimei, son of the Shanghai master Wang Zhen (1867–1938; cat. no. 17). At age sixteen he opted to study Western-style art with Zhang Chongren (1907–1998), who was educated at the Royal Academy in Brussels. The facility Li Huayi developed with rendering realistic subjects in oils proved advantageous during the Cultural Revolution, when he could easily adapt it to the pre-

scribed Socialist Realist manner. Following the close of the Cultural Revolution he traveled to such noted sites as Mount Huang and the Buddhist caves of Dunhuang, seeking to prepare the way for a new artistic direction through a direct experience of nature and a reconnection with China's early artistic heritage. In 1982 he emigrated to the United States, where he earned a master's degree from the San Francisco Academy of Art and gained a firsthand familiarity with Western modernism. He now divides his time between San Francisco and Shanghai.

Although Li Huayi's paintings typically conjure the monumentalism of the great Northern Song (960–1127) landscapes, the apparent rationalism of their construction is founded in chance. He begins his paintings by spreading ink wash, then building on the semi-chance-generated results. The process finds roots both in Chinese painting history and in Abstract Expressionism.

Clearly delineated passages join with the more amorphous to create a sense of a living, changeable landscape. Just as Li Huayi's approach to painting is a personal fusion of past and present, East and West, so too are the landscape forms: the pine trees and rocks in his paintings could as easily be derived from California as from China. The trees in the painting *Forest* are, however, based on a group of ancient cypresses in the grounds of Situ Temple on Mount Dengwei near Suzhou.[1] Planted during the Eastern Han dynasty (25–220 CE) by former Prime Minister Deng Yu (2–58), they grew to be celebrated for their fabulous contorted shapes and venerable age: the Qianlong Emperor (1711–1799) gave them the title *Qingqi guguai* (elegant and strange), and they were painted by such masters as Wen Zhengming (1470–1559). Li Huayi has chosen to foreground a single tree, emphasizing its branches' elegantly dramatic curves, against a backdrop that suggests an infinite natural realm untouched by humanity. BE

1 For a photograph of the trees, see: 禾子,《清奇古怪》 *Qingqi guguai* [Elegant and strange], 新攝影 *Xin sheying* [New photo], December 5, 2007. http://images.google.com/imgres?imgurl=http://image.photos.nphoto.net/200712/05/673273bf1d3eb37ca0a546bab3 3d59e5.jpg&imgrefurl=http://photos.nphoto.net/photos/2007-12/05/ff8080811682b5290116a90b84e1784b .shtml&usg=__l1G77CYu8ePVLCVMzPNVK5mKtBQ=&h =603&w=821&sz=194&hl=en&start=2&sig2=hQlP6bjGCy LG5x7q_tWunA&um=1&tbnid=RsyC-TMglpZgkM:&tbnh= 106&tbnw=144&prev=/images%3Fq%3D%25E5%258F%2 5B8%25E5%25BE%2592%25E9%2582%2593%25E7%25A6 %25B9%26hl%3Den%26client%3Dfirefox-a%26rls%3Dorg. mozilla:en-US:official%26sa%3DN%26um%3D1&ei=enf_ SZ2dI6byswOjo6jeBQ (accessed 4 May 2009).

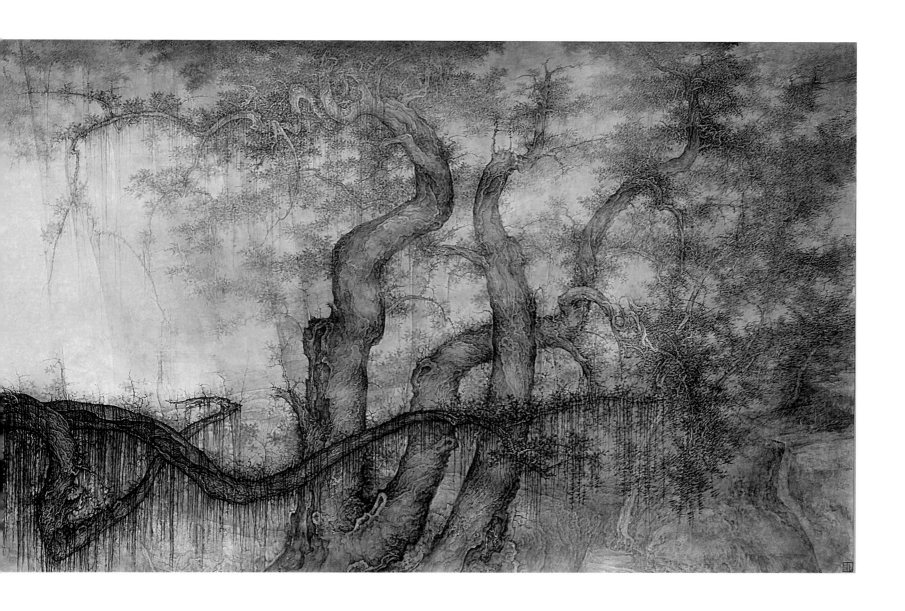

120 *The Dimension of Ink No. 1*, 2008

By Zheng Chongbin (born 1961)
Ink, acrylic, and fixer on paper
H. 144.8 × W. 302.3 cm
Collection of the artist

Born in Shanghai, Zheng Chongbin participated in Shanghai Art Club activities as a youth, and he was privately tutored in ink painting by Mu Yilin (born 1942)—himself a student of the great Shanghai school painters Xie Zhiliu (1910–1997) (cat. no. 19) and Cheng Shifa (born 1921)—and Chen Jialing (born 1937). In 1984 he graduated from the Chinese Painting Department of the Zhejiang Academy of Fine Arts in Hangzhou (now the China National Academy of Fine Arts), where he specialized in figure painting. Inspired in part by the Surrealists' use of negative space, shadows, and psychological nuance,

he developed a group of works on the borderline between figurative and abstract, finally moving to pure abstraction. Following graduation he taught at the academy for four years and then emigrated to the United States, earning his MFA from the San Francisco Art Institute in 1991. He now maintains a home in Marin County (north of San Francisco) and studios in Shanghai and Hangzhou.[1]

Although Zheng Chongbin experimented for a time with installation art, following his move to the United States he returned to ink painting and has pursued the development of a new and highly sophisticated approach

to abstraction. As a means of creating an enhanced sense of depth, he paints with white acrylic and fixer in combination with ink. The *xuan* paper absorbs the materials to varying degrees, resulting in a layering effect, plus they interact with one another in a manner that can be semi-controlled by the artist. Furthermore, he adopted the *paibi* or broad brush in place of traditional brushes, resulting in a heightened mindfulness of long-ingrained painting techniques. *The Dimension of Ink No. 1* brings together the abstract qualities of the calligraphic line (most evident in the broad black areas) with the

three-dimensionality of the figurative tradition (apparent in the white forms left of center), expressed with an understanding of the theatrical use of space drawn from such diverse sources as Francis Bacon (1909–1992), Caravaggio (1573–1610), and major representatives of the monumental Chinese landscape painting tradition, such as Fan Kuan (late tenth–early eleventh century) and Guo Xi (approx. 1020–1090). BE

1 Much of the information in this entry is based on a 2006 interview. See Erickson, "Innovations in Space," 28–31.

Shadow in the Water, 2002–2008

By Liu Jianhua (born 1962)
Installation with porcelain and light
H. 48.0 × W. 1200.0 × D. 8.0 cm.
Collection of the artist

Over the past decade many Chinese artists have commissioned the production of works of art from Jingdezhen, for centuries the elite center of porcelain production and notable as the major source of fine porcelain both for the imperial court and for foreign export. Porcelain is Liu Jianhua's signature medium, but for him to employ it is not a simple matter of contracting out skilled labor: he has been working with this material since he was a child. Born in Ji'an, Jiangxi Province, he moved at the age of twelve to Jingdezhen, where his uncle managed a factory.[1] For eight years he worked in the Jingdezhen Pottery and Porcelain Sculpturing Factory (1977–1985), after which he studied sculpture in the Fine Arts Department of the Jingdezhen Pottery and

Porcelain College (1985–1989). He taught sculpture at the Yunnan Art Institute in Kunming (1989–2004) and split his time between Kunming and Jingdezhen before relocating to assume the position of associate professor in the Sculpture Department of the Shanghai University Fine Arts School.

In the rush to modernize, China's cities have lost much of their individuality: across the country old neighborhoods are razed and trees demolished to make way for skyscrapers created with a uniformity of vision. Liu Jianhua's *Shadow in the Water* suggests the sameness of China's major metropolises, with an endlessly repeating row of towers and skyscrapers. Incredibly, buildings from across China seem to have joined Shanghai's

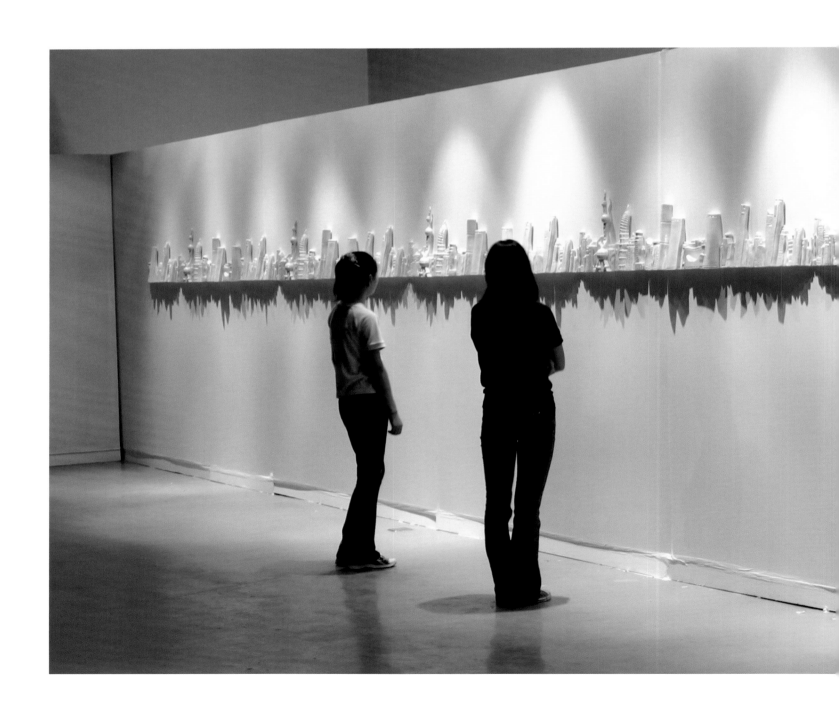

Pudong landmarks along the Huangpu River. They bend as if reflected in the water, and the shadows projected below them play an ambivalent role: together, they suggest that the current rash of modernity is an unsteady illusion. Prior to creating *Shadow in the Water*, Liu had worked primarily in polychrome ceramics and celadons; with this piece, he adopted the monochrome ware *qingbai* as a less literal and therefore more suggestive medium.

Among the buildings featured in *Shadow in the Water* are Beijing's China World Trade Center (low building with concave roof, flanked by two towers), Jingguang Center (skyscraper with a smooth curved facade divided into three segments), and Great Wall Sheraton (to the immediate left of the Jingguang Center); Shenzhen's tallest building, the Diwang Tower (quite tall, with a pair of round turrets); Guangzhou's CITIC Plaza (skyscraper to the right of the China World Trade Center); and Shanghai's Oriental Pearl Tower (tower with joined globes, one of the tallest towers in the world), Jinmao Tower (skyscraper constructed in tiers, to the right of the Oriental Pearl Tower), and Bank of China Tower (tallest building between the Oriental Pearl Tower and the Diwang Tower). BE

1 Beltrame, Lin, and Liu Jianhua, *Liu Jianhua*, n.p.

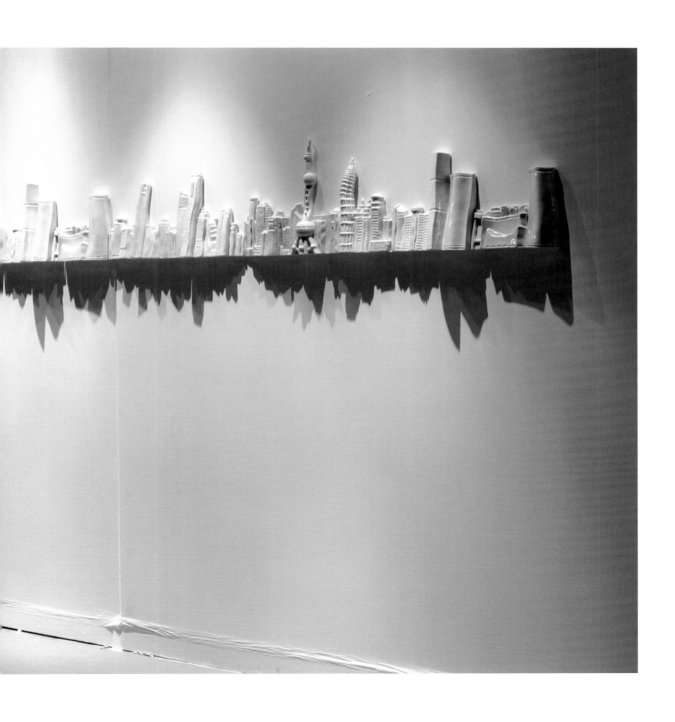

122 *Can You Tell Me?*, 2006

By Liu Jianhua (born 1962)
Installation with stainless steel
Dimensions variable; each "book":
 H. 27.0 × W. 39.0 × D. 4.0 cm
Collection of the artist

When Liu Jianhua moved to Shanghai, he realized that it is in the nature of the city to provoke questions, including fantasies, concerning the future. Always changing, propelled by its role as an economic powerhouse, the city suggests endless possibilities. Fascinated by the multivalent relationships of people to the city, Liu Jianhua devised *Can You Tell Me?*, a work that encourages viewers to ponder and discuss Shanghai's possible futures.

Can You Tell Me? is an installation of up to fifty stainless-steel open "books" arrayed either on a platform or on long narrow tables. Each book presents two questions about Shanghai, one on each page, posed in five languages: Chinese, English, French, German, and

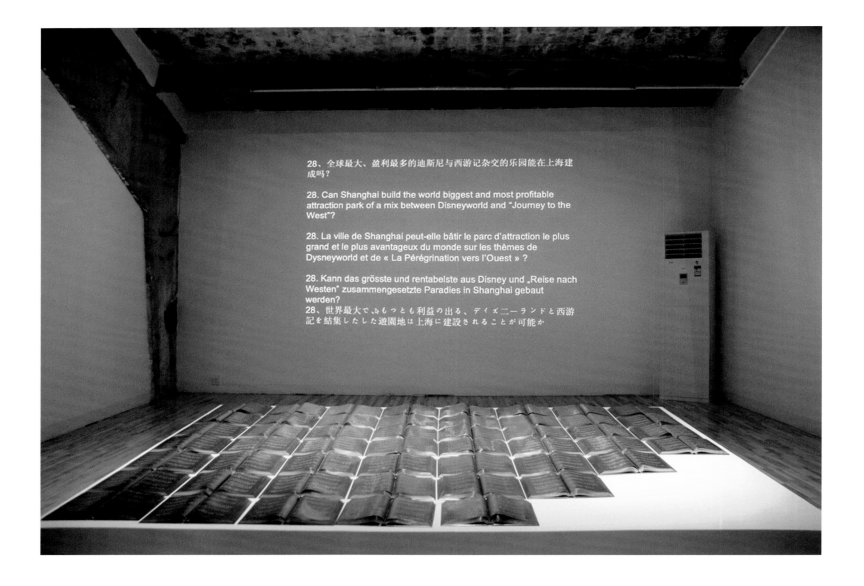

Japanese. Often a video accompanies the installation of books, displaying the list of one hundred numbered questions, which range from the fanciful to the idealistic and realistic, touching on such subjects as economic concerns, personal relationships, and culture. Representative questions include the following:

3. Can Shanghai make the magic of David Copperfield come true, and move the Bund 100 meters backward to widen the avenue?

4. Can Shanghai build the first welfare bank in the world to allow poor people to get money whenever they need?

23. Could the twenty best universities of the world be all built in Shanghai?

34. Due to interested economic relationships, will Shanghai be the city with the widest age gap between husband and wife?

63. Will the first golf course built on a skyscraper's roof appear in Shanghai?

94. Seeking for a cultural and artistic image, will Shanghai import numerous sculptures from all around the world to become the city with the biggest collection? BE

Vestiges of a Process:
ShiKuMen Project 2007, 2007

By Zhang Jian-Jun (born 1955)
Video
5 minutes 47 seconds
Collection of the artist

Zhang Jian-Jun began his art education at the age of seven, with calligraphy. He studied ink painting briefly as part of the first semester art school curriculum at the Fine Arts Department of the Shanghai Drama Institute, after which he focused on oil painting. Following graduation, he began a long-term association with the Shanghai Art Museum, first as a resident artist and later in administrative and curatorial roles. He moved to the United States in 1989 and has held the position of adjunct professor in the Fine Arts Department of New York University since 1997. He divides his time between New York and his native Shanghai, where he teaches at the NYU Shanghai Center.

Returning to China in 1995 after six years in the United States, Zhang Jian-Jun was shocked by the extent to which the urban environment had changed: entire neighborhoods had been demolished and replaced by high-rise buildings of an entirely different character.

His reaction inspired a group of works expressing concern with the continuity of culture and of human values through time and space. One such work is *Vestiges of a Process: ShiKuMen Project 2007,* a video recording a performance in which the artist set up an easel facing one of old Shanghai's most distinctive architectural features, a carved stone doorway, or shikumen, associated with Shanghai's residential alleys or lilong. Zhang painted an image of the carved stone doorway using a medium that fades with time. The video shows the gradual disappearance of the painting of the doorway, serving as a direct metaphor for the disappearance of those architectural features from the streets of Shanghai. As Zhang paints the doorway, and then as the image fades away, local residents pass by, either interested or indifferent, reflecting the degrees of engagement individuals afford the changes occurring in the cityscape around them. BE

124 *Vestiges of a Process:*
Shanghai Garden, 2010

By Zhang Jian-Jun (born 1955)
Installation with antique Shanghai bricks, silicone rubber rocks,
 silicone rubber vase, solar-powered plastic leaves, and rice paper
Dimensions variable; rock #1: H. 202.0 × W. 136.0 × D. 80.0 cm,
 rock #2: H. 120.0 × W. 77.0 × D. 45.0 cm
Collection of the artist

Vestiges of a Process: Shanghai Garden brings together many of Zhang Jian-Jun's long-term interests, fusing signs of humankind and nature, history and contemporary culture. It is a variant of the installation *Sumi-Ink Garden of Re-Creation,* created for the artist's solo exhibition at the He Xiangning Art Museum, Shenzhen (2002) and subsequently exhibited in the Fourth Shanghai Biennale (2002). *Vestiges of a Process: Shanghai Garden* is an installation composed of two Taihu rocks made from silicone rubber, plus a silicone rubber vase, all arrayed atop a pavement of gray antique bricks, acquired from the demolition of Shanghai houses constructed between 1923 and 1926, not far from where Xin Tiandi now stands. The silicone rocks were manufactured in molds formed directly from Taihu rocks, which in traditional garden culture are prized for providing cultured city dwellers with a kind of symbolic access to nature. In designing the silicone vase the artist took as his starting point early ceramic vessels, morphing the original form to create a postmodern re-envisioning of the vessel that reflects a transition between old and new visual idioms. Deployed together, the rocks, the vase, the bricks, and the garden conventions transcend the bounds of their original specific functions, finding broader meaning in the present. Visitors can walk over the bricks and between the rocks, absorbing notions of time and process.

Zhang Jian-Jun believes every era is marked by a characteristic line, form, color, and material. Linking the morphing visual markers is time, as experienced by humankind. Culture is propelled in this manner, with human experience as a universal quality that unifies across time and distance. The artist leads us to an internalized understanding of these issues, via the powerful statements embodied in his most recent works. BE

Note Since this work is a site-specific installation not completed until the exhibition's opening, photographs of the finished piece were not available in time for publication.

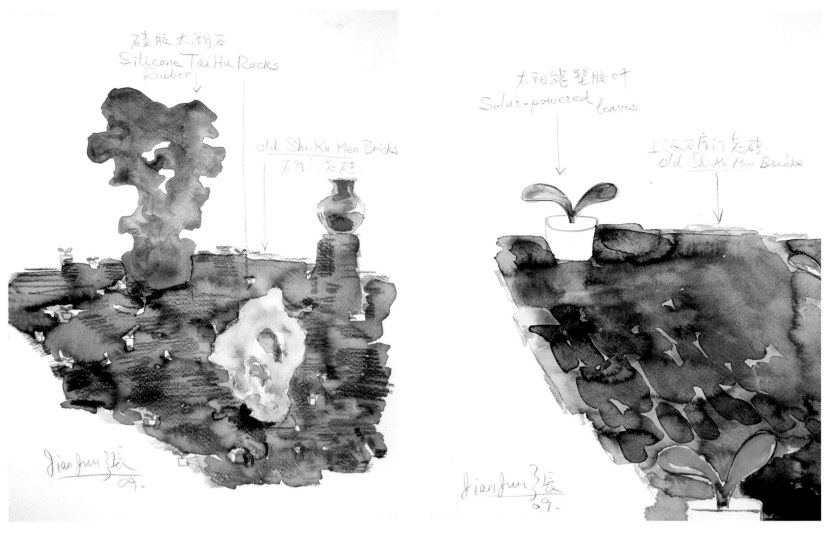

Zhang Jian-Jun, *Vestiges of a Process: Shanghai Garden: Proposal*, 2009.

Demolished houses, the source of the bricks in *Vestiges of a Process: Shanghai Garden*. (Photographs: Zhang Jian-Jun)

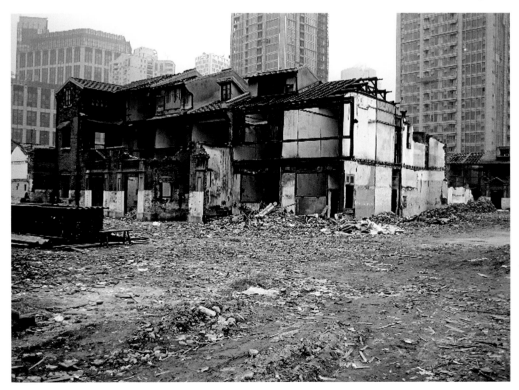

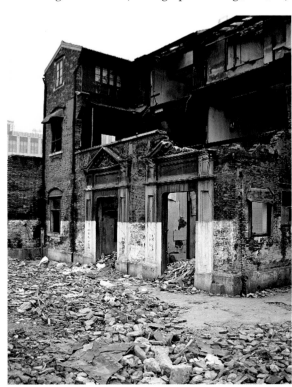

125 *City Light*, 2000

By Yang Fudong (born 1971)
Video
6 minutes 8 seconds
Collection of Eloisa and Chris Haudenschild

Yang Fudong is celebrated for his photographs, videos, and films that frequently express a sense of longing and displacement, often taking as their subject the lives of young urbanites who possess education and beauty but whose positive attributes do not quite mesh with the times. Although he captures the zeitgeist of Shanghai, he was born in Beijing and studied painting at the China National Academy of Fine Arts, Hangzhou (1991–1995), after which he returned to the capital. He studied film for just two weeks at the Beijing Film School (1996); his education as a painter has most significantly shaped his expressive use of lighting and color, as well as his masterfully controlled framing of both still and moving images. In 1998 he relocated to Shanghai.

 City Light is about the disjointed roles and moments that make up daily life. A white-collar worker arises in the morning and sets out, followed by his doppelgänger. Humorously they mirror one another, walking the streets as one holds aloft an umbrella while the other mimics the action. Later they prowl on a mysterious mission, one with a gun and the other brandishing an imaginary weapon. They waltz, with a woman and with one another. Does life as a middle-class office worker necessitate a parallel fantasy life, or is it just that life offers multiple possibilities? Yang Fudong has said that this film reflects his early period in Shanghai, when he supported himself by working for a software company: "Everyday life is like a routine. Sometimes I feel I'm two persons. . . . The me during the day works all the time while the me at night constantly thinks. . . . *City Light* is about a person's split identity. The comical aspects in the film are not necessarily humorous."[1] BE

1 Matt, "Film Is Like Life," 14.

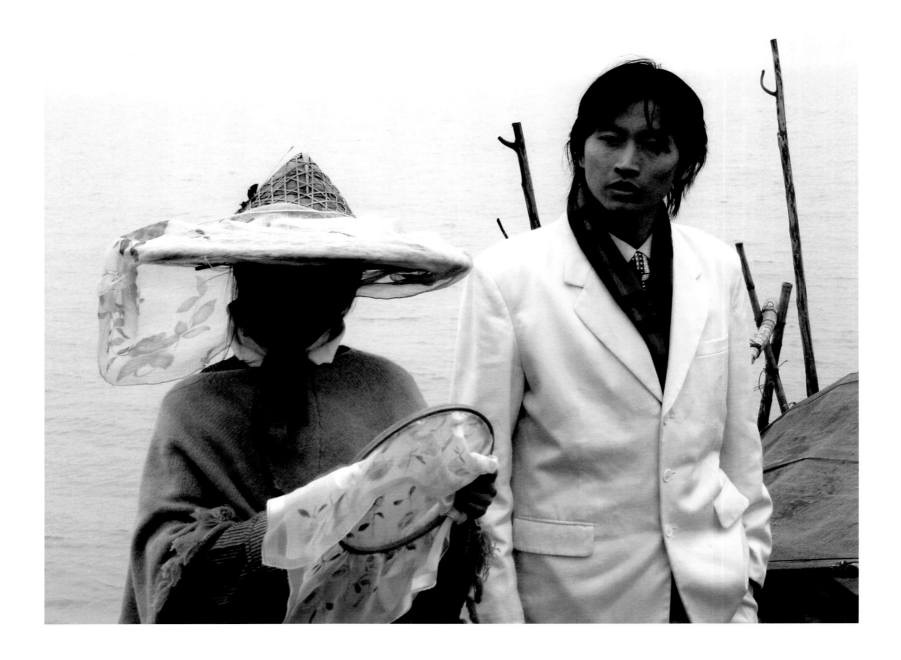

126　*Liu Lan*, 2003

By Yang Fudong (born 1971)
35 mm black-and-white film presented
　　as single-channel digital video
14 minutes
Collection of Eloisa and Chris Haudenschild

Liu Lan unfolds in an imaginary romanticized past that hints at the early twentieth century and yet, due to its lack of specificity, expands into timelessness. The story is timeless, too: the lives of a man and a woman intersect briefly; although they seem like two parts of a whole, they belong to different worlds and must be parted. As the accompanying song relates, "Why are people in love always apart?" Here, the protagonists are a beautiful young country woman and a handsome "intellectual" from the city, traveling a mist-shrouded lake in a small boat. Rendered in black and white, the tranquil, hazy water scenes bear an affinity to traditional Chinese ink landscapes. More than a story of ill-fated lovers, however, *Liu Lan* is a metaphor for the melancholy sense of disjunction experienced by what Yang terms "minor intellectuals" (*xiao wenren*), people who may not stand out from the crowd and yet who maintain integrity in difficult times, seeking to express a harmonious ideal through the example of their lives. The concept of the "minor intellectual" refers back to the third-century Seven Sages of the Bamboo Grove, who withdrew from the fraught political realm to drink wine and engage in elevated discourse.　BE

242

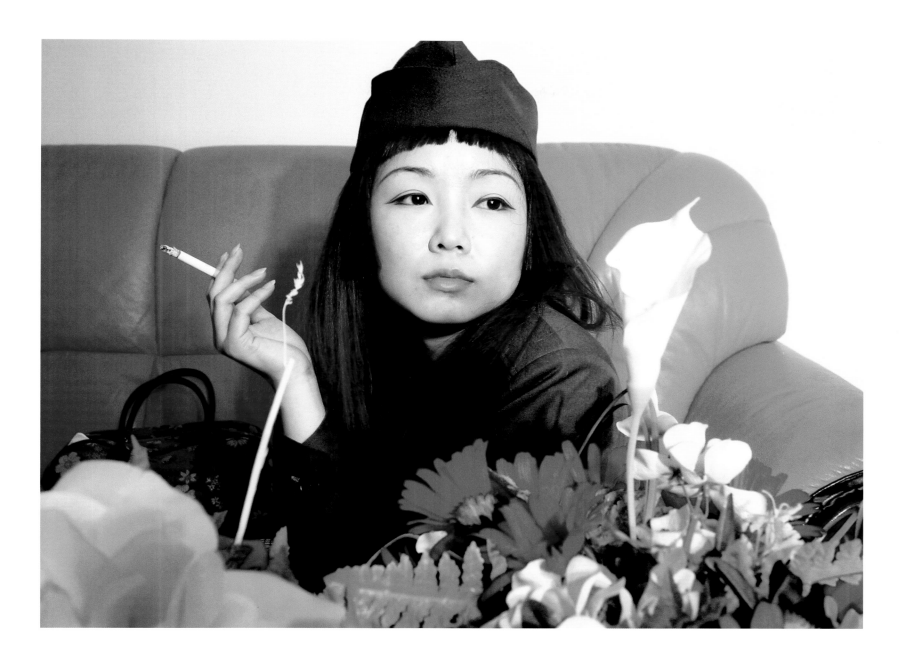

127 *Honey*, 2003

By Yang Fudong (born 1971)
Video
9 minutes 29 seconds
Private collection

While *Liu Lan* is an elegy of restraint in terms of both the story and its presentation, *Honey* is provocatively florid. And although much of the *Liu Lan* narrative is left to the viewer's imagination, this is even more the case with *Honey*, which centers on a mysterious young beauty. Highly self-controlled, coiffed and made up with precision, she reveals little emotion but is sensuously attired in alternating outfits, one resembling a uniform of army green and the other of fur. She smokes and poses on a salmon-pink leather sofa, indifferent to the regard of various young men in cadres' attire. There appears to be a deep and tawdry plot involving espionage, but the details do not thread together into a cohesive narrative. In this atmospheric dream-world the present is melded with an exotic past. BE

128 *The New Book of Mountains and Seas Part 1*, 2006

By Qiu Anxiong (born 1972)
Video
30 minutes 5 seconds
Collection of Mr. and Mrs. Eric Li

Born in Chengdu, Qiu Anxiong studied at the Sichuan Fine Arts Institute (graduated 1994) and at the Art College of Kassel University in Germany (graduated 2003). He is best known for his videos, but he also produces large-scale sculptures and installations. Since 2004 he has been living in Shanghai, where he teaches at the Design College of East China Normal University.

Like many of Qiu Anxiong's videos, *The New Book of Mountains and Seas Part 1* is a stylistic amalgam, based on black-and-white acrylic paintings that resemble Chinese ink paintings and animated with a sketchy quality similar to that of the videos of William Kentridge (born 1955). While Kentridge erases and draws over images

as he works, Qiu can overpaint, an advantage of acrylic over ink as a medium for animation. *The New Book of Mountains and Seas Part 1* required approximately six thousand images and was created in six months.[1]

The original *Classic of Mountains and Seas* is a compilation of ancient texts about geography and mythology, brought into its current form over two millennia ago. It features numerous illustrations of peculiar hybrids, often combining common human and animal features in uncommon ways, and foretelling drastic changes such as drought, war, and disease. *The New Book of Mountains and Seas Part 1* is a history of the world, at first unpeopled, and then gradually filled with

the creations of humankind, beginning with small villages and progressing to cities. A strange flying vehicle drops a box—seemingly a Pandora's Box—into the scenario, after which progress turns ugly. Roads take over, and the reliance on oil is represented through the actions of strange beasts that pump and process the oil. Disaster ensues. Although the video is clearly about the current state of the world, the allegory affords the viewer a welcome distance from which to contemplate the situation. BE

1 Ma, "Biennale Wonder Boy: Qiu Anxiong," *ArtZine China.com*, 2008.

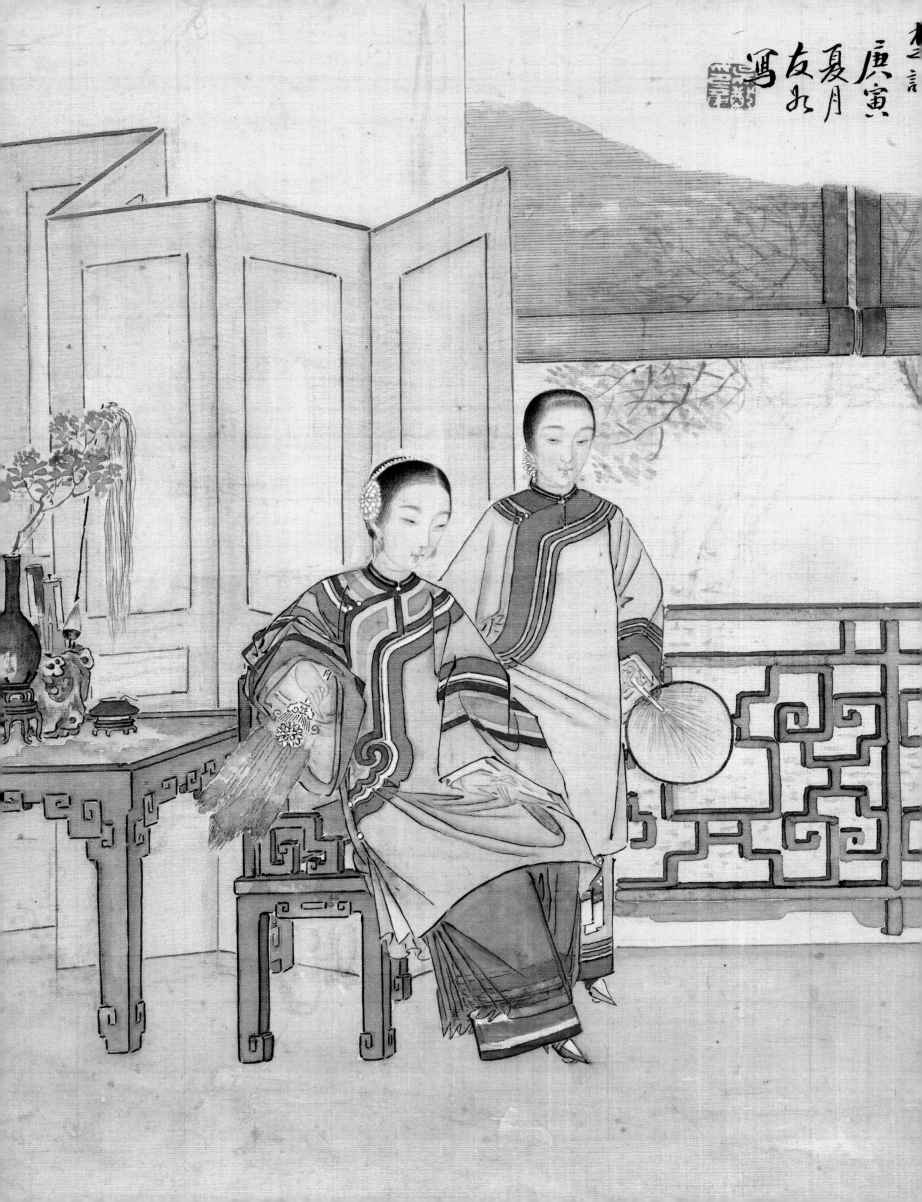

Chronology

1839–1842	First Opium War.
1842	The Treaty of Nanjing establishes Shanghai as a treaty port.
1847	Erection of the Trinity Church in Shanghai.
1851–1864	Taiping Rebellion.
1853–1855	The Shanghai Small-Sword Society launches an uprising and establishes a government office in Dianchun Hall in the old Chinese city.
1854	The Municipal Council of the Shanghai foreign settlements is established.
1856–1860	Second Opium War.
1857	First renovation of the Imperial Maritime Customs House.
1863	British and American settlements are combined as the International Settlement. The French Concession is run separately.
1867	The Pacific Mail Steamship Company launches the first regularly scheduled trans-Pacific service with a route between San Francisco, Hong Kong, and Yokohama and extended service to Shanghai.
1868	The Burlingame Treaty, between the United States and China, establishes formal friendly relations between the two countries, with the United States granting China Most Favored Nation status.
1869	(May 10) The last spike of the American Transcontinental Railroad, which connects Sacramento to Omaha, Nebraska, is driven.
	The Suez Canal opens, allowing water transportation between Europe and Asia without navigating around Africa or carrying goods overland between the Mediterranean and the Red Sea.
1875	Sir Neville Chamberlain arguably creates the game of snooker.
1882	Electric street lighting is installed in Shanghai.
	(May 6) Passage of the American Chinese Exclusion Act.
1884	Introduction of photolithography in Shanghai.
	The inaugural issue of *Dianshizhai huabao* appears.
1885	Zhang Garden opens to the public.
1895	Signing of the Treaty of Shimonoseki.
1896	Film arrives in China.
1897	Commercial Press Limited begins operations.
1904	In Japan the creative print movement (*sōsaku-hanga*) begins.
1905	The first Chinese film appears.
1908	The first movie theater in Shanghai opens.

1912	Fall of the Qing dynasty, establishment of the Republic of China.		The Shanghai Art Academy closes.
	Cai Yuanpei is appointed first Minister of Education in the Republic of China.		Second renovation of the Imperial Maritime Customs House.
	Liu Haisu establishes the Shanghai Art Academy.	1926	Inaugural issue of *The Young Companion*.
1914	The Panama Canal opens.		Sergei Tret'iakov's play *Roar, China!* (Russian: *Rychi, Kitai!*) premieres in Moscow.
1914–1918	World War I.	1928	Lin Fengmian establishes the National Art Movement Society.
1915	The Commercial Press introduces offset lithography in Shanghai.		The Shanghai municipal government is established under the Chinese Nationalist government.
	Zheng Mantuo invents the "rub-and-paint" technique.	1929	Completion of the Zhongshan Mausoleum in Nanjing.
1917	The British stop shipments of opium; the drug becomes illegal in China.		The first official *National Art Exhibition* is opened by Cai Yuanpei in Shanghai.
	Shanghai's first department store, Sincere Company Ltd., opens.		(October 29) The "Black Tuesday" stock market crash in the United States marks the beginning of a worldwide economic downturn.
	The Great World Entertainment Center opens.		
	The October Revolution begins in Moscow.		The Cathay Hotel opens.
1919	The Treaty of Versailles leads to the May Fourth Movement.	1930	Inaugural issue of *Sprouts Monthly*.
1921	The Chinese Communist Party holds its First National Congress in Shanghai.		(March) Inauguration in Shanghai of the League of Left-Wing Writers (*Zuolian*).
1922	Dance halls in Shanghai begin accepting Chinese clientele.		(October) Lu Xun organizes an exhibition of graphic works by artists from Germany and Russia.
1924	(May 21) *Exposition Chinoise d'Art Ancien et Moderne* opens at the Palais du Rhin in Strasbourg.	1931	Lu Xun offers a course on woodblock printmaking taught by Uchiyama Kakichi.
1925	The Shanghai Municipal Council police kill a number of Chinese workers during the "May Thirtieth Incident."		Passage of a new law setting the legal age for marriage at eighteen.
		1932	Japan attacks Shanghai.
	The Xiechang Company begins sale of Singer sewing machines.		Release of the Joseph von Sternberg film *The Shanghai Express*, starring Marlene Dietrich as Shanghai Lily.
	Feng Zikai officially designates the term *manhua* for Chinese cartoons.		The Park Hotel is built.
	Hang Zhiying establishes his own Zhiying Studio.	1933	George Bernard Shaw visits Shanghai.

1934	The Nationalist Party launches the New Life Movement.
	Publication of *All About Shanghai and Environs: A Standard Guidebook* (Shanghai: University Press, Shanghai).
1935	First newspaper publication of the *Sanmao* cartoon series.
	The *International Exhibition of Chinese Art* takes place at Burlington House in London.
1936	(April 15) Inaugural issue of *Woodcut World*.
1937–1945	Sino-Japanese War.
1943	(August 1) The International Settlement and the French Concession are formally handed over to the Shanghai Special Municipality.
1949	(May) The People's Liberation Army marches into Shanghai.
	(October) Establishment of the People's Republic of China.
1950	(June) Outbreak of the Korean War.
1954	Establishment of the Shanghai People's Fine Art Publishing House.
	(February) The East China Artists Association is formed in Shanghai.
1955	Construction is completed for the Sino-Soviet Friendship Building (now called the Shanghai Exhibition Centre, or Shanghai Zhanlanguan).
1956	Hundred Flowers Movement.
1958–1961	The Great Leap Forward.
1966–1976	The Cultural Revolution.
1967	(January) The January Revolution in Shanghai.
1973–1974	The anti-Lin, anti-Confucius campaign.
1974	Opening of the *Shanghai, Yangquan, Lü Da Workers Art Exhibition*.
1976	Death of Mao Zedong.
1978	Deng Xiaoping leads the CCP.
1979	(February) *The Twelve-Man Painting Exhibition* takes place at the Huangpu District Youth Palace.
	Formal diplomatic ties are established with the United States.
1983	Anti-Spiritual Pollution campaign.
1984	Hong Kong communiqué with the United Kingdom.
1985	New Wave or the '85 Art Movement.
1989	(June) Tiananmen Square massacre.
1991	The *Garage* exhibition is curated by Song Haidong and held in the underground parking garage of the Shanghai Education Hall.
1995	Construction is completed for the Oriental Pearl Tower (Dongfang Mingzhu Ta) on the Pudong waterfront.
	Zhang Yimou's film *The Shanghai Triad (Yao, yao, yaodao waipo qiao)* is released.
1996	Lorenz Helbling establishes ShanghART Gallery.
	Shanghai Art Museum inaugurates its biennial program with the first Chinese periodical exhibition of contemporary art.
1999	A supermarket on Huaihai Road is the site of the *Art for Sale* exhibition.
2000	This Shanghai Biennale is regarded as a turning point for the series' renown.
2008	*Intrude: Art & Life 366* is curated by the Zendai Museum of Modern Art.

Checklist in Chinese

1 上海
1855–1862年
無名氏
布面油畫
Peabody Essex Museum收藏

2 外灘圖
1862–1865年
無名氏
水粉
Peabody Essex Museum收藏

3 Augustine Heard and Company
的住宅
1849年
Chowkwa 繪
布面油畫
Peabody Essex Museum收藏

4 寶順洋行
1857–1859年
無名氏
布面油畫
Peabody Essex Museum收藏

5 Russell & Company 圖
1857年
Chowkwa 繪
布面油畫
Peabody Essex Museum收藏

6 罐子
1875年
銀器
Stephen J. 與 Jeremy W. Potash
收藏

7 碗
1875年
銀器
Stephen J. 與 Jeremy W. Potash
收藏

8 隸書:引北魏酈道元著水經注大
夏龍雀銘,
始學篇兩聯;篆書:引金人銘,
東晉葛洪著
抱樸子佚文兩聯
1869年

趙之謙書
紙本墨色軸,四條
上海博物館收藏

9 為琴舟大人(胡寅,浙江台州人)
作陔蘭草堂圖集冊
1864–1884年
二十名家書繪: 費以耕,胡
遠,錢慧安,楊伯潤,張熊,
任薰,朱叔榆,胡寅,胡鐵
梅,王禮,朱偁,顧澐,沙馥,
周鏞,朱銓,李錫光,吳穀
祥,翁同龢,俞樾,徐三庚
紙本設色冊頁,二十二幀
上海博物館收藏

10 楊州山水園林寺廟庭院寫景
1876年
虛穀繪
紙本設色冊頁,十二幀
上海博物館收藏

11 馮耕山像
1877年
任頤繪
紙本墨色軸
上海博物館收藏

12 海天旭日
1891年
吳慶雲繪
紙本設色軸
上海博物館收藏

13 客齋(吳大澂)集古圖
1892年
陸恢與胡琴涵繪
絹本設色手卷
上海博物館收藏

14 寫吳俊卿六十六歲肖像
1909–1910年
倪田繪
紙本墨色軸
上海博物館收藏

15 紅梅圖
1916年
吳昌碩繪

紙本設色軸
上海博物館收藏

16 黃金榮杜月笙肖像
1924年
俞明繪
紙本設色軸
上海博物館收藏

17 龐虛齋抱兔圖
1927年
王震繪
紙本設色軸
上海博物館收藏

18 月梅圖
1933年
陶冷月繪
紙本設色軸
上海博物館收藏

19 花鳥圖
1943年
謝稚柳繪
紙本設色軸
上海博物館收藏

20 持鏡仕女
1950–1965年
林風眠繪
紙本設色軸
上海博物館收藏

21 松下泊舟圖
1950–1965年
林風眠繪
紙本設色
上海博物館收藏

22 青綠山水圖
1978年
劉海粟繪
紙本設色軸
上海博物館收藏

23 幽谷生香圖
1982年
朱屺瞻繪
紙本設色軸
上海博物館收藏

24 上海郵電大樓
1950–1980年代
李詠森繪
水彩
上海美術館收藏

25 美租界界碑
1850年後
鐵，鉛
上海歷史博物館收藏

26 仕女圖
1890年
吳友如繪
冊(12開)絹本設色
上海博物館收藏

27 吳友如畫寶原稿—明眸皓腕
1887–1893年
吳友如繪
紙本墨色
上海歷史博物館收藏

28 吳友如畫寶原稿—別饒風味
1890年代
吳友如繪
紙本墨色
上海歷史博物館收藏

29 吳友如畫寶原稿—媲美夜來
1890年代
吳友如繪
紙本墨色
上海歷史博物館收藏

30 吳友如畫寶原稿—吟詠今夕
1890年代
吳友如繪
紙本墨色
上海歷史博物館收藏

31 吳友如畫寶原稿—香簪寶髻
1890年代
吳友如繪
紙本墨色
上海歷史博物館收藏

32 吳友如畫寶原稿—游目騁懷
1890年代
吳友如繪

紙本墨色
上海歷史博物館收藏

33 吳友如畫寶原稿—視遠惟明
1890年
周慕橋繪
紙本墨色
上海歷史博物館收藏

34 吳友如畫寶原稿—粲粲衣服
1890年代
周慕橋繪
紙本墨色
上海歷史博物館收藏

35 匯丰銀行壁燈
1923年
金属
上海歷史博物館收藏

36 成都路警察署
1930–1939年
Ah Fong照相
銀明膠照片
上海歷史博物館收藏

37 小沙渡路公共菜場
1930年代
無名氏
銀明膠照片
上海歷史博物館收藏

38 上海市立屠宰場
1930年代
無名氏
銀明膠照片
上海歷史博物館收藏

39 馬克公寓
1930年代
王開照相
銀明膠照片
上海歷史博物館收藏

40 百老匯大廈
1934年
無名氏
銀明膠照片
上海歷史博物館收藏

41 美商汽車銷售公司
1930年代
無名氏
銀明膠照片
上海歷史博物館收藏

42 明星公司電影拍攝現場
1930年代
無名氏
銀明膠照片
上海歷史博物館收藏

43 賽馬之后
1930年代
無名氏
銀明膠照片
上海歷史博物館收藏

44 一雙交椅
1920–1935年
紅木器
私人藏品

45 衣架
1920–1935年
紅木器
私人藏品

46 小柜子
1920–1935年
紅木器
私人藏品

47 大柜子，衣柜，床架，
梳妝台，凳子，圓桌，
椅子(4個)，小桌子
1920–1935年
紅木器
私人藏品

48 地毯
1920–1935年
毛線
私人藏品

49 藍色的地毯
1920–1935年
毛線
私人藏品

50 灰色的地毯
1920–1935年
毛線
私人藏品

51 紅色的地毯
1920–1935年
毛線
私人藏品

52 綠色的地毯
1920–1935年
毛線
私人藏品

53 康有為夫人像
現代
徐悲鴻繪
水粉 設色
上海博物館收藏

54 園林
1940年代
徐悲鴻繪
布面油畫
私人藏品

55 常德路
1940年
關良繪
布面油畫
私人藏品

56 碼頭
1940年
關良繪
木板油畫
私人藏品

57 靜物
1943年
關紫蘭繪
絹本油畫
私人藏品

58 良友畫報
1935年1月第101期
良友圖書公司出版
書籍（紙）
上海歷史博物館收藏

59 電影世界
1940年第13期
書籍（紙）
上海歷史博物館收藏

60 美術生活
1936年1月第22期
三一印刷公司出版，新聞報館總
發行
書籍（紙）
上海歷史博物館收藏

61 文華
1933年第43期
書籍（紙）
上海歷史博物館收藏

62 上海南京路－上海風景之一
1932年後
趙維敏作
套色招貼畫
上海歷史博物館收藏

63 上海大世界
1941年
安闌作
套色招貼畫
上海歷史博物館收藏

64 黃浦夜月美人心
1930年代
袁秀堂作
套色招貼畫
上海歷史博物館收藏

65 上海繁華不夜天
1930年代
袁秀堂作
套色招貼畫
上海歷史博物館收藏

66 笑靨頻開
1930年代
金梅生作
套色招貼畫
上海歷史博物館收藏

67 夫婦之道
1930年代
肇芳作

套色招貼畫
上海歷史博物館收藏

68 聯袂出游
1930年代
謝之光作
套色招貼畫
上海歷史博物館收藏

69 對影自憐
1930年代
謝之光作
套色招貼畫
上海歷史博物館收藏

70 南國美人
1930年代
杭穉英作
套色招貼畫
上海歷史博物館收藏

71 蘭湯浴罷
1930年代
杭穉英作
套色招貼畫
上海歷史博物館收藏

72 飛舞欲仙
1930年代
志殷作
套色招貼畫
上海歷史博物館收藏

73 蟹青色中袖女袍
1920年代
駝絨綢面
上海歷史博物館收藏

74 豆沙色中袖女袍
1920年代
綢面
上海歷史博物館收藏

75 短袖旗袍
1920年代
真絲綢面
上海歷史博物館收藏

76 桔黃色短袖女袍
1930年代

綢面
上海歷史博物館收藏

77 无袖旗袍
1930年代
喬其絨綢面
上海歷史博物館收藏

78 南京路
1947年
倪貽德繪
布面油畫
私人藏品

79 外灘
1956年
劉海粟繪
布面油畫
私人藏品

80 上海街道
1959年
龐薰琹繪
布面油畫
私人藏品

81 河南路橋
1950年代
關良繪
布面油畫
私人藏品

82 吾土吾民
1948年
俞云階繪
布面油畫
上海美術館收藏

83 剝玉米
1963年
俞云階繪
布面油畫
上海美術館收藏

84 橘子洲頭——毛主席像
1968年
俞云階繪
布面油畫
上海美術館收藏

85 學工
1974年
俞云階繪
布面油畫
上海美術館收藏

86 配電工
1957或1959年
張隆基繪
布面油畫
上海博物館收藏

87 慶千秋圖
1959年
丰子愷繪
中國畫，紙本設色軸
上海博物館收藏

88 曙光初照演兵場
1964年
錢瘦鐵繪
中國畫，紙本設色
上海美術館收藏

89 挑燈夜戰圖
1950–1966年
袁松年繪
中國畫，紙本設色軸
上海博物館收藏

90 淮海路一角
1970–1980年代
任微音繪
木板搪瓷
上海美術館收藏

91 萌芽月刊
1930年
魯迅與馮雪峰編
書籍（紙）
魯迅紀念館收藏

92 十月
1933年
魯迅譯
書籍（紙）
魯迅紀念館收藏

93 蕭伯納在上海
1933年3月
魯迅與瞿秋白編
書籍（紙）
魯迅紀念館收藏

94 木刻界
1936年4月第1期
唐英偉主編現代版畫會出版
書籍（紙）
魯迅紀念館收藏

95 到前線去
1932年
胡一川作
木刻（紙）
魯迅紀念館收藏

96 青春
1933–1935年
賴少奇作
木刻（紙）
魯迅紀念館收藏

97 逆水行舟
1935年
羅清楨作
木刻（紙）
魯迅紀念館收藏

98 怒吼吧，中國
1935年
李樺作
木刻（紙）
魯迅紀念館收藏

99 都市的角落
1947年
李樺作
木刻（紙）
魯迅紀念館收藏

100 在上海馬路上
1947年
邵克萍作
版畫
上海美術館收藏

101 街頭
1947年
邵克萍作
版畫
上海美術館收藏

102 三毛從軍記
1946年
張樂平作
紙本墨色漫畫，三張
上海美術館收藏

103 浦江夕照
1955年
沈柔堅作
版畫
上海美術館收藏

104 大躍進中
1958年
沈柔堅作
套色版畫
上海博物館收藏

105 浦江晨妝
1961年
邵克萍作
版畫
上海美術館收藏

106 慶祝中華人民共和國成立大游行
（上海）
1950年
杭州國立藝專集體創作
套色招貼畫
上海宣傳畫藝術中心收藏

107 上海黃浦江游行之一
1950年
達華印刷公司印行
套色招貼畫
上海宣傳畫藝術中心收藏

108 黃浦江邊的反美怒潮
1961年
章育青作上海人民美術出版社出版
套色招貼畫
上海宣傳畫藝術中心收藏

109 偉大一月革命勝利萬歲
1967年
上海人民美術出版社出版
套色招貼畫
上海宣傳畫藝術中心收藏

110 批林批孔反修防修
1976年
上海人民美術出版社集體創作
紙本水粉畫
上海宣傳畫藝術中心收藏

111 批林批孔反修防修
1976年
上海人民美術出版社集體創作
套色招貼畫
上海宣傳畫藝術中心收藏

112 复兴公园
1981年
刘海粟绘
布面油画
上海美术馆收藏

113 晨曦
1995年
陈逸飞绘
布面油画
Chong-Moon 与
Reiko T. Lee 收藏

114 18上海弄堂系列
2002年
梁云庭绘
布面油画
上海美术馆收藏

115 十示 1991–3
1991年
丁乙绘
丙烯
艺术家收藏

116 山水 – 纪念黄宾虹 – 幅
2007年
申凡作
装置：霓虹，音乐
艺术家收藏

117 上海莉莉
2009年
周铁海绘
丙烯
艺术家收藏

118 马王堆 2009
2009年
刘大鸿作
刺绣
艺术家收藏

119 寒林图
2004年
李华弍绘
水墨画
私人藏品

120 墨道系列 / 1号
2008年
郑重宾绘
水墨，丙烯，定形剂，宣纸
艺术家收藏

121 水中倒影
2002–2008年
刘建华作
装置：青白瓷，灯光
艺术家收藏

122 你能告诉我吗?
2006年
刘建华作
装置：不锈钢
艺术家收藏

123 过程的瞬间：石库门计划 2007
2007年
张健君作
影像
艺术家收藏

124 过程的瞬间：海上幻园
2010年
张健君作
装置：上海石库门老砖，
硅胶古陶罐，
太阳能塑胶叶，宣纸
艺术家收藏

125 城市之光
　　2000年
　　杨福东作
　　影像
　　Eloisa 与 Chris Haudenschild 收藏

126 留兰
　　2003年
　　杨福东作
　　影像
　　Eloisa 与 Chris Haudenschild 收藏

127 蜜
　　2003年
　　杨福东作
　　影像
　　私人藏品

128 新山海经一
　　2006年
　　邱黯雄作
　　动画，影像
　　Mr. 与 Mrs. Eric Li 收藏

Glossary

Pinyin	Chinese Characters	English
A Zhi	阿稚	nickname of Xie Zhiliu
anquan shengchan	安全生產	"safety in production"
Bao Puzi	抱朴子	title of Taoist text
Bao Tianxiao	包天笑	
cabi dancai	擦筆淡彩	rub-and-paint technique
cabi shuicai	擦筆水彩	rub-and-paint technique
Cheng yin	偁印	seal of Zhu Cheng
chezi	車子	wheel-and-treadle sewing machine
Chiyan	遲燕	"latecomer swallow"
chuangzuo muke	創作木刻	creative woodcuts
Da malu	大馬路	Number-One Road
da xieyi	大寫意	greater freehand technique
dazhong yishu	大眾藝術	public art
Dianshizhai huabao	點石齋畫報	*Dianshizhai Pictorial*
Dianshizhai shiyinju	點石齋石印局	Dianshizhai Lithographic Studio
ding	鼎	tripod
Dongfang Mingzhu Ta	東方明珠塔	Oriental Pearl Tower
Feiyingge huabao	飛影閣畫報	*Feiyingge Pictorial*
Feiyingguan shiyinju	蜚英館石印局	Feiying Hall Lithographic Studio
geming xianshizhuyi yu geming langmanzhuyi xiangjiehe	革命現實主義與革命浪漫主義相結合	"combination of revolutionary realism and revolutionary romanticism"
Gengjian	畊薦	nickname of Li Xiguang
geshan	隔扇	Chinese-style screen panels
gongbi	工筆	line drawing
Gongshou	公壽	nickname of Hu Yuan
Gongzhuan cebaoyin Rong	恭篆冊寶印榮	"seal of Rong in reverent seal script for registering treasures"
guanggao dawang	廣告大王	King of Advertising
guohua	國畫	traditional Chinese painting; ink painting
guohuo	國貨	national goods
Guohuo baihuo gongsi	國貨百貨公司	National Goods Department Store
haipai	海派	"Shanghai style"
Haishang baiyantu	海上百艷圖	hundred beauties of Shanghai
Haisu chuangzuo	海粟創作	"created by [Liu] Haisu"
Hengyun	橫雲	"horizontal clouds"
hongmu	紅木	rosewood
huamei	畫眉	Chinese wagtail ("painted eyes")
Huang Chujiu	黃楚九	
Huang Guomin	黃國民	"Yellow Countryman"
Huifeng yinhang	匯豐銀行	Hong Kong and Shanghai Bank
jiaoban	膠版	offset lithography
jieshao	介紹	short features
jinshi pai	金石派	Epigraphic (Bronze-and-Stone) School
Jinshi qishou	金石齊壽	"immortality to both bronze and stone"
Jisheng	吉生	nickname of Qian Hui'an
Jiuren huahui	九人畫會	Shanghai Society of Nine Artists
Jiuwang manhua xuanchuandui	救亡漫畫宣傳隊	National Salvation Cartoon Propaganda Corps

Pinyin	Chinese Characters	English
Juelan she	決瀾社	Storm Society
Juezhi	覺之	nickname of Hu Yin
Junqing zhiyin	俊卿之印	seal of Junqing (Wu Changshuo)
juren	舉人	degree-holder
Kaiming shudian	開明書店	Kai Ming Book Company
Kutie	苦鐵	"bitter iron"
Laojianzhi er ma	老健智而麻	"old, strong, and wise but dull"
Li Xiguang yin	李錫光印	seal of Li Xiguang
Liang Dingming	梁鼎銘	
Liangyou tushu gongsi	良友圖書公司	Liangyou Publishing Company
lianhuan manhua	連環漫畫	comic strip
Lin Biao	林彪	
Lin Fengmian yin	林風眠印	seal of Lin Fengmian
Liubaiyi	柳白衣	"Liu's white coat"
longque	龍雀	"dragon-sparrow" bow and arrow
Lu Hui siyin	陸恢私印	private seal of Lu Hui
lunwen	論文	essays
luohan chuang	羅漢床	bed-couches
luomo	落墨	"putting ink" technique
Malu Tianshi	馬路天使	*Street Angel*
manhua	漫畫	cartoon, comics
Manhua hui	漫畫會	Cartoon Association
matou	碼頭	wharf; pier
Meijing shuwu	梅景書屋	"Library with a View of Plums"
meiyu	美育	aesthetic education
mingxing	明星	"bright star"
modeng	摩登	"modern"
Mogeng	墨耕	nickname of Ni Tian
muke	木刻	woodcut
Nanhu	南湖	nickname of Yang Borun
Ni Tian zhiyin	倪田之印	seal of Ni Tian
Nian jiushiyi zuo	年九十一作	"created at age 91"
nianhua	年畫	New Year's painting
paibi	排筆	broad brush
pingban yinshua	平版印刷	lithography
Pinghua shuhua she	萍花書畫社	Duckweed Society for Calligraphy and Painting
Pusheng	葡笙	nickname of Zhou Yong
Qian Juntao	錢君匋	
qingbai	青白	monochrome ware
Qingqi guguai	清奇古怪	"elegant and strange"
Qingyun yin	慶雲印	seal of (Wu) Qingyun
qipao	旗袍	"banner robe"
Qiunong	秋農	nickname of Wu Guxiang
Qiuyan	秋言	nickname of Wang Li
Quanguo muke lianhe zhanlanhui	全國木刻聯合展覽會	*National Joint Woodcut Exhibition*
Ruobo	若波	nickname of Gu Yun
Sanmao	三毛	"three hairs"

Pinyin	Chinese Characters	English
Sanshiqi feng caotang	三十七峰草堂	Thatched Cottage on 37 Peaks
Shanchun	山春	nickname of Sha Fu
Shanghai Fengjing	上海風景	photographic guide to Shanghai
Shanghai Meizhuan	上海美專	Shanghai Art Academy
Shanghai renmin meishu chubanshe	上海人民美術出版社	Shanghai People's Fine Art Publishing House
Shanghai shi huaren xiehui	上海市畫人協會	Shanghai City Artists' Society
Shanghai shi xinguohua yanjiu hui	上海市新國畫研究會	Chinese Painting Research Society
Shanghai sitong bada	上海四通八達	"Shanghai was the hub of the wheel"
Shanghai xinhua yishu zhuke xuexiao	上海新華藝術主課學校	Shanghai New China Arts School
Shanghai Zhanlanguan	上海展覽館	Shanghai Exhibition Center
Shangwu yinshu guan	商務印書館	Commercial Press Limited
Shenbao	申報	*Shenbao* newspaper
shi	十	ten
Shijie shuju	世界書局	World Book Company
shikumen	石庫門	two- or three-storied town houses of stone facades
shimao	時髦	fashionable
Shipo tianjing	石破天驚	"working with stone to amaze the world"
shiyin	石印	stone-based lithography
shou	壽	longevity
Shubao	述報	*Shubao* newspaper
Shuhua shanhui	書畫善會	Benevolent Society for Painting and Calligraphy
Shui jing zhu	水經注	*Annotations to the Water Classic*
shuifen	水粉	gouache
Shuping	叔平	nickname of Weng Tonghe
Shuyu	叔榆	seal of Zhu Shuyu
Songnan mengying lu	淞南夢影錄	*Records of the Illusive Dream of Shanghai*
Taicang yisu	太倉一粟	"one grain from Taicang"
Taiping	泰平	Kingdom of Heavenly Peace
Taiping Yulan	泰平御覽	*Peace and Tranquility for Imperial Review*
Tianma huahui	天馬畫會	Heavenly Horse Painting Society
Tongwen shuju	同文書局	Tongwen Press
wang hua	王畫	"imperial painting"
Wang Su	王素	
Wang Tongyu	王同愈	
Wang Tongyu yin	王同愈印	seal of Wang Tongyu
Wang Yirong	王懿榮	
Wang Zhen dali	王震大利	"great fortune to Wang Zhen"
Wu Youru huabao	吳友如畫寶	*A Treasury of Wu Youru's Illustrations*
wuchang	舞場	dance hall
Wuliu houren	五柳後人	"descendant of five willows"
Wumen Tao Yong huaji	吳門陶傭畫記	"painted and recorded by Tao Yong [Tao Lengyue] of the Wu school"
wunü	舞女	dance hostess
wuting	舞亭	dance hall
Wuxu Wu	無須吳	"Wu without mission"
Wuyue wangsun	吳越王孫	"royal descendant of the Wu-Yue region"
Xiandai banhua hui	現代版畫會	Modern Prints Society

xiangpi ban	橡皮版	offset lithography
Xianshi	先施	Sincere Company Ltd.
xiao jiating	小家庭	nuclear family
xiao wenren	小文人	minor intellectuals
xiaoxi	消息	news items
xieyi	寫意	"painting ideas"
xihua	西畫	painting in Western styles and mediums
xin wenren xieyi	新文人寫意	neo-literati freehand technique
Xinji shuangqing	心跡雙清	"tranquil and unperturbed spiritually and physically"
Xinxin	新新	Sun Sun Company, Ltd.
xiyang hong	西洋紅	rose
Xuzhai	虛齋	nickname of Pang Yuanji
Yao Wenyuan	姚文元	
Yao, yao, yao dao waipo qiao	搖，搖，搖到外婆橋	*The Shanghai Triad*
Yi yin	頤印	seal of Ren Yi
Yifeng	藝風	*Art Wind Journal*
Yifeng she	藝風社	Art Wind Society
Yin Fu	蔭甫	nickname of Yu Yue
Yingxi congbao	影戲叢報	*The Journal of Film*
Yingxi zazhi	影戲雜誌	*Film Magazine*
Yipinxiang	一品香	Yipinxiang Restaurant
Yiting	一亭	nickname of Wang Zhen
yiyue geming	一月革命	January Revolution
Yong'an	永安	Wing On Company, Ltd.
youlechang	游樂場	amusement hall
Yu Yue siyin	俞樾私印	private seal of Yu Yue
Yubo huaji	餘伯畫記	"painted and recorded by Yubo [Fei Danxu]"
Yuliang	餘糧	possible nickname of Xu Sangeng
yuyi hua	寓意畫	"implied art"
Zhang Chunqiao	張春橋	
Zhangyuan	張園	Zhang Garden
Zhao Ruqing	趙孺卿	nickname of Zhao Zhiqian
Zhao Zhiqian yin	趙之謙印	seal of Zhao Zhiqian
zhaoxiang shiyin	照相石印	photolithography; zinc-plate lithography
Zheng Mantuo	鄭曼陀	
Zhonghua shuju	中華書局	Chung Hwa Book Company
Zhongshan ling	中山陵	Zhongshan Mausoleum
Zhu Quan zhiyin	朱銓之印	seal of Zhu Quan
zijin	紫金	"purple-gold"
zilai fengshan	自來風扇	punkah
Zixiang	子祥	nickname of Zhang Xiong
Zuolian	左聯	League of Left-Wing Writers

子𡥉祖乙爵

𡥉象人跪形當亦子
字之異體𡥉與中卣文
𡥉字相類A有足者
象𡥉形古文祖𡥉為一
字也

唐子祖乙爵

唐偁子者右在唐斟
虞以前商爵也

父癸

陽識不易得此爵為
劉燕庭方伯舊藏

Bibliography

Ainsworth, Peter. "The Origin of Snooker: The Neville Chamberlain Story." 2007. International Billiards and Snooker Federation. http://www.ibsf.info/pdf/origin-of-snooker.pdf.

All About Shanghai and Environs: A Standard Guidebook. Shanghai: Shanghai University Press, 1934.

Anderson, Benedict. *Imagined Communities: Reflections on the Origin and Spread of Nationalism.* New York: Verso, 1991.

Andrews, Julia F. "A Century in Crisis: Tradition and Modernity in the Art of Twentieth-Century China." In *A Century in Crisis: Tradition and Modernity in the Art of Twentieth-Century China,* edited by Julia F. Andrews and Kuiyi Shen. New York: Guggenheim Museum Publications, 1998.

———. "Commercial Art and China's Modernization." In *A Century of Crisis: Modernity and Tradition in the Art of Twentieth-Century China,* edited by Julia F. Andrews and Kuiyi Shen. New York: Guggenheim Museum Publications, 1998.

———. *Painters and Politics in the People's Republic of China, 1949–1979.* Berkeley, Los Angeles, London: University of California Press, 1994.

Andrews, Julia F., and Kuiyi Shen. "The Modern Woodcut Movement." In *A Century of Crisis: Modernity and Tradition in the Art of Twentieth-Century China,* edited by Julia F. Andrews and Kuiyi Shen. New York: Guggenheim Museum Publications, 1998.

art hub. "40+4, Art is not enough! Not enough." http://www.arthubasia.org/archives/404-art-is-not-enough-not-enough.

Arup. "Dongtan Eco-city." http://www.arup.com/eastasia/project.cfm?pageid=7047.

Axons Concepts Ltd. "1933." http://www.1933shanghai.com/index_en.html.

Bai Xuelan. "Lin Fengmian xiju renwu zhi xingshi yu fazhan licheng" (Modes and Contents of Lin Fengmian's Theatrical Figures and Their Course of Development). *Duoyun,* no. 53 (2000): 154–163.

Banham, Rob. "The Industrialization of the Book, 1800–1970." In *A Companion to the History of the Book,* edited by Simon Eliot and Jonathan Rose. Malden, Oxford: Blackwell Publishing, 2007.

Bao Mingxin. "Shanghai Fashion in the 1930s." In *Shanghai Modern, 1919–1945,* edited by Jo-Anne Birnie Danzker, Ken Lum, and Zheng Shengtian. Ostfildern-Ruit, Germany: Hatje Cantz, 2004.

Barker, David. "The Muban Foundation: Ideals and Aspirations." In *Chinese Printmaking Today: Woodblock Printing in China, 1980–2000,* edited by Anne Farrer. London: The British Library, 2003.

Bartholomew, Terese Tse, Michael Knight, and He Li. *Later Chinese Jades: Ming Dynasty to Early Twentieth Century.* San Francisco: Asian Art Museum of San Francisco, 2007.

Beltrame, Frederica, Jennifer Lin, and Liu Jianhua. *Liu Jianhua: Anomalous Thoughts.* Beijing: Galleria Continua, n.d.

Bergère, Marie-Claire. *The Golden Age of the Chinese Bourgeoisie, 1911–1937.* Translated by Janet Lloyd. Cambridge: Cambridge University Press, 1989.

Berghuis, Thomas J. *Performance Art in China.* Hong Kong: Timezone 8, 2006.

Berg-Pan, Renata. "Mixing Old and New Wisdom: The 'Chinese' Sources of Brecht's *Kaukasischer Kreidekreis* and Other Works." *The German Quarterly* 48, no. 2 (March 1975): 204–228.

Bickers, Robert. "Ordering Shanghai: Policing a Treaty Port, 1854–1900." *Maritime Empires: British Imperial Maritime Trade in the Nineteenth Century*, edited by David Killingray, Margarette Lincoln, and Nigel Rigby. Woodbridge, Eng.; Rochester, NY: The Boydell Press, in association with the National Maritime Museum, 2004.

Bong, Ng Chun, Cheuk Pak Tong, Wong Ying, and Yvonne Lo, eds. *Chinese Woman and Modernity: Calendar Posters of the 1910s–1930s*. Hong Kong: Joint Publishing (H.K.) Co., Ltd., 1996.

Chan, Wellington K. K. "Selling Goods and Promoting a New Commercial Culture: The Four Premier Department Stores on Nanjing Road, 1917–1937." In *Inventing Nanjing Road: Commercial Culture in Shanghai, 1900–1945*, edited by Sherman Cochran. Ithaca, NY: East Asia Program, Cornell University, 1999.

Chandler, Robert J., and Stephen J. Potash. *Gold, Silk, Pioneers & Mail: The Story of the Pacific Mail Steamship Company*. San Francisco: Friends of the San Francisco Maritime Museum Library, 2007.

Chen Chuanxi. "Cong 'wuzhong jinhua' dao 'bianzhong jinhua'" (The Evolution from Types to Species). In *Ershi shiji shanshuihua yanjiu wenji*, edited by Lu Fusheng. Shanghai: Shanghai shuhua chubanshe, 2006.

Chen Duxiu. "Meishu geming" (A Revolution in Fine Arts). *Xin qingnian* 6, no. 1 (January 15, 1919).

Chen Yongyi. "Shiyan de licheng" (Creation of West-and-East Painting in Lin Fengmian's Early Days). *Duoyun*, no. 53 (2000): 15–30.

ChinaCulture.org. "Sun Yat-sen Mausoleum." 2008. http://www.chinaculture.org/library/2008-01/16/content_39019.htm.

China Guide Corporation. "Qian Juntao." 2004. http://www.cgcmall.com/Qian_Juntao_p/vcooqianj.htm.

Chinese Paintings from the Shanghai Museum, 1851–1911. Edinburgh: NMS Publishing, 2000.

Chung, Anita. "Reinterpreting the Shanghai School of Painting." In *Chinese Paintings from the Shanghai Museum, 1851–1911*. Edinburgh: NMS Publishing, 2000.

Clark, John, ed. *Modernity in Asian Art*. Broadway, NSW, Australia: Wild Peony, 1993.

Clark, Paul. *Chinese Cinema: Culture and Politics Since 1949*. Cambridge, Eng.; New York: Cambridge University Press, 1987.

Clarke, David. "Cross-Cultural Dialogue and Artistic Innovation: Teng Baiye and Mark Tobey." In *Shanghai Modern, 1919–1945*, edited by Jo-Anne Birnie Danzker, Ken Lum, and Zheng Shengtian. Ostfildern-Ruit, Germany: Hatje Cantz, 2004.

Clunas, Craig. *Chinese Export Watercolours*. London: Victoria and Albert Museum, 1984.

Coble, Parks. *The Shanghai Capitalists and the Nationalist Government, 1927–1937*. Cambridge, MA: Council on East Asian Studies, Harvard University, 1980.

Cochran, Sherman. *Big Business in China: Sino-Foreign Rivalry in the Cigarette Industry, 1890–1930*. Cambridge, MA: Harvard University Press, 1980.

———. "Commercial Culture in Shanghai, 1900–1945: Imported or Invented? Cut Short or Sustained?" In *Inventing Nanjing Road: Commercial Culture in Shanghai, 1900–1945*, edited by Sherman Cochran. Ithaca, NY: East Asia Program, Cornell University, 1999.

———, ed. *Inventing Nanjing Road: Commercial Culture in Shanghai, 1900–1945*. Ithaca, NY: East Asia Program, Cornell University, 1999.

———. "Marketing Medicine and Advertising Dreams in China, 1900–1950." In *Becoming Chinese: Passages to Modernity and Beyond*, edited by Wen-hsin Yeh. Berkeley, Los Angeles, London: University of California Press, 2000.

Cogdell, Christina. *Eugenic Design: Streamlining America in the 1930s*. Philadelphia: University of Pennsylvania Press, 2004.

Cohen, Joan Lebold. *The New Chinese Painting, 1949–1986*. New York: Harry N. Abrams, 1987.

Cohen, Robin, and Paul Kennedy. *Global Sociology*. 2nd ed. New York: New York University Press, 2007.

Cohn, Don J., ed. and trans. *Vignettes from the Chinese: Lithographs from Shanghai in the Late Nineteenth Century*. Hong Kong: Renditions Paperback, 1987.

Communist Party of China. "Yiyue geming fengjing" (Storm of the January Revolution). 2006. http://cpc.people.com.cn/GB/33837/2534822.html.

Crossman, Carl L. *The Decorative Arts of the China Trade: Paintings, Furnishings, and Exotic Curiosities*. Woodbridge, Eng.: Antique Collectors' Club, 1991.

Crozier, Ralph. "Post-Impressionists

in Pre-War China: The *Juelanshe* (Storm Society) and the Fate of Modernism in Republican China." In *Modernity in Asian Art*, edited by John Clark. Broadway, NSW, Australia: Wild Peony, 1993.

Danzker, Jo-Anne Birnie. "Cultural Exchange." In *Shanghai Modern, 1919–1945*, edited by Jo-Anne Birnie Danzker, Ken Lum, and Zheng Shengtian. Ostfildern-Ruit, Germany: Hatje Cantz, 2004.

Dawson, Layla. *China's New Dawn: An Architectural Transformation*. Munich: Prestel Verlag, 2005.

Dikötter, Frank. *Exotic Commodities: Modern Objects and Everyday Life in China*. New York: Columbia University Press, 2006.

———. *Imperfect Conceptions: Medical Knowledge, Birth Defects and Eugenics in China*. New York: Columbia University Press, 1998.

Ding Xiyuan. *Ren Bonian*. Shanghai: Shanghai shuhua chubanshe, 1989.

———. "Ren Bonian renwu hua zongshu" (Ren Bonian's Figure Paintings). *Mingjia hanmo*, no. 28 (1992): 48–66.

Ding Xiyuan and Hui Laiping, eds. *Zhongguo jindai minghuajia tujian* (Famous Modern Chinese Paintings). Taiwan: Han Mo Xuan Publishing Co. Ltd., 1992.

Dong, Stella. *Shanghai: Gateway to the Celestial Empire, 1860–1949*. Hong Kong: Form Asia Books, Ltd., 2003.

Edgren, J. S. "China." In *A Companion to the History of the Book*, edited by Simon Eliot and Jonathan Rose. Malden, Oxford: Blackwell Publishing, 2007.

Elman, Benjamin A. *A Cultural History of Modern Science in China*. Cambridge, MA; London: Harvard University Press, 2006.

Erh, Deke. Introduction to *Shanghai Art Deco*, by Deke Erh and Tess Johnston. Hong Kong: Old China Hand Press, 2006.

Erickson, Britta. "Innovations in Space: Ink Paintings by Zheng Chongbin." In *Chongbin Zheng: Ink Painting*. N.p., 2007.

———. "Interview with Shengtian Zheng at the Seven Stars Bar, 798, Beijing." *Yishu: Journal of Contemporary Art* 6, no. 4 (Winter/December 2007): 29–33.

———. "Periodical Exhibitions in China: Diversity of Motivation and Format." *Yishu: Journal of Contemporary Art* 8, no. 1 (January/February 2009): 41–46.

Eskilson, Stephen J. *Graphic Design: A New History*. New Haven: Yale University Press, 2007.

Fang Zengxian. "Preface." In *Open Space—'96 Shanghai Art Biennale*, edited by Hu Zhirong and Li Xu. Shanghai: Shanghai Art Museum, 1996.

Farquhar, Mary Ann. "*Sanmao*: Classic Cartoons and Chinese Popular Culture." In *Asian Popular Culture*, edited by John A. Lent. Boulder, San Francisco, Oxford: Westview Press, 1995.

Farrer, Anne, ed. *Chinese Printmaking Today: Woodblock Printing in China, 1980–2000*. London: The British Library, 2003.

Field, Andrew D. "Selling Souls in Sin City: Shanghai Singing and Dancing Hostesses in Print, Film, and Politics, 1920–49." In *Cinema and Urban Culture in Shanghai, 1922–1943*, edited by Yingjin Zhang. Stanford, CA: Stanford University Press, 1999.

Finnane, Antonia. "What Should Women Wear? A National Problem." In *Dress, Sex, and Text in Chinese Culture*, edited by Antonia Finnane and Anne McLaren. Clayton, Australia: Monash Asia Institute, 1999.

Fodor's Travel. "Shanghai Travel Guide." 2009. http://www.fodors.com/world/asia/china/shanghai/.

Fong, Wen C. *Between Two Cultures: Late-Nineteenth and Twentieth-Century Chinese Paintings from the Robert H. Ellsworth Collection in the Metropolitan Museum of Art*. New York: Metropolitan Museum of Art / New Haven, London: Yale University Press, 2001.

Forbes, H. A. Crosby. *Chinese Export Silver: A Legacy of Luxury*. Baltimore: International Exhibitions Foundation, 1984.

Forbes, H. A. Crosby, John Devereux Kernan, and Ruth S. Wilkins. *Chinese Export Silver, 1785 to 1885*. Milton, MA: Museum of the American China Trade, 1975.

Freeborn, Richard. *The Russian Revolutionary Novel: Turgenev to Pasternak*. Cambridge, Eng.: Cambridge University Press, 1982.

Fu, Poshek. "Selling Fantasies at War: Production and Promotion Practices of the Shanghai Cinema, 1937–1941." In *Inventing Nanjing Road: Commercial Culture in Shanghai, 1900–1945*, edited by Sherman Cochran. Ithaca, NY: East Asia Program, Cornell University, 1999.

Galikowski, Maria. *Art and Politics in China, 1949–1984*. Hong Kong: The Chinese University Press, 1998.

Gao Minglu. "Conceptual Art with Anticonceptual Attitude: Mainland China, Taiwan, and Hong Kong." In *Global Conceptualism: Points of Origin, 1950s–1980s*, by Stephen Bann and László Beke.

New York: Queens Museum of Art, 1999.

Gerth, Karl. *China Made: Consumer Culture and the Creation of the Nation.* Cambridge, MA: Harvard University Asia Center, 2003.

Glosser, Susan. *Chinese Visions of Family and State, 1915–1953.* Berkeley: University of California Press, 2003.

Goetzmann, William, and Elisabeth Köll. "The History of Corporate Ownership in China." Paper presented at The Evolution of Corporate Governance and Family Firms, a CEPR/ECGI/INSEAD/NBER/University of Alberta joint conference, Fontainebleau, January 30–31, 2004. http://www.cepr.org/meets/wkcn/5/597/papers/goetzmanl.pdf.

Gongyi Shuku. "*Wei ziyou shu* wen xuan zuo zhe: Lu Xun" (Selections from *Book of False Freedom,* by Lu Xun). http://shuku1.mofcom.gov.cn/site/book_detail.jsp?bookno=8942&seqno=8991&cate=cate1&cate_no=i21.

Harper, Damian, and David Eimer. *Shanghai City Guide.* London: Lonely Planet, 2009.

Henriot, Christian. *Prostitution and Sexuality in Shanghai: A Social History, 1849–1949.* Translated by Noël Castelino. Cambridge, Eng.: Cambridge University Press, 2001.

———. *Shanghai, 1927–1937: Municipal Power, Locality, and Modernization.* Translated by Noël Castelino. Berkeley: University of California Press, 1993.

Henriot, Christian, and Wen-hsin Yeh, eds. *In the Shadow of the Rising Sun: Shanghai under Japanese Occupation.* New York: Cambridge University Press, 2004.

Hershatter, Gail. *Dangerous Pleasures: Prostitution and Modernity in Twentieth-Century Shanghai.* Berkeley: University of California Press, 1997.

Hibbard, Peter. *The Bund Shanghai: China Faces West.* Hong Kong: Odyssey, 2007.

Honig, Emily. *Creating Chinese Ethnicity: Subei People in Shanghai, 1850–1980.* New Haven, CT: Yale University Press, 1992.

———. *Sisters and Strangers: Women in the Shanghai Cotton Mills, 1919–1949.* Stanford, CA: Stanford University Press, 1986.

Huang, Nicole. *Women, War and Domesticity: Shanghai Literature and Popular Culture of the 1940s.* Boston: Brill, 2005.

Huang Shiquan. *Songnan mengying lu* (Records of the Illusive Dream of Shanghai). Reprinted in *Huyou za ji, Songnan mengying lu, Huyou mengyin.* Shanghai: Shanghai guji chubanshe, 1989.

Huang Yuanlin. "Zhongguo manhua fazhan gailun" (An Outline of the Development of Chinese Cartoons). In *Zhongguo xiandai meishu quanji: manhua.* Tianjin: Tianjin renmin meishu chubanshe, 1998.

Hui Lan. "Haipai huihua de jindaixing jiqi chuantong neifaxing yanjiu" (Study on Modernization and Its Traditional Roots of Shanghai-School Paintings). In *Haipai huihua yanjiu wenji.* Shanghai: Shanghai shuhua chubanshe, 2001.

Hunan Provincial Museum. "The Exhibition of Mawangdui Han Tombs: Treasure on Silk and Inscribed Slips." 2006. http://www.hnmuseum.com/hnmuseum/eng/whatson/exhibition/mwd_2_5.jsp#.

Hung, Chang-tai. "War and Peace in Feng Zikai's Wartime Cartoons." *Modern China* 6, no. 1 (January 1990): 39–83.

Jullien, François. *The Impossible Nude: Chinese Art and Western Aesthetics.* Translated by Maev de la Guardia. Chicago, London: The University of Chicago Press, 2007.

Kane, Frank. "Shanghai Plans Ecometropolis on Its Mud Flats." *The Observer, Guardian.co.uk,* January 8, 2006; http://www.guardian.co.uk/print/0,3858,5369214-108142,00.html.

Kang Youwei. "Wanmu caotang canghua mu (jiexuan)" (Catalogue of the Art Collection at the Hut of Ten Thousand Trees [excerpt]). In *Ershi shiji Zhongguo meishu wenxuan,* vol. 1, edited by Lang Shaojun and Shui Zhongtian. Shanghai: Shanghai shuhua, 1997.

Knight, Michael. "Markets and Tastes in Chinese Jade from 1821 to 1949." In *Later Chinese Jades: Ming Dynasty to Early Twentieth Century,* by Terese Tse Bartholomew, Michael Knight, and He Li. San Francisco: Asian Art Museum of San Francisco, 2007.

Knight, Michael, and Li Huayi. *Monumental Landscapes of Li Huayi.* San Francisco: Asian Art Museum of San Francisco, 2004.

Laing, Ellen Johnston. "The British American Tobacco Company Advertising Department and Four of Its Calendar Poster Artists." Prepared for symposium on Urban Cultural Institutions in Early Twentieth Century China, Columbus, Ohio, April 13, 2002. http://mclc.osu.edu/rc/pubs/institutions/laing/laing.htm.

———. *Selling Happiness: Calendar Posters and Visual Culture in Early-Twentieth-Century Shanghai.*

Honolulu: University of Hawai'i Press, 2004.

———. "Woodcuts in the People's Republic of China, 1949–1985." In *The Art of Contemporary Chinese Woodcuts*, edited by Christer von der Burg. London: The Muban Foundation, 2003.

Landsberger, Stefan. *Chinese Propaganda Posters: From Revolution to Modernization*. Amsterdam, Singapore: The Pepin Press, 1998.

———. "Shanghai People's Commune (1967)." 2009. http://www.iisg .nl/landsberger/sc.html.

———. "Zhang Yuqing." 2009. http:// www.iisg.nl/landsberger/sheji/ sj-zyq.html.

Lang Shaojun. "Ershi shiji shanshuihua de chengyu bian" (Inheritance and Transformation in Twentieth-Century Landscape Painting). In *Ershi shiji shanshuihua yanjiu wenji*, edited by Lu Fusheng. Shanghai: Shanghai shuhua chubanshe, 2006.

Lee, Leo Ou-fan. "The Cultural Construction of Modernity in Urban Shanghai: Some Preliminary Explorations." In *Becoming Chinese: Passages to Modernity and Beyond*, edited by Wen-hsin Yeh. Berkeley, Los Angeles, London: University of California Press, 2000.

———. *Shanghai Modern: The Flowering of a New Urban Culture in China, 1930–1945*. Cambridge, MA; London: Harvard University Press, 1999.

———. "Shanghai Modern: Reflections on Urban Culture in China in the 1930s." In *Alternative Modernities*, edited by Dilip Parameshwar Gaonkar. Durham, London: Duke University Press, 2001.

———. "The Urban Milieu of Shang-

hai Cinema, 1930–40: Some Explorations of Film Audience, Film Culture, and Narrative Conventions." In *Cinema and Urban Culture in Shanghai, 1922–1943*, edited by Yingjin Zhang. Stanford, CA: Stanford University Press, 1999.

Li Chao. *Shanghai youhua shi* (A History of Oil Painting in Shanghai). Shanghai: Shanghai People's Fine Arts Publishing House, 1995.

Li Chu-tsing and Wan Qingli. *Zhongguo xiandai huihua shi, 1840–1911* (A History of Modern Chinese Painting). Taipei: Rock Publishing International, 1997.

———. *Zhongguo xiandai huihua shi, 1912–1949* (A History of Modern Chinese Painting). Taipei: Rock Publishing International, 2001.

Li, Lillian M. *China's Silk Trade: Traditional Industry in the Modern World, 1842–1937*. Cambridge, MA; London: Harvard University Press, 1981.

Li Yongsen. "Yi tongxue Jiang Handing" (Remembering my Classmate Jiang Handing). *Duoyun*, no. 5 (1985): 62–67.

Liang Qichao. "Taichou xingzhou yugong jianhuai yi shouci yuanyun." *Yinbingshi heji* 45, pt. 2.

Lin Fengmian. "Yishu de yishu yu shehui de yishu" (Art for Art's Sake and Art for Society's Sake). May 1927. Reprinted in *Lin Fengmian sanwen*, edited by Pei Chen. Guangzhou: Huacheng, 1999.

———. "Zhi quanguo yishu jieshu" (To All Art Fields). Reprinted in *Yishu conglun* (A Series of Articles on Art). Nanjing: Zhengzhong shuju, 1936.

Liu Dahong. *Liu Dahong's Textbook; Advanced Level: Lesson 52 to Lesson 62*. Translated by Diane Lu and Ronald Brown. Shanghai:

Educate the People Publishing House, 2008.

Liu, Haiming. "Chinese Exclusion Laws and the U.S.-China Relationship." *The Cal Poly Pomona Journal of Interdisciplinary Studies*, 2003. http://www.csupomona .edu/~jis/2003/Liu.pdf.

Liu Haisu. "Zhongguohua de jicheng yu chuangxin" (Inheritance and Trail-Blazing in Chinese Painting). *Mingjia hanmo*, no. 1 (1990): 88–91.

Liu Shanlin. *Xiyang faming zai Zhongguo* (Inventions from the West in China). Shanghai: Shanghai guji chubanse, 1999.

Liu Xilin. "Zhu Qizhan de shengya yu yishu" (Life and Art of Zhu Qizhan). *Yishu jia*, no. 253 (June 1996): 346–359.

Lockwood, Stephen Chapman. "Augustine Heard and Company, 1858–1862: American Merchants in China." *Harvard East Asian Monographs* 37. Cambridge, MA: East Asian Research Center, Harvard University, distributed by Harvard University Press, 1971.

Lu, Hanchao. *Beyond the Neon Lights: Everyday Shanghai in the Early Twentieth Century*. Berkeley: University of California Press, 1999.

Lu Xun. "*Xin E huaxuan* xiaoyin" (Brief Preface to *Selected Paintings from New Russia*). February 20, 1930. Reprinted in *Lu Xun quanji*, vol. 7. Beijing: Renmin wenxue, 1981.

Ma, Maggie. "Biennale Wonder Boy: Qiu Anxiong." *ArtZine: A Chinese Contemporary Art Portal*, 2008. Artzinechina, Inc. http://www .artzinechina.com/display_vol_ aid198_en.html.

MacFarquhar, Roderick. "The Cultural Revolution." In *Art and China's Revolution*, edited by Melissa Chiu and Zheng Sheng-

tian. New York: Asia Society in association with Yale University Press, 2008.

Martin, Brian G. *The Shanghai Green Gang: Politics and Organized Crime, 1919–1937.* Berkeley: University of California Press, 2006.

Matt, Gerald. "Film Is Like Life: Gerald Matt Talks to Yang Fudong." In *Yang Fudong,* by Gerald Matt, Bert Rebhandl, and Sabine Folie. Vienna: Rema Print, 2005.

McDougall, Bonnie S., and Kam Louie. *The Literature of China in the Twentieth Century.* New York: Columbia University Press, 1997.

Merritt, Helen. *Modern Japanese Woodblock Prints: The Early Years.* Honolulu: University of Hawai'i Press, 1990.

Mingjia hanmo (Han Mo, an international magazine of Chinese brush art), no. 24. Hong Kong and Taiwan: Han Mo Xuan Publishing Co. Ltd., 1991.

MOCA Shanghai. http://www.moca shanghai.org.

The Modern Girl Around the World Research Group. *The Modern Girl Around the World: Consumption, Modernity, and Globalization.* Durham, NC: Duke University Press, 2009.

The Need Project. "History of Electricity." *Intermediate Energy Infobook,* 2008. http://www.need.org/needpdf/info book_activities/IntInfo/Elec3I .pdf.

Novelli, Luigi. "Itinerary 2: Longtang Housing." In *Shanghai Architecture Guide.* Shanghai: Haiwen Audio-Video Publishers, 2004.

Pang, Laikwan. "Photography, Performance, and the Making of Female Images in Modern China." *Journal of Women's History* 17, no. 4 (Winter 2005): 56–85.

———. "The Pictorial Turn: Realism, Modernity, and China's Print Culture in the Late Nineteenth Century." *Visual Studies* 20, no. 1 (April 2005): 16–36.

Paterson, A. B. "Banjo." "Chapter VII: An Unknown Celebrity." *Happy Dispatches.* http://www.uq.edu .au/~mlwham/banjo/happy_ dispatches/unknown_celebrity .html.

Patterson, Michael. *The Oxford Guide to Plays.* Oxford: Oxford University Press, 2007.

Pederson, Amy. "Contemporary Art with Chinese Characteristics: Shen Fan, Ding Yi, and Xu Zhen." *Yishu: Journal of Contemporary Chinese Art* 1, no. 3 (November 2002): 27–43.

Perry, Elizabeth. *Shanghai on Strike: The Politics of Chinese Labor.* Stanford, CA: Stanford University Press, 1993.

Piazza, Hans. "The Anti-Imperialist League and the Chinese Revolution." In *The Chinese Revolution in the 1920s: Between Triumph and Disaster,* edited by Mechthild Leutner, Roland Felber, Mikhail L. Titarenko, and Alexander M. Grigoriev. London, New York: RoutledgeCurzon, 2002.

Politzer, Eric. "The Changing Face of the Shanghai Bund, circa 1849–1879." *Arts of Asia* 35, no. 2 (2005): 64–81.

Pollack, Barbara. "Art and China's Revolution." *Yishu: Journal of Contemporary Chinese Art* 8, no. 1 (January/February 2009): 84–87.

Pott, F. L. Hawks. *A Short History of Shanghai.* Shanghai: Kelly and Walsh Ltd., 1928.

Powell, John B. *My Twenty-Five Years in China.* New York: Macmillan, 1945.

Qi Fengge. "A New Outlook for Chinese Prints, 1980–2002."

In *Chinese Printmaking Today: Woodblock Printing in China, 1980–2000,* edited by Anne Farrer. London: The British Library, 2003.

Qian Guan. "Lilong Housing: A Traditional Settlement Form." Master's thesis, School of Architecture, McGill University, Montreal, 1996. http://www .mcgill.ca/mchg/student/lilong/ chapter2/.

Reed, Christopher A. *Gutenberg in Shanghai: Chinese Print Capitalism, 1876–1937.* Honolulu: University of Hawai'i Press, 2004.

———. "Re/Collecting the Sources: Shanghai's *Dianshizhai* Pictorial and Its Place in Historical Memories, 1884–1949." *Modern Chinese Literature and Culture* 12, no. 2: 44–72.

Righterfood, Sonia. "Tiaohe zhongxi yishu" (Compromising Chinese Art and Western Art). *Duoyun,* no. 53 (2000): 42–54.

Ristaino, Marcia. *The Jacquinot Safe Zone: Wartime Refugees in Shanghai.* Stanford, CA: Stanford University Press, 2008.

Schoppa, R. Keith. *The Columbia Guide to Modern Chinese History.* New York: Columbia University Press, 2000.

Seymour, Nancy N. *An Index-Dictionary of Chinese Artists, Collectors, and Connoisseurs.* Metuchen, NJ; London: The Scarecrow Press, Inc., 1988.

Shamos, Mike. "A Brief History of the Noble Game of Billiards." 1995. Billiard Congress of America. http://home.bca-pool.com/index .cfm.

Shan Guolin. "Cultural Significance of the Shanghai School." In *Chinese Paintings from the Shanghai Museum, 1851–1911.* Edinburgh: NMS Publishing, 2000.

———. "Lun Haishang huapai" (On Shanghai School Painting). In *Shanghai bowuguan*, vol. 8. Shanghai: Shanghai shuhua chubanshe, 2000.

———. Preface. In *Shanghai mingjia huajia jingpin ji* (Masterworks of Shanghai School Painters from Shanghai Museum Collection), vol. 6, 1–6. Shanghai: Shanghai Museum, 1991.

Shanghai Art Salon & Chinese Arts. "Liang Yunting." *Art Shanghai*, 2002–2003. http://www.cnarts.net/artsalon/2004/eweb/gallery/index.asp?mid=31.

Shanghai Star. "History of a 'new area.'" *Shanghai Star*, April 21, 2005. http://app1.chinadaily.com.cn/star/2005/0421/f05-2.html.

Shanghai Zendai Museum of Modern Art. http://www.zendaiart.com.

Shanghai Zendai Museum of Modern Art. "*Intrude: Art & Life 366.*" http://www.zendaiart.com/En/Default.aspx.

ShanghART. "Zhao Bandi." http://www.shanghartgallery.com/galleryarchive/artists/name/zhaobandi.

ShanghART Gallery. http://www.shanghartgallery.com.

Shen Fan and Christopher Phillips. "Shen Fan: Interview by Christopher Phillips." *ShanghART Gallery.* May 2008. ShanghART Gallery. http://www.shanghartgallery.com/galleryarchive/texts/id/1067.

Shen, Kuiyi. "*Lianhuanhua* and *Manhua*—Picture Books and Comics in Old Shanghai." In *Illustrating Asia: Comics, Humor Magazines, and Picture Books*, edited by John A. Lent. Honolulu: University of Hawai'i Press, 2001.

———. "The Lure of the West: Modern Chinese Oil Painting." In *A Century of Crisis: Modernity and Tradition in the Art of Twentieth-Century China*, edited by Julia F. Andrews and Kuiyi Shen. New York: Guggenheim Museum Publications, 1998.

———. "Modernist Movements in Pre-War China." Paper presented at the symposium on Urban Cultural Institutions in Early Twentieth Century China, Columbus, Ohio, April 13, 2002.

———. "The Modernist Woodcut Movement in 1930s China." In *Shanghai Modern, 1919–1945*, edited by Jo-Anne Birnie Danzker, Ken Lum, and Zheng Shengtian. Ostfildern-Ruit, Germany: Hatje Cantz, 2004.

Shen Roujian. "Tongshi yidai zongshi Fengmian xiansheng" (The Loss of the Great Master Fengmian). *Mingjia hanmo*, no. 24 (1992): 35–37.

Snow, Edgar. *Red China Today: The Other Side of the River*. New York: Random House, 1962.

Song Dong et al., *Yesheng 1997 nian jingzhe shi* (Wildlife: Starting from 1997 Jingzhe). Beijing: Contemporary Art Center, 1997.

Spencer, Richard. "Shanghai's Anglican Cathedral to Rise Again." *Telegraph*, 2009. Telegraph Media Group Limited. http://www.telegraph.co.uk/expat/expatresources/4202282/Shanghai%27s-Anglican-cathedral-to-rise-again.html.

Sullivan, Michael. *Art and Artists of Twentieth-Century China*. Berkeley: University of California Press, 1996.

———. *The Meeting of Eastern and Western Art*. Berkeley, Los Angeles, London: University of California Press, 1989.

———. *Modern Chinese Artists: A Biographical Dictionary*. Berkeley: University of California Press, 2006.

Tang, Xiaobing. *Origins of the Chinese Avant-Garde: The Modern Woodcut Movement*. Berkeley, Los Angeles, London: University of California Press, 2008.

Taylor, Nick. *American-Made: The Enduring Legacy of the WPA: When FDR Put the Nation to Work*. New York: Bantam Books, 2008.

Tong, Cheuk Pak. "A History of Calendar Posters." In *Chinese Woman and Modernity: Calendar Posters of the 1910s–1930s*, edited by Ng Chun Bong, Cheuk Pak Tong, Wong Ying, and Yvonne Lo. Hong Kong: Joint Publishing (H.K.) Co., Ltd., 1996.

Waara, Carrie. "Invention, Industry, Art: The Commercialization of Culture in Republican Art Magazines." In *Inventing Nanjing Road: Commercial Culture in Shanghai, 1900–1945*, edited by Sherman Cochran. Ithaca, NY: East Asia Program, Cornell University, 1999.

Wakeman, Frederic E., Jr., *Policing Shanghai: 1927–1937*. Berkeley: University of California Press, 1995.

Wakeman, Frederic E., Jr., and Wen-hsin Yeh, eds. *Shanghai Sojourners*. Berkeley: University of California Press, 1992.

Walder, Andrew G. *Chang Ch'un-Ch'iao and Shanghai's January Revolution*. Ann Arbor: Center for Chinese Studies, University of Michigan, 1978.

Wang Chiacheng. "Zhao Zhiqian zhuan" (Biography of Chao Chi-ch'ien). In *Lishi wenwu*. Taipei: National Museum of History. Vol. 2, no. 65 (1999): 71–76; vol. 7, no. 84 (2000): 77–81.

Wang Jingxian. "Ren Bonian qiren qiyi" (Life and Art of Ren

Bonian). *Ren Bonian yanjiu,
Duoyun*, no. 55 (2002): 57–112.

Watkins, Nicholas. "Matisse, Henri."
In *The Dictionary of Art*, vol. 20,
edited by Jane Turner. New York:
Grove, 1996.

Wikipedia. "江竹筠" (Jiang
Zhujun). 2008. http://zh
.wikipedia.org/wiki/江姐.

Wikipedia. "Shanghai Tower."
http://en.wikipedia.org/wiki/
Shanghai_Tower.

Wikipedia. "张志新" (Zhang
Zhixin). 2009. http://zh
.wikipedia.org/wiki/张志新.

Wong, Wang-chi. *Politics and Lit-
erature in Shanghai: The Chinese
League of Left-Wing Writers,
1930–1936*. Manchester, Eng.;
New York: Manchester Univer-
sity Press, 1991.

Wood, Frances. "Political and Literary
Context, 1980–2000." In *Chinese
Printmaking Today: Woodblock
Printing in China, 1980–2000*,
edited by Anne Farrer. London:
The British Library, 2003.

Wu Guanzhong. "Yan guilai,
daonian Lin Fengmian laoshi"
(In Memory of My Teacher Lin
Fengmian). *Mingjia hanmo*, no.
24 (1992): 24–32.

Wu Huating. "Shapeless Wives and
Mothers: The Representations
of Women in Early Twentieth
Century China." Paper presented
at the annual meeting of the
International Communication
Association, New Orleans, May
27, 2004.

Wu Hung. *Exhibiting Experimental
Art in China*. Chicago: Smart
Museum of Art, 2000.

———. "The Origins of Chinese
Painting." In *Three Thousand
Years of Chinese Painting*, by
Richard M. Barnhart et al. New
Haven, London: Yale University
Press, 1997.

Wu Mingshi. "Cangku dashi yi
Lin Fengmian" (A Great Master
from a Storehouse, Lin Feng-
mian). *Lianhe shibao*, August 13,
1991.

Wu. Xiangxiang. "*Shubao yingyinben
xu* (Introduction to the Photo-
copy Version of *Shubao*)." *Shubao
(Narrative Daily)*, 1884–1885.
Reprint, Taipei: Taiwan Xue-
sheng Shuju, 1965.

Wu Youru. *Wu Youru Huabao Hai-
shang Baiyantu* (Treasury of Wu
Youru Paintings: One Hundred
Shanghai Beauties), collection 3,
vol. 2. Shanghai, n.d.

Xi Dejin. "Lin Fengmian de yishu"
(Lin Fengmian's Art). *Duoyun*,
no. 53 (2000): 7–14.

Xu Beihong. "Zhongguohua gailiang
lun" (On the Reform of Chi-
nese Painting). 1920. Reprinted
in *Ershi shiji Zhongguo meishu
wenxuan*, vol. 1, edited by Lang
Shaojun and Shui Zhongtian.
Shanghai: Shanghai shuhua,
1997.

Xue Yongnian. "Bai'nian shanshuihua
zhi bianlun gang" (An Outline
of a Hundred Years of Landscape
Painting Development). In *Ershi
shiji shanshuihua yanjiu wenji*,
edited by Lu Fusheng. Shanghai:
Shanghai shuhua chubanshe,
2006.

Ye Xiaoqing. "Commercialisation
and Prostitution in 19th Century
Shanghai." In *Dress, Sex and
Text in Chinese Culture*, edited
by Antonia Finnane and Anne
McLaren. Clayton, Australia:
Monash Asia Institute, 1999.

———. *The Dianshizhai Pictorial:
Shanghai Urban Life, 1884–1898*.
Ann Arbor: Center for Chinese
Studies, University of Michigan,
2003.

Yeh, Catherine Vance. *Shanghai Love:
Courtesans, Intellectuals, and*

Entertainment Culture, 1850–1910.
Seattle; London: University of
Washington Press, 2006.

Yeh, Wen-hsin. *Provincial Passages:
Culture, Space, and the Origins of
Chinese Communism*. Berkeley:
University of California Press,
1996.

———. *Shanghai Splendor: Economic
Sentiments and the Making
of Modern China, 1843–1949*.
Berkeley, Los Angeles, London:
University of California Press,
2007.

Yeh, Wen-hsin, ed. *Becoming Chinese:
Passages to Modernity and Beyond*.
Berkeley: University of Califor-
nia Press, 2000.

———. *Wartime Shanghai*. London:
Routledge, 1998.

Yuan Muzhi. *Street Angel*. Translated
by Andrew F. Jones. MCLC
Resource Center, 2000. http://
mclc.osu.edu/rc/pubs/angel/
default.htm.

Zhang Qing. "Shanghai Modern
and the Art of the 21st Century."
In *Shanghai Modern, 1919–1945*,
edited by Jo-Anne Birnie Danz-
ker, Ken Lum, and Zheng Sheng-
tian. Ostfildern-Ruit, Germany:
Hatje Cantz, 2004.

Zhang, Yingjin. "The Corporeality
of Erotic Imagination: A Study
of Pictorials and Cartoons in
Republican China." In *Illustrating
Asia: Comics, Humor Magazines,
and Picture Books*, edited by
John A. Lent. Honolulu: Univer-
sity of Hawai'i Press, 2001.

Zhang Zhen. *An Amorous History of
the Silver Screen: Shanghai Cin-
ema, 1896–1937*. Chicago, Lon-
don: The University of Chicago
Press, 2005.

Zhao, Xin, and Russell W. Belk.
"Advertising Consumer Culture
in 1930s Shanghai: Globalization
and Localization in *Yuefenpai*."

Journal of Advertising 37, no. 2 (Summer 2008): 45–56.

Zheng Dongtian. "Films and Shanghai." In *Shanghai Modern, 1919–1945*, edited by Jo-Anne Birnie Danzker, Ken Lum, and Zheng Shengtian. Ostfildern-Ruit, Germany: Hatje Cantz, 2004.

Zheng Shengtian and Kazuko Kameda-Madar. "Artists' Biographies." In *Shanghai Modern, 1919–1945*, edited by Jo-Anne Birnie Danzker, Ken Lum, and Zheng Shengtian. Ostfildern-Ruit, Germany: Hatje Cantz, 2004.

Zheng Wen. "Xie Zhiliu nianbiao" (Brief Biography of Xie Zhiliu). *Mingjia hanmo*, no. 44 (1993): 31–37.

Zheng Wuchang. *Zhongguo huaxue quanshi* (A Complete History of the Study of Chinese Painting). 1921. Reprint, Shanghai: Shanghai shuhua chubanshe, 1985.

Zheng Yimei. "Youguan Ren Bonian de ziliao" (References on Ren Bonian). In *Xiaoyangqiu*. Shanghai: Rixin chuban she, 1947.

Zou Mianmian. "Tao Lengyue nianbiao" (Tao Lengyue's Chronicle). *Duoyun*, no. 51 (1999): 255–264.

About the Authors

Nancy Berliner is Curator of Chinese Art at the Peabody Essex Museum in Salem, Massachusetts, where she is also curator of the Yin Yu Tang house and exhibition galleries. In addition, she has curated exhibits of Chinese art at the Museum of Fine Arts, Boston, and the Yale University Art Gallery, among others. She has lectured at Harvard University, Dartmouth College, the Asia Society of Houston, and the China Institute. She has written for the *New York Times*, the Asian *Wall Street Journal*, the *Boston Globe*, and *Asian Art* and *American Craft* magazines, and is the author of *Chinese Folk Art*; *Beyond the Screen: Chinese Furniture of the 16th and 17th Century*; *Friends of the House: Furniture from China's Towns and Villages*; *Inspired by China: Contemporary Furnituremakers Explore Chinese Traditions*; and *Yin Yu Tang: The Architecture and Daily Life of a Chinese House*.

Dany Chan is Curatorial Assistant of Chinese Art at the Asian Art Museum, San Francisco. Her forthcoming article (2010) in *Orientations* will focus on the development of Shanghai graphic arts.

Britta Erickson, Ph.D., is an independent scholar and curator living in Palo Alto, California. She is on the advisory boards of the Ink Society (Hong Kong) and Three Shadows Photography Art Centre (Beijing), as well as the editorial boards of *Yishu: Journal of Contemporary Chinese Art* and *ART Asia Pacific*. In 2006 she was awarded a Fulbright Fellowship to conduct research in Beijing on the Chinese contemporary art market. She has curated major exhibitions at the Arthur M. Sackler Gallery, Washington, D.C., and the Cantor Center for Visual Arts, Stanford. In 2007 she co-curated the Chengdu Biennial, which focused on ink art. Her publications include three books: *The Art of Xu Bing: Words without Meaning, Meaning without Words*; *On the Edge: Contemporary Chinese Artists Encounter the West*; and *China Onward the Estella Collection: Chinese Contemporary Art, 1966–2006*.

He Li is Associate Curator of Chinese Art at the Asian Art Museum, San Francisco. She is co-author of *Power and Glory: Court Arts of China's Ming Dynasty* and author of *Chinese Ceramics: A New Comprehensive Survey, from the Asian Art Museum of San Francisco*.

Michael Knight is Deputy Director of Strategic Programs and Partnerships, and Senior Curator of Chinese Art, at the Asian Art Museum, San Francisco. He is co-author of *Power and Glory: Court Arts of China's Ming Dynasty* and *The Monumental Landscapes of Li Huayi*, and author of *Far Eastern Lacquers in the Collection of the Seattle Art Museum* and *Early Chinese Metalwork in the Collection of the Seattle Art Museum*.

Li Lei is Executive Director of the Shanghai Art Museum, Vice President of both the Shanghai Academy of Plastic Arts and the Academy of Young Literature, and curator of a number of contemporary art exhibitions in Shanghai. He is also a successful artist and has had his works included in many exhibitions in Beijing and Shanghai, as well as in New York, Frankfurt, Linz, Amsterdam, Brussels, and Rome. In France, he is currently represented by ARTFRANCE in Paris, where some of his canvases are permanently on display. Since 1996, a number of books, monographs, and exhibition catalogues have been published on his works in China, several European countries, and the United States. As a member of the Shanghai Artists' Association and the Chinese Artists' Association, he keenly follows China's growing art movement, passionately channeling his efforts into the cultural life of Shanghai.

Shan Guolin is Head of the Department of Painting and Calligraphy at the Shanghai Museum. A leading expert in his field, he is noted for his research on Shanghai-school painting.

Wen-hsin Yeh is the Richard H. and Laurie C. Morrison Professor of History at the Institute of East Asian Studies at the University of California, Berkeley. A leading authority on twentieth-century Chinese history, she is the author or editor of eleven books and numerous articles that examine aspects of Republican history, Chinese modernity, the origins of communism, and related subjects. Her books include the Berkeley Prize–winning *Provincial Passages: Culture, Space, and the Origins of Chinese Communism* and *The Alienated Academy: Culture and Politics in Republican China, 1919–1937*. Her most recent publication, *Shanghai Splendor: Economic Sentiments and the Making of Modern China, 1843–1949*, is an urban history of Shanghai that considers the nature of Chinese capitalism and middle-class society in a century of contestation between colonial power and nationalistic mobilization.

Index

NOTES *Italic page numbers denote illustrations. To distinguish them from works of art, publications are annotated with a description or the date of publication.*

Xu Xi (10th c.), 85
Xu Xiaocang, 82
Xu Yongqing (1880–1953), 51, 52
Xu Zhen (b. 1977), 210, 211
xuan paper, 231

Yakovlev, A. S., *October* (pub. 1923), 180
Yali University, Changsha, Hunan Province, 84
Yan Wenliang (1894–1988), 84, 204
Yan Zhenqing (709–785), 48
Yang Borun (Yang Nanhu, 1837–1911), 47; *Sceneries of the Earthborn–Cymbidium Orchid Thatched House* (1869–1884, cat. no. 9, leaf F), 56, 58, *58*
Yang Fudong (b. 1971), 210; *City Light* (2000, cat. no. 125), 240–241, *241*; *Honey* (2003, cat. no. 127), 243, *243*; *Liu Lan* (2003, cat. no. 126), 242, *242*
Yang Nanhu. *See* Yang Borun
Yang Zhenzhong (b. 1968), 210
Yangzi Insurance Association Building, 37, *37*
Yao Wenyuan (1931–2005), 202
Yasui Sotaro, as influence, 135
Yeh, Wen-hsin, 4–5, 103, 125, 128
Yichun Gallery, Shanghai, 82
Yifei Modeling Agency, 215
Yipinxiang (restaurant), Shanghai, 96, *96*
Yokohama Specie Bank, 37, *37*
The Young Companion (*Liangyou huabao*) (periodical), 128, 135, 140, 248; *The Young Companion* no. 101 (January 1935, cat. no. 58), 136–137, *137*
Yu Ming (1884–1935), 48; *Huang Jinrong and Du Yuesheng* (1924, cat. no. 16), 48, *80*, 81
Yu Qifan, 127
Yu Youhan (b. 1943), 209
Yu Yue (1821–1906), *Sceneries of the Earthborn–Cymbidium Orchid Thatched House* (1869–1884, cat. no. 9, leaf U: inscription), 56, 65, *65*

Yu Yunjie (1917–1992), 161, 205; Mao Zedong (1968, cat. no. 84), 170, 171, *172*; *Our Land, Our People* (1948, cat. no. 82), *viii–ix* (det.), 170, 171; *Peeling Corn* (1963, cat. no. 83), 170, 171, *171*; *Studying Industry* (1974, cat. no. 85), 170, 171–172, *172*
Yuan Shikai (president of Republican China), 81
Yuan Songnian (1895–1966), *Working by Lamplight* (1950–before 1966, cat. no. 89), 176, *176*
Yuan Xiutang: Moonlight over Huangpu River (1930s, cat. no. 64), 146, 147, *147*; *A Prosperous City That Never Sleeps* (1930s, cat. no. 65), 146, 148, *148*
Yu Garden, Shanghai, 29, 57, 74, 77, 81, 131
Yun Nantian. *See* Yun Shouping
Yun Shouping (Yun Nantian, 1633–1690), 47, 61. *See also* school of art, Nantian
Yunnan Art Institute, Kunming, 232

Zao Wou-ki (Zhao Wuji), 132
Zendai Museum of Modern Art, Shanghai, 210–211, 249
Zhang Chongren (1907–1998), 51, 228; sculpture of Chiang Kai-shek by, 126
Zhang Chunqiao (1917–2005), 202
Zhang Daqian (1899–1983), 85
Zhang Gongjian, 60
Zhang Guoliang, *Cloth Sculptures on the Street* (1986), 209, *209*
Zhang Jian-Jun (b. 1955), 208; *Sumi-Ink Garden of Re-Creation* (2002), 238; *Time/Space* (1983), *208*; *Vestiges of a Process: Shanghai Garden: Proposal* (2009), *239*; *Vestiges of a Process: Shanghai Garden* (2010, cat. no. 124), 238, *239*; *Vestiges of a Process: ShiKuMenProject 2007* (2007, cat. no. 123), 236, *237*
Zhang Leping (1910–1992), 52, 205; *A Record of the Wanderings of*

Sanmao, 52; *Sanmao Follows the Army* (1946, cat. no. 102), 52, *190–191*, 191
Zhang Longji (b. 1929), *Power Distribution Worker* (1957 or 1959, cat. no. 86), 173, *173*
Zhang Meisun (1894–1973), 51
Zhang Qi (Zhang Zhiying), 47
Zhang Shichuan, 113
Zhang Xiaolin (1877–1940), 81
Zhang Xiong (Zhang Zixiang, 1803–1886), 47, 61, 204; inscription by, 70, 71, *71*; *Sceneries of the Earthborn–Cymbidium Orchid Thatched House* (1869–1884, cat. no. 9, leaf G), 56, 58–59, *59*
Zhang Yimou, *The Shanghai Triad* (*Yao, yao, yaodao waipo qiao*) (film), 17, 249
Zhang Yuguang, 126
Zhang Yuqing (1909–1993), *Waves of Anti-American Anger Along the Bund* (1961, cat. no. 108), *200–201*, 201
Zhang Zhixin (1930–1975), 227
Zhang Zhiying. *See* Zhang Qi
Zhang Zhongli, 22
Zhang Zixiang. *See* Zhang Xiong
Zhang Garden (Zhang Family Weichun Garden; Zhangyuan), 12, 95, 247
Zhao Bandi (b. 1966), 210, 213n15; *Come and Meet the Panda* (street theater, 2000), 210; Panda Couture (2008), *211*; *Panda Fashion* (fashion shows, 2007–2008), 210; *Zhao Bandi and the Panda* (series), 210
Zhao Fang, *The Course of a Marriage* (1930s, cat. no. 67), 149, *149*
Zhao Shuru (1874–1945), 50
Zhao Weimin, *Nanjing Road* (after 1923, cat. no. 62), 29, 52, 112, 117, 142, *142–143*
Zhao Wuji. *See* Zao Wou-ki
Zhao Zhiqian (1829–1884), 47, 48–49, 55, 78; calligraphies by (1869), 48, 54–55, *54–55*, 65

SHANGHAI
Art of the City

was produced under the auspices of the
Asian Art Museum–Chong-Moon Lee Center
for Asian Art and Culture

PROJECT DIRECTOR AND COLOR SUPERVISOR Thomas Christensen

Produced by Wilsted & Taylor Publishing Services
PROJECT MANAGER Christine Taylor
COPY EDITOR Melody Lacina
DESIGNER AND COMPOSITOR Tag Savage
PROOFREADER Nancy Evans
INDEXER Frances Bowles
PRINTER'S DEVIL Lillian Marie Wilsted

Typeset in Whitman, New Caledonia, and Helvetica Neue
Printed and bound on 157 gsm Gold East Matte
by CS Graphics Pte., Ltd., Singapore